Mimbres Painted Pottery

This publication was made possible by generous support from The Brown Foundation, Inc., of Houston, Texas. The Weatherhead Foundation graciously provided funding for the original edition.

Mimbres Painted Pottery

Revised Edition

J. J. Brody

A School of American Research Press Resident Scholar Book

Santa Fe, New Mexico

School of American Research Press
P. O. Box 2188
Santa Fe, New Mexico 87504-2188
www.sarweb.org

Director: James F. Brooks
Executive Editor: Catherine Cocks
Copy Editor: Jane Kepp
Design and Production: Cynthia Dyer
Indexer: Jan C. Wright
Proofreader: Sarah Soliz
Printer: Maple-Vail Book Group

Library of Congress Cataloging-in-Publication Data

Brody, J. J.
 Mimbres painted pottery / J.J. Brody.— Rev. ed.
 p. cm.
 "A School of American Research resident scholar book."
 Includes bibliographical references and index.
 ISBN 1-930618-66-2 (cloth : alk. paper) 1-930618-27-1 (paper : alk. paper)
 1. Mimbres culture. 2. Mimbres pottery. I. Title.
E99.M76B766 2004
738.3'089'97079—dc22

 2004009108

Cover illustrations: *Left*: WNMU 73.8.132, courtesy of the Western New Mexico University Museum, Eisele Collection, Anthony Howell, photographer; *center*: AMNH 29.1/326, courtesy of the American Museum of Natural History, Photo Studio, R. Mickens, photographer; *right*: UCM 3098, Courtesy of the University of Colorado Museum, Fred Stimson, photographer.

Contents

Illustrations

All vessels listed are Mimbres Classic Black-on-white unless noted otherwise.

Maps

Plates (after page 52)

Figures

Tables

Abbreviations Used in the Captions

Note: Height precedes diameter in all measurements given in the captions.

AMNH	American Museum of Natural History, New York, New York
ASM	Arizona State Museum, University of Arizona, Tucson.
DLMM	Deming Luna Mimbres Museum and Custom House, Deming, New Mexico.
DMNS	Denver Museum of Nature and Science, Denver, Colorado
EMAP	Eastern Mimbres Archaeological Project, Departmentof Anthropology, Arizona State University, Tempe.
HM	Heard Museum, Phoenix, Arizona.
HMUM	Hudson Museum, University of Maine, Orono.
HP	Peabody Museum, Harvard University, Cambridge, Massachusetts.
IARC	Indian Arts Research Center, School of American Research, Santa Fe, New Mexico.
LACMNH	Los Angeles County Museum of Natural History, Los Angeles, California.
LM	Logan Museum, Beloit College, Beloit, Wisconsin.
MF	Mimbres Photo File, Maxwell Museum, University of New Mexico, Albuquerque.
MIAC/LAB	Museum of Indian Art and Culture/Laboratory of Anthropology, Museum of New Mexico, Santa Fe.
MMA	Maxwell Museum of Anthropology, University of New Mexico, Albuquerque.
MNA	Museum of Northern Arizona, Flagstaff.
MRM	Millicent Rogers Museum, Taos, New Mexico.
MWC	Museum of Western Colorado, Grand Junction.
NDUM	Notre Dame University Museum, Notre Dame, Indiana.
NMAI	National Museum of the American Indian, Smithsonian Institution, Washington, DC.
NMNH	National Museum of Natural History, Smithsonian Institution, Washington, DC.
NPS	National Park Service.
PAM	Princeton University Art Museum, Princeton, New Jersey.
SWM	Southwest Museum, Los Angeles, California.
TAM	Texas A&M University, College Station.
TARL	Texas Archaeological Research Laboratory, University of Texas at Austin.
TM	Taylor Museum of the Colorado Springs Fine Arts Center.
UARK	University of Arkansas Museum, Fayetteville.
UCM	University of Colorado Museum, Boulder.
UPM	University Museum, University of Pennsylvania, Philadelphia.
WM	Weisman Art Museum, University of Minnesota, Minneapolis.
WNMU	Western New Mexico University Museum, Silver City.

Preface to the Revised Edition

The first edition of this book, published in 1977, was part of the School of American Research's Southwest Indian Arts Series, conceived by the School's then president, Douglas W. Schwartz, generously supported by the Weatherhead Foundation, and published by the University of New Mexico Press. The book was generally well received and stayed in print for about twenty years. For the most part I liked it, especially the sections about design analysis and iconography, which are reprinted here with relatively few changes. Still, even at the time of publication, I was not happy with all of it, as I made clear in the original preface, which follows this one.

Yet I was optimistic about the future of Mimbres research, and my optimism proved justified. Even as I was writing and editing the original manuscript, between 1973 and 1976, an almost forty-year hiatus in Mimbres archaeological research had already ended. Field programs that began in the early 1970s with Steven LeBlanc and his young Mimbres Foundation colleagues and with Harry Shafer and his Texas A&M University archaeological field schools were only the first of a series of archaeological investigations that are still taking place in Mimbres country. As important as the fieldwork has been the nearly universal commitment by the many different researchers to conscientiously and creatively publish about their work and its implications. Individually and collectively they have modified our ways of thinking about the ancient Mimbres people, cleared away much of the "trash," answered many of the chronological questions, refined taxonomies, and developed some theoretically fascinating propositions about the Mimbreños and their art. Almost simultaneously, Mimbres pottery paintings came to be featured in national and international museum exhibitions that generated the publication of important analytical and interpretive essays about the art by art historians and other scholars.

The many changes I have made in this volume are responses to those contributions. I have rewritten some chapters almost entirely and left others nearly unaltered. To summarize: The original preface is unchanged. The introduction and chapter 1, "Discovery of the

Mimbres," are modified in relatively minor ways that recognize the passage of time and bring the history of Mimbres archaeology up to date. In chapter 2, "The Mimbres in Their Place and Time," I have excised several egregious errors, added details, and made other, more minor changes. Chapter 3, "Mimbres Village Life," is radically altered to incorporate information and interpretations generated since the mid-1970s. I have replaced its original focus on the Swarts Ruin with a synthesis based on more recent fieldwork and on reinterpretations of larger Mimbres villages in the Mimbres Valley such as Galaz, NAN, Mattocks, and Swarts. Chapters 4, "The Mimbres and Their Neighbors," and 5, "Inventing Mimbres Painted Pottery," are also greatly modified to take into account a generation's worth of investigation, analysis, and reinterpretation of Southwestern archaeology and the art and archaeology of the Mimbres region. Chapters 6, "The Potters and Their Craft," and 7, "The Form and Structure of Mimbres Classic Black-on-White Pottery," have been modified with the addition of new insights into the technology of Mimbres pottery painting, its developmental history, and its visual and expressive qualities. Chapter 8, "Representational Paintings," is significantly altered in many respects, but chapter 9, "Ethnoaesthetic and Other Aesthetic Considerations," is substantially unchanged.

I have also adopted with minor modifications—as have most other researchers working with Mimbres materials—the terminology and chronological sequences proposed in 1981 by Roger Anyon, Patricia Gilman, and Steven LeBlanc (see table 1). Thus, "Classic Mimbres period" replaces "Mimbres phase," "Late Pithouse period" overarches the Georgetown, San Francisco, and Three Circle phases, and the Mangas phase and Mangas Black-on-white are abandoned, the latter usually replaced by either Style I or Style II Mimbres Black-on-white or, on occasion, Mimbres Boldface Black-on-white. I join most other specialists in making general use of the style phases initially proposed by Catherine Scott (1983) and later modified by Harry Shafer and Robbie Brewington (1995). However, for reasons noted in chapter 5, and especially because of my conviction that "transition" is a constant in any active art tradition, I consider the name "Transitional (Mimbres) Black-on-white," which some analysts use to classify the unclassifiable paintings that seem to bridge different style categories, tautological. I find it more useful to simply note those paintings that seem to incorporate elements of two or more of the readily defined style phases.

I have also made every effort to delete some common terminology that I consider inappropriate and misleading, such as the word "borrowed" to mean the appropriation by one society from another of ideas, styles, words, or other notions. "To borrow" is an economic transaction—to accept a loan that is expected to be repaid—and I have never heard of the return of a "borrowed" idea, with or without interest. With less conviction I have generally bowed to the political needs of the moment and tried to find reasonably accurate substitutes for the useful notional term "Anasazi," which is now anathema to some Pueblo people. What is still wanting is an agreed-upon neutral term to distinguish the ancient Pueblo societies of the Colorado Plateau from other ancestral Pueblo societies, including those we call Mogollon. Finally, the abbreviations B.C. and A.D. have been replaced in this edition with the "common era" abbreviations B.C.E. and C.E.

There is greater understanding today than there was thirty years ago of the geographical

range of the Mimbreños and the subtle flexibility of their adaptations to their dynamic physical and social environments. There is also lively, ongoing debate about how and why it all ended, about the dispersion of the Mimbres people, about how their pottery art functioned in their society, and about what it might have meant to them. Perhaps most remarkably, the foolish fear of art that once characterized American archaeologists trained during the third quarter of the twentieth century seems finally to be fading. Many Mimbres archaeologists now accept the obvious and agree that expressive art is clearly part of the Mimbres archaeological record and must be examined with as much serious objectivity as any other component of that record. Consequently, in recent years some have made important and creative contributions to formal, theoretical, iconographic, and chronological studies of Mimbres art—and the more they practice, the more skilled they become.

Still, I am both puzzled and bemused by a sense that many archaeologists remain unconvinced that art objects are multifunctional social tools. They continue to believe that the primary objective of representational picture making is to replicate an aspect of the tangible world as it is, rather than to create visual metaphors. I hope that someday most archaeologists will subscribe to the propositions that art is by definition an act of imagination and that it is a fit subject of study in their discipline for no other reason than because it is an ordinary and essential act of social communication practiced in all human societies.

Late in the 1970s, largely through Steve LeBlanc's efforts, the Maxwell Museum of Anthropology at the University of New Mexico, where I then worked, became custodian of a Mimbres photographic archive that now

numbers about sixty-five hundred pictures of Mimbres painted vessels. In subsequent years, many scholars in various disciplines used this invaluable resource, and it became a critical stimulant in developing new understanding and debate about Mimbres art. The archive played, and still plays, an important role in the spate of analytical, technical, theoretical, speculative, and popular publications about Mimbres art that began in the 1970s. Of special value to me, despite inevitable disagreements, are those by Roger Anyon, Steve LeBlanc, Steve Lekson, Marit Munson, Margaret Nelson, Catherine Scott, Harry Shafer, Brian Shaffer, Rina Swentzell, and Mark Thompson. Most are listed in the highly selective bibliography to this edition, which has only to be compared with the much shorter but virtually encyclopedic one published in the first edition of the book to see that far more has been done with Mimbres art and archaeology, on the ground, in museums, and in publications, during the last thirty years than in the previous seventy.

I must also acknowledge the great impact that several thoughtful reviews of the first edition of this book and of an earlier draft of this manuscript had on me. Among others, Roy Carlson (1978) and Florence Hawley Ellis (1978) took me to task for failing to pay more attention to the ethnology, oral traditions, and ethos of the Pueblo Indians and for being less than positive about the interpretive value of those factors for Mimbres materials. I took those criticisms seriously enough to do more homework during the intervening years and to reconsider and modify my earlier positions— but only somewhat, and I expect and welcome further debate on those issues. More recently, two anonymous reviewers of this volume provided some critically important suggestions that, I think, improved the work considerably. I

thank them. Finally, during the last thirty years I have listened to and spoken with so many people about Mimbres painted pottery that conversations, names, faces, and places are all hopelessly blurred in my mind. Still, some emerge and I am more grateful than I can tell for insights gained from listening to Nathan Begay, Eric Blinman, Bernard Cohen, Bill Gilbert, Harry Shafer, Brian Shaffer, and Rina Swentzell.

Life experience has taught me that more often than I like to think, clichés are true, old saws are pertinent, and the road to hell is paved with good intentions patterned by the law of unintended consequences. When I wrote the original edition of *Mimbres Painted Pottery* I should have anticipated, but did not, that it might further stimulate an already overheated market for Mimbres pottery art. It did that, and thereby contributed to the increased scale of looting of Mimbres sites by commercial pothunters that had begun during the 1960s. They were responding to market demand, and their looting totally destroyed many ancient Mimbres villages and degraded many others. Because untouched sites are now few and far between, and the most vulnerable of those that remain are reasonably well protected, I doubt that this new edition will lead to much further harm.

The 1977 edition also contributed more subtly to the rising market value of Mimbres painted pots, in that a monetary premium was placed on privately owned vessels that were pictured in it. Furthermore, implicitly and in some cases erroneously, my book certified them all as authentic, and they all became desirable trophies. I have been asked to identify more specifically those whose authenticity I now question, but in a litigious society it is unwise to publicly call anything "fake" without

technical evidence. Therefore, beyond assuming that any vessel that has neither provenience nor a solid provenance is either a fake or so altered that it might as well be one, I sidestep the issue here. Caveat emptor. Looting follows the money, some collectors are greedy, even more are naive, and the most destructive looting of archaeological sites everywhere in the world is a direct response to an art marketplace that is childishly easy to manipulate. Rather than directly contribute again to an inherently destructive antiquities market, I have used in this edition, with a few necessary and carefully screened exceptions, only Mimbres paintings that are in publicly owned collections, presumably insulated from the marketplace.

This revised edition came about with the support and advice of two valued friends, Joan O'Donnell, then director of the School of American Research (SAR) Press, and Douglas Schwartz, then president of SAR. As the volume moved forward, James F. Brooks, now director of SAR Press, staff editor Catherine Cocks, and freelance editor Jane Kepp eased the process with their guidance and assistance. I am grateful to all of them, to Cynthia Dyer who designed this volume, and to many other people and institutions for their help. In the original volume I acknowledged taking advantage of my position as director of a museum to intrude on other museums and private collectors. Now that I am in that world by courtesy only, I continue to take advantage of my former position and continue also to be warmed by the generosity of onetime strangers and former colleagues.

Many of the same people and institutions who helped me in so many ways to prepare the first edition and are acknowledged in the original preface helped me again with this one, and I thank them one more time. In addition, I add

Cynthia Bettison, Museum of Western New Mexico University; Lisa Stock, Lori Pendleton, and David Hare Thomas, American Museum of Natural History; Mike Lewis, Maxwell Museum of Anthropology; Valerie Verduz and Chris Turnbow, Museum of Indian Art and Culture/Laboratory of Anthropology; Ruth Brown and Sharon Lien, Deming Luna Mimbres Museum (Deming, New Mexico); Steve Whitington, Hudson Museum, University of Maine; Ruth Selig, National Anthropological Archives, Smithsonian Institution; Bruce Bernstein, National Museum of the American Indian, Smithsonian Institution; David Rosenthal, National Museum of Natural History, Smithsonian Institution; Linda Cordell, Deborah Confer, and Stephen Lekson, University of Colorado Museum; and Lyndel King and her incurably helpful staff at the Weisman Museum of Art, University of Minnesota. Once again, so many people spent so many hours helping me locate, look at, and photograph Mimbres pottery that I cannot possibly name them all. I trust they will still consider their help to me as bread cast upon the waters.

Finally, I rededicate this book to that same hardy quartet (and now their associated progeny) who braved the near-Arctic conditions of East Anglia during the oil-crisis winter of 1973–1974 so that the original manuscript could be written. The memory may have faded, but history tells us that chilblains and a three-day work week were British responses to that crisis, and it was in that year we learned that climate, not woad, painted the ancient Picts blue.

Preface to the 1977 Edition

"The creative act is not performed by the artists alone; the spectator brings the work in contact with the external world by deciphering and interpreting its inner qualifications and thus adds his contribution to the creative act."—Marcel Duchamp, 1957

Almost seventy years ago, Marcel Duchamp invented "readymades" and demonstrated that art spectators could have an active art-creative role. A readymade was an object or part of an object that had been made, perhaps industrially, for some nonartistic purpose. These could become works of art by virtue of being discovered and named. Several decades before Duchamp created his first readymade, the industrial world was inventing the concept by its acts of discovery, acts that made art out of artifacts created by and for ancient and modern nonindustrial peoples. The "creation"—by discovering and naming—of primitive art clearly enriched the sensibilities and artistic vocabularies of the industrial world. However, even today it is by no means certain that the original makers of these new-old art objects are generally thought of as artists, any more than were the manufacturers of Duchamp's readymades. Instead it seems that the makers of these artistic things are most often thought of as the insensate tools of something very like a natural force that we call culture.

When we think that way, then the shape an art takes is necessarily perceived as inevitable, formed by culture in much the same way canyons are carved by rivers or skies are colored by atmospheric dust. Rather than being people, artists become tools of culture. By contrast, our own artists are generally thought of as the essence of ego, creative individualists who invent novel ways of expressing unique personalities. We place great value on biographical information (Beethoven's deafness, van Gogh's mental illness, Billie Holiday's drug addiction) that reinforces our image of art as an idiosyncratic activity practiced outside of culture by tormented if talented individuals. Museums, scholars, and collectors carry the concern for documentation a step further and consider the record incomplete if they cannot locate the

precise spot from which Cézanne painted a landscape or discover what the weather was like that day.

Because of the way so many of us think about primitive art, its documentation is all too often shabby. Many of the same museums, scholars, and collectors who know that Mozart wrote a particular song in a particular key to suit the talent of a particular singer have art objects in their collections that were torn from the earth by treasure hunters or taken from remote West African villages by modern-day mountain men who treat the stuff as though it were beaver pelts. Consequently we know nothing about the artists and must guess (with resultant errors) the time and place a thing was made.

The distortion is gross and symmetrical: our artists are no more free of their culture than were those of the Mimbres a thousand years ago. Theirs were as free as ours to play individualistic, expressive games with their art. Ours, by their lifestyle and their products, express alienation from society; theirs expressed integration with society. In both cases, individual artists merely performed or perform the roles assigned to them by their respective societies. In both cases, the respective cultures modified or modify the shape of the art in many of the same ways, with much the same effect.

There are vast differences between the artists of small, tightly integrated societies and those of our sprawling industrial states, and these differences are evident in their respective art products. These are differences only of degree, not of kind, and they cannot be interpreted unless we accept the fact of basic identity. Artists are human beings: people who make art. What I have attempted here is to treat Mimbres art as real art made by real people.

There is much here that I am not satisfied with. I am uncomfortable with the time frames, not at all confident about explanations of historical events and relationships, and believe that I have only begun to explore iconography. Douglas Schwartz wanted this to be a definitive art history. When I began, I thought it could be. It is anything but that. Still, either this book or something very like it had to be written even though a definitive work is years away. There is too much trash to be cleared, too much archaeology to be done before questions of chronology and prehistory can be answered satisfactorily. I am confident that in years to come village and even individual styles will be defined and we will know within a decade and a few miles when and where a particular picture was made. We will also be able to explain the meanings of many of these paintings. All of this will be the work of many minds and will happen only if radical changes occur in our attitudes and beliefs about how art is or was made by small, tightly integrated societies.

I am grateful to many people and institutions for making this book possible. The University of New Mexico allowed me leave time during 1973-74 when the first draft was written in the village of Haddenham, East Anglia. Cambridge University, the University of London, the Horniman Museum, and the British Museum all graciously made library and museum resources available. Special thanks are due the staff of the Maxwell Museum for bearing with me during an overlong gestation period. And of course none of this would have happened without the support and encouragement of Douglas Schwartz, Harry King, and others at the School of American Research. I owe a special debt of gratitude to Wanda

Conger of the School of American Research: her patience is matched only by her persistence and perceptive criticism.

Colleagues and friends who contributed freely of their knowledge and ideas include Doug Schwartz, Jane and David Kelley, Charles Di Peso, Steve LeBlanc, Wes Jernigan, Bruce Bryan, Barton Wright, and many others. Most will find their contributions so mangled as to be invisible. The first six named read the manuscript or parts of it. Jernigan also drew the maps and other diagrams and illustrations. No one but myself is responsible for errors of fact or interpretation.

During the past few years, I have taken unfair advantage of my position as director of a museum to intrude on other museums and private collectors. So many people spent so many hours helping me locate and photograph Mimbres pottery that I cannot possibly name them all. I trust they will consider their help to me as bread cast upon the waters. Except for the Museum of the American Indian, all of the institutions that were of assistance are acknowledged with the illustrations. At the risk of offending others, I must here also thank Mary and John King, Tony Berlant, Joe Ben Wheat, Ron Stewart, and Larry Hammack for acts of special generosity and kindness. And a word must be said for Fred Stimson, a most sensitive photographer and excellent traveling companion. Finally, and even though some of them still haven't read their first book, I dedicate this one to a hardy quartet who learned to wear sweaters in the house, summer or winter, during the Year of the Three-Day Week.

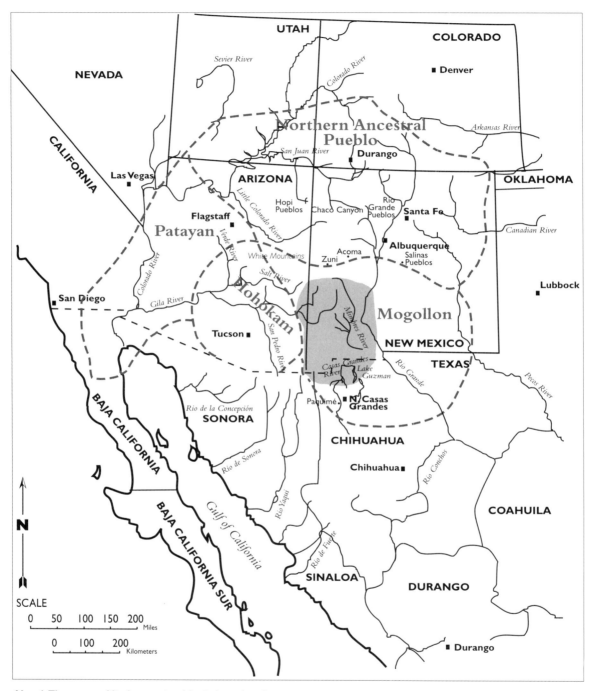

Map 1. The greater Mimbres region (shaded area) and contemporaneous culture areas (after Cordell 1997:24).

Introduction

In the isolated mountain valleys and hot deserts of southwestern New Mexico lie the remains of perhaps a hundred or more small villages where Native Americans now known as the Mimbres people lived between about 1000 and 1150 C.E. (Maps 1 and 2). These ruins would offer little of interest to anyone but the inhabitants of the region and a handful of archaeologists if they had not yielded up a remarkable kind of painted pottery. The name for this ware—Mimbres Black-on-white, or Mimbres Classic Black-on-white—is misleading. The paint is often brown or red rather than black, and the background color may be light gray, cream, or buff rather than white. More to the point, the pottery-naming system favored by Southwestern archaeologists gives no more idea of the character of this pottery than do the unimpressive remains of the villages where it was produced. By any name, Mimbres Black-on-white appears to be a climax ware, a type of pottery on which a certain set of visual ideals and values was pushed to its ultimate limits. This achievement of the Mimbres potters seems highly improbable, for in the expecta-tions of the generation of scholars who first studied them, they were the wrong people, liv-ing in the wrong place and under the wrong circumstances, to carry that particular tradition to a climax.

These potters were not deeply concerned about either ceramic technology or ceramic form. Most of their production was of unpaint-ed but textured utility wares—serviceable, per-haps inelegant, and certainly an acquired taste for modern collectors of Pueblo Indian pot-tery. Their painted pottery usually took the form of relatively deep bowls made with tech-niques that permitted hemispherical vessels to be pulled out of shape, colors to change almost randomly, and exteriors to be marked with fire clouds. Their primary concern was to use pot-tery as a surface on which to paint pictures. The hallmarks of Mimbres Black-on-white are complex geometric, representational, and narrative paintings, often made with an elegant line and powerful, dynamic masses of dark and light areas always placed within framed picture spaces. The contrast between visually subtle pottery forms and enormously attractive

paintings argues that a distinction should be made between the two, for only the latter have generated interest in the modern world—and that to a remarkable degree.

The most usual painting surface for a Mimbres artist was the interior of a hemispherical bowl. With limited technical means but deft skill, using only a few compositional systems and fewer elements, these artists organized and reorganized their concave picture spaces into myriad complex patterns. At their worst they produced moderately pleasing decorations, and at their best, powerful statements of that mysterious decorative-expressive duality that we call art. Iconographically and visually, the finest Mimbres paintings are at once simple and complex, clear and obscure, easily perceived and impossible to read. That several generations of subsistence farmers living in small, isolated villages should have produced art of this order is the central art-historical problem posed by Mimbres painting.

Historical data are essential to the understanding of any art production. Unless we know who created a work of art and why, how and when it was made, whom it affected and in what ways, and how it was judged and valued, the art object is easily transmuted into a "found object," a Duchampian "readymade," or even only another kind of natural object. The threat is always that the original makers will be perceived as human equivalents of the anonymous and nonhuman natural forces that are responsible for making sunsets and rainbows and that their artworks will be treated as found objects with the finders their re-creators (Brody 1974:11–13, 20–21; Lebel 1959:35–41, 77–78).

With Mimbres as with many other ancient arts, the historical, humanizing data that exist are fragmentary and poorly understood. Reordering this limited knowledge so that it yields all possible information about the meanings Mimbres art might have had for Mimbres people is an absolutely necessary first step in reconstructing its history. We have three major sources for such data on the Mimbreños: archaeology, ethnology, and the existing paintings. The Mimbres people, for all of the interest their art has generated, were until recently among the most poorly known of all ancient Southwestern peoples. The most comprehensive archaeological information about them has been developed largely since the 1970s and reported on since the 1980s. Data obtainable through ethnology are necessarily problematical, because identification of the Mimbres as ancestral to any contemporary people is a complex and uncertain proposition. Even if this were not the case, the many hundreds of years that separate the Mimbreños from the modern world would make questionable any assumptions based on the oral traditions or practices of any modern people. The paintings themselves, especially those that represent humans and human activities, do offer a rich source of information. Treated as documents, and in the light of knowledge culled from other sources, they can help flesh out the skeletal structure of Mimbres history. Too often, however, the paintings lack essential dating and provenience information, so they are incomplete as historical documents.

A major objective of this study is to reconstruct the history of Mimbres painting. Toward that end I distinguish between art production and art consumption. The first is limited to a specific time and place, and its parameters can be defined. The second is open-ended, for so long as the paintings—or even their memory—exist, their history will be unfinished. Mimbres art was rediscovered in the twentieth century, and it belongs to the modern industrial and

postindustrial world as well as to that of an unrelated, unrecorded time past. Its history became entwined with that of twentieth-century art, and it continues to interact with contemporary art worldwide. The story would be incomplete if it were to end in the ancient past. Other issues that I touch upon include the very broad and basic questions of why art is produced, and where, and under what circumstances. Mimbres art requires explanation in terms of the relative isolation, the economy, and the lifeways of the people who produced it. And despite the paucity of conventional historical data, information is available to suggest and support hypotheses pertaining to these problems, allowing generalizations to be made.

Finally, I am concerned with the mechanics of painting and with the processes involved when an image is made by applying paint to a blank surface. A picture starts as nothing and becomes a microcosm, a model universe that has its own physical and structural laws. So long as it exists, it transcends whatever aesthetic values motivated its producer or affected the judgments of contemporary or later users. At different times and places it can be appreciated, disliked, or ignored. The only permanent and universal messages it can possibly carry and the only keys available to its objective understanding are embodied in the peculiar logic of its forms and structure. Thus, an analysis of the physical and mechanical nature of a painting is yet another way to approach its meaning. With this end in mind, I examine the structural logic of Mimbres painting in some detail.

Mimbres Painted Pottery

Discovery of the Mimbres

In 1963, a buyer for a New York art dealer was sent to the American Southwest with instructions—or so he said—to purchase ten thousand Mimbres painted pots. This claim elicited several casual reactions at the time: that nowhere near such a number of vessels existed; that most existing pots were in public collections; that the market could not possibly absorb such a quantity; and that the buyer had probably lied.[1] Only the buyer's principal knows what the order was or whether it was filled. It is certain that large numbers of pots were bought, including several forgeries. Most were eventually sold to collectors, and some found their way into public museums.

Sixty years earlier, only a handful of painted Mimbres pots was known outside of south-western New Mexico. Today, hardly a museum of anthropology or natural history in the United States does not have a few examples. Some have hundreds, and at least one has more than a thousand. Fewer examples, though still a significant number, are found in art museums, having generally been selected for their aesthetic and expressive qualities. Several score pieces are in the collections of at least a dozen European and Asian institutions. The total number in

public collections around the world is well over four thousand. The number of contemporary private art or curio collectors who own Mimbres pottery is unknown, but it surely exceeds one thousand. Of these, no fewer than thirty have more than fifty examples each, and at least a dozen others have hundreds. Thus the total number of Mimbres pots in private collections may be greater than that in public ones. When the two are combined, the number of known Mimbres painted pots might well approach that once inconceivable figure of ten thousand.

For all practical purposes, there was no Mimbres art at the beginning of the twentieth century, and so, in a sense, this ancient art belongs to the modern world. Certainly it has behaved like a twentieth-century commodity. When a market for it was demonstrated in about 1914, the supply increased, but prices remained fairly stable.[2] When demand spurted again some fifty years later, supply and prices both increased, and forgeries and "partial" forgeries appeared. As early as the 1920s, a few damaged vessels were restored and partially repainted (in-filled), usually by the collector or members of his or her family, with various

degrees of skill and accuracy (compare figs. 31 and 32). By the 1950s, and especially since the market boom of the late 1960s, the goal for many dealers and collectors was to make ancient vessels look pristine by filling in and repainting all broken and lost parts and eliminating most visible traces of ancient wear and tear (see fig. 29). In extreme cases, damaged vessels were so completely repaired, repainted, and even refired that virtually no part of the original is any longer visible. In some instances, vessels that were originally painted with geometric images have reentered the market enhanced by spurious representational scenes. An essential fact about Mimbres art in the modern world is its conversion from something made by eleventh- and twelfth-century villagers into an art-market commodity with all of its ramifications.

When the Mimbres people left their villages in the twelfth century, their art was effectively erased from all knowledge. Between then and the 1700s, parts of their territory were reoccupied by Mimbreño or other farming peoples, were abandoned once more, and then became home to bands of Chiricahua Apaches, relative newcomers to the region. Until their expulsion by Euro-Americans late in the nineteenth century, the Apaches made it difficult for other people either to live in the territory or to exploit it. Hispano farmers came to the Mimbres Valley in the eighteenth century, giving it the name it now has, and copper mining began about then. A mining camp was established at Santa Rita (see map 2) during the early years of the nineteenth century (Ogle 1939:338), but it was not until the last quarter of that century that military control over the Apaches and the coming of the railroad opened this isolated and difficult country to settlement by Euro-American townspeople and ranchers. Earlier, some exploration of the area had been reported

by military and civilian surveying expeditions, but the late nineteenth-century settlers and some of their military protectors were the first people known to have disturbed the long-dead Mimbres villages. Eventually, their information reached scientists who had the means to interpret the finds, conduct systematic investigations, and communicate the new knowledge to the rest of the world.

Ancient village sites in the Mimbres country may have been noted as early as 1756 by members of a Spanish military expedition (Kessell 1971:147) and were certainly reported by John R. Bartlett, commissioner for a U.S.–Mexico boundary survey, a century later (Bartlett 1854, 1:220–223). Cliff houses discovered in 1875 in the rugged mountain canyons near the headwaters of the Gila River were mentioned in a report by H. L. Henshaw (1879), and the anthropologist Adolph Bandelier recorded some sixty ancient villages along a thirty-mile stretch of the Mimbres River valley in 1883–1884 (Bandelier 1892:350–358). In 1898 William Taylor, a local amateur antiquarian, reported on the excavation of a Mimbres site (Taylor 1898:258–261), and four years later Professor U. Francis Duff, an antiquarian, published a short description of a dozen others (Duff 1902). A decade later additional sites were reported by C. L. Webster, a geologist and occasional archaeologist who had begun work in the area in 1889, when archaeological activity could still be inhibited by Apache hostility (Webster 1912b). Webster recorded that some friends had been killed by Apaches and noted that "four times during these explorations did the writer himself come 'within an ace' of meeting death in the same and other ways" (Webster 1912a:102). Whether Webster exaggerated or not, the fact remains that a series of military posts was established

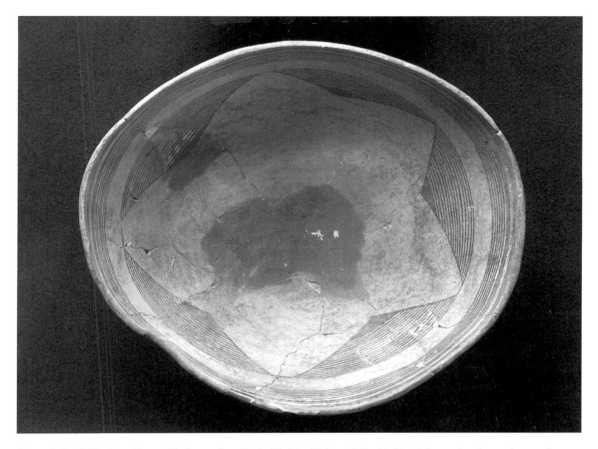

Figure 1. Bowl, Mimbres Classic Black-on-white (Style III), 14 x 29.2 cm, 5.5 x 11.5 in. A five-pointed negative star is at the center of one of the first Mimbres paintings to be removed from southwestern New Mexico. Excavated by Mrs. W. O. Owen before 1902, either at Fort Bayard or in the Gila River drainage. (NMNH 178824)

across the region to protect against Apache raids, and some of these posts were maintained until about 1900.

There is little evidence that any of the early investigators was aware of the unique qualities of Mimbres painted pottery. In 1878 and 1879, looted collections of Mimbres material were sent to the United States National Museum, but painted pottery seems not to have been included (Hough 1907:83–84). Nonetheless, it is certain that some had been unearthed well before the turn of the century, perhaps as early as 1866. In that year Fort Bayard was built about ten miles east of Silver City, near the Santa Rita copper mines, as one of a network of military strongholds designed to contain the Apaches. By happenstance, it was located directly on top of an ancient Mimbres village, and throughout the early history of the fort, excavations at the site were a common recreational feature of cantonment life (Hough 1914:45). In 1902 Mrs. W. O. Owen, wife of

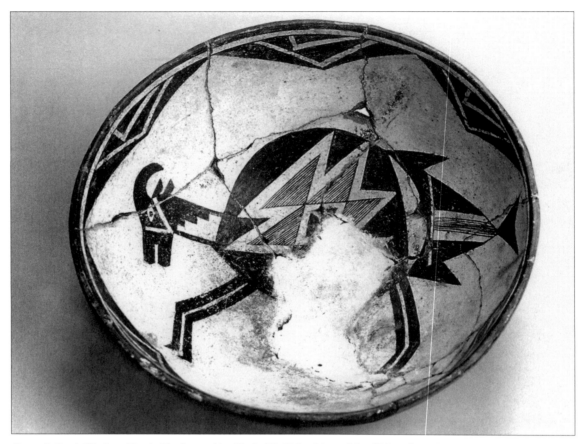

Figure 2. Bowl, Mimbres Classic Black-on-white (Style III), 11.3 x 26 cm, 4.5 x 10.2 in. Animal with bighorn sheep and fish attributes. Excavated by E. D. Osborn at Osborn Ruin south of Deming, N.M. Among vessels sold in 1914 to J. Walter Fewkes for the U.S. National Museum in the earliest recorded purchase of Mimbres pottery (Fewkes 1914:pl.5, fig. 2). (NMNH 286.340NM)

the commandant, gave several painted Mimbres vessels that she had unearthed at Fort Bayard, and possibly also from the Gila River valley, to Walter Hough, chief ethnologist of the United States National Museum, for transmission to that institution (fig. 1). That same year she gave two small Mimbres pictorial bowls to the Cincinnati Art Museum.[3] Hough was visiting on the first of his two archaeological surveys of the region, and his 1907 report contains the first published pictures of Mimbres painted pottery.

In 1902, Ivan DeLashmutt of the University of Arizona guided Hough to a number of Mimbres sites, and in that year and again in 1905, ranchers and townspeople throughout the region helped members of his two expeditions locate and map sites. Some of these ruins had been heavily pothunted, and it was obvious that many local people considered archaeology to be a pleasurable avocation. In reference to sites in the San Francisco River drainage, Hough (1907:41) wrote that "during the period of the

spoilation [sic] of the ruins of the Southwest… [many] had suffered great damage." His optimistic implication that spoliation was a thing of the past was hardly justified. Although many Mimbres ruins were certainly violated before 1905, the damage was only a harbinger of what was to follow. Nonetheless, because of these activities Mimbres sites and Mimbres pottery were known to people in the region. Hough had been given some tantalizing hints about the pottery, but appreciation of its unique artistic character was not to be broadcast for another decade.

Mimbres Art Rediscovered

The first major collections were formed as a result of the amateur excavations that Hough had deplored. At Deming, New Mexico, Dr. S. D. Swope and businessman and rancher E. D. Osborn separately accumulated quantities of Mimbres artifacts, including painted pots. In 1914, Minnie Weaver Swope gave her late husband's collection to the Deming High School, testimony that mere acquisitiveness was not the only motive that had led him into amateur archaeology (Fewkes 1914:6; NAA 1914, Box 60). Osborn played the most active role in bringing Mimbres art to the attention of the world outside southwestern New Mexico. He had amassed a large number of painted vessels from several sites on public and private land, including one on his ranch about twelve miles southeast of Deming. In 1913 he wrote to the United States National Museum, describing his collection and sending photographs of major items. These pictures were the first conclusive evidence that the few pieces acquired by Hough a decade earlier were representative examples of a tradition and not merely oddities.

Osborn's letter and photographs prompted Jesse Walter Fewkes to go to Deming in the spring of 1914. Fewkes was one of the eminent archaeologists of his time, an expert on the American Southwest, and an enthusiastic student of ancient American Indian art. His interest in Osborn's collection amounted to official recognition of Mimbres painting as an important ancient art. After purchasing a number of pieces from Osborn for the National Museum and, with Osborn's assistance, himself excavating at and near the Oldtown Ruin, Fewkes returned to Washington and promptly wrote and published a well-illustrated account of Mimbres art (Fewkes 1914; NAA 1914, Boxes 60, 69). During the next few years Fewkes returned to the Mimbres area on several occasions, and other publications followed, but 1914 was the year in which he formally introduced Mimbres paintings to the world (fig. 2). It was a limited introduction, for anthropological journals were the media, the scientific community was the public, and information only gradually filtered outward to a wider audience.

Over the next decade Fewkes purchased hundreds of painted Mimbres vessels, mainly from Osborn (NAA, Box 69). Those portions of Osborn's collection that he did not acquire for the National Museum he soon sold on behalf of the Smithsonian to other institutions, primarily the American Museum of Natural History and to George Heye's Museum of the American Indian, both in New York (the latter is now the National Museum of the American Indian in Washington and New York), forming the nuclei of their fine collections of Mimbres art. Fewkes understood and expressed regret over the fact that his 1914 report on the Mimbres had stimulated local collecting (NAA 1915, Box 69: Jan. 19), but his concern had more to do with local collectors' competing with him for Mimbres pottery than with the fact that

his purchases stimulated site destruction and the loss of scientific information. In any event, even though other museums were now acquiring major collections of Mimbres pottery, interest in Mimbres art remained essentially parochial, limited to specialized museums and ethnographically oriented collectors. To much of the outside world—even that part of it whose interest in the arts was intense and professional—Mimbres painting remained almost as well hidden until the 1970s as it had been in the years before World War I.

Except for minor excavations by Hough in 1902 and Fewkes in 1914, no professional archaeologist excavated at a site that produced Mimbres Black-on-white pottery before the 1920s. Among the many amateurs who did, Harriet (Hattie) and Cornelius (C. B.) Cosgrove of Silver City were by far the most important (Davis 1995). They first explored Mimbres ruins shortly after moving to Silver City from Kansas in 1907, and by 1919 their enthusiasm had led them to purchase a site at Whiskey Creek between Fort Bayard and Silver City. By renaming the Whiskey Creek ruin "Treasure Hill," they seemed to express an involvement that was hardly scientific, but this was misleading. Swope's interests in archaeology had been at best antiquarian, and Osborn's motives after 1914 were certainly commercial, but the Cosgroves became increasingly professional and scientific in their attitudes. They spent the summers of 1920 and 1923 observing and participating in excavations at Southwestern ruins under the direction of three of the most important Southwestern archaeologists of the day. They worked for, conferred with, and learned from Frederick Hodge at Hawikuh, Neil Judd at Pueblo Bonito in Chaco Canyon, and, most importantly, A. V. Kidder at Pecos Pueblo (Davis 1995:19–28). In 1923 Kidder

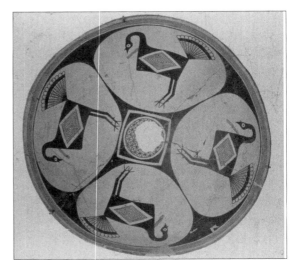

Figure 3. Bowl, Mimbres Classic Black-on-white (Style III), 12.3 x 30 cm, 4.8 x 11.8 in. Four turkeys, each in an ovate framed space. Excavated by the Peabody Museum, Harvard University, at Swarts Ruin, 1924–1927. (HP 94916)

invited them to work for the Peabody Museum at Harvard University and to direct the Peabody's excavations in the Mimbres Valley. They soon made their commitment to the profession of archaeology, retiring from business to become staff members under Kidder at the Peabody Museum. From 1924 to 1927 they excavated the Swarts Ruin in the Mimbres Valley for the Peabody. The hundreds of Mimbres Classic period pottery paintings from that site, as well as others they had collected earlier from other ruins and gave to the Peabody, have made that institution's collection of Mimbres art the greatest anywhere (fig. 3).

The Cosgroves also stimulated interest in Mimbres archaeology in Santa Fe at the School of American Archaeology (now the School of American Research) and the Museum of New Mexico. This resulted in the 1923 excavations at

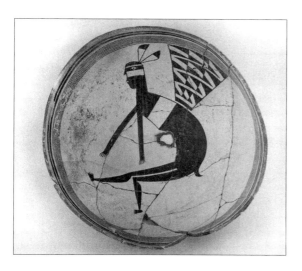

Figure 4. Bowl, Mimbres Classic Black-on-white (Style III), 11.7 x 27 cm, 4.6 x 10.6 in. A rabbit-eared, rabbit-tailed person carries a burden basket. Excavated by the School of American Research and Museum of New Mexico at Cameron Creek Village, 1923. (MIAC/LAB 20420/11)

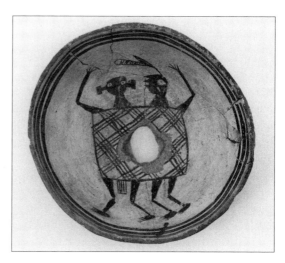

Figure 5. Bowl, Mimbres Classic Black-on-white (Style III), 8 x 17 cm, 3.2 x 6.7 in. Two people under a plaid blanket, the one on the left with a woman's "maiden's whorl" hairdo and fringed apron and the other with an eagle-feather headdress. Excavated by the Beloit College Field School at Mattocks Ruin, 1929–1930. (LM 16130)

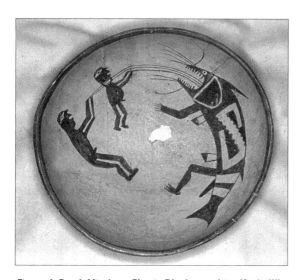

Figure 6. Bowl, Mimbres Classic Black-on-white (Style III), 8.5 x 20-20.75 cm, 3.4 x 7.9-8.2 in. Two men with fish lines seem to have caught a large, part human, part catfishlike animal. See figure 13 for a similar subject. Excavated by Earl Morris at McSherry Ruin in the Mimbres Valley, 1926. (UCM 3267)

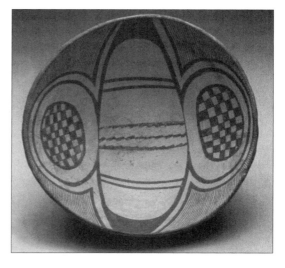

Figure 7. Bowl, Mimbres Boldface Black-on-white (Style II), 11 x 25 cm, 4.3 x 9.8 in. An abstract design suggests a human face with a "maiden's whorl" hairdo. Excavated by the University of Minnesota Field School at the Galaz site, 1929–1931. (WM 11B 416A)

Cameron Creek by Wesley Bradfield (Bradfield 1925, 1927, 1931) and the accumulation of important collections of Mimbres art for the Museum of New Mexico and the San Diego Museum of Man (fig. 4). The Southwest Museum in Los Angeles sponsored one season's excavation at the Galaz site in 1927, directed by the Cosgroves' son Burton (Bryan 1927, 1931a, 1931b, 1931c, 1961, 1962). The Cosgroves also encouraged the 1929 and 1930 excavations at the Mattocks and Starkweather Ruins by Paul Nesbitt of Beloit College in Wisconsin (fig. 5; Nesbitt 1931, 1938), and they helped another legendary amateur-turned-professional archaeologist, Earl Morris, locate Mimbres materials for the University of Colorado in Boulder (fig. 6; Kidder 1932:xvi–xviii). Collegiality was rampant. Bradfield in turn smoothed the way for Albert E. Jenks's excavations at the Galaz site between 1929 and 1931, a project sponsored jointly by the University of Minnesota and the Minneapolis Institute of Art. Though Jenks published almost nothing about his Galaz work, it did produce the large and important collection of Mimbres painted pottery that is now at the Weisman Art Museum of the University of Minnesota (fig. 7; Anyon and LeBlanc 1984; Brody and Swentzell 1996).

Other significant public collections of Mimbres art include those of the Museum of Northern Arizona in Flagstaff—largely a gift of Harriet Cosgrove—the Arizona State Museum in Tucson, the Maxwell Museum of the University of New Mexico in Albuquerque, the Museum of Western New Mexico University in Silver City, and the Deming Luna Mimbres Museum in Deming, New Mexico. In all cases, these collections were either acquired directly as the result of institutional excavations or had been accumulated by amateurs, mostly during the first three decades of the twentieth century, and donated or sold to the institution.

By late in the 1930s, and until recent years, friction often characterized relationships between amateur and professional archaeologists in the Mimbres region. The causes were multiple: competition over an ever-dwindling number of sites, the more than occasional illegality of amateur excavations, the professionals' perception that there was little to distinguish amateur archaeologists who might sell an occasional pot from professional looters, and the local amateurs' perception that professional archaeologists themselves were little better than looters, because until World War II they, too, seemed often to be concerned primarily with acquiring painted pottery. For all of these reasons, and also because many Mimbres sites are on public land and protected by federal legislation, many private collectors preferred and still prefer to remain anonymous, and dealers, including auction houses, often refuse to reveal their sources. The few professional pothunters of those early years also protected the locations of their sites. A by-product of all of this has been the loss of important information about the Mimbres pottery that is now in many public and private collections.

Relationships between professional and amateur archaeologists have been an important element in the rediscovery of Mimbres art. The initial finds were made by amateurs, often willing and even eager to guide professionals to sites, to give part or all of their collections to public institutions, and to help the scientists in any way they could. In return, few asked for little more than a share of the professionals' knowledge and perhaps some personal recognition. But excavation is always destructive, and amateurs, in their eagerness to find artifacts,

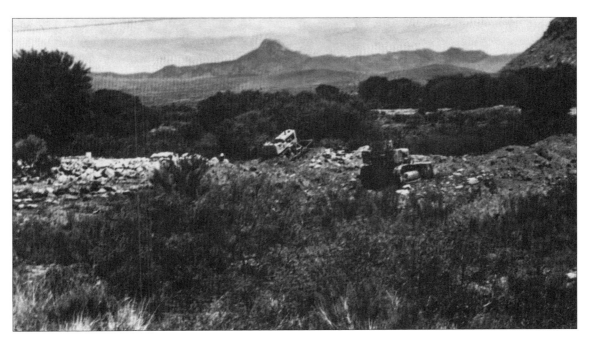

Figure 8. The Galaz site being bulldozed by professional pothunters in 1976. Photograph courtesy of the Mimbres Foundation.

too often destroy information that could have been interpreted by a trained archaeologist. Hough's complaints about "spoilation" were justified and have echoed and re-echoed through time, for an archaeological ruin, once disturbed, can never be made whole again. Thus, professionals will almost inevitably regard unsupervised, untrained amateur excavators as potential vandals. In recent decades, however, as professional pothunters have become ever more destructive, the distinction between looters and amateur or avocational archaeologists has become sharper. Once again, in the face of a common enemy, mutual respect and cooperation is becoming more characteristic of relationships between avocational and professional archaeologists in the Mimbres country.

The professionals' response to the destruc-tiveness of their discipline is to select sites in terms of specific questions and problems, excavate minimally and with tedious care, and maintain copious records that make it possible not only to simulate reconstruction of an excavated site but also to provide an enormous amount of detail about the lives, habits, and relationships of the people who once lived there. Professional archaeology is therefore extraordinarily expensive and proceeds at a snail-like pace that permits only a small number of sites to be investigated during any one generation. But the greatest difference between professional and amateur used to be less a matter of training or method than of attitude. Most professionals excavated a site in the hope of obtaining information; most amateurs excavated a site in the hope of finding artifacts.

Although most avocational archaeologists today share, or profess to share, the values and attitudes of the professionals, residual frictions still limit the sharing of information in southwestern New Mexico.

The exposure of Mimbres art created a demand for it that could not be met by professional archaeology. Institutions that sponsored excavations of Classic Mimbres sites were often unable—for legal and other good reasons—to share collections with other institutions, no matter how large their collections were. Many schools and museums that could not or would not conduct their own excavations wanted the painted pottery in any event. A market had existed from the time the first recorded sale of Mimbres pots was made to one of the great scientific institutions of the world, and institutions formed the core of the market for more than fifty years. But demand was heightened by curio collectors and, later, by art collectors, stimulated by the post-1980 rash of art exhibitions and well-illustrated, art-oriented publications featuring Mimbres pottery (Brody, Scott, and LeBlanc 1983; Brody and Swentzell 1996; Fields and Zemudio-Taylor 2001; Moulard 1984; Townsend 1992).

Since 1914, amateur archaeologists in the Mimbres area have known that they could enrich themselves by finding Mimbres pots. By 1960 or earlier, the commercial motive had led to mining of sites with earth-moving equipment for the sole purpose of finding whole painted vessels. Looting, which became particularly outrageous during periods of local economic recession, accelerated greatly when Native American art, including Mimbres painted pottery, became unprecedentedly popular after about 1968. Wholesale depredations by unscrupulous looters initially led to panic among amateur archaeologists. Many became

understandably eager to excavate as many sites as they could in the shortest possible time, with the certain knowledge that what they did not dig, the mechanized plunderers would (fig. 8). Inflationary pressures between the late 1960s and the 1990s sent prices skyrocketing, and the booming economies and wealth accumulation that characterized international economic conditions between then and the beginning of the new millennium only added to the pressure.[4] Mimbres painted pottery has unprecedented economic value, and at the time of this writing, looters are the primary excavators of Mimbres archaeological sites.

The consequences have been disastrous. Mimbres ruins that had been perfectly secure for seven hundred years and could have been safe for another seven thousand have been disturbed or destroyed. Out of them has come one example after another of Mimbres art, brought to the marketplace anonymously, with no history and no knowledge of its associations or derivations. When site destruction first intensified, relations between professional and amateur archaeologists eroded, and the kinds of mutual assistance that had characterized their dealings in the early part of the twentieth century almost disappeared. The inability of professionals and amateurs to combine effectively against professional pothunters helped make the later history of Mimbres art a tragedy. Some blame for this must fall squarely on the professional archaeologists, in part because of a tendency by some of them to consider all amateurs vandals, in part because they permitted their institutions to become a market factor in Mimbres art, and in part because of their general lack of interest in Mimbres archaeology. Understanding the reasons for this indifference is essential to understanding how Mimbres art became a twentieth-century commodity, a

kind of natural resource to be exploited at low cost for high profit.

The Rise and Fall—and Rise Again— of Mimbres Archaeology

When Mimbres art first came to notice, a major concern of Southwestern archaeologists was to reconstruct the history of the region. To do this it was necessary to distinguish among the different ancient peoples and periods and to develop chronological and cultural frameworks. In the time of Hough and Fewkes, much was done to forward these ends. The major research tools were excavation, investigation of early historical records, and the gathering of traditional oral histories of the native peoples. Fewkes especially was fascinated by this last procedure and worked with the Hopis in an attempt to relate archaeological evidence to their oral traditions (for example, Fewkes 1897, 1919). Others, including Kidder, Hodge, Nels Nelson, and Edgar Lee Hewett, laboriously worked backward from the known to the unknown. They developed techniques for establishing a rough prehistoric chronology and for defining the relationships among different ancient ruins and between those sites and modern Pueblo people. The most important of their methods, used by all but Hewett, involved the analysis of pottery collected during stratigraphically controlled excavations (N. Nelson 1914; Spier 1917). This involved isolating the various layers within a site, describing the pottery fragments found in each level, and then comparing every group of potsherds with those from other strata and other sites. By these means, it became possible to develop chronological sequences that have since proved remarkably accurate. The painstaking descriptions of pottery also had value

for indicating historical relationships among the various sites in the Southwest.

Close study of pottery traditions suggested that the culture history of the southern part of the Southwest was distinct from that of the north. By the same means, it became clear that in the north, the villages of the Mesa Verde, Chaco, and Kayenta regions on the Colorado Plateau and those of the middle and northern Rio Grande drainages were related and had been inhabited by ancestors of the modern Pueblo people (see map 1). Curiously, the word "Anasazi," an English-language corruption of any of several different Navajo terms for the ancient people of the Colorado Plateau, came to be used by archaeologists as a generic term for early Pueblo sites and people. The history and ethnic affiliations of the southern part of the Southwest were more difficult to reconstruct and to this day remain more obscure.

Bandelier, Hough, and Fewkes all recognized that Mimbres Black-on-white differed in its visual qualities only somewhat from the pottery of the northern Southwest, but they had scant evidence to show what relationship, if any, the people who made it had to those as-yet-unnamed ancient people of the north. Still, these pioneers realized that Mimbres Black-on-white wares were radically different in appearance from the dominant red-slipped, red-painted pottery of the region that produced it, and they could not adequately explain the phenomenon. By 1914, if not earlier, Fewkes and Hough had guessed that the Mimbres ruins were roughly contemporaneous with the large pueblos of Chaco Canyon and the cliff houses of Mesa Verde. They suspected, as Bandelier had earlier, that some Mimbres Valley sites were more ancient than, and some were contemporaneous with, those of the Casas Grandes region of northern Mexico, and they wondered

whether the pottery painting of Casas Grandes might not have been derived in part from that of the Mimbres region (Bandelier 1892:350–351; Fewkes 1924:1–3, 27–28).

Few questions about Mimbres history could be answered without careful and professionally defined excavations. The first of these was begun by Wesley Bradfield at Cameron Creek Ruin along a tributary of the Mimbres River in 1923. The next year, the Cosgroves began excavations at the Swarts Ruin east of Cameron Creek along the Mimbres River. In 1929 and 1930, Paul Nesbitt excavated at the Mattocks Ruin, upstream from Swarts, and Jenks worked at the Galaz site between Swarts and Mattocks. Until the 1970s, these were the most thoroughly excavated of all Mimbres sites, and except for Galaz, which was essentially unreported until 1984, their descriptive and analytical reports were the most comprehensive ones published until the 1970s.[5]

The concerns of most early archaeologists were mainly descriptive, historical, and acquisitive. They attempted to reconstruct the realities of village life and to place their sites within cultural and temporal boundaries. But collection of painted pottery was also a driving force. For example, Nesbitt's stated objectives in excavating Mattocks Ruin were to do historically oriented research, to train students in archaeological techniques and procedures, and to "obtain material from this little-known region for museum display" (Nesbitt 1931:11). Similarly, the archaeological field schools at the Galaz site from 1929 to 1931, led by Albert E. Jenks, had as their primary purpose the collection of Mimbres painted pottery (Brody and Swentzell 1996:24). About eight hundred painted Mimbres vessels were acquired at Galaz for the two sponsoring institutions; all of them are now at the Weisman Museum of Art of the

University of Minnesota. Earlier, during the summer of 1927, the Southwest Museum in Los Angeles had sponsored excavations at Galaz, and Bruce Bryan's brief descriptions of that season's work and its results laid great stress on speculative historical interpretations and on the visual quality of the painted pottery collected from the site, particularly representational pictures (Bryan 1927:325, 330; 1961; 1962; see also Anyon and LeBlanc 1984). Although very little was published about the Galaz site at the time, the preservation of students' field notebooks and other excavation notes made it possible for a comprehensive report to be published more than fifty years later (Anyon and LeBlanc 1984). Still, the museum and academic sponsors of excavations of Mimbres sites, as recently as the 1930s, were to some degree as concerned with unearthing painted pottery for museum collections as Fewkes had been fifteen years earlier.

Nonetheless, the Cosgroves, Nesbitt, and Bradfield never lost sight of their professional responsibilities, and each contributed to the reconstruction of Mimbres history. So far as they could determine, the temporal limits of the Mimbres were not vastly different from those proposed by Fewkes in 1914. Their sites seemed to be roughly contemporaneous with what by 1932 was called the Pueblo III, or Great Pueblo, period of the ancient Pueblo sequence, dating between about 1100 and 1300 C.E. Cultural affiliations were more difficult to ascribe. Several horizons were uncovered at all of the sites, and although the most recent at each appeared similar in many respects to traditions of the northern Southwest, those horizons overlay and seemed to derive from pithouse occupations that differed significantly from the pithouse villages of the north. Mimbres Black-on-white pottery

seemed to come from pithouse as well as later Pueblo-like horizons. It became clear that reconstruction of the history of the Mimbreños and their unique pottery required investigation of ruins ancestral to the villages that had made Mimbres Black-on-white. What had been thought of as a regional variant of ancient Pueblo traditions of the northern Southwest was now believed to have had southern and possibly non-Pueblo roots.

At about the same time, archaeologists working in the deserts of south-central Arizona had concluded that their sites were so different from those of the northern plateau that definition of at least two distinct ancient agricultural traditions in the Southwest was required. By about 1934, a southern culture called Hohokam had been defined by H. S. Gladwin, Nora Gladwin, Winifred J. Gladwin, E. B. Sayles, Emil W. Haury, and others based at the University of Arizona in Tucson and at the Gladwins' private archaeological laboratory, Gila Pueblo, near Globe, Arizona (Gladwin 1928; Gladwin and Gladwin 1933; Haury 1932). Archaeologists agree on no hard and fast rules for distinguishing among neighboring ancient cultural traditions that were more or less contemporaneous and more or less similar. Therefore, specialists often treat the announcement of a new ancient culture with cautious skepticism, and it took some years for the Hohokam to be accepted by others as a discrete cultural tradition, contemporaneous with and neighbor to the ancient Pueblos of the Colorado Plateau (Gladwin and Gladwin 1933).[6]

One visible and obvious difference between the northern people and the Hohokam lay in their ceramics. People of the Colorado Plateau produced mostly black-on-white painted pottery, and the Hohokam, red, brown, or buff wares. Knowing that brown and red wares were also commonplace in southwestern New Mexico, investigators of the Hohokam were inevitably attracted eastward and almost incidentally took up the problem of Mimbres origins. H. S. Gladwin was among the first to suggest yet a third basic prehistoric Southwestern farming culture located to the east of the Hohokam and south of the Colorado Plateau. This he called Mogollon (Gladwin and Gladwin 1934), after the steep and rugged mountain country that formed a physical barrier between the northern and southern parts of the Southwest (see map 1). Excavations by Emil Haury at sites along the San Francisco and Mimbres Rivers confirmed the Gladwin thesis and also provided evidence that ancestors of the people who had made Mimbres Black-on-white pottery were a Mogollon subgroup that came to be called the "Mimbres branch" (Haury 1936a). Definition of the Mogollon and their various regional sequences was further refined during the years immediately before and after World War II by Paul S. Martin and John B. Rinaldo of Chicago's Field Museum of Natural History.

As the archaeological work continued, a series of temporal phases came to be recognized for each Mogollon region. Mimbres Black-on-white pottery was now understood to be diagnostic of the final period of the Mimbres branch, then called the Mimbres phase, and the ware was perceived as one of a number of Colorado Plateau Pueblo-like influences that signaled the coming end of a recognizable Mogollon tradition in that region. A synthesis of ancient Mogollon history by Joe Ben Wheat of the University of Colorado described and defined that culture in all of its complexity, up to but not including its later stages (Wheat 1955). Wheat's reconstruction was criticized by some, and William R. Bullard offered an

alternative synthesis several years later (Bullard 1962). However, interest in historically oriented Mogollon archaeological investigations faded away as archaeologists began to focus on problems more anthropological and ahistorical, especially studies concerning human adaptations to the ecological and social environments.

The sense of problem felt by professional archaeologists is, ideally, the critical factor in their selection of sites to be excavated. As early as 1902, Hough's desire to better understand why white- and gray-ware pottery characterized the Colorado Plateau while brown wares were dominant south of there led to his excavations at Luna Village on the San Francisco River northwest of the Mimbres Valley. His report on the work was published in 1914, long before the term "Mogollon" entered the archaeological literature, but the village was Mogollon. Southwestern archaeologists at that time were still too deeply immersed in the broad problems of northern Southwestern prehistory, especially with respect to the large ruins of the region, to spend energy on the small mountain villages of the south. After about 1930 it became apparent that questions of Mimbres origins could be answered only by excavating at sites such as Luna Village that overlapped with but predated the Mimbres Classic period. The archaeologists—Martin, Rinaldo, Haury, Sayles, and others—whose interest was with the early Mogollon were drawn away from sites rich in Mimbres art and attracted to those that might answer questions about earlier periods, including the time of transition by hunting-and-gathering peoples to agriculture, even if they yielded depressingly unattractive pottery (Martin and Plog 1973:3–34).

Everything considered, by the mid-1930s there was little of scientific value to be gained by further excavation of Mimbres Classic sites. The Cosgroves' report on the Swarts Ruin was thorough, Nesbitt's on Mattocks Ruin and Bradfield's posthumous Cameron Creek site report (1931) only slightly less so. Questions that these raised were being answered by work in progress on Mogollon archaeology (LeBlanc 1986). About fifteen hundred Mimbres painted pots had been collected from those three villages alone, and combining these with vessels at the United States National Museum, the University of Minnesota, the American Museum of Natural History, and the Museum of the American Indian, a large amount of pictorial material was readily available to anyone who wanted to use it. By the time the outline of Mogollon prehistory had been drawn, the focus of archaeological problems had shifted radically. Hattie Cosgrove was involved with other projects and no longer young, her husband was dead, and further investigation of Mimbres Classic sites held little attraction for other professionals.

During the early decades of the twentieth century, archaeology, as the "ethnology of the past," became an integral part of the emerging discipline of anthropology. Paul Martin had attempted to reconstruct the social organization of the Mogollon people as early as 1940, and after World War II, American archaeologists became concerned with problems of social anthropology rather than with narrative history (Martin 1940; Martin and Plog 1973:23–34). Thus, questions having to do with social process, change, cultural ecology, demography, and social systems replaced those about ancient history that had dominated Southwestern investigations before 1940. Regional concerns were largely irrelevant to the new problems, sites were selected for their universal rather than their historical implications, and visually or

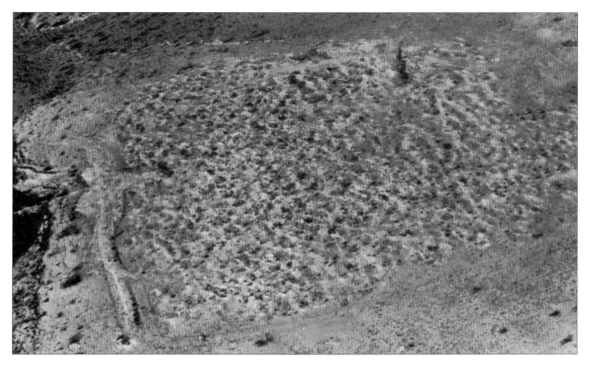

Figure 9. Oldtown Ruin, lower Mimbres Valley, after almost a century of pothunting. Each crater is a hand-excavated pothunting hole. A pothunter's bulldozer trench is at the left; another at the top of the picture was dug in about 1917 to train American troops for trench warfare. Photograph about 1976, courtesy of the Mimbres Foundation.

emotionally powerful artifacts such as Mimbres paintings could be perceived as distractions that might seduce objective scientists away from their planned studies. Mimbres sites were to be avoided unless the investigator had specific plans to study Mimbres art in its original social context.

Aside from problem solution, the only other professionally justified site-selection criterion is threat of destruction. Even though extensive vandalism after the 1960s clearly marked every existing Mimbres site as endangered, new laws protecting archaeological sites initially inhibited their conservation because looters rushed to mine sites before new legislation could take effect. Federal and state laws since the 1950s require that under certain conditions, archaeological sites threatened by construction of roads, dams, or similar projects must be either bypassed or excavated. But although funds are made available to support archaeology at such places, relatively few Classic Mimbres villages have been threatened by construction, and no public funds are offered to rescue sites threatened by vandals, no matter how immediate and obvious the danger.[7]

With so many sites gone, there appeared to be little hope that much more would ever be known about the people who made Mimbres art than was understood by the Cosgroves in 1928. A reversal of this depressing situation

began in the early 1970s. First came a series of surveys and limited excavations sponsored by the Department of Anthropology of Case Western Reserve University in Cleveland, Ohio, under the direction of James E. Fitting. These were training sessions in archaeological method and theory, and their scope was severely limited by time and money (Fitting 1971a, 1971b, 1971c, 1972). Of far greater import was work begun by the Mimbres Archaeological Center (later the Mimbres Foundation) in 1974, under the direction of Steven LeBlanc, then at the Institute of Archaeology of the University of California, Los Angeles, later based at the Maxwell Museum, University of New Mexico, and most recently at the Peabody Museum of Harvard University.

With the support of private foundation funds, LeBlanc's efforts were directed toward contemporary archaeological problems dealing mainly with the development of irrigation agriculture, human ecology, and demography.[8] But culture history was not ignored, and the project was also perceived as a kind of salvage archaeology, "an attempt to save for scientific study all available evidence on the prehistoric people of the Mimbres culture area" (LeBlanc 1975:1). In addition to using more traditional archaeological approaches, LeBlanc and his colleagues collected information from archival sources and disturbed sites, both those that had been pothunted and some that had been partially excavated by professionals in earlier decades. This approach proved surprisingly fruitful and has been pursued by others, including Darrel Creel of the University of Texas, Austin, working at the Oldtown Ruin, which had been devastated by pothunters for more than a century (fig. 9). LeBlanc and many of his colleagues who were students at the time, including Roger Anyon, Patricia Gilman, Paul Minnis, Ben Nelson, and Margaret Nelson, made and continue to make important contributions to the understanding of the Mimbres and other ancient people of the southern Southwest and northern Mexico.

Not long after the Mimbres Foundation began its work, Harry Shafer, of the Department of Anthropology at Texas A&M University, began a long-term project in the Mimbres Valley that focused on sites at the privately owned NAN Ranch, a few miles downstream from the Swarts Ruin. Among ruins there that had been pothunted in Fewkes's time (he himself had briefly excavated at a small Classic site there; NAA 1914, Box 60) was a large pithouse village and Classic Mimbres community known as the NAN Ranch Ruin. Though much more fine-grained and smaller in scale than the Cosgroves' work generations earlier, Shafer's NAN Ranch excavations are in many respects comparable to theirs. But modern archaeological theoretical constructs, techniques, and technology are far more complex and conservation-minded than those of the past. The NAN Ranch excavations have been, and will continue to be, far more informative about the Mimbres people than anything done by earlier generations in the Mimbres region (Shafer 2003).

Meanwhile, Mimbres pots are still being thrown out of the dirt by looters as though newly made. As a contemporary phenomenon, the story of Mimbres art is all too familiar. It is one of exploitation of an irreplaceable resource by irresponsible commercial interests and of the inability of the scientific community to harness potentially powerful and responsible public forces to protect that resource.

The Mimbres in Their Place and Time

Mimbres paintings were mostly made to be used by Mimbres people, both the living and the dead. Much of the art, though made on vessels that usually show evidence of domestic use, is found as grave offerings (Bray 1982). From this observation arose the widely held assumption that some, if not most of it, was made for mortuary use—an assumption contradicted by the once plentiful evidence of shattered black-on-white domestic vessels scattered over long-abandoned Mimbres villages and unsupported by any other evidence except the paintings themselves. Though these two functions, the ritual and the domestic, are usually treated in contemporary discussions as if mutually exclusive, there is no reason to believe that the Mimbres shared that dichotomy. If their attitudes concerning the domestic and the religious spheres were at all like those of historic period Pueblo and other native Southwestern peoples, then it seems far more likely that the vessels were made and painted for use in domestic settings with full knowledge that they could also be available for ritual service.

Occasional examples of Mimbres painted pottery have been found far from the Mimbres homeland, and some of these may have influenced the art of non-Mimbres people. Even more has been found in neighboring communities that were occupied by closely related groups, some of whom seem to have used it as a model for their own pictorial arts. Though the paintings are unique and easily recognized, they also belong to a much wider regional tradition, and on a superficial level they most closely resemble the black-on-white pottery of the ancient Colorado Plateau.

I claimed in the introduction that Mimbres pottery was an improbable climax ware, and the bases for this statement should be examined. First, the communities that produced the art were so small and their economies so geared to subsistence activities that they could hardly have supported any specialized artists. Yet the paintings are so consistently high in quality, and production was stable for so long a time, that something like art specialization seems to be indicated. Thus, questions must be asked about the communities: Despite appearances, could they have supported art specialists? If not, how were they able to maintain such high quality for so long? If so, what economic and

social factors made specialization possible? In either case, who were the artists, how were they supported, and what was their motivation?

The second basis is historical, for Mimbres geometric paintings appear superficially to be much closer to pottery traditions of the north, especially the Chaco-Cíbola region, than to those of the Mimbreños' ancestors. Did these people master a foreign art concept so quickly and completely that within only a few generations they could carry it to an ideal conclusion? If so, how and why did the Mimbres adopt those visual concepts? If not, then is the resemblance coincidental, the converging of two traditions each belonging to a much greater regional art tradition? And if that was the case, can the convergence be explained? Or is it possible that the visual qualities we think of today as diagnostic, particularly the use of black paint on white surfaces and of tightly controlled lines, were not diagnostically important to the Mimbreños—in short, are we focusing on the wrong visual qualities?

We can discover no answer to any of these questions, nor can we be sure that they are even the right questions to ask, unless we can place the Classic Mimbres people in historical, temporal, and physical contexts. Who they were and what they did were conditioned and tempered by the geographical and human environments in which they lived. This chapter and the two following describe those environments.

The Mimbres Territory

Although it is possible to draw precise geographical boundaries around some political units, no precise borders can be placed around the Mimbres country because its largest political unit seems to have been the village. Rather than a political organism, the term "Mimbres" identifies individual villages that were similar in appearance and shared a cluster of material expressions. An approximation of the extent of the densest Mimbres occupation during the Classic Mimbres period is shown in map 2. Ruins that evidence Mimbres influence or occupation are found in all directions beyond these borders, and other ruins found within this wider territory were lived in by distinct though closely related peoples (see map 1). This territorial fluidity should be understood as a consequence of defining the Classic Mimbres people almost solely by their manufacture of a certain kind of pottery. Thus, villages throughout the region still hold the power to alter putative territorial boundaries by having chosen to make or not to make Mimbres Black-on-white.[1]

Mountain ranges formed by volcanism define the Mimbres homeland on every side but the south, where it merges with the Chihuahuan Desert (fig. 10; see map 2). The northern boundary extends toward the sources of the Gila River in the rugged Mogollon Mountains. Farther north, reached by way of the valleys of the San Francisco and Tularosa Rivers near the present Arizona–New Mexico state line, is the parklike Plain of San Agustín, which spills onto an east-west corridor leading to the Rio Grande Valley on the east and funneling into eastern Arizona through pleasant valleys to the west.

Along the western boundary, the San Francisco and Blue Mountain ranges may have inhibited east-west movement, but foot traffic in those directions was relatively simple along the drainage of the Gila River. South of the Gila Valley, the north-south trending mountain ranges of the Basin-and-Range province are well defined. All can be difficult, but none is as dense and difficult as those of the north. West

Figure 10. The Chihuahuan Desert in the lower Mimbres Valley. Photograph by Fred Stimson.

of the Peloncillo Mountains, in the Sonoran Desert, and across the San Simon Valley and south of the Gila River are the more rugged Pinaleño, Dos Cabezas, and Chiricahua ranges. East-west passes exist through or between all of these, but the country is arid and no route is easy.

On the eastern side, north of Cook's Peak, the Black (or Mimbres) Range is formidable, and there are few easy east-west passes to the Rio Grande Valley. No extensive mountains bar traffic south of the Black Range, but again the land is dry and not pleasant for traveling. There are no sharp geographical boundaries in the south other than the Chihuahuan Desert, which can be barrier enough. Somewhere in that desert, probably in the vicinity of the Casas Grandes River in Chihuahua, Mexico, was the southern limit of Mimbres territory (Brand 1935:302). Thus, although their isolation could be breached, the Mimbres were easily reached only along their hot and dry

southern borders or by way of several narrow northern passes.

Sharp environmental contrasts exist within the greater Mimbres territory between northern highlands and southern deserts and between the high, dry Chihuahuan Desert of the southeast, where most of the Mimbres people lived most of the time, and the lower, wetter, and hotter Sonoran Desert of the southwest (Webster and Bahre 2000). The mountains of the north are a bewildering mass of pyramids piled on top of each other, extending over hundreds of square miles. It is neither their depth nor their height that makes them so impassable but the seemingly random way in which canyons have been cut to separate one steep-sided peak from another. The mountains are well watered, and their snowpacks feed streams in the springtime. Fed also by summer rains and underground springs, many streams run all year long to drain into one of four major river systems. The San Francisco River in the northwest is a tributary of the Gila River. The Gila, rising on the west side of the Continental Divide in the Mogollon Mountains, flows westward to join the Colorado River many hundreds of miles away, finally reaching the Pacific Ocean through the Gulf of California. A third river system, the Mimbres, also rises in the Mogollon Mountains, but on the east side of the divide. It flows southeasterly, going underground long before it reaches the ancient, shallow, inland lakes, or playas, of northern Chihuahua, which today are dry for most of the year. Finally, the watershed along the eastern slopes of the Black Range is part of the Rio Grande drainage system. None of the rivers within the Mimbres homeland is navigable.

The hundreds of small and large, permanent and intermittent streams and springs that

feed these rivers rise in the mountains north, northeast, and northwest of the Mimbres heartland. Many have cut steep-walled canyons between mountains—canyons that twist and turn, oriented to all points of the compass. Just as the region itself is isolated by its many mountains, so the valleys within it, including that of the Mimbres River, are isolated from each other by watercourses that may inhibit rather than promote communication and transportation. A typical canyon cut by one of the larger streams will periodically broaden out into a narrow, terraced river valley such as that of the Mimbres River (fig. 11). The floor of its first and lowest terrace will be covered by a layer of alluvium, perhaps 6 to 8 feet deep, deposited by the stream during its flood stages. Steep, rocky slopes often rise abruptly above this, sometimes to a height of 60 or 80 feet, to a second terrace, often composed of layers of dense clay and sand covered by thin topsoil. Hillsides, equally steep and rocky, rise above the second terrace to the mountaintops or to a third and sometimes a fourth terrace before reaching a summit.

Evidence of former volcanism is everywhere in the Mimbres country: hot springs, lava flows, boulder-filled consolidated layers of volcanic ash, enormous craters, or calderas, and, perhaps most obvious, cone-shaped or jagged mountains dramatically upthrust over the plains. South of the mountains, canyons, and river valleys, the landscape changes radically. It is a soil-covered, rolling desert, cut here and there by arroyos that contain water only after heavy summer rains. Many of the arroyos originate in springs and streams flowing from dark volcanic mountain ranges that dramatically interrupt the general flatness. Many arroyos drain into the usually dry basins, or playas, that dot the terrain. In former days these were lakes and

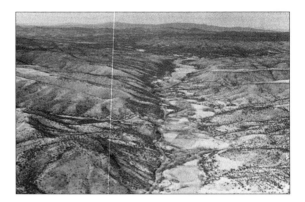

Figure 11. Terraces along the upper Mimbres River. Reproduced by permission from LeBlanc 1975, plate A.

marshes, and a few still remain wet for all or most of the year. Some, such as Playas Lake, are of impressive size. Drier now than in the past, this was once a pleasant if hot country.

Natural Resources

The Mimbreños exploited many of the rich mineral resources in their surrounding mountains. With an average annual precipitation of about 20 inches, the northern mountains are among the best-watered areas of the entire American Southwest (Wheat 1955:5–6). In earlier days, water was also adequate at lower elevations. It was the most vital of all natural resources to the people of the region.

Copper and iron ores, found as nuggets on hillsides or in streambeds, were sometimes ground into paint pigment, as was ocher dug out of hillsides. A variety of clays is present all over the area, most of it derived from the iron-rich volcanic rock of the region but some of it from deposits of fine, white volcanic ash that has been altered into a kaolinite-like clay (Eric Blinman, personal communication 2002;

William X. Chavez, personal communication 2003). These and ocher, turquoise, chert, and rhyolite were some of the minerals mined by the Mimbreños.[2] Boulders, especially of basalt and other volcanic rock, are everywhere, many just the right size for building house walls. Nodules of obsidian, chert, quartz, chalcedony, and other stones suitable for chipping into tools were locally available, and different grades of basalt and other, finer-grained stone could be ground into tool forms. Rare or attractive minerals, including turquoise, steatite, pipestone, drip lime, and fluorite, were used to make beads, pendants, and other kinds of decoration. The rich local deposits of copper, silver, and gold that have been exploited in recent times, however, were untouched by the Mimbres people. Salt may have been collected at or imported from the Zuni salt lakes to the north or from salt pans across the Rio Grande to the northeast. Virtually every mineral the Mimbreños needed or could exploit was available to them. Such commonly used materials as clay and basalt—as well as water—were available throughout the region, though they were more plentiful in the mountains than in the deserts. Some rarer materials, such as turquoise and fine grades of obsidian, were found only at certain highland locations.

The most radical differences between desert and mountain environments are to be found in the plant and animal life that each supports. As elsewhere in the Southwest, changes in vegetation in the Mimbres country correspond to abrupt changes in topography, orientation, soils, altitude, and availability of water. Varieties of succulents, especially cacti and yucca, grow at all but the highest elevations, some at altitudes of 9,000 feet or higher, and grasses grow everywhere. At lower elevations in the mountain ranges, the north sides of steep, rock-strewn hills or canyons may seem almost barren, with clumps of grass, clusters of prickly pear, and an occasional yucca the only prominent growing things. But on south-facing or gentler slopes, and on upper terraces and hilltops, plants of the Upper Chihuahuan life zone thrive. Most characteristic are piñon and juniper trees, acacias, and several varieties of oaks. Saltbush, mesquite, creosote bush, and many other shrubs grow amid patches of grass and scattered succulents on the thin-soiled ground, and healthy stands of large agaves, sotol, ocotillo, and bear grass are seen on south-facing hills at elevations of 6,000 to more than 7,000 feet.

On rolling hills and flat-topped mesas, the piñon-juniper forests continue until there is a radical change of topography or elevation. Where the soil is deeper, and especially on the higher, wetter mountains of the north, the trees grow closer together and forest floors may be more thickly grassed. At higher elevations, piñon and juniper gradually give way to the larger western yellow pines and ponderosas of the Transitional zone. As altitude increases, the pines mix with and are then replaced by magnificent Douglas firs and other high-altitude conifers and stands of tall quaking aspens. Near the summits of the very highest peaks, from about 9,500 to 12,000 feet, is the treeless Canadian zone, where mostly grasses, lichens, and wildflowers grow.

Well-watered, well-drained, shallow depressions occur occasionally between the piñon-juniper belt and the treeless zone, especially on saddles between mountains. Grassy meadows in these bowls are dominated by sagelike shrubs, sumac, and other bushy plants. Far below, on the alluvial terraces of the canyon bottoms and river valleys, are cottonwoods, willows, live oaks, and an occasional walnut tree. Where the alluvium is thick and streams

overflow their banks, flat, grassy meadows and dense clusters of willows and grape, gooseberry, chokecherry, hackberry, and other bushes grow. Extensive marshy areas with thickets of willow, cottonwood, and cattail once characterized the floodplain of the Mimbres River. Most of the large Classic Mimbres sites are found on terraces above the alluvium near these former marshes, usually at elevations below 6,500 feet.

Vegetation along the narrow, most arable, thirty-five or forty-mile stretch of the Mimbres Valley is of the Upper Chihuahuan type, characterized by piñon, juniper, grasses, and succulents, with cottonwoods, willows, cattails, and other riparian plants growing near the stream. Away from the river the landscape is rather barren now—almost grassless and dominated by snakeweed, creosote bush, mesquite, yucca, and cholla in far greater proportions than in the days before large numbers of cattle, introduced late in the nineteenth century, denuded the rich grasslands (Bahre and Hutchinson 2000:67–83; Bartlett 1854, 1:220–236). In several places in his diary entries between October 16 and 20, 1846, Lieutenant W. H. Emory described the country between the Black Range and the Continental Divide, including the Mimbres Valley, as covered with "luxurious" growths of grama and other grasses (Calvin 1951:96–102). Five years later, John R. Bartlett (1854, 1:230) described the portion of the Mimbres Valley roughly between the Mattocks site and Oldtown Ruin as a kind of Eden with extensive wetlands, dense bosques of cottonwood and willow, and even "in the driest time…an abundance of grass and water… and general exuberance of the vegetation." He marveled at the numbers of trout in the river and described surrounding hills "abound[ing] in wild animals" (p. 236).

Altitude decreases toward the south, and so does the water supply. Near the mountain bases the transition from Upper Chihuahuan woodlands to Lower Chihuahuan scrubby desert is often dramatic. Forests are reduced to a scattering of stunted junipers growing amid clumps of grass, creosote bush, greasewood, ocotillo, scrub oak, and healthy cholla, prickly pear, agave, and yucca. On the desert floor, grasses and mesquite and other bushes are plentiful, but the succulents dominate: yucca, agave, ocotillo, and many kinds of small and large cacti including prickly pear, cholla, and barrel cactus *(Ferocactus)*. Creosote bush, saltbush, chamisa, and Apache plume grow here also, almost hidden in the cuts made by arroyos and streambeds. Where there is water there are cottonwoods and live oaks, and reeds and willows grow in and near the occasional lakes or marshes. On some mountainsides of this arid region are small piñons and junipers, stunted relatives of those that occupy the lusher northern mountain slopes. Another dramatic transitional zone is found to the west in the Sonoran-Chihuahuan Desert border region where the states of New Mexico and Arizona meet (Webster and Bahre 2000:6–38).

Animal life is rich throughout the area, and excavated sites offer ample evidence that it was sometimes even more abundant in earlier days. Birds are everywhere, among them many migratory species and varieties of owls, hawks, eagles, buzzards, jays, thrushes, and wrens. In the mountains are wild turkeys, and in the desert, multitudes of doves, quail, grouse, and roadrunners. Major flyways are nearby, and migratory birds of all sorts come in season. Great numbers of geese, ducks, herons, cranes, and other waterfowl were once attracted to the now-dry scattered lakes, playas, and marshes of this desert.

Of the desert food animals, deer, pronghorns,

and bighorn sheep are the largest. Pronghorns roamed the area in great numbers in earlier times, grizzly bears lived there as recently as the late nineteenth century, and bison may have as well (Brand 1937:51–52). It is probable that now-rare desert bighorn sheep once lived in large numbers in the hills and mountains that rise above the desert floor. Foxes, coyotes, javelinas, and coatis are still found, along with varieties of rodents—wood rats, mice, prairie dogs, pocket gophers, and large numbers of cottontails and jackrabbits. Until recently, wolves were not uncommon. Many lizards, snakes, tortoises, turtles, frogs, and toads are numbered among the desert reptiles and amphibians. Among the more distinctive invertebrates are millipedes, centipedes, scorpions, spiders, ant lions, many kinds of beetles, and flying insects of all sorts.

Most of the same species are also found in the northern mountains, where deer are larger and more plentiful and where mountain lions, bobcats, black bears, and coyotes are still seen. Grizzlies and wolves also lived there until recent times; elk, once numerous and then killed off, were reintroduced in about 1912 and are again numerous. Jaguars are rare, occasional visitors. Among the smaller mountain animals, beavers, foxes, skunks, raccoons, ringtail cats, porcupines, gophers, tree and ground squirrels and other rodents, and rabbits are, or once were, numerous. Many food fishes, including trout, inhabit the mountain lakes and streams.

Making Use of the Environment

When the first people to live in this area arrived more than ten thousand years ago, the climate was wetter and colder than today's, and the plant and animal populations were richer and more varied. The latter included giant ground sloths, giant bison, and other extinct as well as modern species. Information about the early human population is sparse, but it seems likely that the land was occupied thinly but continuously throughout the transition to the hot, dry modern period that began about 6000 B.C.E.

Until about the middle of the second millennium before the common era, when some people in the region began to depend on homegrown foods, human survival depended absolutely on the ability to exploit natural food resources (Cordell 1997:127–131). At the time the Mimbres paintings were made, and for many centuries earlier, the people of this land were horticulturalists who also made imaginative use of plentiful natural resources. They not only cultivated staple foods, especially corn and squash, and hunted large and small animals for meat and hides, but they also harvested many wild plants for use as food, medicine, and raw materials needed to manufacture tools and other necessities and amenities. Their exploitation of the land was in large part seasonal and can be described as a balanced set of complementary activities (Minnis 1985; Wheat 1955:157).

Many hunting techniques were known and used (Shaffer and Gardner 1996; Shaffer, Gardner, and Baker 1996). Some were depicted on Mimbres pottery; tools and weapons that have been found archaeologically testify to others; and analogy with historic Pueblo methods suggests still more. Birds, fish, and other small animals were snared, trapped, netted, hooked, or shot with bow and blunt arrows (figs. 12, 13). Decoys may have been used for hunting water birds, and it is probable that large groups of men, women, and children participated in rabbit hunts by driving the animals into nets and killing them with clubs or projectiles, including curved throwing sticks (fig.

14; Kent 1983a:52–60, figs. 21, 22). Larger game such as deer and pronghorn may have been trapped in nets and were certainly stalked by hunters and killed, in earlier days with darts thrown from spear throwers (atlatls) and later with bows and arrows (fig. 15; Woodbury and Zubrow 1979:54–55). Bears and mountain lions were occasionally killed, probably by being trapped or stalked and then shot (pl. 1). Bison may also have been hunted.

Animal bones served as raw material for many tools. The Mimbreños and their ancestors fabricated deer leg bones and ribs into awls and other pointed instruments which they then used to manufacture baskets and textiles. They made deer clavicles, ribs, and scapulae into hide scrapers or other useful tools or notched them as musical rasps. They fashioned large hollow bird bones, especially those of turkeys and eagles, into flutes and whistles. Needles, spatulas, perhaps fishhooks, and decorative items including beads and pendants were all made from bone, and animal teeth were drilled to be suspended on string as pendants or necklaces.

Similarly, the people gathered wild plants for many reasons other than their food value. Wooden tools included fire-making drills, hoes, shovels, digging sticks, cradle boards, throwing sticks, spear and arrow foreshafts, and bows. Wood was an important house-building material, the only significant source of fuel, and the raw material for many kinds of ceremonial objects. The Mimbreños made reeds into arrow shafts or, by filling them with wild tobacco or other herbs, ceremonial cigarettes. They twisted cord from several different wild plant fibers and then knotted, sewed, or wove it into textiles, sandals, carrying bags, nets, and snares. Gourd shells, after their meat had been scraped out and eaten, were cut to become dippers, containers, or pottery-scraping tools.

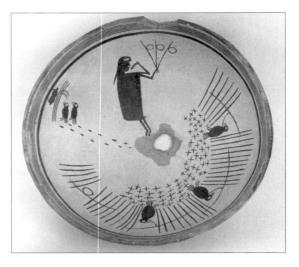

Figure 12. Bowl, Mimbres Classic Black-on-white (Style III), 8.5 x 20–21 cm, 3.4 x 7.9-8.3 in. A man in a planted field holds three bird snares; other snares are attached to a fence around the field. Excavated by E. D. Osborn about 1920 at Pruitt Ranch (?) (Fewkes 1923:fig. 1). Acquired by the Heard Museum circa 1952. (HM NA-Sw-Mg-Az-8)

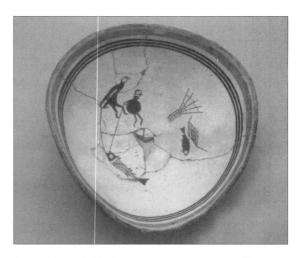

Figure 13. Bowl, Mimbres Classic Black-on-white (Style III), 10.5–11.5 x 23–24.5 cm, 4.1-4.5 x 9.1-9.7 in. Fishing scene with two people, one bird headed, pulling a large fish. A basketry fish trap and what may be a basketry seine are on the opposite wall of the ovate vessel. See figure 6 for a similar subject. Excavated at Osborn Ruin by A. M. Thompson, before 1952. (MIAC/LAB 19971/11)

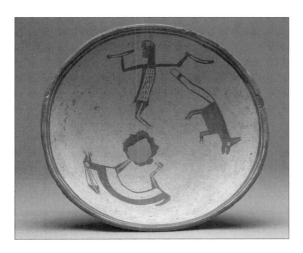

Figure 14. Bowl, Mimbres Classic Black-on-white (Style III), 9 x 24.3 cm, 3.6 x 9.6 in. A hunter with a rabbit stick in each hand wears what may be a rabbit-skin blanket. A jackrabbit is on the opposite wall of the vessel, and a dog-like animal is on the person's left. Purchased in 1919 from the Smithsonian Institution; originally purchased from E. D. Osborn by J. W. Fewkes. (AMNH 29.1/286 [1919/31])

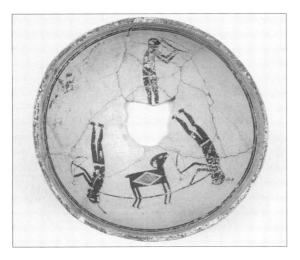

Figure 15. Bowl, Mimbres Classic Black-on-white (Style III), 22.9 x 11.2 cm, 9 x 4.38 in. Three hunters with bows and arrows. Two carry a bighorn sheep suspended from a carrying pole. Hunting was often shown as a group activity. (HMUM 4783)

Virtually all parts of some plants were used in their entirety. For example, the blossoms of the large "soap-tree" yucca *(Yucca elata)* were used as a dye or as food, its fruit was eaten, its sudsy roots were used as soap, and its leaves were made into paintbrushes, braided or twisted into cord, or split to be sewn or woven into sandals or baskets. Bear grass, sumac, bullrushes, and willow were also among the materials used for basket making, and people collected many other plants and their parts to use for ceremonial or medicinal purposes, as dyestuffs, or to fill other decorative needs. Other available wild plant foods included mesquite beans and piñon nuts, acorns, berries, grass seeds, especially goosefoot and amaranth, cactus fruit, the pads of the prickly pear, and many kinds of roots including agave. Cultivated food crops included corn, beans, squash, and sunflowers as well as, most likely, amaranth and goosefoot (Minnis 1985:101–105). Cotton seeds were also used as food, and by about the ninth century cotton had replaced some of the wild plant fibers formerly used to make woven goods. Tobacco-like plants and perhaps also datura were grown for ceremonial and medicinal purposes (see fig. 57; Moore 1979:90–92; Stevenson 1993 [1915]:7, 8, 12–14).

Just as specialized knowledge of the environment was required in the days before farming became a way of life, so also was such knowledge essential for agricultural success. Farming techniques that worked in the well-watered river valleys of the Mimbres heartland might not work in the higher elevations or more arid southern regions. Balancing the advantage of having more water available in the mountains was the effect of altitude on the length of the growing season. Crops would have been threatened by sudden frosts at high elevations, and in the northern mountains even minor

decreases in mean annual temperature could have forced farming people to move to lower but more arid southern regions (Haury 1936a,128). The threat of drought was constant, and river valleys such as that of the middle Mimbres River, at elevations of 5,000 to 6,000 feet, must have seemed ideal for agriculture with their year-round water and reasonably long growing seasons (LeBlanc 1975:3). Floodplain farming could be practiced on the alluvial soils of these valleys, and fields could be irrigated by digging simple, gravity-fed ditches. Dry farming could also be done on terraces above the floodplains.

In times of drought or other stress, the pattern in the Mimbres world, like that among other contemporary Southwesterners, was for people to disperse to small, spring-fed mountain oases that could support one or several families (Nelson and Anyon 1996; Nelson and LeBlanc 1986; M. Nelson 1999). Indeed, archaeologists have good evidence that occupation of such places by Mimbres people along the eastern slopes of the Black Range in the Rio Grande watershed coincided with twelfth-century population declines in the Mimbres Valley (M. Nelson 1993a, 1993b). South of the Mimbres heartland, in more arid foothills and on the desert floor where permanent streams were rare and freshwater springs scarce, dry farming that depended on rainfall and subsurface water was the only practical agricultural method available (Sauer and Brand 1930:419–

420). Agricultural people may have lived in such places only seasonally, migrating to the uplands during dry periods, much as their ancestors had done in earlier, pre-agricultural times (Minnis 1985; Sauer and Brand 1930:431–432).

Much of the Mimbres territory was marginal for intensive agriculture, and even in the best of times and locations, Mimbres farmers must always have been alert to the food potential of their natural environment. In contrast to their limited exploitation of mineral resources, the Mimbreños made full use of the animal and vegetable life that thrived around them. To do this they needed a great deal of specialized knowledge, close cooperation, and many hunting, food preparation, and tool-manufacturing techniques. Above all, familiarity with the landscape in all of its variety and its seasons, information about the locations and habits of animals, and knowledge of where and when wild plants would be ready for harvesting were essential if life was to be reasonably comfortable and secure. Toward this last end, access to a very large territory and reliance on several sets of resources meant protection against immediate disaster should one or another staple item fail. Throughout the time they lived in their land, the Mimbreños continued to use the environmental knowledge and many of the techniques that had been developed over millennia by their ancestors.

Mimbres Village Life

During the Classic Mimbres period (circa 1000–1150 C.E.), the Mimbres people lived in many large and small villages distributed over a fairly large territory. With a few notable exceptions, their largest population centers were in the general vicinity of the Mimbres River valley, which seems also to have been the center of production of Mimbres painted pottery. Perhaps a hundred villages ranging in size from a few rooms to several hundred have been located in and near this valley and along streams tributary to it between Sapillo Creek to the north, which feeds into the Gila River, and the Deming Plain to the south (map 2). Other large and small Mimbres villages are found elsewhere along the upper Gila River and its tributaries, on the eastern slopes of the Black Range, and as far east as the Rio Grande Valley (Lekson 1986a, 1986b, 1989, 1992a; M. Nelson 1999). A few are reported as far west as the Chiricahua Mountains of Arizona, to the southwest in the drainage system of the Animas River in the boot-heel of New Mexico, and as far south as the vicinity of modern Casas Grandes in Chihuahua, Mexico (Kidder, Cosgrove, and

Cosgrove 1949; McCluney 1965; Shafer 1999). Although the Mimbres Valley itself is not large in comparison with the total size of the Mimbres territory, it is an ecological microcosm of the whole, including virtually every environmental niche occupied by any Mimbres people.

The Mimbres River flows continuously in the mountainous north but is dry today for much of the year along its southern reaches. Nonetheless, some of the largest Classic era Mimbres villages were located along the lower river. Most sites in and adjacent to the valley, such as Oldtown Ruin upstream from Deming, have been thoroughly vandalized or entirely destroyed, even those that were partially or wholly excavated before 1930 and then reported upon by archaeologists. For example, the Swarts Ruin was leveled after the Cosgroves completed their work there in 1928. Fortunately for us today, they excavated the entire site and then published a comprehensive report about it (Cosgrove and Cosgrove 1932). Cameron Creek Village, excavated by Wesley Bradfield in the 1920s, was extensively vandalized in later years, and only a small portion of the Galaz

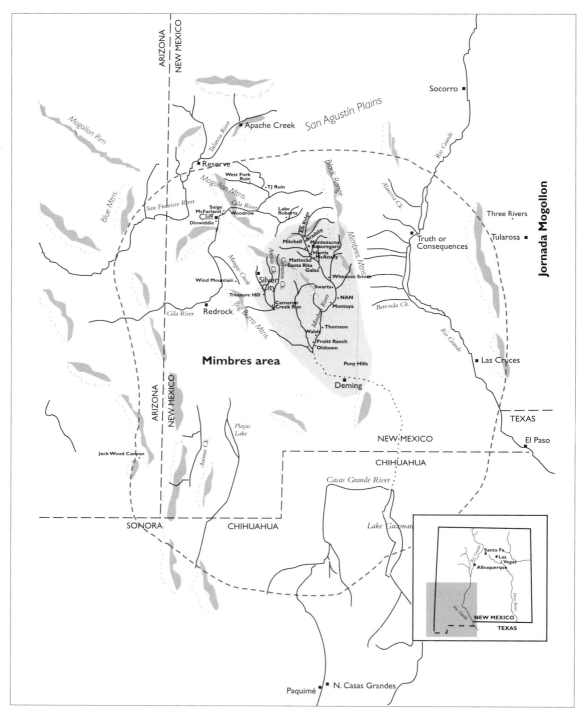

Map 2. The Mimbres region and its area of densest occupation (after Brody, Scott, and LeBlanc 1983: fig. 10, modified using Hegmon 2002:figs. 1, 2).

site, partially excavated by several investigators in the 1920s and early 1930s, was scientifically excavated as a salvage project just prior to its bulldozed obliteration by looters in 1975 (LeBlanc 1983:47–50).

By far most of what we now know and surmise about the ancient Mimbreños is based upon archaeological work done since 1974 and on publications that postdate 1980. A surprising amount of information has been gleaned in recent years through salvage activities—for example, those of the Mimbres Foundation at Galaz and, less desperate, those of Darrel Creel of the University of Texas, Austin, at the devastated Oldtown Ruin. The Mattocks site, partially excavated in the 1920s and reported on by Nesbitt in 1931, is one of the few large Mimbres Valley villages to enjoy the protection of its owners, most recently the Mimbres Foundation. Limited work there under foundation auspices has contributed to important published discussions by Patricia Gilman (1990), among others. Carefully selected portions of the NAN Ranch Ruin, downstream from Swarts, also largely preserved by its owners, were systematically excavated over many seasons between 1978 and 1996 by archaeological field schools directed by Harry Shafer of Texas A&M University. Shafer and his colleagues continue to publish on their work there, adding immeasurably to our knowledge of the Mimbres Valley Mimbreños (Shafer 2003). Late in the 1970s, the Wind Mountain site in the Gila drainage not far west of the Mimbres Valley was partially excavated by Charles Di Peso of the Amerind Foundation. Di Peso's ambitiously planned program was cut short by his final illness, but a full-scale report on his work there was published posthumously (Woosley and McIntyre 1996).

Simultaneously with excavations of the larger Classic period pueblos, Cynthia Bettison, Darrel Creel, Patricia Gilman, LaVerne Herrington, Steven LeBlanc, Stephen Lekson, Paul Minnis, Ben Nelson, Margaret Nelson, Harry Shafer, and many others surveyed, excavated, and reported on smaller Classic, pre-Classic, and post-Classic Mimbres villages and homesteads, ancient irrigation systems, and other ancient cultural remains found throughout the Mimbres region. Their work in and around the Mimbres and upper Gila River drainages, on the eastern slopes of the Black Range, in northern Mexico, and in the New Mexico boot-heel has clarified our understanding of the chronology, culture history, art, and lifeways of the Mimbres people.

When Hattie and Cornelius Cosgrove excavated at Swarts Ruin and wrote their monograph about the site, they lacked basic historical information as well as the benefits of modern archaeological tools and methods. Still, their carefully detailed descriptive report remains valuable to the study of Mimbres art, in part because more documented Mimbres pottery paintings were collected from Swarts than from any other Mimbres site ever excavated under controlled conditions. Most, but by no means all, Classic Mimbres pottery paintings seem to have been made in the Mimbres Valley, and most of those seem to have been made in the larger villages there, such as Swarts, NAN, Mattocks, and Galaz (Gilman, Canouts, and Bishop 1994; James, Brewington, and Shafer 1995; Olinger 1989). Thus, an examination of these large communities, especially Swarts, NAN, and Galaz, may be the best way to begin to develop an understanding of Mimbres pottery art and the people who made it. What follows is a description of an imaginary "typical" Mimbres Valley Classic period village, a synthesis based primarily on the sources just discussed.

Town Sites and Town Plans

The Cosgroves considered Swarts Ruin to be a typical Mimbres site, its atypical features merely evidence that each Mimbres community was in some ways unique. At the time they worked there and wrote about it, most Southwestern prehistorians considered the Mimbreños a southern variant of a northern, Pueblo-like people. Understanding the site as a Classic period Mimbres village of the Mimbres branch of the Mogollon culture—in other words, as evolving from Mogollon rather than Colorado Plateau roots—was impossible until some years later, for the basic work on the culture history of the southern Southwest by Haury, Gladwin, and others, which created a Mogollon context for the Mimbres, had hardly begun.

Swarts Ruin is "typical" in many respects. It was located about fifteen miles south of the present Mimbres post office, in about the middle of the population center of the Classic Mimbres of the Mimbres Valley. The Galaz site lay about eight miles upstream from Swarts, and Mattocks another three (map 2). The river valley narrows sharply several miles north of Mattocks and opens out onto the desert at about 4,500 feet in elevation not far south of the Oldtown Ruin. The NAN Ranch Ruin is about six miles downstream from Swarts, and Oldtown is about five miles south of there. Elevations range from about 5,000 to 6,500 feet at most Classic Mimbres sites in the Mimbres Valley, and Swarts lies at about 5,500 feet. All of the larger Mimbres villages, including those along the Gila River and other drainages, are located either on low natural terraces near a river and barely above the floodplain, as Swarts was, or on higher terraces or low hills above the floodplain. With rare exceptions, most sites, like Swarts, are within a few miles of both well-watered, relatively cool forested mountains and arid, misleadingly barren-looking desert. Their inhabitants were in good position to harvest wild animal and vegetal foods and other resources from both regions.

The Mimbres River probably flowed continuously well downstream from Oldtown when the major villages were occupied. As in John Bartlett's day, during the spring thaw it probably flowed all the way to Lake Guzman in Chihuahua, 130 miles away (Bartlett 1854, 1:222). The occasional disastrous spring floods that occur today may have been tempered in the past by beaver dams, which were probably common until beavers were virtually extirpated by trappers in the 1820s and 1830s. Today, in contrast, from a few miles south of Swarts the river for most of the year is an intermittent stream that sinks underground, reemerging here and there only to sink again before disappearing for good not far south of Oldtown. Although the lower villages might have had less dependable water than those upstream, their broad floodplains, somewhat longer growing seasons, and warmer temperatures were well suited for intensive agriculture using gravity flow ditch irrigation to divert upstream water from the river to the fields (Lekson 1986b: 184; Shafer 1999:125; 2003:110–117). Upstream Classic era villages also irrigated, but the smaller ones in the narrower parts of the valley had less available river-bottom land and shorter growing seasons.

For the most part, Classic period Mimbres Valley villages seem to have been continuously occupied by Mimbres people for at least 250 years. Some, such as Galaz, were in place as early as 600 C.E. (LeBlanc 1983:57–58), near the beginning of the Late Pithouse period (550–1000 C.E.; table 1). But even earlier, Mimbres people farmed in the valley, as is witnessed by several Early Pithouse villages (200–550 C.E.)

Table 1
Chronology of Mimbres Region Archaeology - AD 200 – 1300 (after Diehl and LeBlanc 2001:22 and Hegmon 2002:312).

Period	Date C.E.	Architectural Form	Topographic Setting	Ceramic Types Introduced
Mimbres Classic	1000–1150	Contiguous-room pueblos	First river terrace, if available	Style III, Mimbres Black-on-white
Late Pithouse				
Three Circle phase	750/850–1000	Sharp-cornered rectangular or trapezoidal pithouse with ramp	First river terrace, if available	Styles I and II Mimbres Black-on-white; Three Circle Red-on-white
San Francisco phase	650/700–750/850	Rounded rectangular or trapezoidal pithouse with ramp	First river terrace, if available	Mogollon Red-on-brown
Georgetown phase	550–650/700	Circular or D-shaped pithouse with ramp	First river terrace, if available	San Francisco Red
Early Pithouse	200–550	Circular or amorphous pithouse with ramp or vestibule	Hill or ridgetop, if available	Plain wares, Mogollon Early Red

located on steep hills high above the river (Diehl and LeBlanc 2001). Some larger Classic villages, including Swarts and NAN, were established in about 900 during the population surge that characterized the later part of the Late Pithouse period (the Three Circle phase) (825/875–1000). Population in the valley seems to have peaked at perhaps three thousand to four thousand people toward the end of the eleventh century and began to decline not long afterward (LeBlanc 1983:151–152; Blake, LeBlanc, and Minnis 1986).

Population estimates are notoriously difficult to arrive at, especially since only about half of the houses at any Mimbres village seem to have been occupied at any one time. Nevertheless, few researchers would argue that even the largest village ever housed more than about one hundred to two hundred people. Shafer (1982b:15), for example, estimated that the largest population at the NAN Ranch Ruin encompassed only about a dozen families totaling perhaps sixty persons. Authorities agree that population declined slowly in the early part of the twelfth century and then dropped sharply after 1130. By 1140–1150, all Mimbres Valley villages were essentially abandoned, and the Classic Mimbres painted pottery tradition came to an end (Blake, LeBlanc, and Minnis 1986; LeBlanc 1983:151–152; Shafer 1999:130–131).

Patterns of architectural and social change, as well as changes in painted pottery traditions, seem much the same at all similar-sized villages that have been investigated in the Mimbres

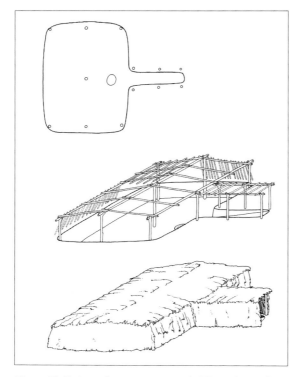

Figure 16. Projected reconstruction of a Three Circle phase pithouse, circa 900 C.E. (after Gladwin 1957:132).

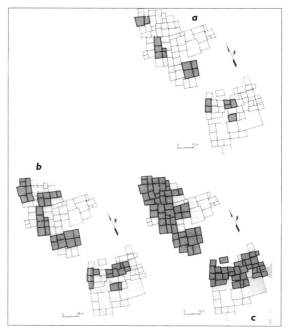

Figure 17. Swarts Village, showing construction between about 1000 and 1130 (after LeBlanc 1983:109, figs. 22, 23, 24). The first construction phase (a) shows six small clusters of rooms that were added to gradually over time (b), finally amalgamating by about 1100 into two large room clusters (c).

Valley and nearby. But it must be emphasized that important variations also appear. For example, whereas a significant number of the dead at Swarts, NAN, and other Classic Mimbres Valley villages were buried below the floors of occupied rooms, quite a different pattern was seen at Wind Mountain, barely thirty miles to the west, a pattern suggesting "a distinct and conscious desire for a physical separation between the living and dead of the settlement" (Woosley and McIntyre 1996:270). Gilman (1980) noted a similar phenomenon elsewhere along the drainage of the upper Gila.

Characteristically, village growth in the Mimbres Valley and elsewhere was a dynamic process that began when several families, rarely more than about ten, built a village of individual, semisubterranean, one-room pithouses (fig. 16). By about 1000 C.E., most pithouses were being replaced by clusters of multiroom, single-story surface structures or room blocks (house blocks), each with several suites of rooms including work areas, general living spaces, storage rooms, and ceremonial rooms that were interconnected by interior doorways (figs. 17–19). Access from the outside was by way of ladders passing through roof hatchways (fig. 19). Some house blocks had only about fifteen rooms, others as many as sixty. Walls were generally of cobbles or other easily accessible stone embedded in

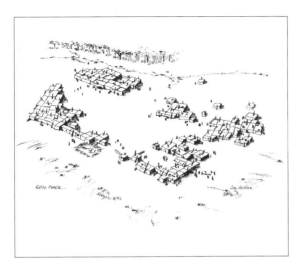

Figure 18. Artist's reconstruction of Galaz Pueblo, circa 1100 (after LeBlanc 1983:105, fig. 20).

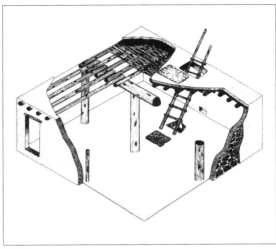

Figure 19. Cutaway drawing of a Mimbres Classic period room, circa 1090 (after LeBlanc 1983:79, fig. 17).

thick mud mortar and covered with adobe plaster. Although exterior room walls were contiguous, house blocks were built in increments of one or a few rooms at a time, often arranged to enclose a small courtyard. The room blocks themselves were positioned to surround a fairly large, informal, central plaza accessible by way of gaps between each unit (figs. 17, 18). Earlier pithouses and other semisubterranean rooms were often cleaned out, burned, filled (often with household trash), and made part of the living surface of the later village (Anyon and LeBlanc 1984; Cosgrove and Cosgrove 1932; Shafer 1995:23; Shafer and Taylor 1986:66).

Early tenth-century Mimbres Valley pithouses were relatively deep, rectangular, one-room structures entered by way of covered ramped corridors located about midway along an east wall (fig. 16). Walls and floors were generally of earth, neatly plastered with adobe, and

a shallow, rounded hearth vented by a smoke hole in the roof was generally located between the midpoint of a room and its side entrance. Earlier houses had gable roofs made of branches laid across support beams and thickly covered with adobe, but flat roofs of similar construction became the mode by the late 900s. Roof support patterns varied, but as in Classic Mimbres times, three or more posts were ordinarily aligned to support one or more large horizontal beams on which rested smaller beams, or *latillas,* and a thick, earthen roof. During the latter part of the tenth century, new, shallow pithouses were built, and older ones were remodeled to have their east-wall ramp entries replaced by rooftop hatchways accessible by ladders. One or two large, rectangular or square hearths were also built to replace the shallow circular ones (Shafer 1995, 1996). These and other architectural details demonstrate a clear evolution in the Mimbres Valley from villages of single-family

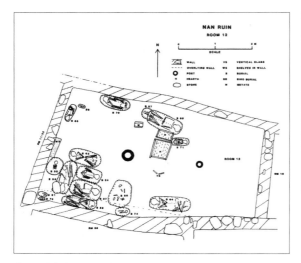

Figure 20. Mimbres Classic period ritual room and cemetery. Room 12, NAN Ranch Ruin (after Shafer 1996).

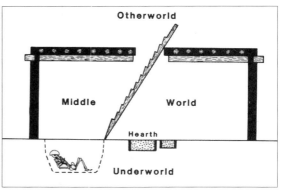

Figure 21. Schematic drawing of a late Three Circle–early Mimbres Classic room, circa 950–1000, showing possible cosmological metaphors (after Shafer 2003:42, fig. 4.2).

pithouse dwellings to multifamily, multiroom surface pueblos, a transition that took place over the span of one or two generations.

A feature of most Mimbres Valley pithouse villages that carried over into the early Classic era was large, semisubterranean rooms that were presumably reserved for community and ceremonial uses. These are often referred to in the literature by the Hopi word *kiva* (LeBlanc 1983:66–71). Except for their greater size, these were similar in many respects to contemporaneous pithouses, the earliest being circular in plan, with circular hearths and east-wall ramp entrances, whereas those of the early 900s were built as rectangles. After about 950 these ceremonial rooms were made with square hearths and rooftop entries. About a century later, they seem to have fallen out of use altogether, their ceremonial functions presumably replaced by the large ritual rooms that were located in most Mimbres pueblo room blocks and perhaps also by the large, open plazas (Shafer 1995:41ff., 1999:123). The implication is clear that in the

Mimbres Valley the focus of specialized ritual rooms shifted from community-wide functions to more restrictive, lineage-based ones. Characteristically, Classic era ceremonial rooms contained pairs of rectangular hearths and were the prime locus for subfloor burials (fig. 20). Shafer (1995, 1999, 2003) interpreted these as combined cemeteries, ancestral shrines, and metaphorical cosmic maps that served to validate the antiquity, heritable rights, and status of the families or lineage group who lived in each cluster of rooms (fig. 21). He argued that their development was linked to both canal irrigation and the pressures of an expanding population within the narrow Mimbres Valley. Those two factors combined to make it important for the long-established families to commemorate an inherent right to the best irrigable farmland.

Assuming Shafer's interpretation to be essentially correct, then the large open plazas that were surrounded by room blocks served community-wide social, economic, and ritual

functions that cut across lineage distinctions. Thus, intracommunity tensions were both displayed and tempered through architectural expressions. At the very least, the plazas were multifunctional gathering places where all people of a community could socialize while making pottery or other necessities and where large-scale, intravillage public events such as feasts or ceremonies could take place. But they were also a kind of cemetery, an alternative burial place for those not interred in a room within a house block or whose remains were cremated. It is clear that finely painted Classic period Mimbres Black-on-white pottery developed in parallel with architectural changes that were responses to rapidly changing demographic, social, political, economic, and ceremonial conditions within the Mimbres Valley communities.

A one-room pithouse probably sheltered only a single nuclear family, but multiroom buildings at the larger villages might have housed fifteen or more such groups, and life in those later community houses might have been far more closely integrated than life in pithouse villages. Living areas as well as work, storage, and ceremonial spaces seem to have been shared by families who presumably were related. Most work, including food preparation and the manufacture of pottery, woven goods, and stone tools, was likely done in a social setting, either at home or in the large plazas.

A question that may never be resolved is whether, and to what degree, the spatial and stylistic characteristics of the larger Classic Mimbres villages were inspired by similar and somewhat earlier Puebloan villages of the Colorado Plateau. Regardless, the architectural program of the eleventh-century Mimbres people was unique in its details and certainly evolved within Mimbres society over the course of several generations in response to local conditions and the dynamics of local history. In that context, it is worth noting that none of the several kiva variations of the Colorado Plateau is replicated in Mimbres pueblos, and conversely, the old Mimbres-style ceremonial rooms that remained in use well into the eleventh century, although similar to those of other Mogollon groups, are not found in the ancient pueblos of the Colorado Plateau. Architecture was only one recognizably local physical expression within a spectrum of related intellectual concepts that the Mimbres people created in response to rapidly changing local circumstances. Their painted pottery was another.

Subsistence

Mimbres villages were, for all practical purposes, self-contained and self-sustaining. Villagers grew corn as their staple crop, along with field beans, squash, sunflowers, cotton, and varieties of amaranth and other grasses. Wild foods, both animal and vegetal, provided an important part of the diet, and the people of the Mimbres Valley during the Classic Mimbres period continued to exploit the total environment in traditional Mogollon ways (Minnis 1985). Food preparation seems to have been relatively simple. Corn was removed from the cob, parched or dried, and stored. Its kernels were ground into flour as needed in milling basins *(metates)* by means of hand grinding stones *(manos)* and used as the base for stews, mush, and fried cakes. Meat was stewed, roasted, broiled, or dried for storage, and other wild and domestic plant foods were prepared and used in a variety of ways.

Corn planted in nearby fields in March or April, after the last of the hard frosts, was harvested five or six months later. Villages higher in the mountains may have had precariously

short growing seasons, but those in the middle and lower Mimbres Valley were in little danger of losing staple crops to untimely frosts. The Mimbres River, a perennial stream fed by springs, melting snow in springtime, and summer thunderstorms, provided a source of canal irrigation water as stable as any in the Southwest and far more reliable than most. By the end of the eleventh century, however, population pressure led people increasingly to begin farming in less favorable places, especially near small springs in upland areas. Initially at least, houses in such places might have been used only seasonally (Nelson and LeBlanc 1986; M. Nelson 1993a, 1993b).

Many wild foods were harvested in and near the Mimbres Valley, and some hunting, especially of small game, probably took place locally during all seasons. Rabbits were a major source of animal protein, jackrabbits most commonly in the more verdant upland areas and cottontails in the more arid lower sections of the river (Sanchez 1996). Longer journeys by both men and women were needed for hunting larger game animals and harvesting other wild plants for food, medicines, and raw materials for manufactured goods and ritual purposes. There is little doubt that most Mimbres people were familiar with a fairly large territory, though how many miles or how many days' journey distant from the Mimbres Valley is a matter of debate (Diehl and LeBlanc 2001:10–12; Gilman 1987; Lekson 1992b). In earlier times, entire villages may have gone on hunting and gathering expeditions, spending several weeks at one or another temporary camp while leaving the home base unoccupied. During the Classic Mimbres era, however, village growth and increased dependence on farming made such periodic abandonments impractical, and some people were likely left behind at all times to maintain homes and care for crops.

All subsistence-related work was cyclical, as were many other activities. Late summer and early autumn were probably the busiest periods, when both cultivated and wild vegetable foods were harvested. Autumn and winter were probably the most active hunting times, and a quiet interlude likely followed on the spring planting. It was probably during predictable lulls in the subsistence cycle that ceremonial, recreational, and manufacturing activities were most concentrated.

Household and Personal Furnishings and Adornment

Because so many Mimbres Valley villages were built on or just above the floodplain, where the high water table makes preservation of organic materials such as wood and cloth unlikely, the archaeological record provides little direct information about household furnishings or personal possessions. However, that limited evidence is supplemented by pottery paintings that are not only informative about clothing and personal appearance but also imply house interiors and different technologies, show tools in use, and provide a variety of other details about daily life.

As was the case everywhere in the Southwest until the twentieth century, Mimbres homes had virtually no furniture. All activities took place on the smoothly plastered floors of rooms (fig. 22) or on the smoothed and hardened earth surfaces of rooftops and outdoor plazas, which also functioned as work spaces. Posture and motor habits, as well as social behavior, would have been adapted to these domestic environmental conditions. Pottery, for example, would ordinarily have been made and painted by artists seated on the floor or ground. Pottery vessels would also have been used on these surfaces, their rounded bottoms

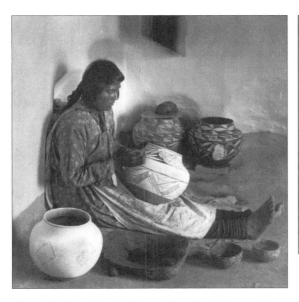

Figure 22. Mary Histia ("Acoma Mary") painting pottery, 1902. Photograph by Adam Clark Vroman. (Seaver Center for Western History Research, LACMNH, no. V-920)

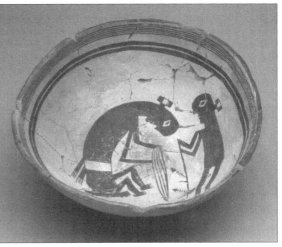

Figure 23. Bowl, Mimbres Classic Black-on-white (Style III), 9.3 x 21.3 cm, 3.7 x 8.4 in. Two male-costumed individuals, one seated on a low stool, the other standing and holding a feathered staff. Both wear their hair tied at the back with a thin, woven belt, as traditional Pueblo men still do, in a bun called a chongo. (MIAC/LAB 19975/11)

perhaps stabilized in scooped-out shallow pits. Because painted pottery was most often seen from above, especially when entry to rooms was through rooftop hatchways, most of it everywhere in the ancient Southwest was patterned for greatest visual effect when seen from above or from a seated position on the floor. The Mimbres were no exception. Their only furniture for which there is any evidence was a low stool, presumably of wood, as depicted in a very few paintings (fig. 23). These resemble stools sometimes seen in nineteenth-century Pueblo homes. Earth or stone benches *(banquettes)*, which sometimes jutted from the walls of historic era Pueblo rooms and which are also found in the ancient and recent ritual architecture of the northern Pueblos, are rarely found in Mimbres rooms. There is no evidence, one way or the other, that Mimbres people suspended poles horizontally from rafters, as in historic and ancient Pueblo room interiors, for the purpose of hanging blankets and other stored objects or for suspending vertical looms.

In an examination of photographs of about 6,500 Mimbres painted vessels, the archaeologist Marit Munson (2000:130) found 326 pictures of humans. Only 123 of those were shown with clearly identifiable sexual features, of which about a third were women (Munson 2000:130). Gender rather than biological sex could reasonably be surmised from costume or context in a somewhat larger proportion of the remainder, but most paintings gave no information about costume, only a few showed hairstyles that might have had gender implications, and the actions and activities of pictorial subjects were often sex and gender ambiguous. In short, Munson found that in the absence of genitalia, the sex or gender of most humans shown on Mimbres pots was problematical.

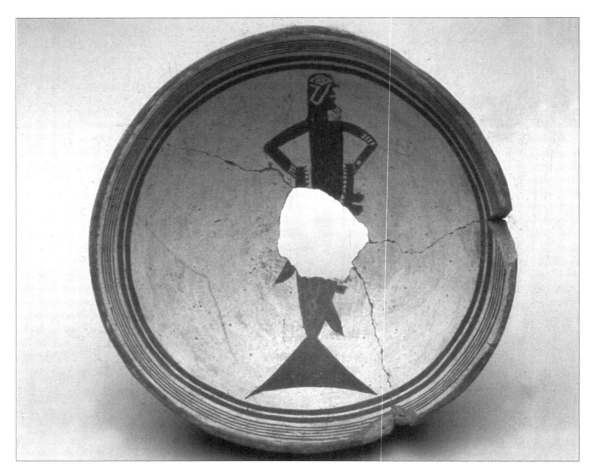

Figure 24. Bowl, Mimbres Classic Black-on-white (Style III), 7.5 x 17 cm, 3.0 x 6.7 in. The lower body of a bearded human wearing Glycymeris clam shell bracelets on the upper left arm and on both wrists is in the mouth of a large fish. Excavated by the University of Minnesota Field School at the Galaz site, 1929–1931. (WM 15B 258)

Even where pottery paintings showed absolute correlations between, for example, sexually defined women and garments such as string aprons (thirty instances), or sexually defined men and certain hairstyles such as the *chongo,* a bun worn by Pueblo Indian men from pre-Columbian times to the present (nine instances; fig. 23), there was no guarantee that all individuals shown wearing string aprons were women or that all those shown wearing chongos were men (Munson 2000:table 1). Such pictures might be of cross-dressing people of the "wrong" sex— for example, ceremonialists portraying persons of the opposite sex, as in the modern pueblos when men are costumed to represent female katsinam (Fewkes 1903:pls. 4, 11, 16, 39). Similarly, context alone does not guarantee that a person shown performing a task normally associated with one sex is not in fact of the other sex. Bear hunting and warfare might

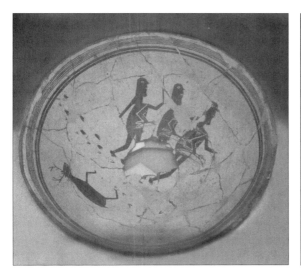

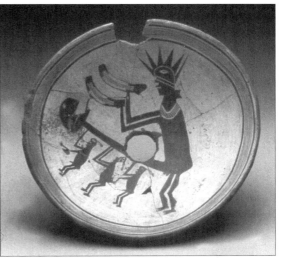

Figure 25. Bowl, Mimbres Classic Black-on-white (Style III), 11 x 25.5 cm, 4.3 x 10.0 in. Three hunters with bows and arrows seem to be following deer tracks. The long-haired one at the end carries a crook-shaped prayer stick. Excavated by E. D. Osborn at Oldtown Ruin and purchased for the U.S. National Museum in 1914 (Fewkes 1914:24, fig. 13). (NMAI 043520)

Figure 26. Bowl, Mimbres Classic Black-on-white (Style III), 12 x 28–30 cm, 4.7 x 11.0-11.8 in. Three men support the erect penis of a gigantic fourth who holds a rabbit stick in each hand, wears an elaborate necklace and a rayed headdress, and has his hair tied in a chongo-like bun. Excavated by the University of Minnesota Field School at the Galaz site, 1929–1931. (WM 15B 39)

ordinarily have been male activities, and pottery making a female one, but there are many historical examples of male potters at various pueblos, including some who ordinarily cross-dressed, and of Pueblo and other Native American women who hunted dangerous game animals or acted as warriors (Batkin 1987:19–22; Erdoes and Ortiz 1984:258–260, 315–318; Fewkes 1903:pls. 3 [Tcakwaina Mana katsina], 11 [He-hee]).

In part because the sex and gender of so many humans in Mimbres paintings were anomalous, Munson suggested that the paintings might have depicted three or four genders, citing many examples of transgendered and contrary-gendered people playing special ceremonial roles at historic era pueblos (Munson

1997, 2000:132–134, table 3). To those should be added Rio Grande Pueblo *caciques,* men who combine in their persons both religious and civil authority and who are the most highly respected of all pueblo officials. Men chosen as caciques are identified with the earth supernatural ("mother of the Indians") who created the Indian people (White 1935:35), are addressed as "mother," may be called by the name of the creator deity, and are referred to as "the mother and father of the people." Thus, in the Pueblo world, overwhelmingly important social, political, and ritual roles are assigned to a man who is considered to be transgendered by that assignment. In Mimbres art, sexually explicit men may be shown in roles that seem ordinarily to have been associated

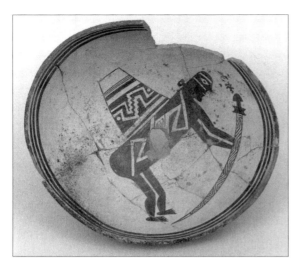

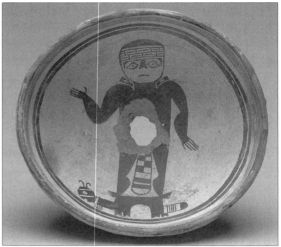

Figure 27. Bowl, Mimbres Classic Black-on-white (Style III), 9.5 x 26.5 cm, 3.7 x 10.4 in. A human wearing a man's chongo-style hairdo carries a burden basket while leaning on an elaborately carved staff. Excavated about 1930 from a site "on a mesa above Silver City" by collector Berry Bowen, of Silver City. (MMA 40.4.277)

Figure 28. Bowl, Mimbres Classic Black-on-white (Style III), 5.5 x 13.5 cm, 2.3 x 5.4 in. A person wearing a headband, earbobs or hair whorls, and a back-dangling belt or apron shaped like a beaver tail stands on or above an inchworm-like animal. Purchased 1919 from the Smithsonian Institution; originally purchased from E. D. Osborn by J. W. Fewkes. (AMNH 29.1/290)

with women, and vice versa (pl. 2).

All things considered, it seems probable that sex and gender ambivalence in Mimbres art was at times intentional and reflective of social circumstances. But deliberate or otherwise, the ambiguities lend support to two separate assumptions: first, that gender roles in Mimbres society were not necessarily fixed, and second, that Mimbres artists and their audiences were comfortable with visual ambiguities and their social implications. Recognition of the apparently deliberate quality of ambiguity in Mimbres art means that only those individuals who are clearly identified by genitalia as male or female should be referred to by those terms, and all others should be identified in sex- or gender-neutral ways.

Most Mimbres paintings of humans are of adults shown without head, facial, or body hair. A few show individuals, presumably men, who have facial hair (fig. 24), and some depict men with head hair hanging down their backs, perhaps plaited or braided. But most men shown with head hair have it tied in a knot or club at the back of the head, much like the chongo still worn by traditional Pueblo men (figs. 25–27; Munson 2000:130, table 1). As a rule, chongos seem to be held in place, as they are today, with a narrow woven belt. Women and female-gendered individuals are sometimes shown with their hair tied into knotlike whorls or buns on either side of the head, sometimes seemingly tied in place by a string or narrow belt (figs. 5, 28). This arrangement can resemble the "butterfly" or "squash blossom" hairstyle that was reserved for use by unmarried women at Hopi,

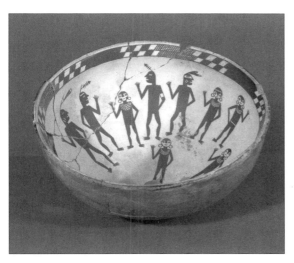

Figure 29. Bowl, Mimbres Classic Black-on-white (Style III), 11.5 x 25 cm, 4.5 x 9.8 in. A group of people observing and participating in a ritual. Excavated in shattered condition by commercial pothunters in about 1968; reconstructed and restored prior to its acquisition by an art museum. (PAM 70.106)

Figure 30. Bowl, Mimbres Classic Black-on-white (Style III), 11.5 x 25.3 cm, 4.5 x 10.0 in. Two people, one with a white body, dressed as a female, and one with a dark body, dressed as a male. Extensively restored. Excavated by Harriet and C. B. Cosgrove about 1920 at their Treasure Hill site on Whiskey Creek, east of Silver City. (MNA 834–3288.4)

Zuni, and other pueblos in the nineteenth and twentieth centuries. Both men and women are shown wearing necklaces or other neck ornaments, pendants, bracelets (presumably of *Glycymeris* clam shells), and earbobs (figs. 29, 30; pl. 3). Women and female-gendered individuals are far more likely than men to have elaborate necklaces or ornamental collars, and they usually wear their bracelets on their forearms, whereas men have them on the upper arms (Munson 2000:138).

Any adult human may be pictured with painted or tattooed facial or, more rarely, body decorations. The most common facial pattern is an "eye mask"—a masklike white or black band mostly shown on men or male-gendered individuals that may cover part or all of the upper face (figs. 27, 31–34; pl. 2; Munson

2000:130, 132, table 1). It is never clear whether eye masks are true masks, facial paint, or tattoos. Munson (2000:132–133) noted that the most common cheek-paint pattern was of paired lines, often called "warrior marks," that are associated in the historic Pueblo world with representations of the Hero or Warrior Twins. In Mimbres art such marks are shown on both men and women.

Men and male-gendered individuals in Mimbres paintings often wear skullcaps (figs. 35, 36) that resemble the warrior hats worn by Pueblo, Apache, and Navajo men of the Southwest. Women as well as men may wear feathers, sometimes shaped or clipped, on the head, in the hair, or attached to hats (fig. 29; Munson 2000:130–133). More men then women wear sleeveless tunics cut square just

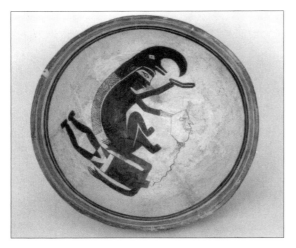

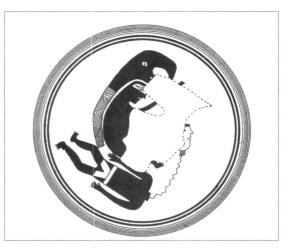

Figure 31. Bowl, Mimbres Classic Black-on-white (Style III), 11.5 x 22.5–26.0 cm, 4.5 x 8.7-10.2 in. Decapitation scene. The person wearing a horned serpent headdress has a stone knife in one hand and the white, partially decapitated head of the victim—still connected to its body by a zigzag line—in the other. Excavated at the Eby 4 site by Earl Morris for the University of Colorado, 1926. Compare this repaired, repainted vessel to an earlier drawing of the same vessel (fig. 32) and to a similarly painted vessel excavated about a decade earlier (fig. 33). (UCM 3198)

Figure 32. Bowl, Mimbres Classic Black-on-white (Style III). Decapitation scene. A drawing of the vessel shown in fig. 31 made by Harriet Cosgrove, 1926, before it was repaired and repainted (from Davis 1995:146). (UCM 3198)

below the hips. Most tunics are plain, but some are fringed or patterned as though painted, woven, or dyed. Most are generally consistent in cut and decoration with ancient textiles found elsewhere in the Southwest (Kent 1983a; Teague 1998). Women, but not men, are shown wearing headbands, many of which are patterned (Munson 2000:131, table 1). Men are shown wearing openwork patterned gaiters that extend from just below the knees to the ankles (figs. 37, 38). These resemble the looped, knitted, or crocheted cotton or wool footless leggings, stockings, or gaiters sometimes worn by men at modern pueblos as elements of ritual costume in public dances (Brody 1997:pls. 1,

13, 15, among many others; Kent 1983b:fig. 72; Kurath and Garcia 1970:71, 72, 79, 170, 212, 229; Sweet 1985:figs. 7, 8, 17; see also Kent 1983a:figs. 17, 18 for looped socks from Southwestern archaeological sites).

Men and male-gendered individuals wear several different kinds of sashes and belts, usually tied to their right side, and a few wear wide, white belts tied at the front in an inverted V (fig. 30). Kilts or skirts are rare. Men and male-gendered people may wear loincloths, square-toed woven sandals, and, very rarely, full-length, close-fitting patterned stockings or leggings with feet. Women and female-gendered individuals also wear sandals and belts with long

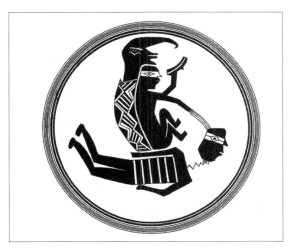

Figure 33. Bowl, Mimbres Classic Black-on-white (Style III), dimensions unknown. A drawing by Harriet Cosgrove, probably done from the original vessel in about 1926 (from Davis 1995:180). In 1916, J. W. Fewkes offered to purchase this vessel for the U.S. National Museum from a Mr. Pryor, who had excavated it from a NAN Ranch site. It was in the E. D. Osborn collection when Fewkes published a different drawing of it in 1923, but its whereabouts since 1926 are unknown (NAA 1915, Box 69: Dec. 14; Fewkes 1923:29; fig. 13).

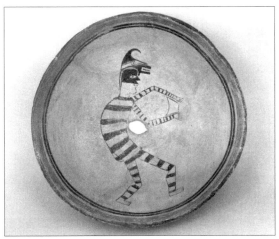

Figure 34. Bowl, Mimbres Classic Black-on-white (Style III), 11 x 23.5–24.5 cm, 4.3 x 9.3-9.7 in. Dancer(?) in a striped costume or body paint wears a horned serpent headdress and a black eye-mask or face paint. Excavated by Richard Eisele in 1921, site unknown. (TM 4589)

fringes hanging down the back (fig. 30). These closely resemble women's aprons known from ancient Puebloan sites on the Colorado Plateau (fig. 39), although the Mimbres variant may have been a two-piece rather than a one-piece garment (see fig. 66).

There is little or no direct evidence of weaving at any Late Pithouse or Classic Mimbres Valley site, but cotton was grown there, and most clothing and blankets and some objects such as arrow quivers that are shown in pottery paintings appear to be of loom-woven fabrics that probably were made locally (figs. 5, 36, 38; Creel 1999; Minnis 1985:101). Most depictions of baskets show large, flat-bottomed, wide-mouthed burden baskets that were carried on the back or head, usually by women but sometimes by men (figs. 4, 27, 164; pls. 2, 3, 20). These may have been coil-made or twined and are patterned in ways that resemble Classic period Mimbres geometric pottery paintings, especially those on jar exteriors. They also resemble ancient coil-made burden baskets collected from a wide range of sites throughout the greater Southwest.

There seems to be no clear evidence, either direct or pictorial, that the Mimbreños used rabbit-skin or turkey-feather blankets. Considering the antiquity and wide distribution of such textiles in the Southwest and the utility of

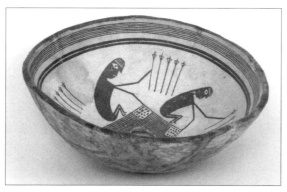

Figure 35. Bowl, Mimbres Classic Black-on-white (Style III), 8 x 22.7 cm, 3.2 x 8.9 in. Four people wearing skullcaps and handling arrow shafts are seated around a blanket with gaming pieces visible in the center (see fig. 36). Excavated by the School of American Research and Museum of New Mexico at Cameron Creek Village, 1923 (MIAC/LAB 43438/11)

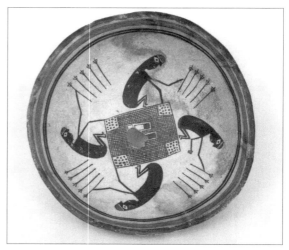

Figure 36. Top view of figure 35.

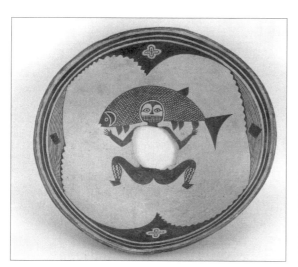

Figure 37. Bowl, Mimbres Classic Black-on-white (Style III), 10 x 26 cm, 3.9 x 10.2 in. A squatting person in openwork gaiters either wears a fish headdress or is directly in front of a large fish. Excavated in 1920 by E. D. Osborn. (HM NA-Sw-Mg-Az-33, 8.26.70)

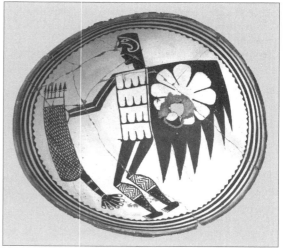

Figure 38. Bowl, Mimbres Classic Black-on-white (Style III), 9 x 23 cm, 3.5 x 9.1 in. A warrior wears a (feather-covered?) tunic and an openwork gaiter over each lower leg. A fabric-covered shield painted(?) with a large floral design seems to be suspended from the left shoulder, and a basketry or textile arrow quiver is held in the right hand. (HP 94584)

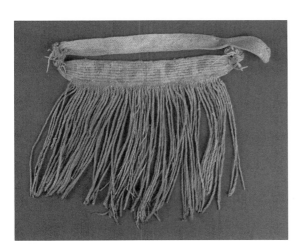

Figure 39. Woman's cotton fringed apron attached to a woven belt. The lower portion of the fringe has not survived. Ancient Colorado Plateau Pueblo, 1000–1200, northern Arizona. (ASM 25982; Kent 1983a:97, fig. 42)

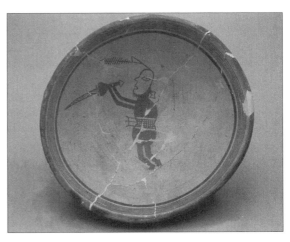

Figure 40. Bowl, Mimbres Classic Black-on-white (Style III), 9.8 x 22.9 cm, 2.9 x 9.0 in. A bearded person wearing a tightly cinched belt and his hair tied in a chongo has a clipped feather on his head and holds a carved staff in his hands positioned to suggest "sword-swallowing." Excavated by the University of Minnesota Field School at the Galaz site, 1929–1931. (WM 2B 80)

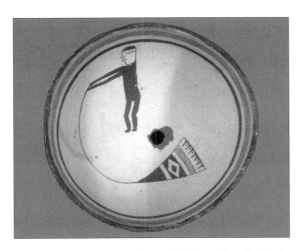

Figure 41. Bowl, Mimbres Classic Black-on-white (Style III), 9 x 19 cm, 3.5 x 7.5 in. A bird's-eye view of a person in a skullcap spinning a bull-roarer shaped and painted like a bird's tail above his head. A bull-roarer makes a deep, whirring sound as it picks up speed. For a similar perspective see fig. 217. Excavated by the Mimbres Foundation at Mattocks Ruin, 1976. (MMA 77.67.2)

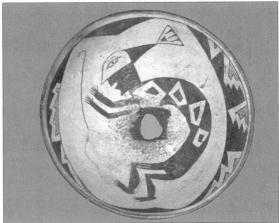

Figure 42. Bowl, Mimbres Classic Black-on-white (Style III), 9 x 20.1–20.9 cm, 3.6 x 8.1–8.4 in. A dancer(?) wearing a fish headdress has in front of him a crooked staff like those used as prayer offerings in historic era pueblos. Excavated by the Texas A&M University Field School at NAN Ranch Ruin, 1978–circa 1996. (TAM 3–378)

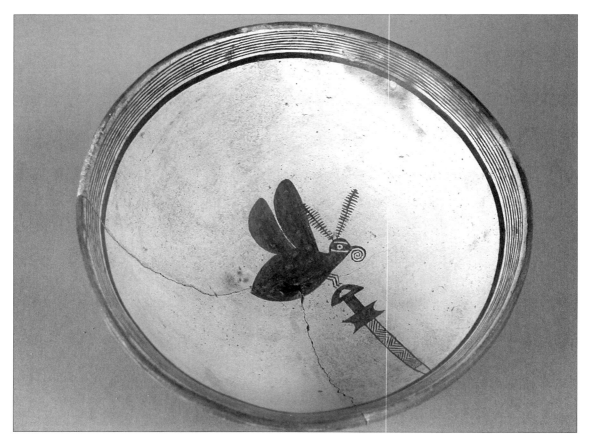

Figure 43. Bowl, Mimbres Classic Black-on-white (Style III), 7 x 18 cm, 2.8 x 7.1 in. A flying insect with an elaborately carved, swordlike staff below it. Excavated by the Mimbres Foundation, at the Bradsby site. (MMA 78.44.6)

lightweight, warm garments in the Mimbres area, it is probable that both were made and used there. In any event, the pottery paintings offer at least two examples of what may be feathered tunics (figs. 14, 38). In contrast to pottery making, which was probably a woman's craft throughout the ancient Pueblo Southwest, loom weaving of blankets has most often been a male enterprise at most pueblos, both historically and, with less certainty, in ancient times. No such division of labor seems to have been the case for basketry and belt making.

Ceremonialism

It is impossible to isolate ceremonialism from any other aspect of Mimbres life, but some purely ritual activities can be recognized or surmised from the archaeological record, including pottery paintings. Many ritual subjects in the paintings seem directed toward subsistence and survival matters: fertility, hunting, water, birth, death, and illness. A very few Classic Mimbres pottery paintings show details of complex ceremonies and rituals that may have been managed by priests, and many show

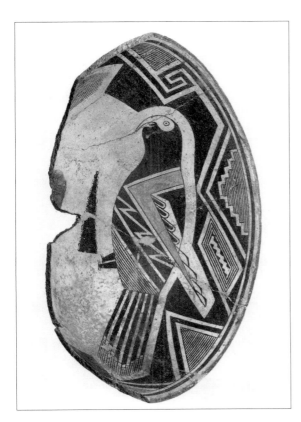

Figure 44. Bowl fragment, Mimbres Classic Polychrome (Style III), 12 x 32 cm, 4.7 x 12.6 in. Macaw. Purchased from E. D. Osborn by J. W. Fewkes, before 1923 (Fewkes 1923:34, fig. 46, 1924:36, fig. 37). (NMNH 326309NM)

objects that seem to be emblems of authority, such as face and head masks, headdresses, bull-roarers, and knobbed, carved, or feathered staffs, all of which are known to be associated with ritual in the modern Pueblo world (figs. 27, 31, 40, 41). Men and women and female- and male-gendered individuals may all be shown wearing masks or elaborate headdresses (figs. 26, 31, 34, 37, 42; pls. 2, 18). Knobbed staffs that might have been made and used as digging or planting sticks are often seen in unusual nar-

rative settings (figs. 40, 43; pl. 3), and crooked ones that resemble a kind of prayer offering used in Southwestern shrines from very ancient times to the present may be shown as full-size walking sticks (figs. 164, 200; pl. 20; Ellis and Hammack 1968). It is clear that the simple identification of an object as resembling something known to have been used in ancient or historic era rituals is not, by itself, adequate to support arguments for its similar use in ritual by the Mimbres.

Where sex or gender identification is clear, more men or male-gendered individuals than women or female-gendered individuals can be identified as ritualists (fig. 31; pl. 2). But in many instances it is impossible to identify the sex or gender of a person who seems to be so engaged. Munson noted that a high proportion of contrary-gendered individuals were actors, often passive, in ritual situations (Munson 2000:134–136, table 4). Among objects shown in paintings or found in Mimbres archaeological sites that suggest past and present Pueblo ceremonial practices are prayer-stick offerings, headdresses and other costume items, masks, shaped or clipped feathers, turquoise, and birds and bird feathers, including exotic species such as the scarlet macaw, whose long, brilliant tail feathers were probably plucked for ceremonial use as they are today by Pueblo people (fig. 44, pls 2 and 4; Creel and McKusick 1994; Minnis et al. 1993).

Certain Three Circle phase and Classic Mimbres architectural forms parallel cosmological architectural features of modern and historic era pueblos, including kiva-like structural and orientation features that are found in both domestic and ceremonial rooms at Mimbres villages (Shafer 1995). Chief among these is rooftop entry by way of a ladder through a hatchway. The ladder is ordinarily placed over

a formalized fire pit located along one central axis of a square or rectangular room, so that people entering or leaving had to pass through the smoke of a fire. The corners of such rooms were oriented toward either the cardinal or the intercardinal directions. Similar configurations in modern Pueblo architecture are among many features of the built and natural environments that modern Pueblo people interpret as symbolic of multidimensional cosmic maps (Ortiz 1969; Swentzell 1989, 1997). They are among many visual metaphors that link this earth surface to an upper world, including the sky in both its daylight and nighttime manifestations, and to the several lower ones. Vertical central axes serve as points of communication that may be symbolized by the hearth, ladder, and hatchway, and the ladder entry in today's kivas may be referred to as a rainbow linking the sky above, meteorological phenomena, and the earth below.

Other parallels suggest that among the Mimbres, as among the modern Pueblos, several priest-led esoteric societies, perhaps lineage or clan based, were each caretakers for and practitioners of a portion of the sacred knowledge of an entire community. The duties of such esoteric groups would not have been confined to the world of the spirit and the promotion of cosmic harmony. Some societies would also have been for curing or medicine, and each would have been an effective local political institution. Collectively, they may have formed the core of the political structure of a community.

These and other identified, perceived, or suggested similarities between the ritual and symbolic expressions of the Classic Mimbres and ancient and historic era Pueblo people, including the forms and uses of prayer sticks, ceremonial staffs (pl. 3), bull-roarers (fig. 41), sword swallowing (fig. 40), shrines, and other

elements of cosmic iconography, may evidence nothing more than common Archaic origins that were widely shared throughout the Southwest, northern Mexico, and other parts of the Western Hemisphere (Ellis and Hammack 1968; Shafer 1995). Interactions between and among all peoples of the greater Southwest had been a constant for millennia, and it is by no means clear how those resemblances came to be—nor should clarity be expected. And it must be emphasized that most of the perceived similarities noted in the literature between rituals and ritual dances shown on Mimbres paintings and those performed in the pueblos are more generic than specific (Carlson 1982; Shaffer, Nicholson, and Gardner 1993). For example, Pueblo-like corn and harvest dances, almost commonplace during the historic era, are hardly hinted at in Mimbres paintings. The few masks that are shown in Mimbres art bear no particular resemblance to any known Pueblo katsina image, either ancient, as shown in rock art, or recent. And there are relatively few similarities and many differences between the iconographies of Pueblo and Mimbres art. Despite some resemblances to Pueblo ceremonialism, Classic Mimbres ceremonial life seems to have been quite different in most visual respects (see the sections on iconography in chapters 7 and 9).

The distinctive qualities of Classic Mimbres ritual may be best illustrated by mortuary practices. Beginning late in the Three Circle phase and continuing throughout the Classic Mimbres period, it was customary for Mimbres Valley Mimbreños to bury their dead beneath the floors of occupied rooms, especially under the large and distinctive post-1050 dual-hearth ceremonial rooms (Shafer 1999:126). For example, of more than one thousand burials exhumed by the Cosgroves at the Swarts

Ruin, nine hundred were under the floors of Classic period rooms, many in individual, unlined pits. It is unclear how many were excavated from dual-hearth ceremonial rooms, nor is it clear what number of burials predated the Classic period, having been interred in earlier rooms that were later overlain by Classic period buildings. It is likely that many of these people had been buried in underlying pithouses that had already been abandoned, these having been the ordinary burial places of earlier Mimbres people, as they were of ancient Pueblo people (Bradfield 1931; LeBlanc 1983:86).

More recent excavations clarify the picture. At NAN Ranch Ruin, excavations in the 1980s and 1990s showed that 80 percent of burials were under room floors, with the great majority found beneath the floors of dual-hearth ceremonial rooms (Shafer 1988, 1990, 1991a, 1991b, 1991c, 1991d). For that reason, among others, Shafer (1999:126, 128) considered these rooms to have served as family cemeteries. At some villages, subfloor burial pits were rock lined or thickly lined and sealed with adobe, and everywhere offerings of pottery, tools, exotic stones, turquoise, shell and stone jewelry, and food were found in almost every intramural grave. In one instance, the tools of a potter were buried with an elderly woman (Shafer 1985).

But at NAN, as at every other Classic period Mimbres site, the most usual offering, generally placed over the head of the deceased, was a painted Mimbres Black-on-white bowl deliberately broken by having had a hole struck in its bottom with a pointed tool. Called a "breath hole" at some modern Pueblos, the punctures have more often been called "kill holes," at least since Fewkes's time (Fewkes 1914:11; Brody and Swentzell 1996:56). Before the Classic era, during the Late Pithouse phase, vessels were often shattered when buried. In

Classic period settings it is not unusual to find more than one pottery offering buried with an individual, and tellingly, there is no obvious pattern associating the number or quality of the offerings or the painted images on them with the age or sex of the person buried with them.

In most Classic era Mimbres Valley villages, those not buried under room floors were interred, often cremated, in plaza areas. At Cameron Creek Village, Galaz, NAN, and elsewhere, such burials were accompanied by few grave goods other than the pottery jars, sometimes "killed," that were used as burial urns (Bradfield 1931; LeBlanc 1983:107, fig. 21; Shafer 1999:126). The relatively large number of known plaza burials at NAN and a few other places suggests that they represent an important variation in social, ceremonial, and ritual relationships within Mimbres villages that is presently unexplained (Shafer 1996:6).

The mortuary practices of these late Three Circle and Classic Mimbres people were far different from those of any other ancient Southwestern people that we know of, including their own Mimbres Valley ancestors and other Mogollon people. Other Southwesterners sometimes buried their dead under the floors of occupied rooms, and some "killed" or otherwise damaged ceramic vessels and other mortuary offerings, but only the Mimbres did so consistently. The only others known to have so regularly buried their dead beneath floors of occupied rooms were some later residents of the Casas Grandes area in Chihuahua, who may have been among the descendants of the Mimbres Valley people.

Hohokam people ordinarily cremated their dead and buried the remains in pottery urns, and other Southwesterners sometimes practiced cremation, but the remains were not always

placed in pottery containers, and in some places cremations were buried under the floors of house rooms (Hayes 1981:173–176). In any case, cremations at Classic Mimbres villages differed in important and symbolic ways from more ordinary local mortuary practices, and they are distinctively different from any known for any other Southwestern group. The association of the dead with an extraordinary painted pottery tradition, the deliberate destruction of that pottery when it became a grave offering, and the establishment of a physical link between the living and the dead by continued occupation of rooms under which the dead were buried all appear to be unique expressions of the relationships between Classic Mimbres people and their ancestors.

Everyday Life: Games, Goods, and Trade

It is impossible to distinguish the purely ceremonial activities of the Mimbres from the everyday, purely secular ones, and it probably did not occur to Mimbres people to differentiate between the two. For example, there is tangible evidence, including pictures on Classic Mimbres painted pottery, for sports such as the ancient game of kickball that probably had multiple functions including both the ceremonial and the social. Likewise, most hunting was probably as much recreational, social, and ceremonial as it was economic (figs. 15, 25).[1] Group rabbit hunts, for example, as shown on painted bowls, resemble hunts at historic era pueblos that brought people together for all of those purposes (Shaffer and Gardner 1995a). The time invested in hunting larger, more dangerous, and less accessible animals such as mountain lions and bears (pl. 1) was disproportionately high for the economic return of their meat and skins.

Social, recreational, and ceremonial concerns must also have been motivating factors. Among less active forms of recreation illustrated on pottery that carry complex social implications are storytelling and gambling. Some narrative paintings seem to illustrate legends suggestive of a rich and didactic tradition of oral literature (figs. 13, 26, 31, 36; Carr 1979). The many dice-like counters found at Classic Mimbres villages and dice games shown in pottery paintings attest to several variations of gambling hand games, including some that may have had ceremonial functions (fig. 36).

As in earlier times, most manufactured goods necessary to maintain life and provide comfort were made in every village. Considering the wide variety and relatively small quantities of goods needed and the limited size of the workforce, craft specialization could not have been highly developed. Certainly, people who were more skilled than others at making certain things and doing certain tasks might have produced surplus goods for trading purposes, but it seems far more likely that they reciprocally shared their skills with relatives, friends, and neighbors. Still, it is improbable that all skills and all knowledge were freely shared. Ritual knowledge, for one, would almost surely have been limited to specialists and might well have been of economic benefit to its possessors. Other economic activities, such as turquoise mining and trading, especially over long distances, were probably carried out occasionally by trained people (Cosgrove and Cosgrove 1932:109).

For technical reasons, some kinds of manufactures, such as pottery, could be made only during certain seasons. Others could be fabricated at any time and were probably made at need or during lulls in the subsistence work cycle. Each person probably made all or most

of the things needed for his or her work, and in that respect, sex-oriented craft specialization was a reflection of a more general division of labor. But while men were presumably responsible for making most hunting tools, and women for most household and food gathering equipment, there were surely many exceptions. Textiles, baskets, and other goods might well have been made by anyone or, in accord with some agreed-upon social formula, by members of one or the other sex.

Most Mimbreños were probably familiar with large areas of countryside within a few days' journey of their home—a radius of perhaps forty to sixty miles (Diehl and LeBlanc 2001:9–21). That some might also have known more distant places is suggested by such exotics as tropical macaws, marine shells, pottery paintings suggestive of marine fish species, bison bones, and ornaments and pottery from faraway places, all of which have been collected from many Mimbres villages. Mimbreños were in contact, directly or indirectly, with other Mogollon people, with ancient Pueblo people of the Colorado Plateau, with the Hohokam, with people of northern Mexico, and with those of the coasts of southern California and the Gulf of California (Brand 1938; Bryan 1927:330–331; Jett and Moyle 1986; Kidder, Cosgrove, and Cosgrove 1949:144–147; Sauer and Brand 1930:444–445; Schaafsma and Riley 1999). There is good evidence that they participated in an active trade network, especially to the south and west. Almost all the foreign goods found at Mimbres villages have been ritual or luxury items or other nonessentials. How much, if any, of those exotic materials was obtained directly from the source, and by what means, is unknown, and although Mimbreños were not ignorant of the world around them, their dependence on outside resources was negligible.

The Individual and Community Life

The people we call Mimbres were probably not at all concerned about what to call themselves. They knew who and what they were and in relative isolation managed to achieve lives of moderate comfort and reasonable security. Individually and collectively they were constrained by their environment, the need to exploit it, and the cyclical nature of that exploitation. Material objects and mechanical and social techniques were invented, adopted, and adapted to deal with problems of survival and success. These imposed further restrictions on each person, for each was part of a system that was simultaneously conservative and dynamic. And as in any other organic and working cultural system, the restrictions imposed on individuals were so varied, diffused, and impersonal as to be both acceptable and largely invisible.

With so much to be done, from house building to relieving the pains of arthritis, and with so few people available to do it, no one could be entirely a specialist. The community's success depended on close cooperation and the assurance that each person knew whom to call on for help in solving problems that might arise in almost every facet of existence. In terms of everyday life, Mimbreños were generalists, born into a system and trained from birth to maintain it or, coming into it later, learning to maintain it while making new contributions to it. There was little time, energy, or motivation for radical innovation or radical change. Results were what counted, and pragmatism required that proven methods be repeated. The freedom to fail is a luxury that only full-time specialists and large-scale, complex societies can afford, and whether as artist or artisan, man or woman, individual Mimbreños rarely if ever had the price. Change tempered by conservatism describes the Classic Mimbres period and its art.

The material success of Mimbres Classic life is self-evident. Villages grew, and as they grew they created technologically and socially appropriate solutions, such as ditch irrigation and lineage cemeteries within room blocks, to deal with the problems of growth. The evidence for small-scale, evolutionary change is everywhere, from the slow replacement during the tenth century of pithouse villages by above-ground pueblos to the almost equally slow twelfth-century population decline and ultimate abandonment of so many once-thriving Mimbres villages. Nowhere is there dramatically compelling evidence to explain either the Mimbreños' virtual abandonment of the Mimbres Valley or the end of their unique pottery-painting tradition. Yet those things happened gradually between about 1100 and 1150, and the valley was only lightly populated for the next two hundred or three hundred years by people who followed somewhat different material traditions and whom we call by other names—Black Mountain and Salado. But for all we know, those later occupants of the Mimbres Valley included many descendants of the Mimbreños, and there is some reason to believe that not all of the Mimbres Valley was abandoned by the Mimbres people (Creel 1999:108).

The end of those villages and their tradi-tions was not an isolated event: "Fertile valleys, the Southwest over, tell the same story of intensive aboriginal occupation, then desertion. The factors involved…are larger and more comprehensive than any isolated drainage can give" (Haury 1936a: 129). Emil Haury's observation remains true to this day, and it has become clear that human populations grew, aggregated, and dispersed throughout the semiarid Southwest in response to local and regional fluctuations of climate that might often have been relatively minor, or to some other local events. In the Mimbres Valley villages, the art of pottery painting in the Mimbres tradition remained vital and inventive almost to the very end of the Mimbres Classic occupation. Elsewhere, in outlying regions where the tradition may have begun a bit later, it seems to have continued for about another generation. It would appear that wherever the Mimbres Valley people went, they carried with them a set of intellectual concepts and manual skills that were not to be abandoned for some time longer (M. Nelson 1999). To begin to understand what happened in the Mimbres Valley, it is necessary to examine more fully the history of the entire region, for clearly the Mimbres Valley and Mimbreños everywhere, despite their isolation, were deeply affected by events and activities in neighboring areas.

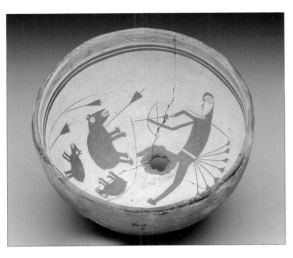

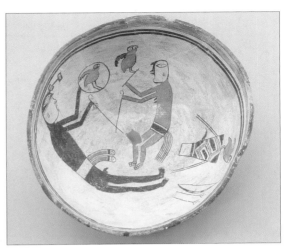

Plate 1. Bowl, Mimbres Classic Black-on-white (Style III), 12 x 21 cm, 4.7 x 8.3 in. Hunter shooting arrows at a bear and two cubs in a cavelike space. Compare the masklike profile of the hunter with that of the woman macaw trainer in plate 2. Excavated by the University of Minnesota Field School at the Galaz site, 1929–1931. (WM 15B-156)

Plate 2. Bowl, Mimbres Classic Polychrome (Style III), 12 x 28 cm, 4.7 x 11.0 in. Macaw caretakers, trainers, or priests. In Mimbres paintings, many more women than men are shown handling macaws (Creel and McKusick 1994). The birds have no tail feathers, which presumably were plucked for ritual use. Excavated by the Beloit College Field School at Mattocks Ruin, 1929–1930. (LM 16123)

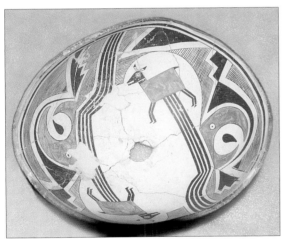

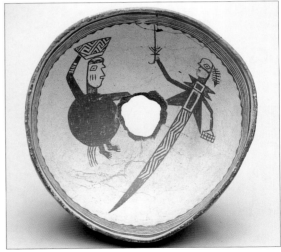

Plate 3. Bowl, Mimbres Classic Polychrome (Style III), 17 x 33 cm (length 28 cm), 6.7 x 13 in. Two deer and two macaw heads are integrated within an elaborate geometric frame. Excavated by E. D. Osborn at Oldtown Ruin before 1914 and purchased for the Heye Foundation, Museum of the American Indian (now the National Museum of the American Indian) in 1914 by J. W. Fewkes (Fewkes 1914:38, figs. 27, 29). (NMAI 4/3527)

Plate 4. Bowl, Mimbres Classic Black-on-white (Style III), 7.4 x 17 cm, 2.9 x 6.7 in. A basketry or pottery bowl transforms into a "woman" wearing a string apron, bracelets on her right forearm, and balancing a flat-bottomed container on her head. To her left, an elaborately carved staff with the head and arms of a human holds a prayer plume in the right hand and in the left, an object resembling symbols of office sometimes carried by historic-era Hopi priests. Excavated by the University of Minnesota Field School at the Galaz site, 1929–1931. (WM 15B 221)

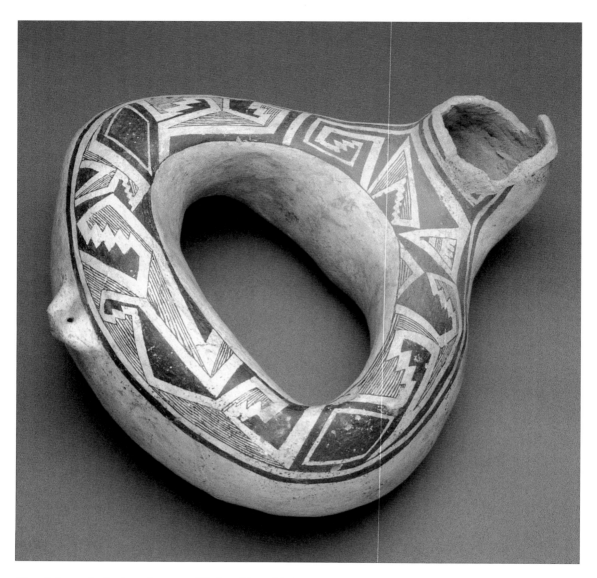

Plate 5. Eccentrically shaped canteen, Mimbres Classic Black-on-white (Style III), 10.2 x 27.9 cm, 4.0 x 11.0 in. Fragments of a human effigy head broken in ancient times remain on the neck and spout of this red-black container. Excavated before 1940; excavation history unknown. (MIAC/LAB 8617)

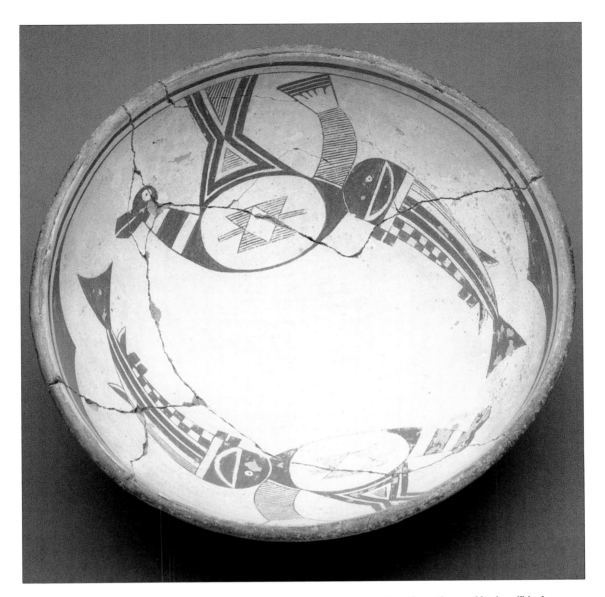

Plate 6. Bowl, Mimbres Classic Black-on-white (Style III), 12 x 24.5 cm, 4.7 x 9.7 in. One of many Mimbres "black-on-white" vessels that oxidized when fired to become entirely or partially red. Each fish pictured here is associated with a compound animal that is part rabbit, part fish, and part bird and has neck stripes suggestive of pronghorn antelope. Excavated by A. M. Thompson at an unknown location before 1952. (MIAC/LAB 19926)

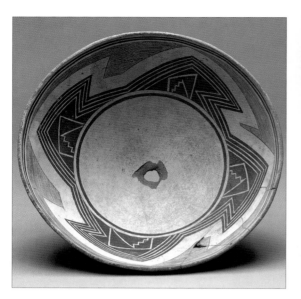

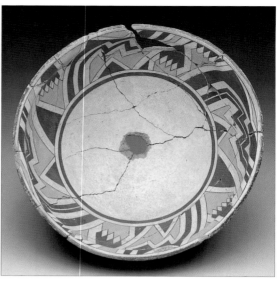

Plate 7. Bowl, Mimbres Classic Black-on-white (Style III), 12.5 x 29 cm, 4.9 x 11.4 in. Interlocking, angular, coglike motifs rotate around a central void. Purchased 1916 from the Smithsonian Institution; originally acquired from E. D. Osborn by J. W. Fewkes. (AMNH 29.0/5925)

Plate 8. Bowl, Mimbres Polychrome (Style III), 14 x 27 cm, 5.5 x 10.6 in. Pale yellow replaces fine-line hatching as a third color in polychrome variants of Mimbres Style III paintings. Excavated by the University of Minnesota Field School at the Galaz site, 1929–1931. (WM 15B 54)

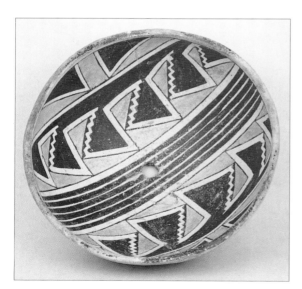

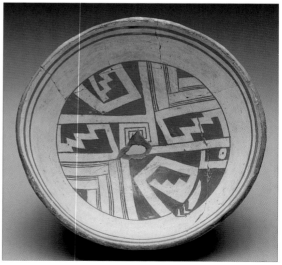

Plate 9. Bowl, Mimbres Polychrome (Style III), 7 x 16.5– 17.1 cm, 2.75 x 6.5–6.75 in. A twofold pattern in black, light brown, and white. Excavated by Mary and John King at an unknown location, circa 1950–1970. (DLMM 94.94.46)

Plate 10. Bowl, Mimbres Classic Black-on-white (Style III), 11.2 x 22 cm, 4.5 x 8.7 in. Hidden within a nonrepresenta- tional painting is a tightly wound insect that resembles a squash bug. One eye is visible at the wide end of the long, curved snout, and three of its feet are at the tip of the snout (see pl. 13). Excavated by the University of Minnesota Field School at the Galaz site, 1929–1931. (WM 11B 529)

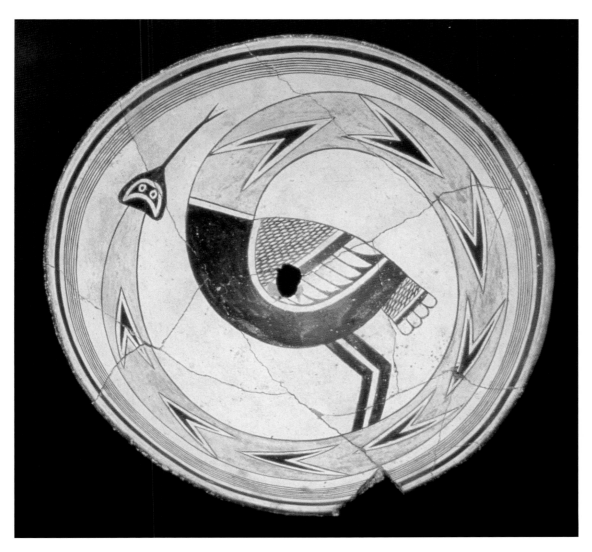

Plate 11. Bowl, Mimbres Polychrome (Style III), 9.2 x 24.9–25.9 cm, 3.75 x 9.8–10.25 in. The neck of a long-legged water-bird transforms into a snake with a rattlesnake-like head. Although the bird does not closely resemble the cormorant-like anhinga, an occasional visitor to southern New Mexico, the snake-bird association suggests anhingas who, when they swim to feed, can be mistaken for black water snakes. Anhingas are the "water turkeys" that symbolize earth, air, and water in several Native American religions of the southeastern United States. Excavated by the Texas A&M University Field School at NAN Ranch Ruin, 1978–circa 1996. (TAM 9–1353 [29:B199])

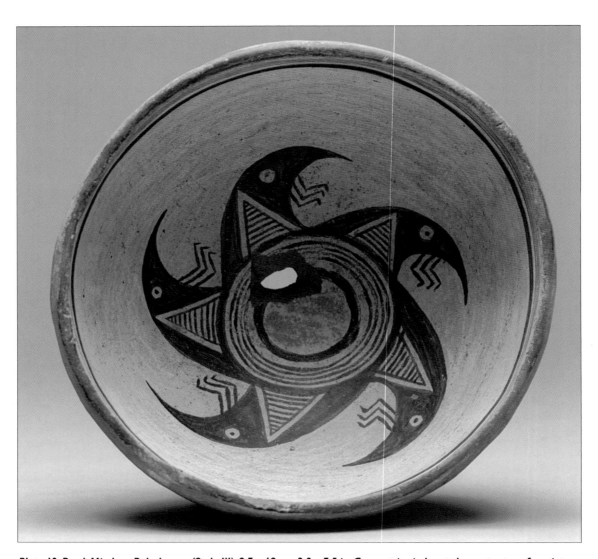

Plate 12. Bowl, Mimbres Polychrome (Style III), 9.7 x 19 cm, 3.8 x 7.5 in. Concentric circles at the center transform into a five-pointed star that further transforms into five squash bug–like insects (see pl. 10). Purchased 1919 from the Smithsonian Institution; originally acquired from E. D. Osborn by J. W. Fewkes (Fewkes 1923:44, fig. 119). (AMNH 29.1/341)

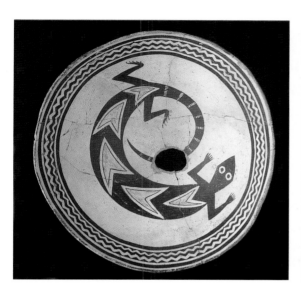

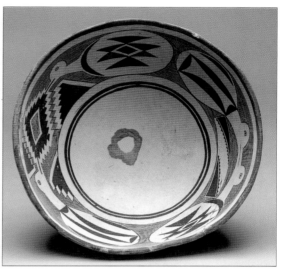

Plate 13. Bowl, Mimbres Polychrome (Style III), 10 x 23.5 cm, 3.9 x 9.3 in. The patterns on the back and tail of this lizard are more imaginary than representational, but its proportions and posture suggest either a skink or whiptail lizard. Excavated by the Peabody Museum, Harvard University, at Swarts Ruin, 1924–1927. (HP 94789)

Plate 14. Bowl, Mimbres Classic Black-on-white (Style III), 14 x 28.4 cm, 5.5 x 11.2 in. Two pairs of ducklike birds emerge from eggs. To compensate for an eccentric shape, the artist added a diamond between the birds at the wide end of the vessel. Purchased 1919 from the Smithsonian Institution; originally acquired from E. D. Osborn by J. W. Fewkes (Fewkes 1923:36, fig. 54). (AMNH 29.1/326)

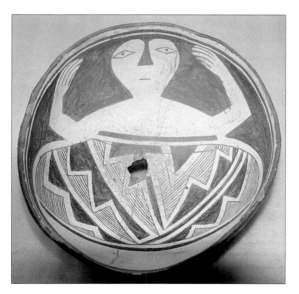

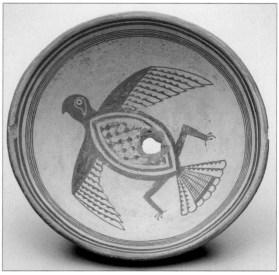

Plate 15. Bowl, Mimbres Classic Black-on-white (Style III), 9.5 x 18.5–21 cm, 3.7 x 7.3-8.3 in. A painting of a Mimbres painted olla seen from the side is in front of a negatively painted human figure. Excavated at the Eby 1 site for the University of Colorado, 1926. (UCM 3098)

Plate 16. Bowl, Mimbres Classic Black-on-white (Style III), 8 x 20 cm, 3.2 x 7.9 in. Flying bird with hawk or falcon attributes. Excavated by the University of Minnesota Field School at the Galaz site, 1929–1931. (WM 15B 487)

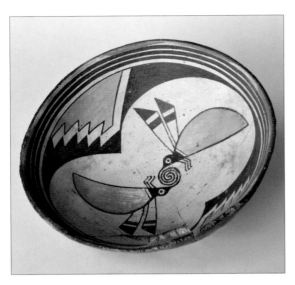

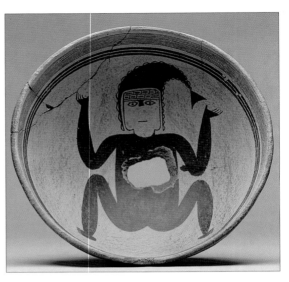

Plate 17. Bowl, Mimbres Polychrome (Style III), 7 x 19 cm, 2.8 x 7.5 in. A pair of flying insects with interlocking tongues forms a double spiral. Excavated at the Pruitt site by Richard Eisele, before 1926. (WNMU 73.8.132)

Plate 18. Bowl, Mimbres Classic Black-on-white (Style III), 11.5 x 26.5 cm, 4.5 x 10 in. A squatting figure wears a headband and a fishlike headpiece. Purchased 1919 from the Smithsonian Institution; originally acquired from E. D. Osborn by J. W. Fewkes. (AMNH 29.1/285)

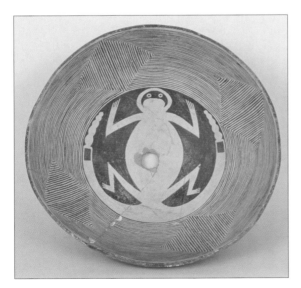

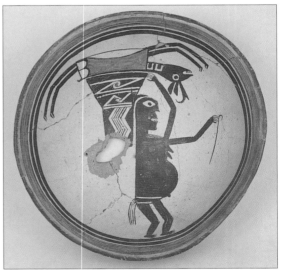

Plate 19. Bowl, Mimbres Classic Black-on-white (Style III), 12 x 28.5–29 cm, 4.7 x 11.2–11.4 in. A composite animal with the body of a frog or toad, humanlike hands and feet, and a doubled rattlesnake tail. Excavated by Earl Morris for the University of Colorado at the Eby 2 site, 1926. (UCM 3201)

Plate 20. Bowl, Mimbres Polychrome (Style III), 7.5 x 18.3– 18.8 cm, 3.0 x 7.2–7.4 in. A woman with a staff carries a pronghorn on her burden basket. Richard Eisele collection circa 1926; William Edner collection circa 1937; excavation history unknown. (MWC G-495)

The Mimbres and Their Neighbors

The Mimbreños are generally recognized as a subdivision or branch of a larger group of Southwestern agricultural people whom archaeologists call "Mogollon," whose material remains are not dissimilar from those of other ancient peoples of the region. Even during the Mimbres Classic period, when material distinctions were greatest, most Mimbres objects looked very much like equivalent things being made by other Southwesterners. In the eyes of archaeologists, the Mimbres people "disappeared" when their manufactures took forms that were virtually identical to those of their non-Mimbres neighbors.

During the fourteen hundred or so years during which recognizably "Mimbres" people lived, thrived, and created their own complexities in the Mimbres Valley— from about 200 B.C.E. to 1150 C.E.—populations expanded throughout the Southwest, the inventory of material products multiplied everywhere, and style differences proliferated. Some authorities use those differences to define a relatively large number of different groups, or "cultures," during later periods, calling each by a different name and recognizing them by their manufac-ture of stylistically different sets of similar material objects. Others are more sparing in their use of such designations, perhaps having greater tolerance in their expectations about variation in the material behavior of peoples and communities. I make no attempt here to reconcile these different views, except to advance a single objective: to explore relationships among Southwestern peoples that may bear on the history of Mimbres art.

Diversity rather than homogeneity seems to best characterize the later Mogollon peoples, who can be distinguished from each other by style, technology, and, perhaps most importantly, geography. It may even be that the term "Mogollon" describes nothing more than several groups of diverse people who shared a few commonalities, such as making red- and brown-ware pottery, that differentiate them from neighboring groups whom we call by different names, such as Hohokam, Sinagua, and Anasazi, or ancestral Pueblo. Regardless, several distinctive material and ritual traditions that evolved locally among Mimbres people and that are most visibly and vividly expressed in painted pottery and mortuary practices

distinguish the Classic Mimbres period from all others.

The interplay I want to discuss is, therefore, essentially local: it is the interplay between some generations-old traditions of the Mimbreños and their material modifications of those traditions in response to internal and external forces. The painted pottery of the Classic Mimbres period may be perceived differently by different modern people. It might be seen as a radical innovation resulting from the local adoption of an alien tradition (diffusion), as an idiosyncratic invention by some local genius, or—the position taken here—as an evolution in form and iconography based largely upon local prototypes but also involving adaptations and innovations that were responsive to knowledge of nonlocal traditions. Those options may be thought of as central issues in understanding the history of Mimbres art, but they may have less to do with history than with researchers' personal beliefs and attitudes. Because I conceive of all art as a form of social behavior, I expect the art of any group, most of the time, to conform to, reflect, and express the general patterns of behavior of that group, rather than to diverge from those patterns. Both diffusion and genius have their places in an art history, but those places are always located within the social, economic, ecological, and historical contexts of the history of a people. Idiosyncratic invention is to history and culture what raindrops are to a lake.

Early Times: Cochise and Desert Archaic

Relatively little is known about the earliest people to occupy what became Mimbres territory. Spear points and knives of Clovis, Folsom, and other big-game-hunting Paleoindian tool

types such as the Sulphur Spring phase of the Cochise tradition have been found in the southern parts of the region. These indicate use or occupation starting about eleven thousand years ago (Cordell 1997:fig. 3.7). Somewhat more recent, from about nine thousand years ago, is evidence of the local Desert Archaic tradition called "Cochise" found in caves and at open sites mostly along the northern and western margins of what was to be the Mimbres country. Desert Archaic people of the Southwest characteristically depended upon foraged wild plant foods and small game animals and are considered to have been among the ancestors of most, if not all, later Southwestern horticultural and agricultural societies (Cordell 1997; Irwin-Williams 1979). Local variants of other, similar Desert Culture traditions occurred in all surrounding areas, in what are now Utah, Nevada, California, west Texas, and northern Mexico.

Toward the end of Cochise times, people's use of the environment was in many respects identical to that of the early Mogollon people, who are generally thought to have been among the Cochise culture's direct descendants (Hayden 1970). Their hunting and food-gathering activities were balanced, and they evidently cultivated some local plants and even maize, initially domesticated far to the south in Mexico as early as about 6000 B.P. Animal and plant products were basic raw materials for manufacturing a variety of goods more limited in number but often quite similar to those made later. Cave locations have been the most fruitful sources of information about all Desert Archaic people, but caves were by no means their only shelters or living areas. Several Archaic era villages with shallow pithouses and large food-storage pits are now known that are thought to have been transitional to the seden-

tary, agriculturally based villages that appeared throughout the Southwest after about 200 C.E. (Archaeological Conservancy 1999:11; Huckell 1995). Many large Archaic food-grinding stones have been found near caves and in open country far distant from cave or village sites. From these implements and other evidence it appears that open sites were used repeatedly by the same groups of people, who left their heavy tools to be used on future visits. These base camps were selected because of accessibility to water and to some plant food to be harvested, and their seasonal character seems to be beyond question.

House remains of the earliest Cochise people have not been found, and there is no information about the kinds of shelters that were made or used, other than caves. During the middle Cochise and later periods, they excavated large pits in cave floors, presumably for storing food, and these may have been the inspiration for the small, shallow, oval pithouses built during later Cochise times that were the housing prototypes for successor societies. Dug to a depth of about 2 feet and covered by roofs supported by wooden posts, the earliest Archaic houses had fire pits and were entered by way of side openings. They had few other distinguishing features. Aside from houses, food-grinding stones, other stone tools, and a variety of wooden and woven products, almost nothing is known about Cochise art and only a little about Cochise ceremonial life.

Corn and squash, both Mexican crops introduced from the south, were first cultivated in the American Southwest about thirty-five hundred years ago, more or less the time of the earliest Cochise villages. At first, cultivated crops may have been nurtured with about the same minimal care as that which Desert Culture people gave to wild plants such as mesquite.

But during the first millennium B.C.E., dependence upon cultivated foods increased, and other changes took place in the material and nonmaterial lives of people living in different parts of the Southwest. Among the groups defined by these changes were the Mogollon.

The Early and Late Mogollon

Mogollon dependence on agricultural foods went hand in hand with sedentary village life and a variety of new social, political, and religious practices. Innovations in material goods are the evidence for and symbols of these changes, and variations in those expressions define the various Mogollon periods and regional groupings, whose boundaries in time and space are imprecise. The southern groups, Mimbres and San Simon, occupied desert, foothill, and nearby upland locations, and the eastern branch, called Jornada Mogollon, also lived in desert country. With the possible exception of the Mimbres people, these desert Mogollon groups' lifeways differed in many respects from those of the northern Mogollon highland groups, and in fewer ways from each other (Diehl and LeBlanc 2001:7–9). The synthesis that follows best fits the southern groups (Bullard 1962:184–187; Wheat 1955).

The earliest Mogollon people are best known from cave sites in the Pine Lawn and San Simon Valleys, where radiocarbon dates demonstrate long and continuous occupations (Martin et al. 1952:483). Perishable materials from these caves, including food and clothing, provide rare details about daily life and show a slow evolution from an essentially hunting-and-gathering Desert Archaic way of life to a horticultural one. Cochise Archaic people were living in the Pine Lawn Valley about four or five thousand years ago, and by 200 C.E.—more

or less the time their descendants began making pottery—they are identified as Mogollon (Cordell 1997:202–205). Some Archaic types of stone tools continued in use until about 500 C.E., and until about then, subsistence patterns, manufacturing techniques, and methods for exploiting the environment changed only slightly. Even though corn, beans, and squash were cultivated, wild food use seems to have been about as great in the early Mogollon periods as in the preceding Cochise times. Not until about 500 or 600 C.E., when an improved variety of corn began to be grown, was there any significant increase in the use of cultivated foods and a corresponding decrease in dependence on wild food harvests (Wheat 1955:155–156). The most southern of the Mogollon groups or branches, the San Simon and the Mimbres, are among the oldest, dating to about 200 C.E. (Cordell 1997:203).

Early Mogollon houses everywhere seem to have been larger and more complex variations of Cochise pithouses, but even before 1000 C.E., the several regional variations of Mogollon pithouses had become distinctive from one another. In most places, early Mogollon villages were located on hilltops, ridges, or the highest available ground and were organized much as in previous times—as clusters of individual homes, all facing more or less east, with no easily perceived pattern of streets or plazas. The numbers and sizes of villages grew, and there is other evidence for expanding population, especially after the sixth century C.E. After then, too, there appeared a series of technological and stylistic innovations in the kinds of tools and other tangible objects that people made and used. Some of these innovations, such as the cultivation and weaving of cotton and the replacement of spear throwers and darts with bows and arrows, were introduced

by unknown means from the south. Others, such as radical style changes in architecture that began before about 1000 C.E., seem to have evolved within the Mogollon communities, perhaps as direct or indirect responses to interactions with northern Pueblo groups. Everywhere, increased dependence on agriculture required specialized techniques and tools that were different from those needed for wild food exploitation in the same areas. Daily and seasonal patterns of movement and activity were radically affected by the new agricultural dependence and its requirements, and the scarcity of good arable land more than likely had other important societal effects such as changes in ownership and inheritance systems, law, and patterns of social obligation.

Related and equally radical changes occurred in religious systems. As dependence on corn increased, so probably did formalized rituals aimed at ensuring successful harvests as well as the success of the new way of life. Large community ceremonial houses were built in early Mogollon times, and well before 1000 C.E. these became more specialized, stylized, and widespread. There is graphic evidence in rock art and pottery paintings that hunting rituals were important, but by 1000, corn, water, and fertility had come to dominate religious iconography and also, perhaps, religious activity (P. Schaafsma 1992:48–77). For the next several hundred years, images in several media show supernatural beings, figures that appear to be masked dancers impersonating them, and other ritual activities (figs. 4, 34, 97). The elaborate paraphernalia and ceremonies sometimes painted on pottery at Classic Mimbres sites suggest that after about 1000, religious societies and their priests, male and female, were in charge of complex ritual activities (fig. 29; pl. 2).

As time passed and populations grew, differ-

ences among the various Mogollon groups—perhaps reinforced by geography, ecology, and local history—become more visible in the archaeological record. The material culture and lifestyle of each Mogollon region took on some of the character of its closest neighbors, Mogollon or non-Mogollon, and they all differed far more sharply from one another after about 900 or 1000 C.E. than at any earlier time.[1] As early as the eighth century, the material life of Mimbres people was in many respects different from that of other Mogollones, and by about the eleventh century, Classic Mimbres architecture and painted pottery had taken on a distinctive, northern-Pueblo-like character. Parallel, roughly contemporaneous changes in architecture and pottery characterize other, more northerly mountain Mogollon people, especially those identified with the neighboring Reserve phase. Finally, the abandonment of both the Mimbres Valley and the material expressions that identify the Mimbres as a coherent group was echoed throughout the Mogollon world. Before the beginning of the fourteenth century, Mogollon communities everywhere had either been abandoned or were so altered in character that their Mogollon identity can be said to have ended.

Dating of the Classic Mimbres Period

Until the 1970s, the best reported excavations of Classic Mimbres sites were done before precise dating techniques had been developed and before either the Hohokam or the Mogollon had been described and defined. Classic Mimbres people were therefore classified as an ancient Pueblo variant. It was hardly suspected that their history was as old as or older than that of the people of the Colorado Plateau or that any perceived similarities between the two might be as much a matter of convergence as of diffusion. For those reasons, the Classic Mimbres sites that were first excavated must be reinterpreted and dated anew on the basis of old field reports, new artifact analyses, new test excavations, and new dating methods and technologies. Among the most useful of the last are archaeomagnetic dating of hearths and other burned architectural features and a variety of methods for dating ancient wood and other organic materials, including tree-ring dating and radioactive carbon 14 analysis. Along with these methods, dating must still rely heavily on traditional and indirect archaeological methods such as pottery typology and the cross-referencing of pottery types, both non-Mimbres wares found at Mimbres sites and Mimbres pottery found elsewhere.

Cross-dating of pottery is an imprecise art made complicated for Mimbres Classic Black-on-white by the fact that in places distant from the Mimbres Valley, some such pottery may have been made for about a generation after its abandonment by the Mimbres Valley Mimbreños (M. Nelson 1999). In any case, intrusive wares found at any site can be evidence only that exotic and perhaps valued objects were in use at a given place in a given time; they may have no bearing on actual dates of occupation of that place. Further, even the results of the precise dating methods that are now available, such as tree-ring analysis and radiocarbon dating, must be interpreted in terms of contexts of discovery when applied to pottery, stone, or other inorganic materials. For these reasons and more, archaeologists use as many dating methods as they can during their analyses.

Classic Mimbres Black-on-white is the diagnostic pottery type of the Classic Mimbres

period, but transitional varieties of an earlier ware, Mimbres Boldface Black-on-white (once called Mangas Black-on-white), were made during the early Classic period. Continuity of the painting styles called Mimbres Boldface and Mimbres Classic is quite clear. Detailed stylistic analyses by Catherine Scott (1983) and Harry Shafer and Robbie Brewington (1995) usefully subdivide these sequential types into several temporal stages, or "types," and also suggest some localized variations. Small quantities of Mimbres Boldface were widely traded in the southern Southwest, and dates obtained from a number of places suggest that it was made from about the middle of the San Francisco phase of the Late Pithouse period (about 750 C.E.) to about 1020. Classic Mimbres Black-on-white was less widely distributed. It is found in relatively large quantities at Jornada Mogollon sites east of the Rio Grande, and most of these vessels came from the Mimbres Valley, suggesting a special relationship between the peoples of the two areas (Shafer 1996:7–8). Lesser quantities are reported from Hohokam sites, but the type is rarely found at Colorado Plateau sites. Associated materials range in date from the late tenth to the fourteenth century but cluster in the eleventh and twelfth centuries.

Many tree-ring dates obtained since the early 1970s at Mimbres Valley locations support the view that Classic Mimbres Black-on-white was no longer made there after about 1130 (LeBlanc 1983; Shafer and Brewington 1995). The few Mimbres Black-on-white pottery fragments reported from fourteenth-century eastern Mogollon sites are certainly intrusive and anomalous, and they may represent heirlooms (Breternitz 1966:86; Jane Kelley 1966, personal communication 1974). Conversely, intrusive pottery reported from Classic Mimbres

villages includes Hohokam, northern Mogollon, and Colorado Plateau and other northern Pueblo wares made between the ninth and twelfth centuries. It should be stressed that thirteenth- and fourteenth-century northern and western Mogollon red and black wares, and other later southern wares of the Black Mountain, Animas, Casas Grandes, and Salado traditions, that are found at Classic Mimbres sites seem always to be associated with later communities that were built directly over or immediately adjacent to a Classic Mimbres village.

A wide range of manufacturing dates for Classic Mimbres Black-on-white was published in earlier years that effectively provides beginning and end dates for the Classic Mimbres period. A.V. Kidder and the Cosgroves dated the type with remarkable precision from about 950 to 1150 (Cosgrove and Cosgrove 1932:110–113; Kidder, Cosgrove, and Cosgrove 1949). Emil Haury (1943) postulated an end date of about 1250, and David Breternitz (1966:86) assumed the period of manufacture to have been between 1000 and 1275. Frederick Dockstader (1961) gave dates of 1000 to 1350, and Charles Di Peso, from about 1050 to 1200 (Di Peso, Rinaldo, and Fenner 1974:306–308). I had earlier estimated dates of manufacture from about 1000 to 1200 (Brody 1977). Edward Danson (1957) and James E. Fitting (1971a) each judged that the highland parts of Mimbres territory were abandoned in about 1250, as were Mimbres sites farther south, particularly in the Animas Valley (Kidder, Cosgrove, and Cosgrove 1949; McCluney 1965).

There is little question that Mimbres people built seasonally occupied houses and small villages in many outlying areas throughout the twelfth century and perhaps even later. There is evidence, now largely anecdotal, of presumably

contemporaneous, large, "typical Mimbres villages" in the Rio Grande Valley as well (Lehmer 1948:71; M. Nelson 1999). But there is little information about pottery manufacture outside of the Mimbres heartland and almost none to suggest when the distinctive pottery-painting tradition ended in locations outside the Mimbres Valley (Nelson and LeBlanc 1986; M. Nelson 1999). Peak production of Classic Mimbres pottery in the valley seems to have occurred over a period of perhaps 160 years, from about 970 to about 1130 (Shafer and Brewington 1995:7). At different places it may have begun a bit sooner or ended somewhat later, but no fewer than seven and possibly as many as ten generations of artists painted Classic Mimbres Black-on-white pictures.

Neighboring Peoples

The Classic Mimbres emerged from Mogollon traditions and was shaped by the pressures of a growing population that depended upon agriculture in a semiarid, highland environment with limited arable land. The Mimbreños were subject to ecological stresses that might have arisen from relatively minor changes in climate. How they reacted to those pressures depended in part on their knowledge of how neighboring peoples resolved similar situations and whether those responses might be adapted to suit local conditions. Their neighbors included other Mogollon and Mogollon-like groups as well as two other energetic, dynamic traditions that were experiencing similar problems. Those two are generally referred to as the Hohokam, who lived to the west of the Mimbres, and the northern ancestral Pueblo people of the Colorado Plateau and adjacent regions, once commonly called the Anasazi (see map 1).

In early periods, the Hohokam seem to have been a major source of innovations adopted by nearby Mogollon people, including the Mimbres. But by Classic Mimbres times, Mimbres expressions in architecture and painted pottery had taken on distinctively northern Pueblo textures and qualities. Material responses to interactions between the Mimbres and other Mogollon people are more difficult to isolate or describe. For example, the material expressions of the Mimbres and other Mogollon people living in adjacent parts of the Chihuahuan and Sonoran Deserts are sometimes so similar as to be indistinguishable from each other. Mimbres-like villages are located as far south as the Casas Grandes area of Chihuahua, but with the possible and admittedly important exception of symbolic and ritual expressions and trade goods, few visible effects upon the Classic Mimbres came from that direction. Later occupations or reoccupations of the Mimbres country were much more profoundly affected by innovations from that southern region (Schaafsma and Riley 1999).

The Hohokam were probably the first truly sedentary agricultural people of the American Southwest. Sometime before 700 C.E. they developed what became a large and complex network of irrigation canals between the Gila and Salt Rivers in the flat deserts of south-central Arizona. There they also built many distinctive communities, some of which were continuously occupied for many hundreds of years. The fundamental characteristics of Hohokam society were established during its Pioneer period (200–775 C.E.), when it became a well-established regional tradition. Pioneer period villages were made up of small clusters of houses built within shallow pits around courtyards. Distinctive manufactures of this time included carved stone bowls, clay figurines,

red-slipped pottery, and, by 500 C.E., a few pottery vessels painted with red designs on gray or buff backgrounds.

During their Colonial period (775–975), the Hohokam expanded greatly in all directions, some going as far north as the vicinity of present-day Flagstaff, Arizona. They reached their maximum territorial extent during the Sedentary period (975–1150) and then, in their Classic period (1150–1400/1450), withdrew toward their original core area. Ritual ball courts were a characteristic feature of Hohokam villages after about 800, and low truncated pyramids or platform mounds became important during the Classic period. Clay and stone figurines, stone bowls and palettes, and great numbers of carved, inlaid, or etched bracelets, pendants, necklaces, and other ornaments made primarily with shell from the Gulf of California were created during all periods. Ball courts, platform mounds, figurines, macaws, copper bells, and, not least, painted pottery using red or brown paint on gray or buff surfaces are among the Hohokam's expressions that link them to contemporaneous peoples of northern, western, and perhaps central Mexico.

Throughout, there were regional variations in the Hohokam world characterized by greater dependence on cultivation in some areas and on wild food harvests in others. The life rhythms in the latter places were more like those of local Archaic people and also of contemporaneous neighboring Mogollon and other desert folk of northern Mexico. In contrast, Hohokam people who moved to the colder, wetter, mountain environments north of the Gila–Salt Valley had to modify so many aspects of their material lives that they came to appear sharply differentiated from their lowland Hohokam neighbors.

Hohokam red-painted gray or buff pottery is visually similar to some Mogollon wares but was finished in a technologically distinct manner. The hand-built, coil-made vessels were smoothed and their shapes refined while the clay was still plastic by means of the potter's slapping vessel exteriors with a wooden paddle while holding a mushroom-shaped stone anvil against the interior surface. With rare exceptions, all other ancient Southwestern traditions relied on scraping techniques for smoothing and shaping, rather than on the paddle-and-anvil method. In the San Pedro Valley of southeastern Arizona, where eastern Hohokam and San Simon Mogollon people met, sites intermix and such differences are blurred. The similarity of pottery between Hohokam and Mogollon is strongest here, with each group freely adapting ideas introduced by the other. Farther east, in the border areas between the San Simon and Mimbres peoples, a similar situation prevailed, and the likelihood is that San Simon people acted as conscious or unconscious intermediaries between the Mimbres and the Hohokam (Sayles 1945; Wheat 1955:27–29).

Until about 900 C.E., when Colorado Plateau–like modifications of both Hohokam and Mogollon societies became quite visible, many material expressions of the two groups, Hohokam and Mogollon, were broadly similar yet characteristically different (Gladwin 1945:iii–iv; Haury 1936a: 127). Both peoples lived in pithouse villages, but the Hohokam built houses that were generally large, rectangular structures set in shallow pits, whereas Mogollon people excavated pits that were used as the lower walls of either rounded or rectangular houses. Hohokam villages were more clearly patterned than those of the Mogollon, with houses clustered around courtyards, plazas, or other focal points. Both peoples made brown or buff pottery whose colors were in great part a function of geological landscapes that produced iron-

rich clays, but their ceramic technologies differed. Both groups were agricultural, but they differed significantly in agricultural technologies and degree of reliance on wild food harvesting and hunting. They were close neighbors but until late were generally non-competitive, each choosing to occupy a different environmental setting that required different techniques for effective exploitation.

Some Mimbres-Hohokam similarities were a matter of common Desert Archaic origins. Others resulted from their sharing later inno-vations, yet direct contacts between the two seem to have been minimal. Some Mimbres pottery, including Boldface Black-on-white and Mimbres Classic Black-on-white, is found at Hohokam villages, and Hohokam pottery found at Mimbres sites includes Colonial and Sedentary period vessels. There was also trade in stone tools and ornaments. Most Hohokam objects found at Mimbres villages are decorative; they include primarily carved shell ornaments but possibly also stone bowls. Hohokam material interactions with the Mimbres seem to have occurred mainly through trade in luxury goods, especially raw materials such as seashells, that traveled east to Mimbres villages. There is scant evidence of whatever goods the Mimbreños exchanged in return.

The Hohokam have the appearance of being singularly homogeneous when compared with the enormously diverse ancient Pueblo groups who once lived on and near the Colorado Plateau. Among the modern-day descendants of the ancestral Pueblos are counted many Tiwa, Towa, Tanoan, and Keresan speakers of the Rio Grande Pueblos, Shoshonean and Tanoan speakers of the Hopi mesas, and Zuni and Keresan speakers of the pueblos that lie in between. The Piro and Tompiro languages of the southeasternmost pueblos are now extinct.

This linguistic diversity is ample evidence of a complex ancestry whose diversity has been explored during more than a century of archaeological investigations. On the face of it, the ancient Pueblo people were many groups rather than one, and the term is almost exclu-sively descriptive of the material history of an unknown and unknowable number of ancient farming peoples of the Colorado Plateau whose economic lifeways were shaped largely by geography and climate.

The essential feature of ancient Puebloan history was the widespread and pragmatic adoption by different peoples throughout the Colorado Plateau of a generalized set of eco-nomic, social, religious, and material ideas. These included sedentism supported by several different methods of cultivating corn, beans, and squash and residence in small, independent, and essentially egalitarian villages in which kinship systems were inseparable from political and religious organizations and obligations. Among their most distinctive material expres-sions were architecture and painted pottery. Until about 1300 C.E., the Colorado Plateau people decidedly preferred pottery painted with black lines on white surfaces. After then, when most peoples of the region had moved away from the center of their original home-land and toward the edges to the east, south, and west, decorative preferences became more varied and complex. In architecture, after an initial period of Mogollon-like pithouse con-struction (circa 250–750 C.E.), most Colorado Plateau villages were built as above-ground, multifamily, multiroom, and, in many places, multistory houses of stone or adobe. These sometimes focused on a plaza or, when villages grew to include a number of large buildings, two or more plazas. Large, semisubterranean, circular, rectangular, or square ceremonial

rooms or buildings, which are today called by the Hopi word *kiva*, were usually located in plazas or in front of room blocks, and small kivas were often integrated within residential buildings. Sometimes, as at Pueblo Bonito in Chaco Canyon, a large number of kivas were located inside a building complex. Often, two or more large kivas were built in one plaza. Several regional variations existed in kiva size, form, and architectural details, yet most kivas evoke ancient pithouse architecture and were doubtless derived from that earlier residential form.

Like other early Southwestern agricultural peoples, the earliest Colorado Plateau village-dwelling societies began with the gradual adoption of horticulture by scattered groups of Archaic Desert Culture people living along the drainage of the upper San Juan River and in the middle Rio Grande Valley. By about 400 C.E., some of these groups were nearly fully sedentary and agricultural. Initially, their villages were similar to those of early Mogollon groups, especially in southern borderland areas. Houses at first were shallow or deep pithouses with east-facing, tunnel-like ramped entrances, but later pithouses used rooftop entry by way of a ladder through a central hatchway. Gray-ware pottery, sometimes covered with a red clay or red ochre in imitation of Mogollon wares, was made from the iron-poor clays characteristic of the Colorado Plateau. By the 500s, some vessels were being painted with gray or black lines, and from about that time most northern wares took on a distinctive local character.

By about 1000 C.E., the ancient Pueblo region had expanded to include most peoples of northern New Mexico, northern Arizona, portions of southeastern Nevada, southern and central Utah, and southwestern Colorado. Almost certainly, most of that expansion involved both local population growth and the adaptation of local Desert Culture societies and incoming groups to a new way of life, rather than any kind of expansionist political or religious process. Several regional centers developed, each identified primarily by its use of distinctive styles of painted pottery, architecture, and, to a lesser degree, iconography. The most visible of these centers today are at Mesa Verde in southwestern Colorado, in the Kayenta area of northeastern Arizona, and in the Chaco-Cíbola region of northwestern New Mexico. By 700 C.E., except in borderlands, similarities to Mogollon regional traditions had become almost invisible.

In border regions, especially along the southern margins of the Colorado Plateau and in the adjoining Mogollon highlands, interactions between peoples left their visible marks. Red- or brown-ware pottery was made in some parts of the Colorado Plateau throughout the black-on-white era, and designs derived from northern Pueblo traditions were sometimes painted on northern Mogollon pottery. Occasional similarities can be seen also in ceremonial and domestic pithouse architecture, and contacts seem to have been continuous between the two regions, especially during the 900s and later. After about 1000, northern Pueblo innovations, perhaps brought by people who were moving away from the Colorado Plateau, appear with increasing frequency at northern Mogollon villages, as evidenced by domestic and ritual building styles, burial patterns, pottery styles, and other manufactures.

During the next three hundred years, as many Mogollon people moved northward and the center of the ancient Pueblo world moved to the eastern, southern, and western parts of their former homeland, both societies were transformed. Those transformations are most

visible in the architecture, remarkable polychrome pottery, iconography, and ritual artifacts found all along the Mogollon–northern Pueblo borderlands, from the White Mountains of Arizona to the Salinas Pueblo region in New Mexico. The Reserve and Mimbres areas were among the first Mogollon regions whose architecture and pottery were transformed in ways that seem almost predictive of the massive changes that, before 1300, created a new Pueblo world from what had once been distinctively different Colorado Plateau and northern Mogollon societies.

Classic Mimbres as well as earlier Mimbres sites have been located in Chihuahua as far south as the Río Carmen, and thirteenth-century descendants of those people, following the end of the Classic Mimbres period, became part of the Casas Grandes tradition that is identified today with the ruins of the large town of Paquimé (Shafer 1999:121–133). Excavations in the Casas Grandes region suggest that, as happened in so many other parts of the arid Southwest, indigenous peoples there transformed themselves from Desert Archaic to sedentary societies that were mostly but not entirely dependent on agricultural products (Schaafsma and Riley 1999).

From about 700 to about 1100 C.E., a high proportion of trade pottery in the Casas Grandes region seems to have come from the Mimbres people (Di Peso, Rinaldo, and Fenner 1974:250, 308). Di Peso, among others, surmised that several iconographic themes of ritual, ceremonial, and religious nature that are found in Classic Mimbres painted pottery and petroglyphs might have been transmitted from deep within Mexico by way of Casas Grandes. That suggestion was based on little more than logic, and in any case, it is likely that the two areas exerted mutual and balanced influences on each other well before towns in the Casas Grandes region grew in size and influence during the thirteenth century.

Throughout most of Mimbres times, all societies of the Southwest seemed to benefit equally from contact with their neighbors, and there is no compelling evidence to suggest dominance by any one group over any other. If early Pueblo people adopted Mogollon ideas or innovations, they altered them to fit their own circumstances. Later, several northern Mogollon groups seem to have absorbed northern ideas slowly and selectively, adapting them to suit prevailing local traditions. Painted pottery throughout the region illustrates these points. It is difficult if not impossible to classify painted pottery made before the tenth century by San Simon Mogollon people as either Mogollon or Hohokam, and except for their black-on-white pottery, "Mimbres people" living in the Casas Grandes region are almost indistinguishable from their neighbors. Occasionally, these exchanges bore unexpected fruit. By the thirteenth century in the northern Mogollon mountain districts, the interchange of ideas between Mogollon and Colorado Plateau people led to the development of a richly creative polychrome pottery tradition that spread after about 1250 to many parts of the newly emerging Pueblo Southwest (Carlson 1970). Much modified and in its many variations, aspects of that tradition persist to the present day among some Pueblo communities.

The twelfth- through fourteenth-century migrations affected all Southwestern people. Most Colorado Plateau centers were abandoned, and a bewildering series of population shifts continued for some 150 or 200 years, during which many of today's pueblos were established. After about 1300, the largest populations and greatest number of Pueblo towns were located

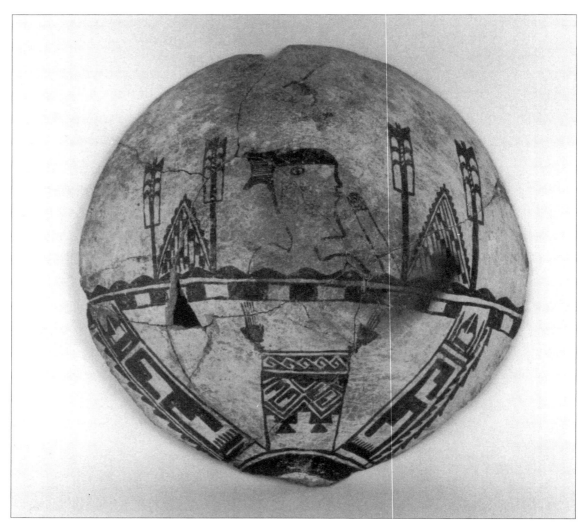

Figure 45. Canteen, Tabira Black-on-white. (circa 1545–1672, shown upside down). Salinas National Monument, N.M. Gran Quivira, Mound 7, diameter 23.2 cm, 9.25 in. (NPS Q 3947)

on either side of the Rio Grande Valley, from south of modern-day Socorro to Taos. Other centers lay east of the Rio Grande in the Pecos River drainage, westward in the Tusayan district of northeastern Arizona, and along the south-eastern edge of the Colorado Plateau, especially near the modern pueblos of Zuni and Acoma (see map 1).

Mogollon people seem to have moved in all directions. Those who went north toward Acoma, Zuni, and Hopi integrated so well that identification of any ancient Mogollones with

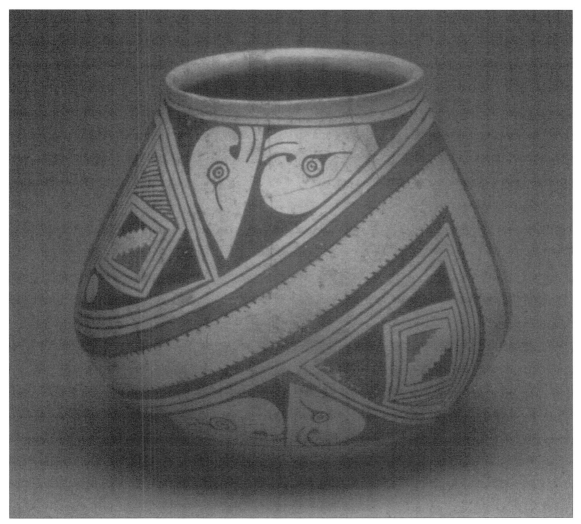

Figure 46. Jar, Ramos Polychrome, Casas Grandes tradition (circa 1280–1450), Chihuahua, Mexico, 21.2 x 22.6 cm, 8.4 x 8.9 in. Stylized macaw heads integrated with geometric patterns are almost ubiquitous on Casas Grandes pottery of this era. (MIAC/LAB 20900/11)

any modern Pueblo population is based on nothing more than logic and geography, which are often used to interpret oral traditions that may be many hundreds of years old (Ellis 1967; Ford, Schroeder, and Peckham 1972). Mimbres people may also have moved in several different directions, especially toward the south, east, and north, but at present there is no way of knowing with precision or assurance where any of them went or how they relate to any modern population (Brand 1935; Danson 1957; Haury 1936a; Sauer and Brand 1930; Shafer 1999:130–133;

Turner 1999:229–233). Not long after the Classic Mimbres villages of the Mimbres Valley were virtually abandoned, new villages were established there, and the valley was occupied into the 1400s by people variously identified with the Animas, Black Mountain, and Salado traditions (Creel 1999). Some may even have been direct descendants of Classic Mimbres people.

If Mimbres-like painted pottery images and rock art found east of the Rio Grande (figs. 45, 97) can be taken as evidence of Mimbres movement in that direction, it may be that some Mimbres descendants mingled with the ancestral Pueblo and Jornada Mogollon people who created the Salinas pueblos in the vicinity of Chupadera Mesa and Mesa de los Jumanas during late prehistoric and early historic times. By the same token, some iconographic and conceptual resemblances between Mimbres pottery paintings and those of the quite different Casas Grandes tradition seem more than coincidental, and some historical connection between the two can be posited (compare pl. 4 and fig. 46).

Whatever the case, the Mimbreños' abandonment of their home territory was not an isolated event but was instead among the earliest of many such movements of Southwestern farming peoples that took place over the next few centuries. No one explanation seems to account for all of those events, but in some sense all of them were triggered by some combination of historical fact, such as population growth, and environmental stress, such as drought or a cooling trend that could restrict agricultural success in this arid, agriculturally marginal part of the world. Leaving their home territory may well have been a traumatic event for Mimbres people, but trauma had certainly not been involved in the radical changes of their lifestyle that occurred during the Classic Mimbres period. During that time they seem to have invented solutions to new problems resulting largely from population growth, all the while selectively, creatively, and pragmatically modifying other solutions that may have been suggested by Colorado Plateau prototypes.

Superficially at least, Classic Mimbres architecture and painted pottery may be interpreted as variations on Pueblo themes. But that perception can be misleading, for Mimbres society as we know it from its fragmentary tangible remains is essentially unique. The painted pottery tradition that was invented in the Mimbres Valley during the tenth century served decorative and communicative functions that most clearly express those unique qualities. Mimbres painted pottery symbolized a newly evolved social system and its novel economic, political, and religious forms. It was an integral part of the life of the Classic Mimbres people.

Inventing Mimbres Painted Pottery

The Mimbres Black-on-white painting tradition began during the 700s C.E. and continued until about 1150. As I discuss this tradition here and in succeeding chapters, I do not follow a strictly chronological order. Mimbreño potters and pottery painters invented novel technological processes and modified others as their tradition evolved, but those innovations were not synchronous with the stylistic and iconographic ones that characterize their art. The style and the subject matter of the art, though closely linked, each had its own rhythm of development as well. Many more paintings were made during the last 150 years of the tradition than in earlier times, and the later art, known as Mimbres Classic Black-on-white—or, with typical archaeological understatement, "Style III"—brought the tradition to a climax and a close. For good reason, chapters 7–9 are mostly about those last 150 years; much of this one is about what preceded them.

Mimbres pottery painting involved two separate but closely related pictorial traditions, one figurative and the other geometric. The figurative tradition, which seems to have derived from Hohokam painted pottery imagery but soon evolved locally in unique directions, to a great degree came to define the Classic Mimbres period. Although it may have had some effect on later local and more distant pottery-painting traditions, its unique character ended with the end of the Classic Mimbres era.[1]

The geometric tradition seems to have had another history entirely. It began long before the Classic Mimbres period and developed slowly in several Mogollon regions, including the Mimbres. In its earlier manifestations it resembled and almost certainly derived from Hohokam prototypes, and it may also owe something to generalized northern Mexican pottery-painting traditions. Later, it came to resemble the black-on-white pottery paintings of the Colorado Plateau, and it also interacted with other northern-Pueblo-inspired Mogollon painting traditions. Because of the long time involved in its development, and because each change was logically integrated with earlier modes, continuity rather than radical innovation characterizes its history. Classic Mimbres geometric paintings are distinguished from those made by earlier Mimbres people mostly by qualitative differences in detail, coloration,

and execution, especially line quality and careful paint application. Although these changes had the effect of converging some pictorial ideals of the Mimbreños with those of Colorado Plateau Pueblo peoples, it will be seen that in its main features and qualities, Classic Mimbres painting was indigenous. Any supposed northern Pueblo influences were, in the final analysis, only general and superficial.

Certain elements of the Mimbres geometric tradition were continued in later times at other places and by other people. Even so, it is difficult to determine the points of continuity between Mimbres painting and that of any later people, because those elements were used on wares that are easily distinguished from those made either in the Mimbres Valley or at other Classic Mimbres locations. Conversely, continuity and the slow and logical growth of a painting system characterize visual relationships between Mimbres Classic Black-on-white and earlier Mimbres Valley pottery-painting modes. The transitions are virtually seamless as substyles or subtypes grade one into the other.

Mogollon Pottery Painting Before the Classic Mimbres Period

The earliest manufacture of Mogollon pottery seems to have begun as a complex brought in from some unknown northern Mexican source or sources, with its forms as well as technical methods all part of the package (Wheat 1955:72–73). Unpainted, polished brown or red wares were the first Mogollon pottery, and variants of these formed the vast majority of all ceramics made in all Mogollon branches from about 200 C.E. until about 1000. Hardly more than twenty distinct shapes were made, and most of those were variations of hemispherical bowl or globular jar forms.

Painting did not become a significant decorative mode in any Mogollon region until the 700s, and even after then, unlike in most other Southwestern regions, the texturing of pottery surfaces remained the decorative procedure of choice for most Mogollon people. Texturing patterns and techniques were much the same in all Mogollon regions, but painting had a much more varied history. Modes of painting on fragments of Mogollon pottery dating from about 400 C.E. that have been collected from regions to the west of the Mimbres resemble decorative modes then current in northern Mexico. They are characterized by the use of broad red lines on unslipped brown-ware bowls.[2] Execution was casual, and designs are seldom more elaborate than the simple segmentation of a vessel's interior with a few broad lines. Despite their crudeness and lack of detail, these paintings set important precedents. By using an entire visible surface as a design field and then dividing that space into equally sized, center-oriented segments, usually four, the early potters established the organizational principles that dominated all later Mogollon pottery painting, including that of the Classic Mimbres.

The tradition was carried a step further between about 400 and 600 C.E. in the San Simon branch with the manufacture of a ware called Dos Cabezas Red-on-brown (fig. 47). Its paintings were refinements of the visual ideas suggested earlier and were executed only in deep hemispherical bowls that often had fire clouds on their unpainted exteriors. Four-section design patterns were made with broad red lines painted over red-slipped but unpolished vessel interiors. Large triangles were often suspended from another red line drawn around the rim, and these triangles were usually joined at the center of a bowl. With chevrons,

Figure 47. Bowl, Dos Cabezas Red-on-brown, 7.5 x 15.9 cm, 3 x 6.4 in. University of Arizona excavations in south-eastern Arizona, 1924. (ASM A36437)

they comprised the total inventory of design elements and motifs (Sayles 1945:42). This design system was similar to that used by contemporary neighboring peoples to the south, and with only minor variations it persisted in some areas well into the tenth century.

The geographical focus of Mogollon painting shifted to the north and east between about 600 and 900 C.E. The Black River, Pine Lawn Valley, and Mimbres regions became the Mogollon pottery-painting centers, all producing red or brown wares that are virtually indistinguishable from each other. They also produced the equally generic Mogollon Red-on-brown (circa 650–750), which is considered to be the diagnostic painted pottery type of the San Francisco phase (Diehl and LeBlanc 2001:17; Wheat 1955:88–90). Made in relatively small quantities, Mogollon Red-on-brown was a further refinement of earlier Mogollon painted wares, and except for its paintings, it is virtually identical to unpainted Mogollon red or brown

pottery. On both, a thin red-brown clay was applied as a slip, or thin wash, to the interior surfaces and often to the exterior surfaces of bowls, which were usually polished by burnishing. Painted designs might then be applied to bowl interiors with a clay pigment that fired to a red-brown color. Unpainted exterior surfaces were often patterned with finger-pressed indentations (dints or dimples) made at the time the potters welded the clay coils together to form the vessels. Whether deliberate or not, these do suggest the dint marks that are seen or felt on the anvil side of pottery surfaces smoothed by paddle-and-anvil methods.

Paintings similar to those on bowl interiors were sometimes made on the visible surfaces of other vessel shapes such as plates, jars, and beakers. Even when slipped surfaces were not polished, the painted lines were burnished, and the resulting contrast between shiny lines and dull ground helped intensify differences between otherwise closely related colors (fig. 48). The burnishing of lines on clay-painted pottery also characterizes all later Mimbres painted wares, especially those from the Mimbres Valley, but no other pottery from anywhere else in the American Southwest, thus underlining the local nature of the tradition. Other points of continuity include the common appearance on Mogollon Red-on-brown bowl exteriors of black or gray carbon streaks, called "fire clouds," that were acquired during the pottery-firing process. Such clouds are easily prevented by protecting vessels from direct contact with fuel during firing. Their systematic occurrence can mean only that the Mimbres either considered fire clouds innocuous or thought them desirable. They are a hallmark of all Mimbres painted pottery.

The entire inner surface of a bowl, framed off by a single line at the rim, was considered

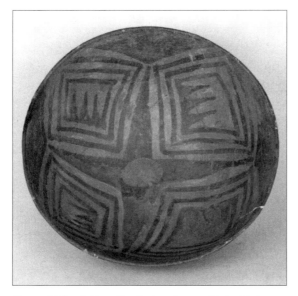

Figure 48. Bowl, Mogollon Red-on-brown, 11.4 x 24.4 cm, 4.5 x 9.6 in. Excavated before 1934; no details known. (MIAC/LAB 8393/11)

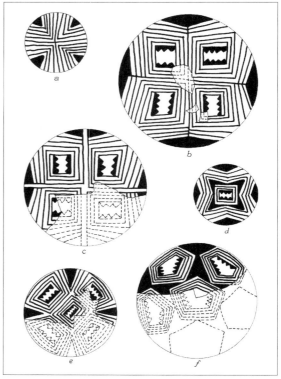

Figure 49. Design systems used in Mogollon Red-on-brown pottery paintings (after Haury 1936b:14, fig. 3).

to be the design field in the Mogollon Red-on-brown tradition. Broad and imprecise painted lines usually subdivided that field into four wedge-shaped sections, each filled with a repeat pattern of one or a few simple, broadly painted linear motifs. Solid triangles suspended from the rim line were another common motif (fig. 49a–c). Quartering lines are sometimes absent, in which case a vessel was segmented by implication. Design variations included the use of double dividing lines, with the space between each pair of lines flanked by solid suspended triangles, as well as the use of pentagonal structures with pendant rim solids (fig. 49d, e).

Solids, chevrons, rectangular scrolls, and nested polygons were used as fillers. The innermost of a group of nested polygons sometimes had a reserved center in which a saw-toothed

motif was painted, and similar rectangular units with motifs painted inside them are sometimes seen at the center of a vessel. As in most earlier Mogollon paintings, no large areas were left unfilled, and the kind of dark-light imagery that so captivated Classic Mimbres painters was not yet hinted at. With the greater variety and precision of its design structures, Mogollon Red-on-brown also used a greater variety of filler elements than earlier Mogollon traditions, and many of these elements seem to have been first used in the Mimbres area. Among them are simple curvilinear patterns, interlocking elements, fringed lines, and cross-hatching

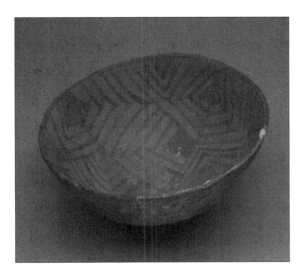

Figure 50. Bowl, Three Circle Red-on-white, 10.8 x 15.9 cm, 4.3 x 6.3 in. This type is the earliest of the Mogollon white-slipped painted wares. (MIAC/LAB 20212/11)

(Haury 1936b:12, 13). Compared with later Mogollon painted pottery designs, Mogollon Red-on-brown designs are unrefined and repetitive, but they have a vigor and spontaneity seldom matched in the more complex and tightly controlled later wares. The style was a logical development from earlier Mogollon painted wares and an equally logical precursor of later ones.

Three Circle Red-on-white painted pottery replaced Mogollon Red-on-brown to some degree in the same regions, perhaps as early as the 670s C.E., but more likely between about 730 and 770 (Haury 1936b:18–19; Shafer and Brewington 1995:7, 8; Wheat 1955:90–91). It is at best a poorly defined type, made in small quantities for only a generation or two and clearly transitional between Mogollon Red-on-brown and the earliest Mimbres Black-on-white style. A white slip, probably made from

either of at least two different kinds of locally available kaolinitic clays (Eric Blinman, personal communication 2002; William X. Chavez, personal communication 2002), was used on brown-paste pottery to make this the first of the Mogollon white-slipped wares. Several thin coats of white may have been applied to cover bowl interiors or jar exteriors for the primary purpose of providing a white or whitish background for red-line designs that were made with clay slip pigments (fig. 50). About half of these early white-slipped vessels were further colored by a red or brown slip over otherwise unpainted exterior surfaces. Exteriors were commonly marked by fire clouds.

Three Circle bowls are more hemispherical than those of earlier periods, and their white slips are usually chalky, thick, and polished and have a tendency to crackle or flake. The slip often fired to an ivory color, in harmonic contrast with the rust-red painted lines of the decorations applied over it. Brushwork was more precise and lines were finer than in Mogollon Red-on-brown paintings, and with this type, a trend toward precision as a painting ideal became well established. Design systems and elements are substantially like those of the earlier red-on-browns, but the proportion of solid to linear fillers is greater, small unpainted areas occur more frequently, spirals and other curvilinear motifs are introduced, and sometimes there are suggestions of a deliberate play with positive-negative dualities. Designs on bowls were usually carried to the rim, but framing lines below the rim occurred more often than in earlier times.

Three Circle Red-on-white was made for a relatively brief time and probably in fewer places than Mogollon Red-on-brown. Its period of manufacture overlapped with production of the earliest, or Style I, Mimbres Black-on-white

pottery, which replaced the earlier white-slipped type in the Mimbres region (Martin and Rinaldo 1950:362–369; Wheat 1955:91–92). More complex and refined than any earlier Mogollon painted pottery, Three Circle designs are quite variable and clearly relate to Style I paintings, so much so that it is often uncertain whether any one vessel should be classified as one rather than the other (fig. 51). It was only as the black-on-white styles matured that the Mimbres pottery painting tradition came to differ significantly from Three Circle Red-on-white in its visual qualities.

But from first to last, all Mimbres pottery-painting styles and substyles were sequentially linked and technically very much alike. The most significant technical differences among them have to do with firing methods. In all of the later Mimbres Black-on-white styles, pot-ters simply reduced the flow of oxygen in their kilns toward the end of the firing process to create what is known as a reduction atmosphere, in which the iron in their clay paints would fire black instead of oxidizing to a rust-red color. As part of that process, they may also have modified firing temperatures. Otherwise, there are few technical differences between the earliest and the latest of the Mimbres painted pottery styles.

Though often treated as though distinctly different, early and late styles of Mimbres Black-on-white form a stylistic continuum that developed over the course of almost three hundred years, from about 750 or 775 C.E. (about the middle of the San Francisco phase) to about 1130 or 1150 (the end of the Classic Mimbres period in the Mimbres Valley). Indiv-idual painted vessels made at either end of that continuum are easily differentiated from one another, but close analyses of series of vessels from the Mimbres Valley clearly demonstrate a

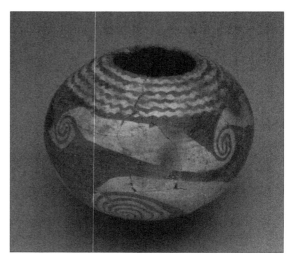

Figure 51. Bowl, Mimbres Boldface (Style I), 14.4 x 17.5 cm, 5.7 x 6.9 in. The red-brown slip paint is like that of Three Circle Red-on-white, but the dark-light patterning, powerful negative shapes, and zigzag framing lines are typical of Style I Mimbres paintings (see fig. 53). Similar designs and paint were used in all succeeding styles of Mimbres painted pottery. Excavated by the School of American Research and Museum of New Mexico at Cameron Creek Village, 1923. (MIAC/LAB 20224/11)

developmental sequence with at least three recognizably different style gradients. These are referred to, from early to late, as Styles I, II, and III (Scott 1983). Style I (circa 750/775–900s) is generally synonymous with what was once called Mimbres Boldface Black-on-white (Mangus Black-on-white), and Style III (circa 1000/1025–1130/1150) is the same as Mimbres Classic Black-on-white. Style II (900s–1000/1025) is intermediary between the other two (fig. 52) and is sometimes referred to as Transitional Black-on-white. Early and late variants of each style are also recognized, allowing for a more or less systematic identifi-cation of later "Boldface" paintings from the Mimbres Valley as either early or late Style II,

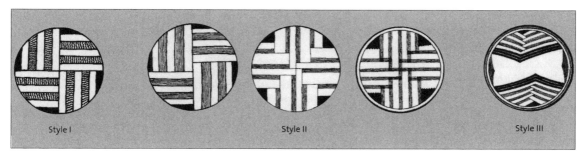

Figure 52. Mimbres painting styles I, II, and III (after Brody and Swentzell 1996:117).

of early "Classic" ones as Style II/III, and of early, middle, and late Classic and polychrome variations as late Style III (Shafer and Brewington 1995). I discuss Style III in detail in chapters 7–9.

Mimbres Black-on-white Style I came to differ from Three Circle Red-on-white in many more respects than paint color, but design similarities are sometimes so close that paint and slip color are the only qualities distinguishing one from the other. To add to the confusion, the painted designs on a relatively large proportion of Mimbres Black-on-white vessels in all styles come in a range of colors from brown to red that are conventionally called "black." For those reasons, a subjective judgment that one vessel is more smoothly finished and painted with firmer lines than another may be all that causes it to be classified as Style I Black-on-white rather than as Three Circle Red-on-white (Martin and Rinaldo 1950:362–369).

As time passed, design differences increased, and Mimbres painted vessels took on new shapes and proportions that reduce the diagnostic value of paint color. But since color variations in Mimbres painted pottery of all periods and styles were almost entirely a function of technical control over the firing process, and since

control over firing atmospheres was never perfectly achieved, it is impossible to know whether color variations in any given instance were intentional or accidental. In short, color alone is never enough to distinguish any Mimbres painted pottery tradition or style from any other. All Mimbres pottery paint was subject to ambient color variations ranging from rust red through chocolate brown to rich black, while the white surfaces range in color from pale gray through cream to a warm, pale pinkish yellow.

The most common Style I vessel form is a hemispherical bowl. Early ones are relatively small and deep and have in-turning rims that may be so exaggerated as to create a globular, jarlike form similar to a shape commonly used in Three Circle Red-on-white bowls (fig. 51). Later bowls tend to be larger and proportionately shallower and are generally similar to forms produced by Classic Mimbres potters (fig. 53). Beginning with Style I and continuing through the Classic Mimbres period, Mimbres potters also made ovoid, elliptical, and asymmetrical bowls. Sometimes referred to as "warped" shapes, these were formed as ordinary circular bowls and then reshaped while the clay was still plastic and before the vessel was

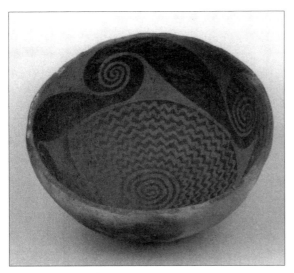

Figure 53. Bowl, Mimbres Boldface Black-on-white (Style I), 7 x 13 cm, 2.8 x 5.1 in. Compare the curvilinear motifs with those in figure 51. Excavated by the Mimbres Foundation at the Galaz site, 1975–1976. (MMA 77.67.20)

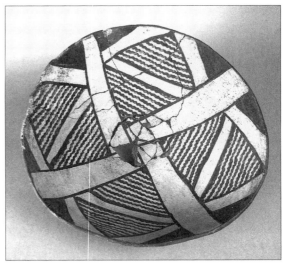

Figure 54. Bowl, Mimbres Boldface Black-on-white (Style I), 10 x 24.5–26.5 cm, 3.9 x 9.7-10.4 in. Fourfold pattern structured by overlapping white rectangles in a basket-weave pattern. The triangular fillers give the illusion of creating a four-pointed star underlying the white rectangles. Excavated by the Mimbres Foundation at the Galaz site, 1975–1976. (MMA 77.42.25)

slipped, painted, and fired (figs. 54, 58).[3] These vessels work well for pouring liquids or dry granular materials such as grass seeds and corn-meal, and many seem to have been shaped with those ends in mind. The painted designs are modified to fit within the asymmetrical forms, but in all other respects the paintings on these vessels resemble those on other, contemporaneous bowls. As on Three Circle and all later Mimbres painted bowls, fire clouds are common on Style I bowl exteriors.

Style I bowl paintings extend to the very rim of a vessel, and their layouts and compositional schemes usually differ little from those of earlier and contemporaneous Mogollon painted wares. Some Style I paintings are representational, and these are stylistic bridges between Hohokam prototypes and later Classic Mimbres figurative paintings (compare figs. 55, 56 with figs. 75, 76). As new layout variations, design

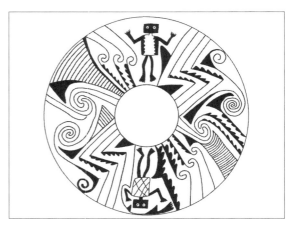

Figure 55. Bowl, Mimbres Boldface Black-on-white (Style I), 10 x 31 cm, 3.9 x 12.2 in. Two humans in a geometric pattern. Excavated by E. D. Osborn (site unknown) and purchased about 1923 for the Heye Foundation, Museum of the American Indian (now the National Museum of the American Indian), by J. W. Fewkes (Fewkes 1923:28, fig. 12). Drawing by Harriet Cosgrove. (NMAI 5/1350)

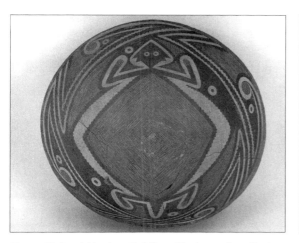

Figure 56. Bowl, Mimbres Boldface Black-on-white (Style II), 13 x 34–35 cm, 5.1 x 13.4-13.8 in. Stylized lizard within a "self-frame" integrated within a complex geometric pattern. Excavated by E. D. Osborn, site and date unknown. (HM NA-Sw-Mg-Az-11)

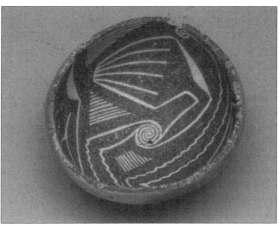

Figure 57. Bowl, Mimbres Boldface Black-on-white (Style I), 5.2 x 12 cm, 2.2 x 4.8 in. Two unopened flowers, possibly squash blossoms, organized as a complex negative design. One of several almost identical paintings from different Mimbres Valley locations. Excavated by the School of American Research and the Museum of New Mexico at Cameron Creek Village, 1923. (MIAC/LAB 20393/11)

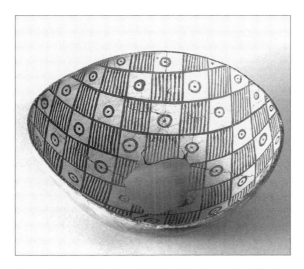

Figure 58. Bowl, Mimbres Boldface Black-on-white (Style I–II), 9.2 x 24 cm, 3.6 x 9.5 in. Unframed checkerboard design organized in an infinitely continuous pattern reminiscent of contemporaneous Hohokam pottery paintings. Excavated about 1930 by Dr. Berry Bowen, of Silver City, near the Mimbres Post Office. (MMA 40.4.282)

elements, and motifs such as scrolls were introduced, subtle changes began to appear in brushwork, design rhythms, dark and light patterning, and the very character of Mimbres painting (figs. 57, 58). The creators of late Style I paintings and of paintings transitional to Style II frequently used radial layout patterns, recombined sectioned design areas to develop large central motifs, and used framing lines with designs suspended from them as space-defining elements. Linear precision became an ideal, and subtle variations of large, unpainted or finely painted hatched or cross-hatched zones developed that shifted the balance of dark and light toward the visually ambiguous norms of Mimbres Classic (Style III) painting (fig. 62). Rhythmically dynamic patterns of interlocking curvilinear scrolls, often combined with triangles and wavy-line hatching, were among a number of new patterns using

geometric motifs and elements that were
introduced during Style I times and elaborated
upon by succeeding generations of Mimbres
pottery artists (figs. 51, 53, 55, 62–64).

The initial appearance of Mimbres Style I
pottery paintings in the Mogollon continuum
is relatively easy to pinpoint, because the
combination of more elaborate and complex
designs, well-controlled brushwork, and more
or less consistent use of black paint distinguishes
them from their prototypes. No such highly
visible criteria are available for the rest of the
continuum; Style I merges in a sequence of
small changes through Style II into Style III.
Visual distinctions are often subtle—a matter
of evaluating subjective criteria such as line
control or design complexity and observing
visually minor compositional details such as
the presence or absence of a framing line that
isolates a picture space from the lip or upper
rim of its vessel. Both Style I and Style II
paintings extend to a rim line, which is usually
black but may be white (fig. 63), at the lip of a
bowl. Whereas Style I motifs on any given vessel
seem to merge almost seamlessly with each
other (figs. 54, 57), Style II is characterized by the
isolation of design zones and the motifs painted
within them by use of devices such as negative
patterns, strong dark-light contrasts, and broad
framing lines (figs. 59, 60). Alternatively, design
zones in Style II vessels were isolated by wide,
unpainted areas. Late Style I and Style II pottery
painters created more intense and dramatic
dark-light contrasts than were ever used in
earlier times, and they anticipated many of the
variations and intensifications that characterize
Style III and the Mimbres Classic painting
tradition (figs. 61, 65).

Style I and most Style II paintings are ordi-
narily bounded by a single, relatively broad line
at the rim of the vessel. Paintings meet that rim

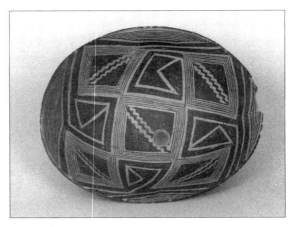

*Figure 59. Bowl, Mimbres Boldface Black-on-white (early
Style II), 7.3 x 19.3–24.2 cm, 2.9 x 7.6-9.5 in. "Tic-tac-toe"
pattern framed and differentiated by dark-light distribu-
tions. Excavated by A. M. Thompson at an unknown loca-
tion before 1952. (MIAC/LAB 19938/11)*

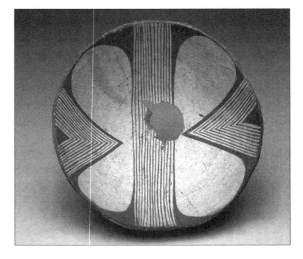

*Figure 60. Bowl, Mimbres Boldface Black-on-white (Style
II), 7 x 16–17 cm, 2.8 x 6.3-6.7 in. Negative, four-part,
flowerlike, cloudlike pattern that is a by-product of
painted triangles and a central rectangle. Excavated by
the University of Minnesota Field School at the Galaz
site, 1929–1931. (WM 15B 19)*

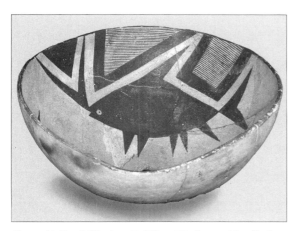

Figure 61. Bowl, Mimbres Boldface Black-on-white (Style II–III), 11.5 x 27 cm, 4.5 x 10.6 in. Two stylized fish integrated with heavily outlined triangles and rectangles. (TARL 740–108)

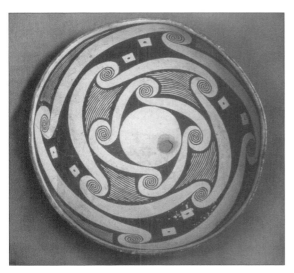

Figure 62. Bowl, Mimbres Boldface Black-on-white (late Style II), 14 x 30.5 cm, 5.5 x 12.0 in. Three sets of interlocking, curvilinear, positive-negative scroll forms circulate around a central void. Similar paintings were made by Mimbres artists from the beginning of the tradition until its end. Excavated by the Peabody Museum, Harvard University, at Swarts Ruin, 1924–1927. (HP 94438)

line, are confined by it, and may even appear to be suspended from it. In a sense, the rim line confirms the indivisibility of the painting and the bowl on which it is painted, for it frames off the inner space of the bowl from the world around it and isolates the picture space as a micro-universe. Some late Style II and early Style III paintings are separated from the rim line by a narrow unpainted area and then attached to a second line, or "rim band," below that (fig. 64). Most Style III paintings have a rim line, a narrow unpainted band below that, and then either a framing line, multiple framing lines, or a complex frame, all of which isolate paintings within clearly defined, three-dimensional picture spaces inside a bowl. The Style III framing system separates a painting and the vessel on which it is made into two related entities (figs. 1, 66). Style III paintings are more elaborate, more dramatic, more ambiguous both visually and expressively, more complex compositionally and iconographically, and more precise in their execution than any earlier Mimbres pottery paintings.

Style I and early Style II figurative pictures were either isolated within the void of their picture space as a kind of vignette or integrated decoratively with whatever painted frame defined the picture space. In either case, such paintings are relatively uncommon, and many of them are so poorly documented that lack of data inhibits our understanding of the development of the figurative mode. But even tentative observations shed some light on the symbolic and decorative objectives of the painters. Those paintings that have been obtained through controlled excavations suggest that early figurative paintings were less illusionistic or realistic, more conventionalized, and more decorative than later ones. Life-forms were sometimes so well integrated with nonfigurative patterns

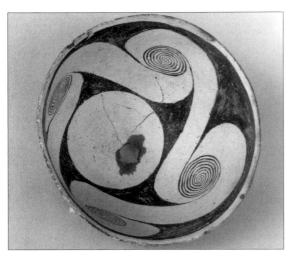

Figure 63. Bowl, Mimbres Boldface Black-on-white (Style III), 13 x 22.5 cm, 5.1 x 8.9 in. Four large, interlocking, positive-negative scrolls circulate around the walls of a deep, flat-bottomed bowl. Collected by Dr. Berry Bowen, of Silver City, on a family excavation at the Pruitt site, Mimbres Valley, circa 1920–1930. (MMA 40.4.101)

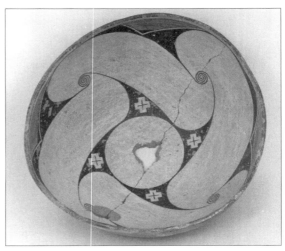

Figure 64. Bowl, Mimbres Classic Black-on-white (Style III), 12.5 x 25.5–26.5 cm, 4.9 x 10.0-10.4 in. An elegant interlocking scroll incorporates four starlike motifs near the center. Excavated by Harriet and C. B. Cosgrove at the Treasure Hill site, about 1920. (MNA 834/NA 3288.74)

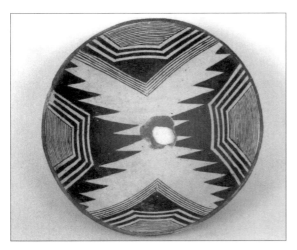

Figure 65. Bowl, Mimbres Boldface Black-on-white (late Style II), 8.2 x 22 cm, 3.2 x 8.7 in. A large, central X-shaped negative form is the by-product of triangles and polygons suspended from the rim band. Excavated at an unknown site in the Mimbres Valley. (UCM 7744)

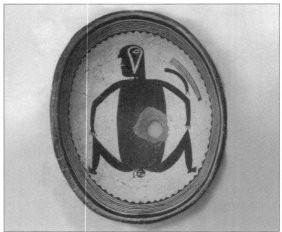

Figure 66. Bowl, Mimbres Classic Black-on-white (Style III), 5.5 x 17 cm., 2.2 x 6.7 in. A fringed woman's apron and a belt are above the left arm of a woman giving birth. Excavated by the Peabody Museum, Harvard University, 1924–1927) at Swarts Ruin. (HP 94632)

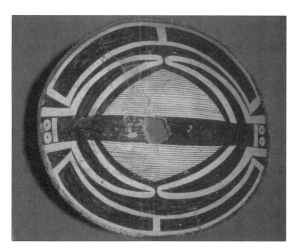

Figure 67. Bowl, Mimbres Boldface Black-on-white (early Style II), 7 x 18.2 cm, 2.8 x 7.2 in. Two pop-eyed, winged, birdlike creatures share a single long rectangular body. Excavated by the Peabody Museum, Harvard University, at Swarts Ruin, 1924–1927. (HP 94743)

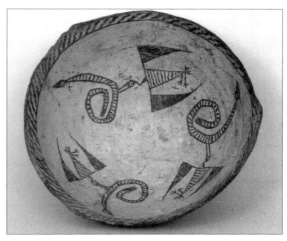

Figure 68. Bowl, Mimbres Boldface Black-on-white (Style I), 9 x 22.5 cm, 3.5 x 8.9 in. Three Hohokam-style, pelican-like birds with snakes in their mouths fly just below the rim of a Mimbres bowl. Excavated by Mary and John King about mid-twentieth century at Cameron Creek Village. (DLMM 94.94.30)

inside large design zones, and by interior frames that were shaped around the images, that they read effectively as parts of a geometric pattern (figs. 56, 57, 67). They were often treated as abstract decorative symbols rather than as illustrations of some experienced reality, and even when they were given vitality by posture or attitude, the conventionalized modes dominated (figs. 67, 68). Most such early representations suggest emblems that lack narrative content, and there is every indication that illustrative techniques and the desire to reproduce anatomical details and develop illusions of real-world space came only later, after the production of conventionalized life drawings had become more systematic and more widely practiced.

Because most Mimbres pottery paintings can be dated in no more than broad, general terms, the development of the painting styles can be only logically surmised. There seems to have been a straight-line progression in figura-tive painting toward greater realism and greater pictorial complexity. But even though the more complex and realistic paintings are probably all late, it is conceivable that any single painting, especially those with characteristics that appear to be early, might have been made at any of several points along the continuum of an artist's working life, which could easily have spanned forty years or more. Forty years can overlap three generations, and nostalgia, respect for the past, ideology, introspection, the desire to please, or even whim might have stimulated the creation of an anomalous painting at any time during the course of that life. More than two hundred years may have separated the earliest Style I figurative pictures from the earliest examples of Style III, but those centuries could have been experienced and shared over as few as four or five working lifetimes. Style alone cannot be an infallible indicator of the age of a painting.

Earlier sources for representational Mimbres painting are not found in other Mogollon wares, and the Hohokam inspiration that seems to have been its source was soon submerged by later Mimbreño inventions. This is in contrast to Mimbres geometric painting, whose structural modes are vigorous elaborations and modifications of themes tentatively established as early as the seventh century in the San Simon branch. Both the Mimbres and the San Simon Mogollon traditions emphasized many of the same visual factors: overall patterning, division of a vessel into quarters or fifths with the center of a bowl as the visual focal point, and use of triangles as the dominating design element. At the other end of the continuum, all later Mogollon pottery traditions tended to develop linear precision and strong dark-light contrasts, so that differences between Mimbres pottery paintings and contemporaneous ones made by other Mogollon people were largely a matter of the emphasis placed upon one or another set of similar visual ideals.

Classic Mimbres Black-on-white geometric paintings were as much a local and specialized variation of Mogollon pictorial traditions as they were a sudden divergence from them. Colorado Plateau visual ideas, especially from Chaco-Cíbola black-on-white sources, were certainly involved, but the Mimbreños selectively modified them to conform to earlier local patterns. They effected similar and parallel changes in other Mogollon painting traditions at about the same time. Firing methods used for achieving black-on-white effects, for example, might have been learned directly or by observation from northern Pueblo sources, but if so, adoption of northern methods was still a logical extension of the previously established fascination with dark-light patterning seen in Three Circle pottery paintings. The emphasis placed on brush control, too, might have been a

response to northern aesthetic attitudes, but interest in brush control was evident in local pottery long before any Mimbres Black-on-white paintings were made.

Mimbres Styles I and II can both be perceived as transitional steps leading from Three Circle Red-on-white to the culminating Style III tradition of the Classic period. That perception, however, makes sense only from the perspective of the present, for "transition" is a retrospective concept whose historical meanings reflect the ways in which any present may perceive the past. Any artist at any time and in any place can produce works that are ahead of, behind, peripheral to, or irrelevant to whatever tradition future observers come to recognize as "mainstream" or as part of a sequence leading from there to here. Each Mimbres artist in her or his own time was ignorant about the future of the art that was being shaped, and while we might imagine that Style III paintings were the end products of an inevitable sequence, the reality is that they are only what actually happened.

No part of the sequence was inevitable, and the potential to emphasize other characteristics was always present. In the beginning, and at least through the Mogollon Red-on-brown period, emphasis in painting lines might just as reasonably have been placed on boldness, fluidity, and spontaneity, all of which were the expressive ideals of contemporaneous Hohokam pottery artists. Until the end of the Mogollon Red-on-brown period, Mogollon design systems had at least as much potential for developing along static principles as along active ones, and passivity rather than tension might have become a visual ideal. But conscious or unconscious decisions were made to shape the art in one direction rather than another, and any sources that might help to

move the art in a preferred direction were welcome. That some of these changes were promoted by knowledge of distant traditions in no way implies that the Mimbres depended upon those traditions. Rather, it seems at least as likely that Mimbres pottery-painting artists were on a trajectory to invent their black-on-white tradition and its technology even if no models had been available to them.

Among the interchanges between the Mogollon and other peoples that affected the shape and form of Mogollon pottery painting, three were of particular importance. The first and most basic was with the unknown group or groups from whom the pottery-making craft was first learned. The second, almost equally fundamental, was with the Hohokam, whose painted pottery seems to have provided the first models for Mogollon painters. The character of these models came to be indelibly planted as the most basic possible source for all later Mogollon painting. The third interchange, and for the Mimbres and some other groups the most visible, was with the Chaco-Cíbola black-on-white traditions of the southeastern Colorado Plateau.

Mimbres Painted Pottery and the Hohokam Tradition

Beyond identifying the vast territory of northern Mexico as the probable source for both Hohokam and Mogollon pottery technologies, it is impossible at present to specify points of origin for either system. Differences in production methods were great enough to make it likely that separate traditions were involved from the beginning. Potters of both traditions used iron-rich clays, and their use, at first, of similar firing technologies meant that each tradition produced similar-colored pottery.

But almost from the first, there were significant differences in shape preferences, decorative impulses, and some manufacturing methods.

Hohokam vessels seem always to have been hand built with thick coils, then smoothed and finished by paddle-and-anvil methods rather than by the Mogollon and, somewhat later, northern Pueblo procedures of scraping and polishing. These differences take on great analytical significance, not only because they are diagnostic but also because they carry historical implications if we assume, as we probably should, that these societies were conservative in their technological methods and training systems. The pottery-making methods themselves are about equally efficient and produce comparable results on the surface, but each requires training and practice before the requisite craft and motor skills are learned. Learning took place within local communities and probably within the context of kin groups. Because community sizes were relatively small, and kin relationships fundamental to the social order, it may be assumed that every individual learned to work with and to respect traditional technical methods, aesthetic systems, and modes of expression (Crown 2001; Kamp 2001). So long as craft products met certain minimum utilitarian and aesthetic standards, the first socially approved, easily taught, and easily learned process that was technically successful could effectively foreclose most further experimentation. All later technical and aesthetic innovations can then be perceived as expressions of historical changes in social standards. Even minor innovations can be taken as evidence, not so much of nonlocal origins, even if those can be demonstrated, but of important social changes that occurred within a community.

Hohokam potters consistently put their greatest decorative energies into painting, and

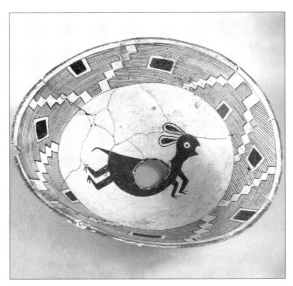

Figure 69. Bowl, Mimbres Classic Black-on-white (Style III), 16.5 x 19.5–31 cm, 6.5 x 7.7–12.2 in. A rabbit is in the center of a large, deep, oblong, flared-rim bowl. Excavated by the Mimbres Foundation at Mattocks Ruin, 1976. (MMA 77.58.10)

Figure 70. Bowl, Sweetwater Red-on-gray, 4.2 x 10.4 cm, 1.75 x 4.25 in. Excavated by the University of Arizona, Snaketown, Gila River, Salt-Gila Basin. (ASM A 25062)

their pottery paintings had important effects on Mogollon pottery-painting traditions that were, at best, slow to develop in all Mogollon regions. The Hohokam also developed a large inventory of vessel shapes, some of which were adopted or adapted by Mogollon potters. Among their many forms were flat plates or dishes, helmet or soup-plate shapes, flared-rim bowls with perpendicular walls, and jars (ollas) with low centers of gravity and sharply angular upper shoulders.

Early Hohokam ceramic influences extended as far east as the Mimbres region, where deep, flared-rim bowl forms derived from Hohokam models are known for all periods (see figs. 69, 71). The similarity between the oldest Mogollon painted wares and even earlier Hohokam painted vessels is almost total. In vessel shape,

design layout, elements, motifs, and draftsmanship, Dos Cabezas Red-on-brown ware, made by San Simon Mogollon people, is a Hohokam type that differs from its prototypes only in manufacturing methods (compare figs. 47 and 70). This seemingly total acceptance of "foreign" visual ideals makes palatable the concept of the San Simon branch as a "blend" of Mogollon and Hohokam cultures (Wheat 1955:27–29).

As later Mogollon painted wares increased in proportion to other kinds of Mogollon pottery, they took on an increasingly independent character, and similarities between Mogollon and Hohokam wares decreased with distance and time. Hohokam visual ideas continued to be absorbed well into the Mimbres Style I period, but by then they were being processed and transformed through the filter of a recogniz-

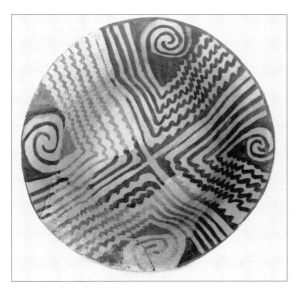

Figure 71. Bowl, Santa Cruz Red-on-buff, 10.8 x 22.5 cm, 4.4 x 9 in. Excavated by the University of Arizona, Snaketown, Gila River, Salt-Gila Basin. (ASM A 36986)

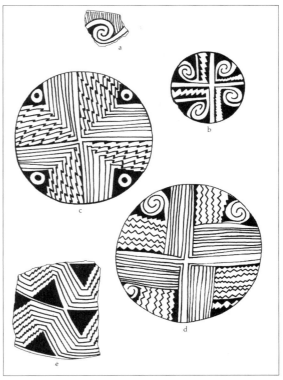

Figure 72. Common motifs used on Hohokam pottery (after Haury 1976:Figs. 12.28, 12.32, and 12.40). Composite drawing by Wesley Jernigan

ably independent Mimbres Mogollon pottery-painting aesthetic. Among later Hohokam expressions that appear in the inventory of Mimbres motifs are wavy hachures and interlocking scrolls growing out of solid triangular figures (figs. 71, 72). Stimulation of a Mimbres figurative painting tradition by exposure to Hohokam models also happened well after the emergence of a distinctive Mimbres design tradition. These adaptations were quite selective, and each tradition diverged in its own way from what may once have been a common set of visual ideals.

The most basic points of similarity were in the habits, first, of using all of a visible surface as the design field and, second, relying on center-oriented segmented patterning of pictorial elements that were placed on interior surfaces.

Unlike the Mimbres, whose concentration on bowl interior designs was almost obsessive, Hohokam painters worked with a great variety of vessel forms and developed somewhat different kinds of patterning systems for each. Until very late, when Colorado Plateau–inspired segmented or banded patterns became common on Hohokam pottery, the usual Hohokam objective was to cover most of the visible surface of a vessel with visual activity by use of repeated motifs (figs. 71, 73). On interior surfaces, these were often confined within structural subdivisions (fig. 72) similar or identical to those used by Mogollon painters, especially those making

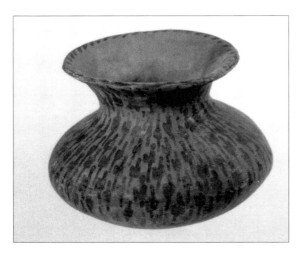

Figure 73. Jar, Gila Butte Red-on-buff, 12 x 14.7 cm, 4.75 x 5.9 in. Excavated by the University of Arizona, Hodges Ruin, Rillito River, Tucson Basin. (ASM 7279)

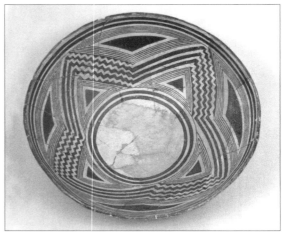

Figure 74. Bowl, Mimbres Classic Black-on-white (Style III), 11 x 27 cm, 4.3 x 10.6 in. The prototypes for the continuous zigzag and straight lines that define the four-pointed star motif were in Hohokam pottery paintings and were likely derived from basketry patterns. Excavated at the Eby 2 site for the University of Colorado, 1926. (UCM 9369)

Mimbres Style I paintings. Repeated motifs on exterior surfaces of Hohokam vessels usually either were in horizontal registers set on a diagonal bias or were interwoven over an entire visible surface.

Until late, painted lines on Hohokam pottery tended to be heavy, and the brushwork, vigorous and spontaneous. There was some play with negative painting and dark-light patterning, but the purposeful positive–negative ambiguity of Mimbres painting was hardly attempted and in any event would have been impossible to achieve because of the close color relationships between red paint and buff ground. In early times, painted lines often seem casual or uncontrolled, but between about the eighth century and the tenth, Hohokam painters achieved a fine balance between control and spontaneity. By contrast, the later tight-lined Hohokam painted vessels seem uninspired.

Part of the success of Hohokam painting was due to its use of tension-producing motifs such as scrolls that emerged from or were opposed to straight lines or solid triangles (fig. 72a, b), chevrons that were painted with one straight and one wavy line (fig. 72c), and oppositions of straight-line and wavy-line hatched figures (fig. 72d, e). Large unpainted spaces were rare; most of a visible surface was covered by painted designs. Contrasting and repetitive motifs or other, similar devices were therefore essential to the creation of lively paintings. Many Hohokam motifs were incorporated into Mimbres Black-on-white paintings, where they were transformed and used for entirely different visual effects (compare figs. 64, 74 with 71, 72a, b, d).

Life-forms were a minor but well-established theme of Hohokam pottery painting. On exterior surfaces they were usually simple, linear, active, and realistically conventionalized repeat motifs that were painted with the same spon-

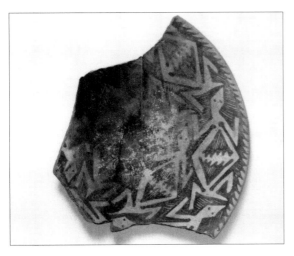

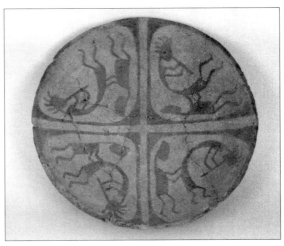

Figure 75. Plate, Gila Butte Red-on-buff, width of fragment 20 cm, 8 in. Excavated by the University of Arizona at Snaketown in the Salt-Gila Basin. (ASM A 26880)

Figure 76. Plate, Santa Cruz Red-on-buff, 7 x 17.1cm, 2.75 x 6.75 in. (MIAC/LAB 8754/11)

taneity and visual objectives as geometric motifs (fig. 73). Similar treatment is seen also in life-forms painted on interior surfaces, but there they were more often developed into dominating motifs, sometimes integrated into quartered patterns and often framed within shapes derived from the silhouette of the figure (figs. 75, 76). Similarities between these derivatively framed figures and some Style II Mimbres figurative paintings are obvious, and there is little doubt that Mimbres artists acquired a cluster of visual concepts from Hohokam prototypes (figs. 56, 57). Conceptually, freely drawn frames whose contours are derived from the silhouette of an image are entirely compatible with spontaneity, but less so with a tradition that gives more value to linear control and planned dramatic effects. As the Mimbres pottery painting tradition matured, Hohokam life-form conventions became increasingly unsuitable as a pictorial ideal. Mimbres figurative paintings became far more elaborate than those of the

Hohokam in every way, and it seems clear that although the Mimbres representational painting tradition was initially inspired by Hohokam examples, as time passed there came to be fewer and fewer stylistic or iconographic points of compatibility or resemblance between the two.

Historically, it appears as though relationships between the decorative traditions of the Hohokam and the Mogollon, especially the Mimbres, were essentially one-sided. The basic structural system of all Mogollon painted pottery was not only derived from but, for the most part, remained very like that of the Hohokam. The Mogollon pictorial idiom was, for several hundred years, largely a variation of a Hohokam theme. With the adoption of white slips and black paint in the Mimbres region and elsewhere, Mogollon pottery paintings took on a new character that was largely independent of the Hohokam, and after that, Hohokam art became largely irrelevant to the new traditions. Even so, Mimbres artists still sometimes selec-

tively translated Hohokam prototypes during later times to fit the requirements of what had become a truly local aesthetic.

Until the emergence of Mimbres Black-on-white styles, painted pottery was only a minor factor in any Mogollon region, and local imitations of Hohokam painted pottery were little more than substitutes for an imported product. As copyists, the Mogollon painters could contribute little to any tradition that served as their model. The early white-slipped Mogollon pottery that is found in small quantities at eleventh-century Hohokam sites was mostly contemporaneous with a vigorous era of Hohokam pottery making. For the most part, those Mogollon trade wares were on a different aesthetic trajectory and had little to offer the Hohokam beyond the novelty of their color-dependent effects. By the time black-on-white painting traditions that were essentially independent of Hohokam models had matured in several Mogollon regions, northern Hohokam people were in direct contact with ancient Pueblo people of the Colorado Plateau. The shift in Hohokam visual ideals that took place during their Sedentary period (1000–1150) was at least as much a response to those interactions as to knowledge of any Mogollon black-on-white tradition.

Mimbres Painted Pottery and Northern Pueblo Traditions

The interrelationships between Mogollon painted pottery, including that of the Mimbres, and northern Pueblo traditions had a different history. Because the basic pottery-making technologies and many of the forms of early Mogollon and northern wares were essentially identical but had first appeared in Mogollon regions, it is generally assumed that northern

Pueblo pottery-making traditions were introduced by way of the Mogollon. But northern Pueblo potters soon began to concentrate on painting rather than texturing as a primary mode of pottery decoration, and by the eighth century of the common era, they had developed far more complex and diverse painting traditions than those of any contemporaneous Mogollon groups. Ancient Pueblo brown and red wares from the Colorado Plateau are relatively rare, are usually early, and had a limited distribution. They resemble Mogollon prototypes and even include gray-paste pottery that was painted red after firing to enhance the resemblance. But as early as the 600s, northern potters were using reduction firing methods with iron-poor clays to produce gray wares, including some that had black linear paintings on them. Within a few short generations, several different black-on-white painting traditions emerged that became the hallmarks of ancient pottery from the Colorado Plateau. Initially, these had little impact on wares from other regions, and the few Mogollon potters who occasionally made painted pottery looked to the south or west, to the Hohokam, for their inspiration.

Unlike the makers of the southern wares, who tended to cover a visible surface with evenly distributed patterns of thick red lines on a brown or tan ground, the makers of early black-painted pottery in the northern Southwest characteristically used open layouts and relatively thin, scraggly lines that seem to float in a sea of white or gray space. The earliest designs often seem almost random and unstructured, as when lines with appendages bisect the interior of a bowl (fig. 77) or when a few clumsily drawn triangles are draped around the shoulder of a jar. Still, despite their crudity, these paintings foreshadow some of the essential character-

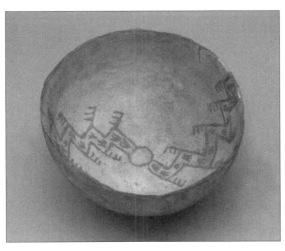

Figure 77. Bowl, Arboles Black-on-white, 10 x 17 cm, 4 x 6.75 in., prior history unknown. (MIAC/LAB 54227/11)

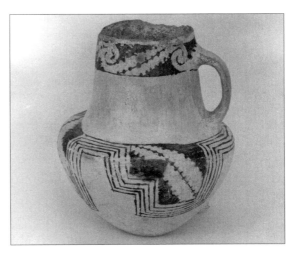

Figure 78. Jar, Tunicha Black-on-white, 18.6 x 15.2 cm, 7.3 x 6.0 in. Donated 1966; prior history unknown. (MMA 66.93.11)

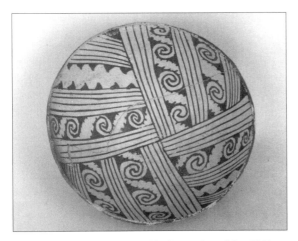

Figure 79. Bowl, Kiatuthlana Black-on-white, 8.2 x 19.7 cm, 3.2 x 7.8 in. Excavated by the U.S. National Museum at the Allentown site, 1933. (MIAC/LAB 8224/11)

istics of later black-on-white decorative systems among all northern Pueblo peoples. The dominant and sometimes the only visual element is a thin, tense line, and visual effectiveness is a function of its precision. It is stiff-wristed and tight, and unless it is used precisely (as in figs. 78, 79), its tensions can seem awkward (as in fig. 77). It is the antithesis of Hohokam and early Mogollon draftsmanship, which relied heavily on the loose-wristed application of swiftly drawn, thick lines whose vigor, spontaneity, and expressiveness made precision irrelevant and even counterproductive.

In time, a great diversity of related pottery traditions was made on the Colorado Plateau, and in a very real way it defines the diversity among peoples that came to characterize the region. Several independent regional design systems came to be used, most of which relied on separately framed design spaces that defined and articulated the different parts of a vessel. This essentially architectonic approach seems to have been derived from the structural compositions of the region's very ancient basketry design system, which segmented design units and isolated them on different parts of the

container. In both pottery and basketry, emphasis was placed on the architecture of a vessel by locating framed design spaces on each of its parts, such as the upper and lower body, neck, shoulder, wall, and base (fig. 78). When overall patterns were used, ancient northern Pueblo pottery painters tended to subdivide a surface into a series of independent panels that related rhythmically and symmetrically to each other, as did contemporaneous Mimbres and Hohokam artists (compare figs. 71, 79, 80). Even when identical and interacting, each was treated visually as an isolated, independent design unit.

In some regions, such as Mesa Verde in the north and the Kayenta area in the west, dark-light, positive-negative patterning was the dominant mode. In other places, especially the Chaco-Cíbola region—the eastern and south-central part of Puebloan world, which bordered on Mogollon areas—the tendency was to modify dark-light contrasts with lightweight linear designs, especially hatched and cross-hatched areas that created intermediate gray tones suggestive of separate color areas (Plog 2003). Everywhere, white slip was treated as both a positive design element and a background to linear or solid black or gray motifs and elements. Design spaces were divided and subdivided as active zones, each filled with linear or solid elements: triangles, diamonds, or rhomboids. Right-angle scroll patterns became common, whereas curves and interlocking curved scrolls were generally small and used sparingly. Almost any kind of linear or geometric motif or element was likely to be in use in one or another design district.

Some fine painted wares were made earlier, but the first vigorous northern Pueblo painting tradition dates from after 750 or 800 C.E., more or less contemporaneous with Three Circle

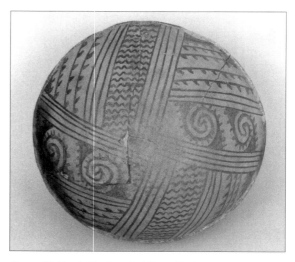

Figure 80. Bowl, Mimbres Boldface Black-on-white (Style I), 12.5 x 20.1 cm, 4.9 x 7.9 in. Excavated about 1920 in the Tularosa River drainage area. (MIAC/LAB 20419/11)

Red-on-white. It could have had little impact on any Mogollon painting style until the ninth century, or after the Mimbres Style I tradition had already begun. Chaco-Cíbola and related black-on-white painting styles of the southeastern Colorado Plateau reached a climax at about the time of the transition in Mimbres painting from Style II to Style III, in about the late tenth or early eleventh century. Kayenta and Mesa Verde traditions that stressed positive-negative paintings began at about the same time but became most vigorous a generation or more after the end of the Mimbres Classic. The black-on-white traditions of the Colorado Plateau did not come to an end until about 1300 and on close examination seem improbable as primary source material for any Mimbres Black-on-white style.

Relatively few examples of northern black-on-white pottery have been reported from Mimbres sites, and most are either contempo-

raneous with Style I and early Style II or post-date late Style II and early Style III Mimbres pottery (Breternitz 1966; Bryan 1961; Cosgrove and Cosgrove 1932:92–99). The most common of the earlier black-on-white wares found at Mimbres sites are the widespread Chaco-Cíbola linear types called Red Mesa Black-on-white and Kiatuthlana Black-on-white. With a few remarkable exceptions (compare figs. 79 and 80), most of their similarities to Mimbres pottery paintings seem to be primarily a function of color and fine line draftsmanship. Later northern types, such as Socorro and Chupadero Black-on-white, are from the borderlands between the Mogollon region and the northern Southwest. They not only overlap temporally with the late Style III vessels but may well have been influenced by them. Thus, there is little evidence that Mimbres pottery painters had much direct knowledge of or interest in northern pottery-painting traditions during the time when their own black-on-white pottery-painting aesthetic was reaching maturity. However, their indirect and occasional experiences with northern wares seem likely to have contributed in a general way to the emerging tradition.

On close examination, Mimbres and northern Pueblo black-on-white pottery decorations are quite different in detail. Technology and techniques including reduction firing, line control, color, the use of white space as a positive design element and of hatching to produce grays, and the subdivision of design areas into intricate panels about sum up the inventory of similarities. Logically, Mimbres potters were inspired to make black-on-white wares by their knowledge of northern prototypes, and their black-on-white firing technology might well have been inspired by northern methods. But the Mimbres artists who first used black paint on white surfaces did so to paint pictures in which positive-negative images were sharply defined, a decorative theme they and their forebears had been exploring for several generations. They continued to develop that kind of imagery well before systematic experimentation with similar concepts seems to have occurred in any ancient northern Pueblo district. And when similar themes became important on the Colorado Plateau, it was mostly in the distant Kayenta and Mesa Verde districts, where there is virtually no evidence of any contact with the Mimbres at any time.

Mimbres use of northern methods and techniques was selective and deliberate and had much more to do with changes that were already taking place in the Mimbres design tradition than with the sudden adoption of foreign visual themes or ideals. Further, it parallels changes in the architecture of the Mimbres people, in that architectural resemblances to northern modes can, on close examination, also be seen as expressive local adaptations to local events (Shafer 1995, 2003:40–54). It is conceivable, even probable, that Classic Mimbres pottery painting and architectural solutions and aesthetics might have been different if no northern Pueblo pottery or architecture had been available to suggest alternatives to Hohokam models. But it is more certain that the internal logic of events in the Mimbres Valley brought Mimbres design into the orbit of the loosely defined traditions of the northern Southwest that we call "ancient Pueblo." The systematic nature of these changes in Mimbres pottery painting and architectural traditions gives meaning and adds another dimension to our understanding of parallel changes that were occurring at about the same time in social organization, ritual life, and many other aspects of Mimbres society.

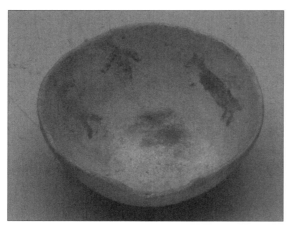

Figure 81. Bowl, Rosa Black-on-white, 6.5 x 13.2 cm, 2.6 x 5.2 in. Donated 1969; prior history unknown. (MIAC/LAB 43819/11)

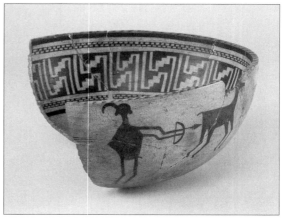

Figure 82. Bowl, Mesa Verde Black-on-white, 15 x 28.2 cm, 5.9 x 11.1 in. Excavated by the Wetherill brothers between 1889 and 1892. (UPM 22982)

Although figurative paintings occur on very early northern Pueblo pottery, there was no consistent and patterned use of such forms in any northern district until long after the Classic Mimbres figurative tradition was no longer practiced and had become effectively invisible. Ancient Pueblo life-forms on pottery were usually schematic, highly conventionalized, and geometric. They generally are birds or quadrupeds, but also sometimes realistic humans or other animals in narrative or anecdotal situations (figs. 81, 82). The more realistic images are usually pictographic in character, isolated on an interior or exterior surface, unframed, and painted with little or no reference to an overall design pattern. Their resemblance to rock art is both conceptual and iconographic, for in both kinds of pictures, the space in which figures are placed is generally unframed and limitless. The absence of framing structures and formal patterning makes it improbable that any of these occasional and sometimes roughly executed paintings could have influenced the

Mimbres figurative tradition.

Mimbres Painted Pottery and Other Contemporary and Later Traditions

Other Mogollon contemporaries of Classic Mimbres people also painted black-on-white pottery as well as black-on-red wares that were radically different from earlier styles. And in the White Mountains of Arizona and along the headwaters of the Little Colorado and Gila Rivers, north and west of the Mimbres region, the era following the end of the Classic Mimbres tradition was also characterized by a wide range of pictorial inventions. Polychrome wares made in those areas and in central Arizona were the most radically inventive of all later ancient Southwestern painted pottery traditions and would have the greatest impact on South-western painted pottery in subsequent centuries. In retrospect, until the twentieth century, Mimbres Black-on-white wares had little or no effect on any later wares, especially

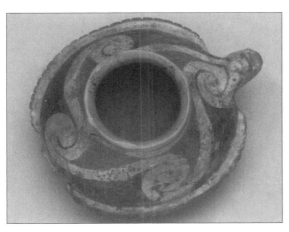

Figure 83. Effigy jar, Ramos or Animas Polychrome, 7.5 x 10.5–12.5 cm, 3.0 x 4.1–4.9 in. Horned lizard effigy. (MIAC/LAB 20600/11)

in comparison with the impact that the novel shapes, color combinations, techniques, pictorial dynamics, and iconography of the twelfth- to fourteenth-century polychromes had on the emerging Pueblo traditions.

Mimbres Black-on-white pottery was not uncommon in the Casas Grandes region of northern Chihuahua, and some of it may have been made at villages in that area. Some Mimbres sites in southern New Mexico and northern Chihuahua were later reoccupied by people making Casas Grandes-style polychrome pottery (Black Mountain Phase). Not only were these later occupants familiar with Mimbres Black-on-white pottery because they lived among the sherds, but some of them may even have been descended from the Mimbres. Meanwhile, other Mimbres people, perhaps many of them, resettled in the Casas Grandes region when they left the Classic Mimbres homeland in the twelfth century (Shafer 2003:172, 217).

Several quite distinctive polychrome wares

and their local variations characterized the very large post-Mimbres Casas Grandes region between the thirteenth and fifteenth centuries, when Paquimé was a thriving center. In many ways they suggest both Southwestern and Mesoamerican ceramic traditions. In color, line, and motifs, they show similarities with contemporaneous Hopi, Salado, and Rio Grande Pueblo wares, and they seem to share many iconographic details with Salado pottery, which was a common trade ware in the Casas Grandes district. Some Casas Grandes iconographic themes, including horned serpents, macaws, and turkeys, are known also from earlier Mimbres pottery paintings. But in Mimbres art these motifs are quite variable in detail, are generally painted in narrative contexts, and are by no means common. In Casas Grandes art they are highly conventionalized, iconic, and almost commonplace. Still, occasional vessels painted in the Casas Grandes tradition do more than hint at a Mimbres connection, and both iconographic and conceptual similarities can be identified (compare fig. 46 with pl. 4, and fig. 63 with 83).

In the northern Mogollon borderlands of the Chaco-Cíbola region, the confluence of Mogollon traditions with the architecture, black-on-white pottery, and other material and nonmaterial aspects of northern Pueblo life was stronger than in the Mimbres area. However, most of the best-documented evidence of close contacts in that region postdates the end of the Classic Mimbres era (Lowell 1991; Reid 1989; Zedeño 1994). Northern Mogollon black-on-white pottery contemporaneous with Style II and Classic Mimbres wares is plentiful, but much of it is poorly documented, and we are left with little more than visual impressions of painted pottery traditions that are more like northern wares in their character

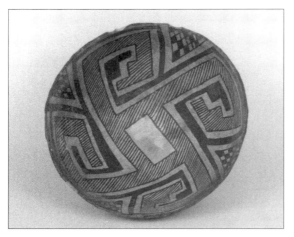

Figure 84. Bowl, Reserve Black-on-white, 10 x 23.5 cm, 3.9 x 9.3 in. Donated 1961; prior history unknown. (MMA 61.3.295)

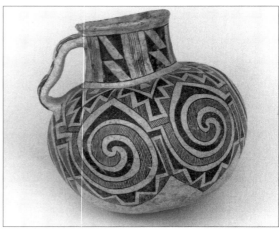

Figure 85. Jar, Tularosa Black-on-white, 18 x 17.5 cm, 7.1 x 6.9 in. Donated 1947; prior history unknown. (MMA 47.8.11)

than like Mimbres wares but that often suggest a Mogollon idiom.

Among the traditions contemporaneous with or temporally overlapping Mimbres Black-on-white are Reserve Black-on-white (950–1100; fig. 84), Tularosa Black-on-white (1100–1250; fig. 85), Socorro Black-on-white (1050–1200/1275; fig. 86), and Chupadero Black-on-white (1100–1200; fig. 87). None of these produced significant numbers of figurative paintings, and only rarely do any suggest Mimbres treatment. Reserve and Tularosa vessels were made mainly along streams feeding the upper Gila River, where they border on Mimbres villages, and north to the Mogollon–Colorado Plateau borderlands along the drainage of the upper Little Colorado River and to the east of it (see map 1). Both types can resemble Mimbres Black-on-white in drafts-manship and patterning (figs. 84, 85), so much so that the Classic Mimbres qualities of some Reserve vessels can cause confusion in their

classification. But ordinarily, both types differ in visual details that tend to bring them closer to northern forms, and both, especially Tularosa Black-on-white, display innovative compositional schemes and iconographic motifs that exerted great influence in other regions. Technically, both are white- or gray-ware traditions that employed white slip on all visible surfaces, whereas Mimbres Black-on-white is a brown-ware tradition that ordinarily used white slip on only one visible surface.

Rather than concentrate, as Mimbres painters did, on interior bowl surfaces as the primary painting space, pottery painters in the other Mogollon black-on-white traditions painted a much higher proportion of jars and other exterior-surfaced forms, with important effects on their design systems. As in Mimbres and most other pottery paintings of the northern Southwest, pictorial space was usually organized into design units that defined and were defined by the neck, upper shoulder,

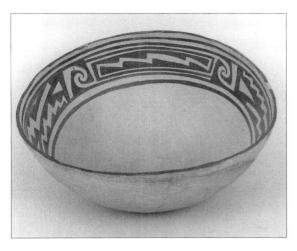

Figure 86. Bowl, Socorro Black-on-white, 13 x 28.5 cm, 5.1 x 11.2 in. Donated 1970, from the vicinity of Grants, N.M. (MMA 70.60.12)

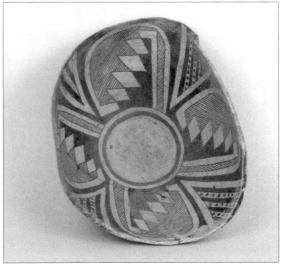

Figure 87. Bowl, Chupadero Black-on-white. 10–14 x 21.5–30.5 cm, 3.9–5.5 x 8.5–12.0 in. A rare example of warpage by an intense fire, probably from a burning room. Excavated by Richard C. Eisele before about 1935 from a site (post–Mimbres Classic?) on the Walking X Ranch south of Silver City. (WNMU 73.8.089)

upper body, and lower body of jar forms or by the interior upper wall and bottom of bowls. Paintings were sometimes structured into panels, but more often vessel surfaces were covered with continuous, interwoven, repeated motifs.

Interlocking right-angle scrolls and diagonal, wickerlike interlacing of straight hachures are common themes in Reserve Black-on-white pottery. Curvilinear interlocking scrolls and terraces were favored in the Tularosa system, and these could be visually powerful. But few Tularosa paintings have the intensity of a Mimbres picture that is dominated by an instantly perceived dynamic image or one that uses deliberately ambiguous and dramatic positive–negative motifs. Still, the most critical differences lay in patterning concepts. In opposition to the Mimbres preference for dark-light tensions, the others spread color evenly over visible surfaces to create gray harmonies that tend to cancel out the tensions produced by the use of linear oppositions. In that respect,

Reserve and Tularosa paintings most closely resemble several earlier styles of the geographically proximate Chaco-Cíbola region (fig. 88). Simultaneously, their makers' general preference for overall patterning is suggestive of earlier Mogollon and even Hohokam aesthetic preferences.

Socorro Black-on-white (1050–1200/1275) was made over a long period of time along the southeastern edge of the northern Pueblo–Mogollon border region. It is recognized less by design features than by technical ones: it is a thin-walled, high-fired gray ware with a distinctive thin, gray-white slip. Bowls were occasionally produced that were deliberately shaped into ovoids or ellipses. Several different design systems seem to be associated with this

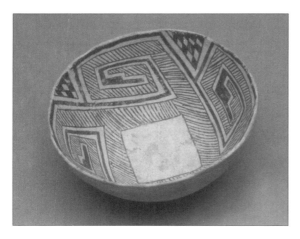

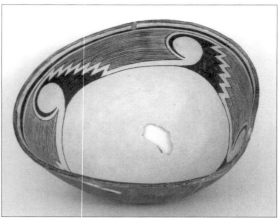

Figure 88. Bowl, Gallup Black-on-white, 8.6 x 21.8 cm, 3.4 x 8.6 in. Excavated by the Museum of New Mexico from a site north of Acoma Pueblo. (MIAC/LAB 18530/11)

Figure 89. Bowl, Mimbres Classic Black-on-white, 15.5 x 32 cm, 6.1 x 12.6 in. Donated about 1970; prior history unknown. (DMNS 7156)

ware, but its temporal and regional implications are poorly understood. Emphasis was often given to linear precision, carefully structured layouts, and patterns of repeated elements used as fillers within large, overall design zones (fig. 86). Some Socorro paintings are quite similar in structure, pattern, and motif to geometric Mimbres Black-on-white pictures. The similarities extend to such technical matters as vessel shape and an apparent fondness for fire clouds and to formal ones including shapes and proportions of bowls (compare figs. 86 and 89).

Relatively few Mimbres-like Socorro vessels have been found during controlled excavations, and most lack such basic data as provenience and date associations. Consequently, their relationship to the Mimbres tradition is confusing. For the most part, there is no way to tell whether they were contemporaneous with Mimbres vessels, later revivals, perhaps even made by descendants of Mimbres emigrants, or

sometimes one, sometimes another, and sometimes neither.

Chupadero Black-on-white (fig. 87) is sometimes thought of as a variant of Socorro Black-on-white. It was made mostly east of the Rio Grande in the Salinas and northern Jornada Mogollon areas and is among the most common non-Mimbres black-on-white types found in Classic Mimbres sites. Its similarity to Classic Mimbres pottery can be close, and some Chupadero bowls are said to have been found as grave offerings in Mimbres burials.

Generations later, one of the few Pueblo representational pottery-painting traditions emerged in the same Chupadera Mesa–Jumanas Mesa–Salinas area. It is found occasionally on relatively rare, early historic types called Tabira Black-on-white and Tabira Polychrome, and more than any other later pottery paintings, it comes closest to achieving the direct immediacy of Classic Mimbres pictures (fig. 45). Tabira

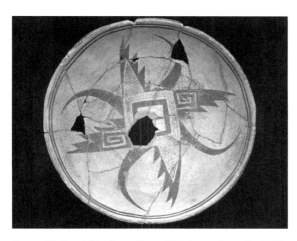

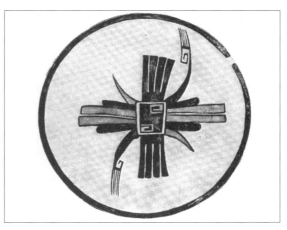

Figure 90. Bowl, Mimbres Classic Black-on-white (Style III), 11.5 x 23 cm, 4.5 x 9.1 in. Collected by Richard E. Eisele before 1926; prior history unknown. (TM 4490)

Figure 91. Bowl, Sikyatki Polychrome, dimensions unavailable. Excavated by the U.S. National Museum about 1895. (Seventeenth Annual Report of the Bureau of American Ethnology, part 2, pl. CLXI.)

figurative images are usually painted with black lines on a white or gray ground, are often shown in a void, and are not closely integrated with either their frames or their vessel forms. Although they may lack the control and subtlety of the much earlier Mimbres pictures, the structural relationships of Tabira painted figures to background space more closely resemble those of the Mimbres than any other known possible prototype. Still, the temporal gap between Mimbres and Tabira appears to be unbridgeable.

In any case, when the Socorro tradition ended, its linear values were generally replaced by those of the broad-lined eastern polychrome tradition, which soon become almost universal in the Pueblo world of the middle Rio Grande. The adoption by later Pueblo people of a broad, imprecise line that can be both emotionally expressive and undisciplined seems to have been an emphatic rejection of most earlier ancient

Pueblo linear ideals, including those of the Mimbres. Some fine-line traditions continued, however, in other parts of the northern Southwest, especially in the ancestral Hopi country of northeastern Arizona. Ancient Hopi wares form one of the more complete Southwestern series and show unbroken derivation from local and near-local prototypes modified by knowledge of fourteenth-century northern Mogollon polychromes. While there seems to be little possibility of a Mimbres contribution to that highly developed aesthetic, there are some rare but intriguing similarities (figs. 90, 91). Figurative painting became important in Hopi pottery art during and after the fourteenth century and had great influence on later representational paintings produced elsewhere in the Southwest. That figurative tradition was at its most dynamic in Sikyatki Polychrome and related types of the fifteenth and sixteenth centuries, which appear to have no connection

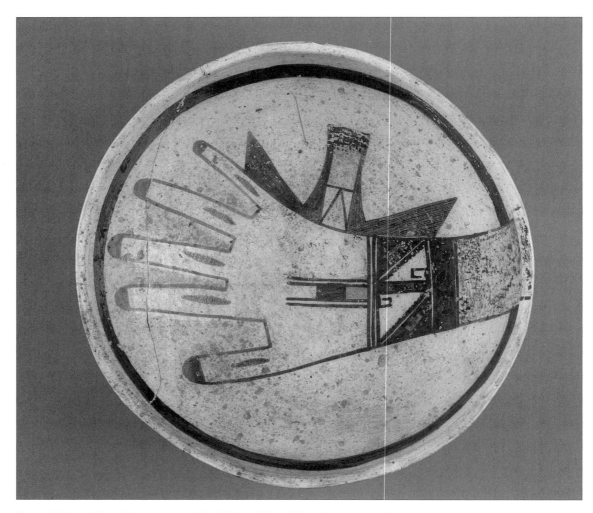

Figure 92. Bowl, Sikyatki Polychrome, 15 x 28.2 cm, 5.9 x 11.1 in. Excavated at Kawaika-a on Antelope Mesa near Keams Canyon and east of the present-day Hopi First Mesa. Purchased at Keams Canyon Trading Post by University Museum curator Stewart Culin, 1901. (UPM 39051)

at all to Mimbres pottery. To the contrary, differences in aesthetic character, iconography, subject matter, and pictorial methods are so great as to make such a connection improbable.

For example, Sikyatki life-forms appear within a much greater variety of compositional spaces than are seen in Mimbres art and with a variety of colors, textures, and richly tactile visual effects that are in sharp contrast to the unrelievedly smooth Mimbres Black-on-white paintings. In many Sikyatki paintings, life-forms are decorative elaborations of a repeat motif,

much as in earlier northern Pueblo and Hohokam figurative pictures. In most others, one or two figures are shown in tightly integrated compositions (fig. 92) that stand in sharp contrast to the characteristic Mimbres use of background voids in figurative paintings. Unlike multiple-figure Mimbres paintings that treat pictorial space as dynamic and mobile, Sikyatki multiple-figure compositions tend to treat a painting surface as if it were a flat, static plane that could and should be oriented to a vertical axis. Finally, virtually all Sikyatki representational images, which have only a few points of similarity to Mimbres images, have associations with the ritual iconography of the modern Pueblos. This is in sharp contrast to Mimbres representations, which portray a far greater variety of subjects whose significance today is at best obscure.

Several other figurative painting traditions developed among late prehistoric and early historic Pueblo groups, but all of them seem derived in great part from Sikyatki models. Even the most Mimbres-looking of the Tabira representational pictures are iconographically closer to Sikyatki than to Mimbres. In short, the Mimbres representational system seems not to have generated a successor tradition until its twentieth-century revival.

The polychrome wares of the northern and western Mogollon region, some of which incorporated design ideas developed in the Tularosa tradition, were among the most influential prototypes for painted pottery made throughout the Southwest during and after the migrations of the late twelfth through the fourteenth century. Patterning systems were quite diverse. For example, the Salado tradition of south-central Arizona and the western Mogollon regions tended to elaborate on Hohokam-Mogollon procedures of overall coverage and center-oriented segmentation, whereas eastern Mogollon wares integrated more architectonic concepts whose origins lay in the pottery paintings of the northern Pueblo traditions. Ultimately, major population shifts eastward meant that the great majority of late prehistoric and early historic painted pottery evolved from syntheses of northern Mogollon and eastern Colorado Plateau modes, with design areas patterned according to the peculiarities of vessel form and with paneled bands the dominant structural device.

The influence of the Mimbres tradition on any of these polychrome types and on most later black-on-white ones was negligible to the point of invisibility. The design problems of most later traditions were so different from those defined by Mimbres artists that it was hardly possible for Mimbres painting to have any effect on them. Visual similarities of Mimbres vessels to late prehistoric and early historic Pueblo polychromes are slight, generalized, and easily attributable to their sharing of common origins. Black-on-white pottery painting ended in most parts of the Southwest by about the close of the fourteenth century, and although bichromes were made after that in a few locations in the northern Rio Grande and the Salinas region, they were modifications of either local polychrome systems or late Mesa Verde Black-on-white traditions. Hints and echos of Mimbres painting are most discernible in regions closer to Mimbres country and relatively far from the new middle Rio Grande Pueblo heartland.

In sum, until the twentieth century, neither representational nor geometric Mimbres painting seems to have had any but the most modest effects on any contemporaneous or later Southwestern pictorial traditions. Mimbres influence is sometimes visible on more or less

contemporaneous pottery produced in neighboring regions, especially in the Reserve, Tularosa, Socorro, and Chupadero Black-on-white traditions, but even on those wares, most of the resemblances seem to have been superficial and cosmetic. Even the most explicit Mimbres design elements that are found on Casas Grandes vessels made generations later are only occasional (figs. 46, 83), and it would be difficult to argue convincingly for any but the most peripheral kinds of continuities.

It would seem that the pictorial, ideological, and visual problems addressed by Mimbres artists were invisible to or had little or no relevance for most of their contemporaries and for virtually all later traditions. Yet Mimbres paintings were historically, technically, and stylistically a part of the larger painted pottery tradition of the greater Southwest. Mimbres pottery painting was at one time or another deeply or superficially affected by technical and aesthetic developments that took place among neighboring peoples. Initially, and for a long time thereafter, it was a relatively minor art, derivative, involving few people, and with a low level of production. The development of the unique aesthetic of the Classic Mimbres period was less an event than a 350-year process. It took place at a time when the Mimbres were crossing a demographic threshold, and the pottery paintings tell of a burgeoning population searching for means to control a variety of growth-created pressures. Nowhere so far in the archaeological record is there a hint to explain why the Mimbreños, alone of all Southwestern peoples, chose to devote so much of their creative energy to that particular art in that particular way.

CHAPTER SIX

The Potters and Their Craft

Mimbres potters today are anonymous. Few, if any, of their workshops or kilns have been positively identified, and except for the pottery itself, little physical evidence of their industry remains. In this respect they are no different from all other ancient potters of the American Southwest. Throughout the region, their bonfire kilns are rarely found or recognized. Tools were small and mostly perishable, and work areas had few furnishings or other identifiable features. This is what we would expect if the ancient potters worked in ways similar to those of the historic era Pueblo Indians, whose pottery production leaves little physical evidence other than the end products and sherds from kiln accidents. Fine-scale and close examination of the Mimbres vessels themselves and analogies drawn with modern Pueblo practices seem to be the best and perhaps the only ways to gain some understanding of the processes and methods of the Mimbres potters.

By analogy, it has generally been accepted that the people who made and decorated the ancient pottery of the Southwest were women trained in their craft by their own kin or by older relatives of their husbands, depending on locality and the marriage practices of a particular community (Crown 2001; Kamp 2001). It is also often assumed that even though makers' marks are rarely recognized on ancient Southwestern pottery and were virtually unknown on historic wares until after about 1920, the work of each potter in a village was recognized by her contemporaries through subtle idiosyncrasies in design, vessel form, and craftsmanship. That assumption fails to take into account two potentially significant facts. First, pottery making can be and often was at many historic pueblos a social activity during which more than one person could contribute to the making of a vessel. And second, the time lapse of as much as several days between the making of a vessel and its drying sufficiently to be slipped and painted helps create a conceptual distinction between making a vessel and painting it. These may be recognized as separate processes that need not be done by the same person. In historic era pueblos, the two tasks were often carried out by different people (Batkin 1987).[1]

Most Mimbres narrative pictures, even those of people engaged in activities generally associated with men, such as big-game hunting

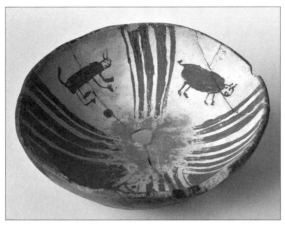

Figure 93. Bowl, Mimbres Classic Black-on-white (stylistically nonconforming), 6.5 x 19 cm, 2.6 x 7.5 in. Both the poorly made vessel and its painting appear to be the work of a child. Excavated by Richard Eisely circa 1926 near the ranger station, upper Mimbres Valley. (WNMU 73.8.249)

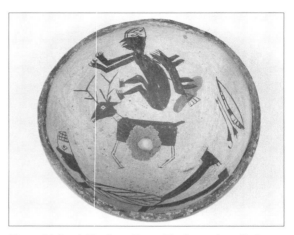

Figure 94. Bowl, Mimbres Classic Black-on-white (Style III), 7.0 x 14.6 cm, 2.75 x 5.75 in. A relatively unskilled painting that conforms to Style III criteria and appears to be the work of an adult. Excavation history unknown. (HMUM 114)

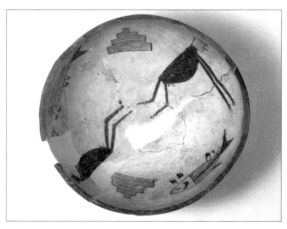

Figure 95. Bowl, Mimbres Classic Black-on-white (Style III), 11.5 x 22.5 cm, 4.5 x 8.9 in. The fish seem painted with greater skill and assurance than are the geometric motifs or the two humans. Excavated at the Goforth Ruin; purchased 1928. (ASM GP6553)

and what seem to be male-dominated ceremonies, are painted on well-made vessels with the kind of facility that can be mastered only over a lengthy apprenticeship by a skilled pottery painter, most of whom are assumed to have been women (see figs. 26, 29, 31, 36, 38; pl. 1). Some poorly made vessels that are also poorly painted seem to be entirely the work of children or other novices (fig. 93). Other paintings, almost always narrative scenes that are decidedly clumsy in their execution but that appear on well-made vessels, suggest the work of an iconographically knowledgeable adult other than the potter, possibly a male but in any event relatively unskilled as a pottery painter (figs. 14, 94, 95). Males very likely participated in a pictorial tradition that is closely related to Classic Mimbres pottery painting—the carving of petroglyphs. Some petroglyph sites displaying Mimbres-style images are in and near the Mimbres Valley; others are as far away as the Chiricahua Mountains in Arizona, more than 100 miles to the west (fig. 96), and the Jornada Mogollon regions of New Mexico, more than 120 miles to the east (fig. 97). These show that important stylistic and

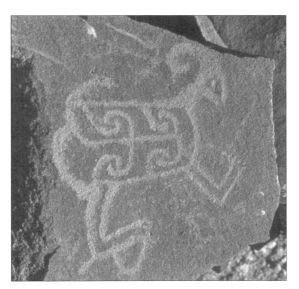

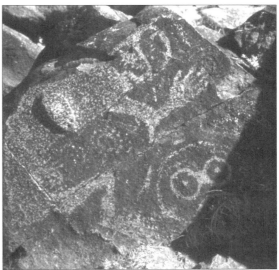

Figure 96. Petroglyph, Classic Mimbres style, Chiricahua Mountains, Ariz., 100 miles southwest of the Mimbres Valley, circa 1100. Photograph by J. J. Brody.

Figure 97. Petroglyph, Classic Mimbres style, Three Rivers, N.M., 120 miles east and north of the Mimbres Valley, circa 1100. Photograph by J. J. Brody.

iconographic elements of Mimbres pottery paintings were also used in an art medium that, at historic era pueblos, is generally associated with men (Young 1988:201–202).

If some Mimbres men did paint pottery, they did no great violence to Southwestern traditions. Although few male Pueblo potters are known of before the late twentieth century—except for transvestites, whose "man-woman" gender roles sometimes included pottery making—male participation in Pueblo pottery making activities is, and has been, commonplace (Batkin 1987:19–21). At least since the 1850s, Pueblo men have been documented as gathering and preparing clay and tempering materials, building kilns, firing, painting pottery, and doing everything else except fabricating vessels (Batkin 1987:21–22). At several late nineteenth- and early twentieth-century pueb-

los there seemed to be no question that pottery painting was an appropriate male art, and in all of them men were expected to assist women potters, if only as hewers of wood and drawers of water. On the basis of both logic and the historical record, then, I make the assumption that among the Mimbres, both pottery making and pottery painting were almost always done by women but that painting may occasionally have been done by men. In any case, it is unarguable that the usual high quality of Mimbres narrative paintings on pottery demonstrates that no matter who painted them, the artists were generally well trained, skilled, creative, and experienced.

Most painted Mimbres pots were made to be used in the villages where they have been found, and they were made by potters and painters who spent most of their time doing

other things. Some, more gifted than others, might have made or painted vessels for those less skilled, who might have made or painted none at all. Indeed, Mimbres Classic era pottery painting gives the impression of being so consistently high in quality that something like specialization must have developed. This impression is misleading, for only the finest examples are usually published or seen, and examination of several thousand vessels suggests a much wider range in quality than is generally on view in museum exhibits, private collections, and publications (figs. 93, 94, 98). In fact, no evidence suggests that anything approaching full-time craft specialization or professionalism existed. Still, the Mimbres unquestionably made fine art without the luxury of having full-time artists.

Probably, all or most women of a Mimbres community learned pottery making when they were young, as one of the useful and necessary craft skills. Like other crafts, it was probably learned by observation and practice supplemented by some instruction by experienced craftspeople. The entire training process took place within a community, and the obligations of pupil to teacher were probably no more than those assumed by kin relationships and respect for age. Women learned how to paint pottery as they learned how to make it, and those who were most skilled necessarily honed their skills by constant practice. If men also painted pots, their training was probably limited to that one skill, which they, too, had to maintain by constant practice. With emphasis on pottery manufacture as a useful craft, its techniques, forms, and decorative systems would have been largely tradition bound, and conscious striving for radical innovations or highly individualistic personal styles would have been unthinkable.

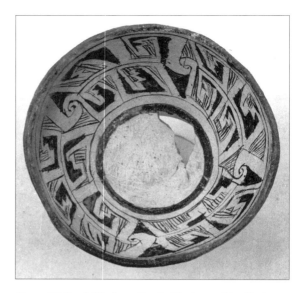

Figure 98. Bowl, Mimbres Classic Black-on-white (Style III), 6.5 x 11.5 cm, 2.6 x 4.5 in. Geometric pattern painted by an unskilled hand. Excavated by the Peabody Museum, Harvard University, at Swarts Ruin, 1924–1927. (HP 94491)

Tradition as developed and transmitted by and through the community was the compelling feature of craft training that fortified conservative attitudes. The Mimbres aesthetic evolved slowly and with a seemingly inevitable logic that permitted innovations only within strictly understood limits. The most radical innovation was the introduction of representational subjects, but the forms these took evolved in accordance with the rules. Within its limitations, however, this conservative visual tradition provided the parameters for and even encouraged invention. The visual elements of Mimbres painting were simple and basic and therefore could be combined and recombined endlessly. Thus, despite the restrictions of custom and a finite number of patterning procedures, personal and expressive picture making was possible and is usually

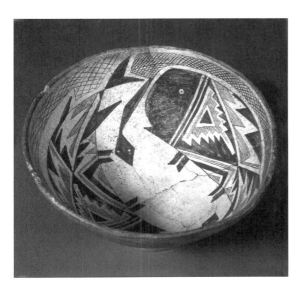

Figure 99. Bowl, Mimbres Classic Black-on-white (Style III), 12.5 x 27 cm, 4.9 x 10.6 in. Two fish. Excavated by Arizona State University along the eastern slopes of the Black Range. (EMAP, LA 45103, 2-4-13/2)

grayer slips that were less well polished than those in the Mimbres Valley, and they painted much thinner bottom framing lines on their bowl interiors than was customary elsewhere. Thin or no framing lines seem characteristic also of paintings made farther east, along the drainage of the Rio Grande (fig. 99). The technical and stylistic descriptions given here are a synthesis based primarily on Mimbres Valley examples and do not apply in all respects to Mimbres vessels made in other areas. The next generation of analysts will sort out those details.

The phenomenon of an art without full-time artists required a relatively restrictive tradition, for without simplicity of means and form and without a set of easily followed rules, the part-time artists could never have achieved consistency. Exceptional Mimbres painters produced exceptional paintings, but the quality of their work was always related to group standards or social ideals. The restrictive traditions of the group and its high expectations ensured a predominantly high level of performance that served as the base for the occasional production of a memorable picture.

That similar limitations can be a means for achieving personal creative satisfaction is eloquently illustrated by pottery making in the pueblos during the twentieth century. At Zuni in about 1925, all pottery painters worked with the same inventory of techniques, forms, structural formulas, and design motifs. Each combined and recombined these in a slightly different manner, and all considered every novel combination to be an invention. The work of individual potters was recognized by characteristic motif combinations, patternings, and craft techniques. Other potters and the community at large judged and criticized the work according to these factors, even though the range of variation was narrow and the

recognized by subtle variations of customary modes.

Regional variation, though not well understood, also characterized Mimbres pottery-painting traditions. Only recently, by the use of analytical technologies such as neutron activation analysis, through which clay sources can be determined, have archaeologists been able to demonstrate objectively that, at least in the places tested, Mimbres painted pottery was generally made at the place where it was found (James, Brewington, and Shafer 1995; Olinger 1989). With the support of such information, it is slowly becoming possible to recognize regional substyles by their characteristically subtle deviations from expected style and craft criteria. For example, Mimbres pottery painters in some upper Gila villages seem to have used

differences subtle. Potters accepted the restraints of tradition without question, did their best to make pottery that conformed to the generally recognized but unstated standards of the village, and expressed no awareness of personal creative restrictions (Bunzel 1929).

Traditional standards of form and design can change with surprising swiftness in the most conservative of systems, only to be reintegrated by the habits of traditional thought. Throughout the Pueblo region during and after the period of late prehistoric migrations, community after community replaced black-on-white and other bichromatic pottery with polychromes (Brody 1991:81–113; Dittert and Plog 1980). Both the change and its restrictive codification took little longer than the time needed to move from one place to another. Even more radical changes have been documented during recent times, following the introduction of industrially made products that effectively rendered most native pottery obsolete. The craft remained vigorous only in those pueblos that developed new forms and designs to suit new, non-Pueblo markets. This process took place within the matrix of weakened but still ongoing pottery-making systems, and the new forms and designs were swiftly absorbed into the basic traditions, even though most production since the early twentieth century has been for use by non-Native outsiders (Wade 1974).

These survivals demonstrate the vital role played by technology and training in the maintenance of traditional art. The radical changes in form and design epitomized by the potter Nampeyo at the Hopi-Tewa town of Hano in about 1890 were accepted by most local potters and systematized within ten or fifteen years (Kramer 1996:159–178). They have since changed only slowly and in tradition-patterned ways. Even more startling changes and some outright inventions introduced at other pueblos by individuals such as Maria and Julian Martinez at San Ildefonso in the years since about 1910 have been similarly absorbed (Peterson 1977; Spivey 1979). While changes in form or design were accepted either quickly or not at all, technical innovations that could have altered the training systems or otherwise upset traditional modes of behavior were, until recently, entirely rejected in the traditional Pueblo world. Attempts to introduce potter's wheels, electric or gas-fired kilns, high-firing clays, and glazes all failed until about the last quarter of the twentieth century. Designs and forms were only the symbols of conservative traditions whose survival depended absolutely on the social meaning and value of a technological system.

In the Mimbres towns, traditional forces must have worked in much the same way. Radical innovations in form and design could occur under the proper circumstances, and no lengthy period was needed for them to be accepted and absorbed. So long as there was stability of technology, training systems, and related social values, the fundamental tradition could absorb any amount of visual change. Within such constraints, each potter and painter had ample opportunity to express his or her individuality, most obviously by manipulating pottery shapes and design elements, more subtly and pervasively by developing personal qualities of line and other technical means so that each vessel made or painted became a kind of signature.

Manufacture

The basic raw materials used in manufacturing the pottery were low-firing, redeposited clays that are widely distributed throughout the Mimbres region. Small quantities of clay

could be dug at easily accessible places including arroyo banks, plaza areas, and locations in or near a village where adobe for house construction was mixed. The clay would then be taken to a work area and processed, which involved little more than breaking it up, removing pebbles, vegetation, and other foreign matter, and then soaking it in water for several weeks or months. The cleaned clay graded itself by settling stratigraphically by weight, and aging in water promoted biological action that improved plasticity. Neither mining nor refining were difficult or time-consuming jobs, and hardly more than one or two basketfuls of clay were needed to make a kiln load of fifteen or twenty vessels.

Clay taken out of the soaking and aging solution, with most impurities removed, was formed into small loaves that were kneaded, probably in a metate or grinding stone, to make their texture consistent and to remove air pockets. Clay collected in the alluvial areas of the Mimbres Valley ordinarily had sand inclusions, which could either be removed or left as a tempering material. Other tempering material was added as needed. Without the inclusion of nonplastics as temper, the interior of a formed clay piece would dry and shrink more slowly than the exterior, causing the unfired vessel to check and crack. Tempering materials varied. For large cooking and storage jars, potters generally used sand, and for bowls, mostly volcanic stone—generally hard rhyolite or soft volcanic ash, and sometimes the two together. Stone for temper was crushed by being pounded in a stone mortar with a stone pestle, and fragments of both inevitably became intermixed with the end product. Particles of river sand that remained in the clay even after refining also functioned as temper.

The amount of temper to be added was judged on the basis of experience and training, with the need to ensure even drying balanced against the loss of plasticity and smoothness caused by the additive. Several hours of concentrated work were required to knead and temper enough clay to make a kiln load of pottery. To do the entire lot at once might have created storage problems, and potters probably prepared only enough clay to make a few vessels at one time, with the added advantage that the drudgery was spaced in a series of short bursts.

Once the clay was kneaded, tempered, and made plastic enough to permit the rolling of coils, construction of a vessel could begin. Most vessels were probably formed in a shallow container such as the bottom of a pottery bowl that served as a support mold in which the vessel could be rotated while being formed. A pot was probably begun with a clay coil wound around itself to form a base, to which other coils were added, each probably about 1/2 inch in diameter and 6 to 8 inches long. Vessels grew outward and upward from the center, with new coils added to earlier ones as the potter carefully welded the plastic material into a single, seamless structure.

If coils were too wet, a vessel would not hold its shape under construction. If they were too dry, they would crack as they were wound into place. The potter kept her hands moist while working, and she periodically moistened the growing vessel. As she placed and welded each coil to the one below it, she flattened and smoothed the new coil by hand pressure, so that the finishing process was under way during construction. If a potter failed to weld and smooth the coils while they were plastic, not only would the pot be weak, but air bubbles in the clay might expand and explode when heated, destroying the vessel itself during firing

and damaging or destroying other vessels in the kiln.

The clay was prepared and the pot formed on a smooth slab, probably of stone, placed on or slightly above the floor of a room. If set outdoors, it would have had to be sheltered from wind and direct sunlight to prevent the clay from drying too rapidly. In any case, it is unlikely that pottery was made in freezing weather. Most potters probably sat or knelt in one place on the ground or earthen floor as they worked, turning the forming vessel in its mold as coils were added. A pot started in a container spun easily, and its soft base was protected. Any other method would have required much more careful handling, and the forming vessel would somehow have had to be kept from sticking to the work surface.

Up to this point, a single technology was used to form most pottery vessels, no matter how they were to be finished. Decorated pots were either textured or painted, and finishing systems differed for each class of decoration. Texturing, usually done while the clay was still plastic, could be as simple as roughening an entire surface with a corn cob or bundle of grass or as complex as shingling, corrugating, or making other elaborate modifications of the body coils as a vessel was being built up (fig. 100). Among some contemporaneous and all earlier Mogollon people, texturing was by far the most usual decorative technique. Classic period Mimbres potters continued to make traditional Mogollon textured wares and even developed some new types, but painting was their most characteristic means of decoration. Most Mogollon textured pottery featured all-over patterns on only one surface, and regardless of their elaboration, few offer the visual interest to modern audiences that any of the painted wares do. The forms and firing methods

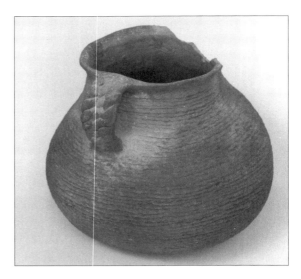

Figure 100. Jar, Mimbres Corrugated, with a braided handle, 18.5 x 21 cm, 7.3 x 8.3 in. Probably Mimbres Valley, excavated by the Dr. Berry Bowen family, about 1930. (MMA 40.4.145)

used for textured vessels differed somewhat from those of painted pottery.

The most common shape for painted vessels was a hemispherical bowl about 10 inches in diameter and less than 5 inches high. Other forms included small globular jars, ollas, and effigies, but few vessels of any shape were larger than 14 inches in any one dimension. A standard-size bowl could be made in one sitting and at the end of that time was still plastic, although firm enough to retain its shape. A jar or olla would have to be made more slowly, for fear that the weight of its upper parts would collapse it inward if the clay were too wet. An experienced potter who had other daily tasks to perform might take a week or two to build the fifteen or twenty pieces needed for an efficient kiln firing. Roughly the same amount of time was probably required to slip, polish, and paint a kiln load. If the pottery could be kept

Figure 101. Bowl, Mimbres Classic Black-on-white (Style III) (exterior of fig. 12), 8.5 x 20–21 cm, 3.4 x 7.9–8.3 in. Fire clouds, roughly finished exteriors, and smears of white slip near the rim are typical of Mimbres Black-on-white paintings from the Mimbres Valley. (HM NA-Sw-Mg-Az-8)

moist, then mass–production finishing methods would have speeded up the forming process, but except for occasions when two or more potters worked together on the same vessels, it is unlikely that such methods were used. Instead, Mimbres potters probably shaped only one or two vessels at a sitting and finished those, except for slipping and painting, before beginning any others.

Finishing methods included hand smoothing, scraping, polishing, and slipping. Most smoothing was done as coils were added to form a vessel. When it had dried somewhat, its surface was scraped with a piece of gourd, a potsherd, or any other material that could be cut to fit the desired curvature. Scraping removed most traces of coil construction and of the almost inevitable bellying out that occurred when the forming vessel first rose above its mold. Any cracks that developed dur-

ing drying were patched with welds of wet clay at this stage. Bits of temper were often lifted by the scraper and dragged along the surface, scarring it, and these marks also required patching and smoothing. Meanwhile, all finishing processes combined to reduce the thickness of a vessel wall to about 3/16 inch.

Bowl interiors were generally finished with more care than their exteriors, and drag marks and partially smoothed coils are often seen on the outsides of Mimbres bowls (fig. 101). During scraping, the plasticity of a vessel needed careful balancing, and the vessel as well as the potter's hands and tools were often moistened. If a pot was too pliable, it would scar easily and might slump; if it was too dry, coil smoothing was difficult, and the brittle clay might break under the pressure of the potter's hands and tools.

After being smoothed, but while still plastic, a pot was sometimes reshaped before being left to dry until it became hard and ready to be slipped with a fine, white volcanic ash–derived clay. Slip clays were not as common as body clays, but deposits of fine, kaolinitic, ash–derived clays are known today near Santa Rita, just west of the central Mimbres Valley, and at other locations throughout the region (William X. Chavez, personal communication 2002). This slip was usually applied as a thin wash to only one surface of a vessel, and only small quantities were needed. A cloth, a piece of leather or fur, or a bundle of fine fibrous material could be used for slip application. The watery mixture was soaked up instantly, bonding to the dry vessel. White slip served one purpose only: to provide the pottery painter with a smooth, white painting surface. To be effective, it had to be thick enough to cover the red-brown paste of the clay body, but if slip was applied too thickly, its bond with a vessel was insecure, and it might crackle or flake. Therefore, several thin

layers were probably applied rather than one thick one. Unlike most white-slipped pottery from the northern Pueblo regions, which were generally slipped on all visible surfaces, Mimbres bowls were almost always slipped only on the inside. Although occasional bowls, possibly from outlying areas, had exterior slips, most others have only finger smears or a narrow, uneven, and unpolished collar of white on the outer wall just below the rim. This was no more than the smearing of surplus slip, which tended to pile up on the lip of a vessel or accumulate on the potter's hands.

Almost as soon as it was applied, the slip was ready to be polished with a smooth, hard stone. Moistened polishing stones were used as burnishing tools, rubbed against the slip with a short, hard, back-and-forth motion whose direction varied. Burnishing marks are often visible and, rather than being rotational, are generally at right angles or diagonal to the rim of a vessel. The polishing stone was lubricated with water, and as burnishing took place, this moisture and hand pressure further strengthened the bond between slip and vessel paste. The ideal seems to have been a satin-smooth, somewhat reflective, even-toned, pure white surface, but as a rule, Mimbres slip clays tend to be somewhat gray and not very reflective. Once burnishing was done, a slipped and polished vessel was ready to be painted.

Pottery Painting

The decorative quality of a Classic Mimbres bowl is most obviously seen in its painting. Yet every step of the manufacturing process had decorative consequences of great importance for the lines and patterns of a picture, and at each stage pure craftsmanship was a vital part of the aesthetic process. Well-kneaded clay with a nicely balanced temper content is more easily worked into a refined shape and accepts a smoother finish than clay that has been indifferently prepared. A well-smoothed surface is more easily slipped and painted than one that is lumpy or striated. A neatly applied, even-colored, well-polished slip is far superior as a painting surface to one that lacks any of those qualities. Slip that does not adhere to the paste will ultimately crackle, flake, or powder, destroying any painting that might have been applied to it. Thus the potter, whether or not she was also the painter, played an essential and creative role in the making of Mimbres paintings.

Pictures were rarely placed on unslipped surfaces, and figurative paintings occur almost exclusively on bowl interiors. The usual color combination was black-on-white, but intermediate grays were created by use of fine-line hatching, and a third color was sometimes used, made from a slip that fired red-brown. Further, depending on firing conditions, the iron-rich clay paint might come out of the kiln red-brown, and the white slip, gray or cream colored. The color of the end product was as much a matter of firing technology and control as of raw materials. The many Mimbres paintings that are partially or entirely red-brown rather than black demonstrate how aesthetic choices may have been expressed through the firing process. Mimbres potters used an iron-rich, red, slip-quality clay as their paint pigment, grinding it into a fine powder and then mixing it with water. They may have added an inky paste made of a boiled plant such as Rocky Mountain beeweed to serve as a binder, bonding the red slip to the white slip (Eric Blinman, personal communication 2002).

A wet brush worked into the paint picked up enough pigment to make a line that would be partially absorbed by the porous white slip

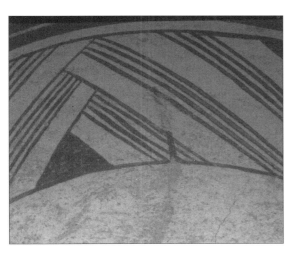

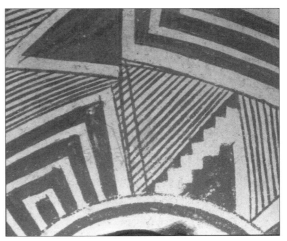

Figure 102. Bowl, Mimbres Classic Black-on-white (Style III), 8.4 x 17 cm, 3.45 x 6.75 in. Detail showing the scar on the white slip made by the scraped erasure of a line error. From West Fork Ruin, west fork of the Gila River, excavated as a Museum of New Mexico highway salvage project. (MIAC/LAB 18042/11)

Figure 103. Bowl, Mimbres Classic Black-on-white (Style III), 10.3 x 23.4 cm, 4.4 x 9.3 in. Detail showing how line errors were ordinarily overpainted rather than erased. Excavated by the School of American Research and the Museum of New Mexico at Cameron Creek Village, 1923. (MIAC/LAB 55364/11)

of an unfired pot and then fuse to the slip when the pot was fired. Small grains of red pigment combined with the vegetal component of the paint and soaked into the slip, making total erasure of a line practically impossible. Paint could be removed only by removing the slip that had absorbed it, but unless all of the slip was removed, a patch mark was left as the indelible and sometimes unsightly evidence of an erasure (fig. 102). Slip could be removed only by the tedious process of scraping it off an unfired and fragile vessel, or a painting error could be covered by fresh application of slip, but most often, errors were simply ignored (figs. 103–105). Paint had to be applied with a sure stroke and precise knowledge of where each brush mark was supposed to go and what it was supposed to do. Finally, when a painting was finished, the painted lines were burnished with a small polishing stone or other fine tool

to make them better adhere to the vessel and to enhance the aesthetic qualities of the painting (fig. 106).

Most brushes were probably made of a leaf of narrow-leaf yucca split to the thickness of a desired line and cut to lengths of 3 to 7 inches. One to three inches of that length were stripped of their outer fiber and chewed soft to be used for paint application; the remainder was left as a handle. A yucca brush is a highly specialized tool, so limp when wet that if it is held and used as if it were either stiff or flexible, it makes an uncontrollable, ragged line. But once a person learns to control this unresponsive, blunt-ended, square-sided instrument, it is ideal for making straight, even-edged lines on a curved, concave, or convex surface. When wet, it will rest on the surface, and if pulled gently, it will follow all the contours of a complex shape (fig. 104). Moved at the proper speed and held

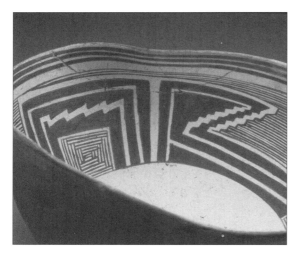

Figure 104. Bowl, Mimbres Classic Black-on-white (Style III), 16.5 x 21–31 cm, 6.6 x 8.4–12.2 in. Detail showing how painted designs were adjusted to conform to eccentric bowl shapes. Excavated in Hidalgo County, N.M., as a Museum of New Mexico highway salvage project. (MIAC/LAB 48178/11)

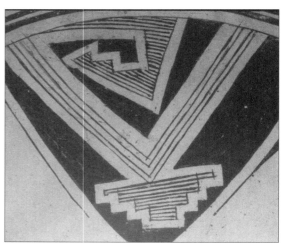

Figure 105. Bowl, Mimbres Classic Black-on-white (Style III), 12 x 26.7 cm, 4.8 x 10.6 in. Detail showing overlapping and overpainted lines. Excavation history unknown. (MIAC/LAB 54238/11)

Figure 106. Bowl, Mimbres Classic Black-on-white (Style III), 11 x 22 cm, 4.5 x 8.75 in. Detail showing burnished lines and blocks of color. Excavated in Luna County, N.M., as a Museum of New Mexico highway salvage project. (MIAC/LAB 37945/11)

firmly, it will deposit even quantities of paint, making a line unvarying in thickness. It will do the same if held without motion at the proper angle against the side of a moving vessel. Line direction can be changed by turning the brush or repositioning the pot, and any kind of line except continuous thick-thin ones can be neatly and easily drawn.

These brushes were the most important decorative tools in the Mimbres painters' inventory. The potters' tools were mostly simple and unspecialized and included digging sticks for mining clay, baskets for carrying it, and large storage vessels in which to soak, cure, and store it. Grinding stones (metates) for reducing dry, unprocessed clay to powder, a fine-grained stone work surface, a stone mortar and pestle for grinding temper and perhaps a finer set for grinding paint pigment, the bottom of a basket

or a broken pottery vessel to serve as a support mold, small containers used as paint palettes or for storing materials, pottery or gourd scrapers, something flexible for applying the slip, and smooth, hard, fine-textured polishing stones completed the inventory. Of the total, only good polishing stones may have been hard to find or make, and Mimbres potters may have treated these the way many modern Pueblo potters do: as heirlooms to be treasured and passed by gift or inheritance from generation to generation.

Firing

Pottery was probably made only during the warm part of the year, when it could be fired under optimal conditions on sunny, still, dry days. Vessels likely were left to dry for about a week or ten days before firing to allow for the evaporation of moisture that would otherwise expand in the heat of the kiln, causing the pottery to explode. In the arid climate, drying required nothing more than the ordinary low humidity of a mild or warm day and protection from direct sunlight. On the morning of a day selected for firing, a kiln would be built in an open space, most likely in a wooded area some distance from the village, where fuel was more easily accessible. A number of kiln variations are known from the Southwestern archaeological and ethnographic record, suggesting a range of kiln forms that the Mimbres potters might have used, but no Mimbres kilns have been identified to date.

The kiln foundation could have been a shallow rectangular or circular depression, perhaps at most 6 feet long or 4 in diameter, with or without a cobblestone floor to retain heat or a low stone table to be used as a pot rest to protect the unfired vessels from direct flames. A wood fire was most likely built in the depression to preheat the surface and reduce thermal shock. Another layer of wood placed on the ashes of that fire formed the kiln floor. If the unfired vessels were not raised above the floor, then the floor was most likely covered with large pieces of broken pottery to protect the vessels from direct contact with the fuel. A layer of unfired pots would then be placed upside down on the sherds or other protective raised surface, and an additional layer or layers of vessels might be stacked upside down above the first. The entire pile would then be covered with more pottery sherds to isolate the unfired wares from the dried wood that was stacked over and around the entire mass to complete the kiln. That so many Mimbres bowls have fire clouds on their exteriors and so few on their interiors suggests that openings were left in the protective layer above the unfired vessels but not in the one below them. A kiln made to hold fifteen or twenty vessels of average size could be built and prepared for firing during the course of a morning. When ignited, it would burn for perhaps ninety minutes at temperatures of about 800 degrees C. Within a couple of hours after the kiln had consumed itself, the completed pottery would be cool enough to be removed and cleaned, ready for use.

The clay and red-slip paint both contained iron, which would have oxidized at temperatures ranging from 800 to 1,200 degrees C, provided there was a strong draft in the burning kiln. If oxidized, colors after firing would range from pink through tan and brick-red to brown. In a reduction atmosphere, without the free flow of air, the colors of paste and paint would range toward gray and black, while the kaolinite slip, unless it had iron impurities in it, would fire white to pale gray. Strict control of the firing atmosphere is hardly possible with an

outdoor, bonfire kiln, for air will flow in at all times unless the fire is smothered, and a strong breeze can turn a reductive firing into an oxidizing one. At best, the high iron content of the clays used to make Mimbres pottery, when fired in an oxidizing atmosphere—as seems always to have been the case—virtually ensured the production of brown-ware vessels that had one surface covered by a thin slip of iron-poor, white clay. If, toward the end of a firing, oxygen was cut off to create a reduction atmosphere, the oxidized rust-red slip paint would turn black; otherwise, it would be a rich red-brown.

Classic Mimbres potters were aware of the effects of firing atmospheres and attempted to control them. Many still made traditional unpainted Mogollon red and brown wares, perhaps using the same clay sources they used for their painted wares, and they had to know that color differences resulted primarily from differences in firing atmospheres. Even so, the black-on-white surface effects are singularly erratic, with a high proportion of vessels having oxidized or partially oxidized paint on a gray-white slip and gray-brown paste body. Such effects can result only when a reducing atmosphere becomes an oxidizing one late during firing, with temperatures still above 800 degrees C. In that case, any iron in the previously reduced clays will turn red or brown. Most Classic Mimbres paintings are black, but so many are partly black and partly red or brown that it seems reasonable to conclude that in some instances, if not most, the effect was desired and deliberate rather than a consequence of poor firing control (pl. 5).

Logically, potters as concerned as the Mimbres were with visual quality and surface appearance would be expected to have built windscreens to prevent vagrant breezes from accidentally oxidizing their kilns. I interpret their consistent failure to do so as the exercise of a deliberate aesthetic choice: they courted accidents by controlling firing conditions to encourage the creation of painted vessels with colors ranging from black to red on the same surface. Even though a majority of Classic era Mimbres Black-on-white pottery is truly black on white, so many vessels with oxidized paint were collected from the uppermost, and therefore most recent, level at the Mattocks Ruin that Paul Nesbitt (1931) treated them as a separate named type (pl. 6). He may not have been entirely wrong to do so.

Other preventable "accidents" on Mimbres painted pots suggest a pattern. Black streaks, or fire clouds, on bowl exteriors are virtually ubiquitous, all resulting from pieces of burning fuel resting against the upside-down vessels during firing (fig. 101). Though fire clouds are easily prevented and not at all common in most other Southwestern black-on-white traditions, few Mimbres potters took great care to protect their vessels from them. Finally, although Mimbres hemispherical bowls were generally made as circular in outline as possible, a substantial minority were reshaped while the clay was still plastic—possibly by accident but more likely with deliberation—to become ovoids or near ovoids before being skillfully painted and then fired (figs. 13, 54, 89; pl. 3, among many others). In the past, such vessels were usually described as having been accidentally warped during firing, but that appears to be a technical improbability (Eric Blinman, personal communication 2002; Bill Gilbert, personal communication 2001, 2002). It seems clear that Mimbres potters deliberately courted certain kinds of accidents and imperfections—an unexpected aspect of their aesthetic and a counterbalance to the perfection of patterning that they usually sought and often achieved in their paintings.

Firing temperatures were not high by modern ceramic standards, but Mimbres kilns achieved temperatures well above the minimum necessary to complete the physical transformation of raw clay into durable pottery. Mimbres clay was a low-firing variety; pots that are sometimes found in burned rooms were vitrified or warped beyond use at temperatures that could scarcely have exceeded 1,500 degrees C (see fig. 87). With kilns rarely capable of achieving temperatures higher than 1,100 degrees C, the Mimbreños and other ancient Southwestern potters had found a technology appropriate to their materials. Once the contents of a kiln were removed and the protective sherds taken away, only ashes, broken vessels, burned earth, and perhaps burned rocks were left to mark the spot. If a kiln site, soon reduced to nothing more than a shallow pit, a pile of rocks, and fire-reddened earth, was not in the immediate vicinity of a Mimbres village, it might never be found and recognized again.

Mimbres pots are hard, durable, porous, and brittle. Storage and cooking vessels were left unpainted and unslipped, and if they acquired a thick coat of grease they were waterproof and made excellent containers for boiling or simmering foods. Ungreased vessels also held water but were porous enough that stored liquids were kept fresh and cool by evaporation through the body walls, acquiring an earthy taste that can be considered pleasant. Foods stored in such containers are perfectly protected from vermin of all sorts, and in the dry climate, humidity could be kept low enough to leave little danger of spoilage due to fungi or mildew. The excellence of these storage vessels is amply demonstrated each time an ancient Southwestern pot is found with corn kernels or other food still intact and apparently edible after the passage of hundreds of years.

Painted bowls, with relatively soft slips and easily chipped paint on their only usable surface, had far more limited uses. Many were serving dishes or food containers, and their scratched and otherwise defaced interiors attest to the incompatibility of this use with painted designs. Any kinds of vessels, including those that were the most beautiful and many with figurative designs, could be used as mortuary offerings with holes punched in them as a burial rite. The impression may or may not be accurate that figurative painted vessels were handled with greater care than others, leaving fewer that are seriously defaced by use. Selective bias in older museum collections and by private collectors favors well-preserved figurative paintings. The impression can be tested only by careful examination of the relatively small number of vessels collected since the 1970s during controlled archaeological excavations.

Like most other ancient Southwestern pottery, Mimbres bowls are a good utilitarian ware, their greatest drawback being their fragility. The average life of similar vessels worldwide has been estimated at one to five years (Rice 1987:303). But if easily broken, the pottery was also easily made. Materials were common and at hand, most tools were simple and unspecialized, and a household that broke twenty pots in twelve months could replace the loss with ten days of work spread over a month. The cost was low, and pottery making and pottery painting were crafts that provided avenues for people to display personal, expressive, and creative skills. The technical and social constraints of the craft provided no more than the matrix or field needed to make the work intelligible to its users, who were ordinarily members of the potter's own small community. The end products had important communicative and aesthetic capabilities, and the care taken

by Mimbres potters in making and decorating their vessels attests to the aesthetic and symbolic values given to the art by that community.

The specific symbolic values and social purposes of the painted pottery remain largely a puzzle. Certainly, many painted vessels were ultimately incorporated into mortuary rituals, but there seems to be no way of knowing whether vessels were selected for that purpose because they were containers, because of the pictures on them, or for some other reason. It is fairly certain that most painted vessels, if not all, were made to be used in domestic settings for food service, storage, and other household purposes. The accelerated production of painted pottery after about 950 C.E. and the spectacular elaboration of the art during the eleventh and twelfth centuries were intimately associated with other symbolic innovations that followed upon dramatic population increases, new economic technologies involving irrigation and intensive agriculture, and social reorganization. Pottery painting was only one of several symbolic expressions triggered by those events, and along with new patterns of village organization, new architectural styles, and new mortuary and other ritual and ceremonial practices, it played a role in articulating this new way of life.

That role is only beginning to be clarified. Recent speculations suggest that the new architecture and new mortuary practices were means for the lineages that controlled the best agricultural lands to legitimate their position by demonstrating their antiquity (Shafer 1995, 1996, 1999). Having ancestors buried in their own lineage-associated ceremonial rooms was a testament to authenticate their claims. But how can a community of exclusionary lineages maintain solidarity? Community strength requires a balancing mechanism to unify competing kin groups. In somewhat parallel circumstances after the 1300s, the ancestors of many modern Pueblos drew communal strength by organizing multifaceted katsina societies whose membership was recruited from entire communities (Adams 1991, 1994; Eggan 1994; Schaafsma, ed., 1994). Embodying virtually all of life's mysteries—from fertility, birth, death, and immortality to history and weather— katsina societies are thought by some to be pictured in Mimbres paintings of ceremonial activities (Carlson 1982; Hays 1994:47–62; P. Schaafsma 1994:63–79).

Whether perceived similarities between Mimbres rituals and those of katsina societies are real or coincidental and what the historical relationships between the two might have been are, I believe, untestable and unanswerable questions. The important point is that some Mimbres paintings do show large-scale, public ritual dramas that may represent community-wide ceremonies (fig. 29). If, as seems reasonable, public feasting was an element of such ceremonies, then many beautifully painted serving vessels would have been needed periodically by the larger Mimbres communities (Shafer 1996:8–10; 2003). It is a commonplace that the practical, political, and social roles of art may come together for the purposes of gift giving and otherwise impressing out-of-town and other unrelated guests.

The Form and Structure of Mimbres Classic Black-on-White Pottery

Pottery painting was the diagnostic art of the Mimbres people by the 900s C.E., when they shifted their major expressive interest away from the tactile and plastic potentialities of clay and toward the development of smooth painting surfaces. Their overwhelming aesthetic concern from then on lay in the pictorial potentials of vessel surfaces rather than in vessels' tactile forms. Thus Mimbres pottery came to differ significantly from most earlier and many contemporaneous Mogollon pottery traditions, especially during the time when Mimbres Classic (Style III) paintings were being made (1000–1150). In this and the next two chapters I focus on that period, though not exclusively.

From the beginning of the black-on-white painting tradition, but especially during the Classic era, open bowls were by far the most common form for all Mimbres Black-on-white painted vessels; globular jars and high-shouldered ollas are the only other painted shapes found in any quantities. Unusual shapes, including effigy jars, ladles, and dippers, were also painted (fig. 107). Most Mimbres bowls are round bottomed and somewhat wider than

twice their height, making them not quite hemispherical. The most common variants are shallow forms that were used for many Style I and early Style II paintings and, appearing much later in the Classic era, globular ones with flared rims and high, flat-bottomed vessels that expanded outward, rather like wastebaskets or flower pots, and were painted both inside and out (figs. 108, 109). Flaring rims are usually no more than an inch wide and project from vessel walls at approximately right angles. Their elaborate rim profiles suggest a tentative step toward using the plasticity of the clay for decorative ends.

Most bowls are about 10 inches in diameter and between 4 and 5 inches deep. Smaller ones are common and proportionately shallower than those of average size. Bowls larger than 11 inches across are rare and tend to be proportionately deeper. Almost all out-of-round bowls are of average size or slightly larger and have been lengthened along one axis to create an elliptical shape. Even though the distortion ordinarily produces a useful pouring spout, many of these shapes often seem to be accidental. Paintings on such forms were generally

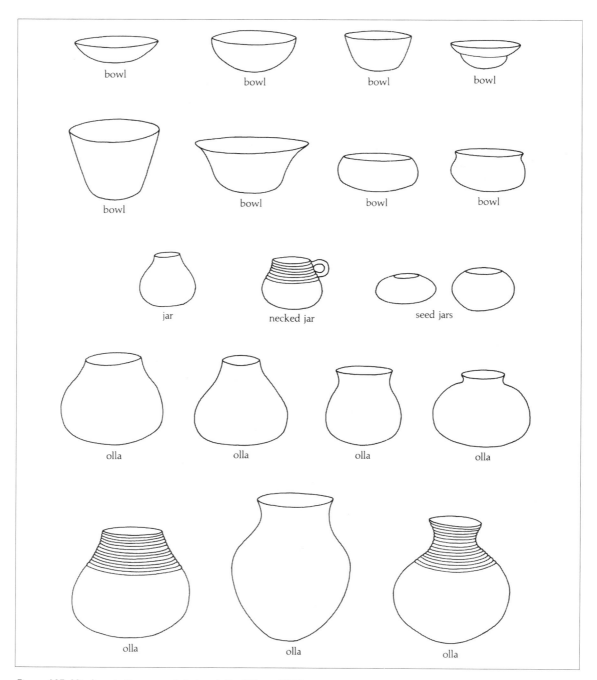

Figure 107. Mimbres pottery vessel shapes (after Wheat 1955).

Figure 108. Deep, flat-bottomed bowl, Mimbres Classic Black-on-white (Style III), 16 x 23.3 cm, 6.3 x 9.2 in. Bowls of this shape are uncommon and are usually slipped and painted on both interior and exterior surfaces. Interior paintings are almost always complex geometric abstractions with motifs suggestive of lightning, rain, and other elemental forces including, as here, isolated starlike crosses. Excavated at the Eby 2 site for the University of Colorado, 1926. (UCM 9371)

Figure 109. Exterior of figure 108. Exterior paintings on deep, flat-bottomed bowls are almost always isolated abstract or figurative motifs and are rarely framed.

composed as though the bowls were circular rather than elliptical, but the paintings are often modified to fit the eccentric shapes (figs. 58, 59, 104, 116).

Jar and olla forms are much alike in being globular with relatively small, central orifices, and their painted decorations are usually confined to the upper parts of their outer surfaces. Several varieties of small vessels with this configuration were made, including canteens, seed jars, and necked jars (fig. 107). A vertical neck or spout usually projects upward from the center of these forms, and a very few have one or two handles or as many as four suspension rings attached to their shoulders above the midpoint. Handles range in elaboration from simple flat

straps to complex braided coils, and some are decorated with tiny modeled or painted animals or animal heads. Most handles are vertical and joined to the pot near its lip and at its shoulder or widest part of the upper body. Suspension rings range in shape from simple pierced nipples to braided loops. Ollas are larger than other painted vessels and usually have a necked central orifice, no handles or suspension rings, a pronounced shoulder, and a pointed, rounded, or somewhat flattened base (figs. 110, 111). The rims of necked vessels are often everted.

Perceptually, the greatest differences in decoration between globular and hemispherical forms have to do with convexity and concavity. The proportions of the two forms are similar, and design problems hinged on the question of whether the inner or the outer side of a hemisphere was to be painted. Because most domestic activities took place on an earthen floor, painted pottery vessels were ordinarily

Figure 110. Olla, Mimbres Classic Black-on-white (Style III), 29.6 x 20 cm., 11.75 x 8 in. Paintings on ollas are almost always kept within a band on the shoulder of a vessel between its neck and underbody. Excavated by Texas A&M University Field School at NAN Ranch Ruin, 1978–circa 1996. © Margaret Hinton, reproduced by permission. Photograph courtesy of Brian Shaffer. (TAM 4–486)

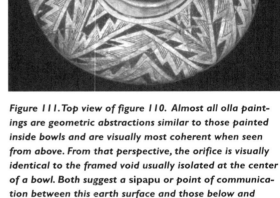

Figure 111. Top view of figure 110. Almost all olla paintings are geometric abstractions similar to those painted inside bowls and are visually most coherent when seen from above. From that perspective, the orifice is visually identical to the framed void usually isolated at the center of a bowl. Both suggest a sipapu or point of communication between this earth surface and those below and above. © Margaret Hinton, reproduced by permission. Photograph courtesy of Brian Shaffer.

seen first from above and then from the side if a viewer was seated. Because vessels were also mobile when in use, they were rarely perceived as static.

When the convex shape of the shoulder of an olla was painted as if it were a concave bowl interior, the olla painting would mimic bowl paintings when seen from above (fig. 111). The necked mouth of the olla supported this illusion by its resemblance to the circular, unpainted center of a geometrically painted bowl. From other positions, only portions of an olla design would be seen, and it could not be perceived as a unified whole. In similar fashion, bowl paintings were often composed so that only portions could be seen from a seated position, in which case they could be extraor-

dinarily dynamic when slowly moved. Other forms, especially effigies, presented other kinds of visual problems that were solved in analogous ways.

A variety of effigies was made—mostly nonhuman animals—but some are known from only one or two examples, and none is plentiful. Bird effigies are the most common and are usually variations of the standard jar shape, with mouth and neck shifted from the center to one end to become the head and neck of the bird (figs. 112, 113). They are often ovoid or triangular in plan. Like other life-form representations, they vary greatly in their degree of realism. On some, the only anatomical details are painted patterns suggestive of wing, tail, and breast feathers, and these vessels are

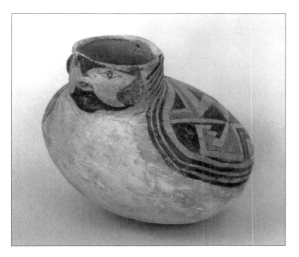

Figure 112. Bird effigy jar with human face, Mimbres Classic Black-on-white (Style III), 21 x 26 cm, 8.3 x 10.2 in. Excavated by Richard Eisele before 1932, site unknown. (WNMU 73.8.387)

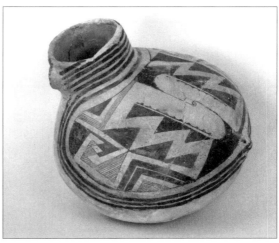

Figure 113. Top view of figure 113 showing how the painting is structured to suggest a pattern that might be made by the wing and back feathers of a bird.

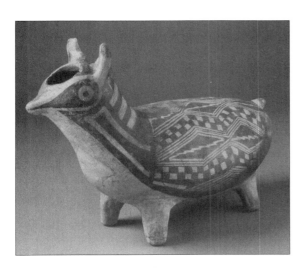

Figure 114. Quadruped effigy jar, Mimbres Classic Black-on-white (Style III), 29 x 19.5 cm,., 11.4 x 7.7 in.. Except for the stripes at the back of the animal's neck, the painted pattern gives little information about its species. Excavated by the Peabody Museum, Harvard University, at Swarts Ruin, 1924–1927. (HP 94932)

sometimes as much shoe shaped as bird shaped. Others have modeled heads that form the spout, projecting tails, and modeled wings, neck, and body. Some have two, three, or four legs that rarely resemble those of a bird.

Effigies of other animals are generally similar. Most have four legs, but except for horned animals, species identification is often problematical (fig. 114). Bowl-shaped effigies were also made; they were usually painted on their interiors but could also be painted on the outside. Some are small and elliptical with arched handles attached at each end, parallel to the long axis of the vessel. Their animal features are limited to modeled heads, tails, and feet, all attached to and projecting from the bowl body at appropriate places.

Perhaps the most elaborate and rarest of the effigies are those of humans, known mostly from fragments. Facial features are often missing, as if the effigies had been deliberately broken

and their pieces distributed in more than one location. Most are seated with crossed arms and legs that are modeled from clay coils applied to the surface of a vertical, tubular container. The container is the human trunk, and a modeled head, open at the top or back, forms a pouring spout. The heads are disproportionately large but generally have realistic features made by pinching, painting, and adding shaped bits of clay. In almost every instance effigy forms were painted with black on a white slip. Exotic or specialized forms such as scoops, ladles, and miniature vessels, some of which may have been made as toys, and a variety of odd shapes that were made for unknown purposes were also painted (fig. 115; pl. 5).

The Painting Tradition

The decorative possibilities open to any Mimbres painter were, in theory, infinite. In practice, the artists accepted, as all artists do, a set of arbitrary limitations or rules that had an internal logic. An understanding of their decorative system must refer to those rules, their logic, and their effects.

Among the systematic exclusions accepted by Mimbres pottery painters was the use of paint textures other than a shiny surface and, with some late exceptions, of more than two colors on any one surface. Thus, paint was used mainly either for its linear graphic value or as a solid filler. In keeping with this strategy, Mimbres draftsmanship of figurative images was essentially two-dimensional and avoided the use of shading or other devices that might create illusions of three-dimensional solidity. Most figurative paintings were placed within a framed space that generally avoided all pictorial references to real-world space: they seem to be in a spatial void. Artists usually chose to paint

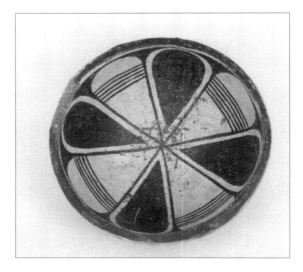

Figure 115. Miniature bowl, Mimbres Classic Black-on-white (Style III), height 4 cm., 1.65 in. The geometric design in an ABAB rhythm creates a flowerlike motif of alternating dark and light petal forms. Excavated by Harriet and C. B. Cosgrove before 1936 in Grant County, N.M. (MNA 834/NA 3288.65)

only within well-defined patterning areas on only one surface of a vessel, and their compositions, representational or otherwise, consistently developed balanced sets of shallow and unavoidable spatial illusions. Consequently, their framed pictures could not become an integral part of the vessel, for they portrayed imaginary activities taking place within the space confined by that vessel.

Except for their figurative paintings, they were committed to both geometric regularity and the use of dynamic symmetries to create inevitable and rigorous rhythmic formality. Although paintings and their supporting surfaces were recognized as two separate things, the character of each shaped surface was considered when picture spaces were defined, and painted frames and motifs were made to conform to

the particular shapes on which they were placed. Finally, the tensions between the shape of a vessel and its painted surface intensified all of the dynamic possibilities that inhered in any painted pattern.

At the heart of this tradition was the conception of a pot as a surface on which to put a painting. Relationships between the two were inorganic: neither was essential to the other, and each could exist as an independent entity. This concept was modified by a set of mechanisms that had the effect of creating pseudo-organic relationships between pictures and their supporting surfaces. Among these mechanisms were a commitment to maintaining a shallow pictorial space by generally avoiding three-dimensional illusions of deep space; adjusting picture-framing lines so that painted shapes conformed to the shifting planes of the globular or spherical painting surface; repeating a few basic geometric elements in mathematically predictable sequences; and, above all, treating painted and unpainted areas ("backgrounds") as visual equals. Despite the conceptual mutual independence of picture and picture surface, in practice the tradition demanded close visual interrelationships between the shape of a vessel and the forms that were painted on it.

In many respects these rules and features were not exclusive to the Mimbres but were, and are, common to most Native American pottery traditions of the Southwest. The specific Mimbres rendering of this regional tradition is defined by local innovations and mechanical details rather than by any basic modifications of the system. Some of the details are unique, but most are not, being instead clusters of attributes any one of which might be shared with other regional subtraditions or co-traditions. Perhaps the most startling Mimbres innovation was in figurative painting, which

was unique not only in style and in its relatively great frequency but also in its consistency of execution and the creativity of its compositional organizations. In these pictures, Mimbres artists frequently abandoned the mathematical inevitability of geometric rhythms, and sometimes, with apparent deliberation, they implied a three-dimensional pictorial world. Even so, most of these pictures maintain a shallow pictorial space, and their organizational schemes are often symmetrical and geometric. They differ from the geometric pictures mostly in subject matter and narrative requirements.

The Mimbres variation of the Southwestern decorative tradition is defined primarily by choice of subject or motif and concentration on certain kinds of rhythm, symmetry, pictorial structure, draftsmanship, coloration, and tensions. Geometric paintings were almost always organized according to one or another of a limited group of geometrical schemes, and their motifs and elements were also severely limited to sets of basic geometrical figures. The various schemes and figures could be combined and recombined in infinite series, but none of these inventions would have the effect of modifying the underlying concepts. Though the conceptual rules were limiting, their logic provided the artists with a framework within which they had the freedom to manipulate, interpolate, interpret, and invent. Everything followed from the basic premise that paint was applied to the surface of a vessel as a sort of skin, hugging it and adjusting its two-dimensionality to the three-dimensional reality of the space enclosed by the vessel.

Pictorial composition was largely determined by vessel form, and the limitation in the number of basic vessel shapes and their simplicity lent support to the primacy of painting over all other decorative means. All Mimbres Classic

vessels have relatively large expanses of gently curving, smooth, hemispherical or globular surfaces. Systems of pictorial organization that were invented to cover one form could, with a minimum of adjustment, be made suitable for another, and concavity and convexity were merely two sides of the same hemisphere.

Perceptual judgments are another matter entirely. Bowl paintings on concave interior surfaces can be perceived as entities, but only portions of paintings on convex exterior surfaces that are viewed at, near, or above eye level can ever be perceived at any one time: they cannot be seen as whole units except from above (figs. 110, 111). That issue was moot for the Mimbres people, for they, like all other Southwesterners of their time, usually first saw pottery paintings from above. But the issue is real enough for people of the present industrial world, with their vastly different viewing habits. We expect to see the painted vessels as static forms that either rest on surfaces at or near eye level or are suspended vertically on a wall. Paintings on jars, ollas, and similar forms require alternative organizations if they are to be as visually effective as those that are on bowls in modern Euro-American society. As it happened, Mimbres paintings on all forms were usually organized in about the same manner, as though perception would be immediate and total. The Mimbres concentration on bowl-derived pictorial solutions was more than statistical; it was a state of mind based upon viewing habits and viewing habitats.

The patterning of geometric paintings on bowls usually followed certain structural characteristics of the vessel form. Framing lines were placed immediately below the rim of a vessel, and similar lines were usually drawn around its bottom. Together, these lines ordinarily defined a banded picture space on the wall of a bowl and an unpainted space reserved as a void, usually circular, in its center (figs. 116, 117). Whereas potters seldom emphasized the architectural parts of the bowl—rim, walls, and base—painters isolated and stressed them. When no bottom frame was drawn, the bowl center was given importance by the use of some alternative painting structure, usually lines that can be perceived as simultaneously radiating outward from the center and inward toward it. These emphasize the symmetry and hemispherical nature of the form.

The picture space was further subdivided by patterning systems that tended to integrate all parts of a design into a single unit. For example, each segment of a quartered pattern might enclose a centered design, but the dominant image is of a single figure rather than four separate ones (figs. 115–117). Division of a vessel into quarters, with or without a reserved center, was the most common method of structuring bowl paintings, but segmentation into two, three, or five or more parts was also done. In most instances the divisions are radial, and the dividing lines, either actually or by implication, pass through the center of the vessel (figs. 118–121).

The unpainted, reserved space in a bowl center could become its visual focal point. If representational designs were placed in it, any sidewall patterns were reduced to serve as more or less ornate frames. Such reduction in the importance of the vessel walls also occurred if geometric designs were isolated in a bowl's center (fig. 121). But most often, center spaces were either left blank or included within an all-over pattern. In the first case, the artist concentrated on the vessel walls (fig. 122); in the second, he or she applied paint to all parts of the surface (fig. 123).

In rare instances, wall patterns are static and

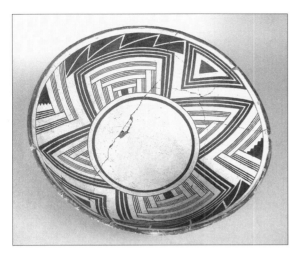

Figure 116. Bowl, Mimbres Classic Black-on-white (Style III), 12.5 x 26.5–29.5 cm, 4.9 x 10.4-11.6 in. A four-part geometric motif with an ABAB rhythm surrounds the unpainted center space. Excavated by the Mimbres Foundation at Mattocks Ruin, 1976. (MMA 77.67.28)

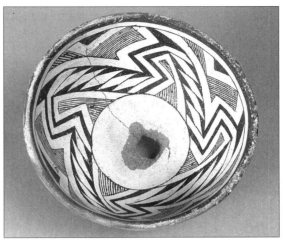

Figure 117. Bowl, Mimbres Classic Black-on-white (Style III), 7 x 15 cm, 2.8 x 5.9 in. A geometric design with an AAAA rhythm forms a dominant rotating motif around a reserved center. Excavated by the Mimbres Foundation at Mattocks Ruin, 1976. (MMA 78.44.7)

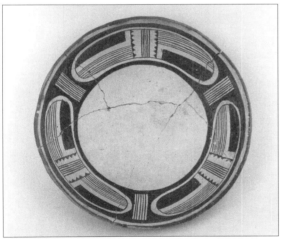

Figure 118. Bowl, Mimbres Classic Black-on-white (Style III), 7.3 x 20.4 cm, 2.9 x 8.0 in. A three-unit geometric pattern is confined to a design area on the upper wall of the vessel. Collected by William Endner before 1937; excavation history unknown. (MWC G431)

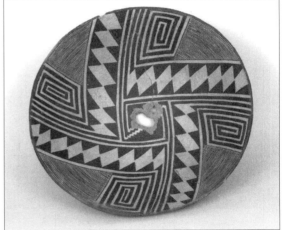

Figure 119. Bowl, Mimbres Classic Black-on-white (Style II–III), 9.3 x 27.5 cm, 3.7 x 10.8 in. A fourfold geometric pattern fills the space while rotating around a central point. Excavated at the Eby 2 site for the University of Colorado, 1926. (UCM 9370)

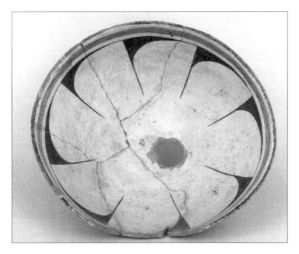

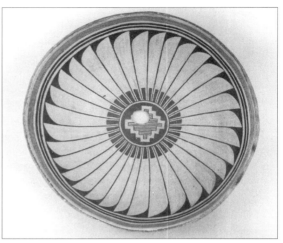

Figure 120. Bowl, Mimbres Classic Black-on-white (Style III), 12.4 x 26.4 cm, 4.9 x 10.4 in. An eight-unit floral or feather fan motif that is largely a product of negative space rotates around a central point. Excavated about 1930 in the upper Mimbres Valley by the Dr. Berry Bowen family. (MMA 40.4.206)

Figure 121. Bowl, Mimbres Classic Black-on-white (Style III), 11.5 x 25.5 cm, 4.5 x 10.0 in. A thirty-two-part floral or feather fan motif rotates around a central four-terrace design. Collected by E. D. Osborn at an unknown location and reproduced in Fewkes 1923:44, fig. 120. (HM NA-Sw-Mg-Az-5)

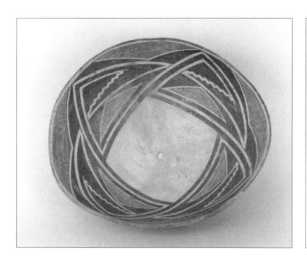

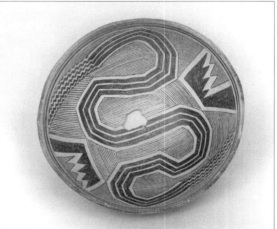

Figure 122. Bowl, Mimbres Classic Black-on-white (Style III), 14–15 x 29–32 cm, 5.5-5.9 x 11.4-12.6 in. Interlocking motifs rotate in a fourfold pattern around a square central void. Excavated by the Beloit College Field School at Mattocks Ruin, 1929–1930. (MIAC/LAB 8531/11)

Figure 123. Bowl, Mimbres Classic Black-on-white (Style III), 10 x 25 cm, 3.9 x 9.8 in. An overall pattern is structured into a two-part composition by a sinuous central motif. Excavated by Richard Eisele before 1926, site unknown. (TM 4592)

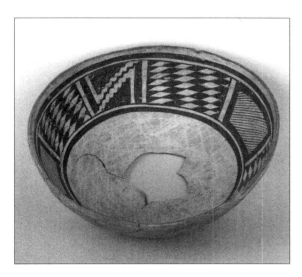

Figure 124. Bowl, Mimbres Classic Black-on-white (Style III), 11 x 27 cm, 4.3 x 10.6 in. A static band is patterned by ABCABC structural rhythm. Excavated by Richard Eisele before 1932, site unknown. (WNMU 73.8.195)

Mimbres painters organized pictorial space on a bowl so that it conformed to the architectural parts of the vessel. They then violated the resulting horizontal registers by crossing them with a series of radiating divisions. Other tension-creating devices included the creation of kinetic effects by using offset radiating lines, twofold (bifold) rotational symmetry, smooth curves contrasted against straight lines, ambiguous positive-negative forms, and systematic repetition of sharply angular elements and motifs (figs. 65, 125–128; pl. 7). Their system required the painted skin of a pot to conform to the vessel shape but permitted secondary patterns to ignore the architectonic form determinants—and therein lies its vitality.

Designs on shapes other than bowls either used bowl structural systems with little modification or depended on series of repeated, self-contained panels. Except when olla and jar forms are seen from above, the paintings on them are rarely perceived as so satisfying or dynamic as paintings on bowls (figs. 129, 130). Exterior designs that depend on panel structure are static when seen from the side, and they tend to behave as series of separate, self-contained but related pictures. From that position the organizational structure of a painting can never be seen but only surmised.

Painted effigies are even more restrained in their patterning, especially when a commitment to representation takes precedence over decorative intentions, in which case spatial organization is dictated by the physical character of the life-form. For example, a bird-human effigy may have painted panels placed in wing, back, tail, and neck areas that are structured in terms of both the shape of the vessel and the conventions of bird representation, rather than by the goal of creating a visually abstract pictorial composition (figs. 112, 113). Such panels were

motifs are confined to rectangular panels (fig. 124), as was the case in many northern Pueblo painting traditions of the Colorado Plateau. But dynamic patterning was the usual rule, a tense by-product of the Mimbres response to the Southwestern assumption that a painting on a pot was both a part of and apart from the vessel. Classic era Mimbres pottery designs were structured by an "unusual" variety of symmetries and layouts, including those "that are characteristic of design traditions from the Hohokam and Anasazi traditions" (Washburn 1992:220). That variety seems to testify not only to the fact that Mimbres artists drew inspiration from several sources but also to the way in which they thoroughly integrated fundamental elements of those original inspirations into what became a remarkably inventive and uniquely Mimbres stylistic tradition.

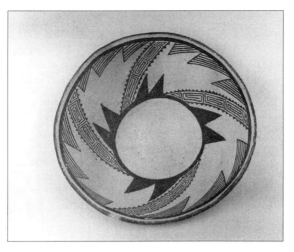

Figure 125. Bowl, Mimbres Classic Black-on-white (Style III), 9 x 23 cm, 3.5 x 9.1 in. A four-part pattern in black, white, and gray rotating around a central void suggests spatial depth. Excavated by Richard Eisele before 1936, site unknown. (TM 4491)

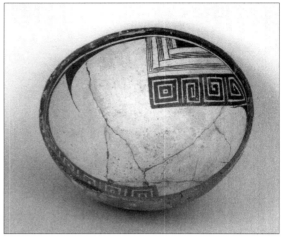

Figure 126. Bowl, Mimbres Classic Black-on-white (Style III), 9.5 x 21 cm, 3.7 x 8.3 in. A bifold triangular pattern suspended from the rim frame transforms into a large, rotating negative feather or flower-petal form. Excavated by Richard Eisele at the Coulson site. (WNMU 73.8.294)

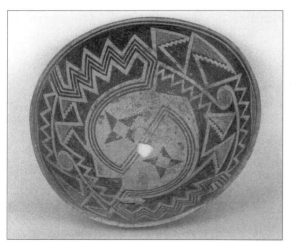

Figure 127. Bowl, Mimbres Classic Black-on-white (Style III), 13–14.5 x 33–37 cm, 5.1-5.7 x 13.0-14.6 in. A dark, complex bifold pattern dominated by interlocking zigzag motifs is bisected by a sinuous band enclosing a pair of large, four-pointed stars, perhaps emblematic of the planet Venus and the Hero Twins, at the center of the bowl. Excavated by Richard Eisele at the Coulson site. (WNMU 73.8.177)

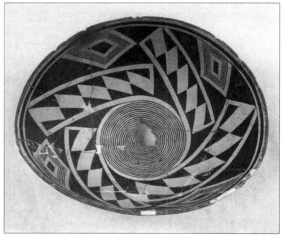

Figure 128. Bowl, Mimbres Classic Black-on-white (Style III), 10–10.3 x 23–27 cm, 3.9-4.1 x 9.1-10.6 in. A fourfold pattern is dominated by four dark rectangles filled with white rhomboids that seem to spin from the central space as though launched by a pair of interlocking fine-line spirals. Excavated by the Peabody Museum, Harvard University, at Swarts Ruin, 1924–1927. (HP 95934)

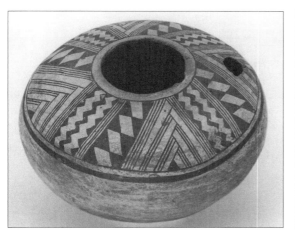

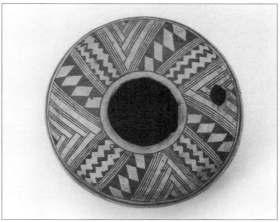

Figure 129. Seed jar, Mimbres Classic Black-on-white (Style III), 14 x 20.4 cm, 5.5 x 8.0 in. Four sets of three motifs each (ABC ABC ABC ABC) are organized as a continuous band on the upper shoulder of this small vessel. Excavated by the Beloit College Field School at Mattocks Ruin, 1929–1930. (LM 16172)

Figure 130. Top view of figure 129. When seen from above, the design rotates as a fourfold pattern around the central orifice.

usually filled with geometrical figures that often seem to have no representational value, even though they are shaped and organized as representational units.

Basic Pictorial Structures

The most common and elementary of Mimbres visual devices was line, and with line the artists created all painted decoration, even using lines to define areas that would later be filled with solid blocks of paint (fig. 131). It is commonplace to consider the lines as either curved or straight, but most were painted on curved surfaces that deny the possibility of a straight line. Still, the painters created the illusion and effect of ruler-straight lines, and it is generally more convenient to accept the illusion than to deny it. Most Mimbres lines are even-sided and narrow and appear to be con-

tinuous. But their continuity is a function of the skill of artists trained to fuse several relatively short brush strokes into a single, smoothly painted, continuous line. The thick-thin linear variations or broken lines that do occur seem always to be departures from an ideal, the result of momentary loss of concentration, less-than-skillful brush handling, or the technical inability of an individual to draw a straight line (figs. 93, 94, 98, 105).

In geometric paintings, continuous lines generally move in one of only three directions: parallel to the pot rim to form a complete circle; at right angles to the rim to bisect the vessel; or at about a 45-degree angle to the rim to segment the vessel diagonally from rim to rim. Paintings seem usually to start with a line placed parallel to and just below the rim that encircles the vessel and serves as the upper frame of the design area. Unless an all-over pattern was to

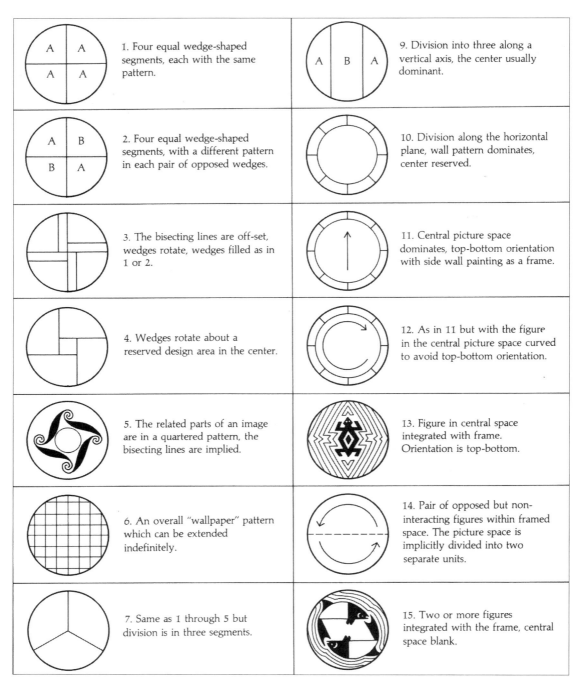

1. Four equal wedge-shaped segments, each with the same pattern.

2. Four equal wedge-shaped segments, with a different pattern in each pair of opposed wedges.

3. The bisecting lines are off-set, wedges rotate, wedges filled as in 1 or 2.

4. Wedges rotate about a reserved design area in the center.

5. The related parts of an image are in a quartered pattern, the bisecting lines are implied.

6. An overall "wallpaper" pattern which can be extended indefinitely.

7. Same as 1 through 5 but division is in three segments.

9. Division into three along a vertical axis, the center usually dominant.

10. Division along the horizontal plane, wall pattern dominates, center reserved.

11. Central picture space dominates, top-bottom orientation with side wall painting as a frame.

12. As in 11 but with the figure in the central picture space curved to avoid top-bottom orientation.

13. Figure in central space integrated with frame. Orientation is top-bottom.

14. Pair of opposed but non-interacting figures within framed space. The picture space is implicitly divided into two separate units.

15. Two or more figures integrated with the frame, central space blank.

Figure 131. Basic layout patterns of Mimbres Black-on-white paintings.

be developed, another circle about equal in weight to the rim frame was carefully drawn around the bottom of the bowl to serve as a lower frame, defining the picture space of the vessel wall while isolating the bowl center as a spatial void. Other circles parallel to the first were often drawn to define subsidiary design zones or elaborate on the upper frame.

Additional long lines were then drawn at right or oblique angles to the first to define other major decorative zones, bisect or quarter the vessel, outline a dominant central form, or otherwise provide the framework for the complex and dynamic structure that covered the surface defined by the framing lines. Design zones established by the second group of lines might be further divided with short lines to form filler units made up of geometrical elements such as rhomboids, triangles, rectangles, or squares. In combination, these subunits often formed readily identifiable motifs that sometimes had short filler lines placed within them. Throughout, all lines were complete, either by being made continuous, as in a circle, or by running from one crossing point to another.

Long lines that bisect a vessel from rim to rim form sweeping curves. Somewhat exaggerated and in combination with straight lines or other curved lines, these were the framework for distinctive and dynamic central motifs. Other curved lines included short arcs that combined with straight lines to form small design zones or large motifs. Curved lines were also used to make continuous and sometimes interlocking tight scrolls and elegant S-shaped motifs. Less common linear variations included zigzags and short lines, sometimes used as dashes but more often in combinations to form motifs.

Solid areas were always delineated before being filled and were never anything but an alternative way of filling a defined space. In

some cases, narrow lines were made to expand until they functioned as a solid filler, and solid areas were sometimes made so dominant that the unpainted white slip left between two solids was all that remained to carry an image. These strikingly ambiguous positive-negative patterns are among the most active and effective of all Mimbres geometric paintings (figs. 64, 120, 127).

Basic design structures, including the dominating shapes and rhythms, were established with the first few lines drawn on any vessel. Details and elaborations might develop slowly and perhaps spontaneously, but at the outset the painter necessarily had a mental image of the intended compositional structure and perhaps even of the picture to be painted. As a painting developed, with its motifs and elements placed in zoned areas, it was possible to change an image or modify the original intention by smothering the structure with an overlay of pattern. But the original lines could not be erased without destroying an entire pattern, and the end result was a logical if complex variant of a basic scheme established with the first few brush marks.

Most of the paintings are monochromatic, and line functions as a visual substitute for color. The spectrum was narrow, ranging from white (or the absence of paint) to solid black or red-brown (or the total covering of the white slip). A variety of hachures created grays that could relieve the stark dark-light contrasts that otherwise prevailed. The tone and intensity of the grays were functions of line width and spacing, with light and middle values predominant. Occasionally, hatching dominates, but most often it serves only to relieve sharp contrasts and act as a bridge between dark and light parts of a picture (figs. 132–136). On the rare polychrome vessels, a third color made with a thin red slip was used as a filler and generally

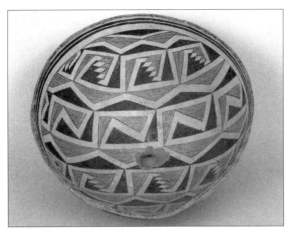

Figure 132. Bowl, Mimbres Classic Black-on-white (Style III), 12 x 31 cm, 4.7 x 12.2 in. A continuous pattern of repeated interlocking keys and triangles in three colors—black, gray (hachures), and white—suggests an adaptation of a Hohokam pottery-painting theme. Excavated at the Eby 2 site for the University of Colorado, 1926. (UCM 3113)

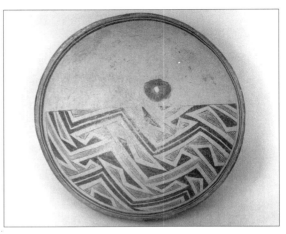

Figure 133. Bowl, Mimbres Classic Black-on-white (Style III), 10 x 23.5 cm, 3.9 x 9.3 in. With one-half of its surface left blank, the painting, otherwise similar to that of figure 132, suggests the moon half-way through its cycle. Excavated by Richard Eisele before 1926, site unknown. (TM 4483)

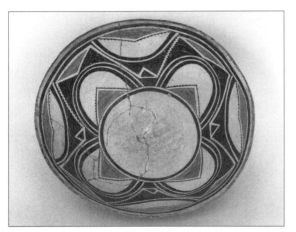

Figure 134. Bowl, Mimbres Classic Black-on-white (Style III), 17.8 x 31.8 cm, 7.0 x 12.5 in. A complex pattern of interlocking angular and rounded forms that seem to overlie each other forms an illusion of spatial depth. Excavated by A. M. Thompson at an unknown location before about 1925. (MIAC/LAB 44000/11)

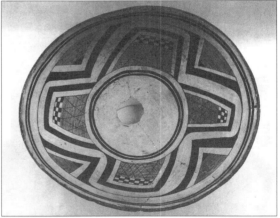

Figure 135. Bowl, Mimbres Classic Black-on-white (Style III), 13 x 28–32 cm, 5.1 x 11.0-12.6 in. Two concentric, four-armed, starlike motifs surround a central void. Excavated by the Peabody Museum, Harvard University, at Swarts Ruin, 1924–1927. (HP 96170)

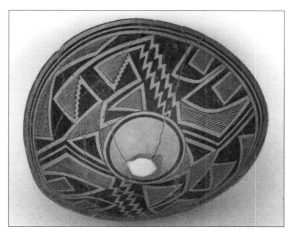

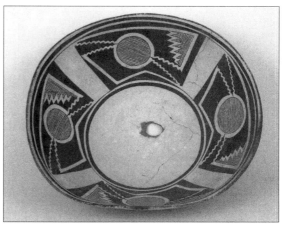

Figure 136. Bowl, Mimbres Classic Black-on-white (Style III), 13.6 x 32.2–34.1 cm, 5.4 x 12.7–13.4 in. A bifold pattern comprised of triangles, keys, zigzags, and rhomboids in black, white, and gray fills the deep, ovoid-shaped space of a pouring vessel. Excavated by A. M. Thompson at an unknown location before about 1925. (MIAC/LAB 19920/11)

Figure 137. Bowl, Mimbres Classic Black-on-white (Style III), 24.5–26.3 x 11 cm., 9.75–10.5 x 4.45 in. A relatively static four-unit geometric pattern with unusual circular motifs is organized in an AAAA rhythm. Excavated at the McSherry Ruin for the University of Colorado, 1926. (UCM 7741)

functioned as hatching did, to establish an intermediate color (pls. 8, 9).

Line quality was remarkably consistent throughout the entire Classic Mimbres period and throughout the Mimbres region. As much as any other single factor it dramatizes the power of traditional training, for the only variation, other than those arising from relative skill of execution, is in line thickness. Some lines were thinner than others, but any that are wider than about 1/16 inch were made by pairing narrow lines and filling the space between them. Because brushes could not hold much paint, long lines were made as series of connected dashes that skilled painters could make invisible. The importance of line is manifest, and every Mimbres painting was both opportunity and challenge to an artist who was expected to demonstrate linear skills.

Motifs and Images

The visual elements used in Mimbres painting are even more limited in number than the structural systems. The most common, excluding line, are triangles and circles. Diamonds, rhomboids, squares, crosses, and spirals can also be considered elemental units, but the first three are made of paired triangles and the last two are line variants. A single kind of element could be repeated to make a complex design; two were used most often, three sometimes, more than three rarely (figs. 134, 136, 137). Circles were used mainly to describe large design zones, especially central ones, and also to describe the shape of a subunit (fig. 137). Wedge-shaped triangles were a natural consequence of any quartered design structure and were also used to describe large design zones. Small-scale triangles are the most commonly

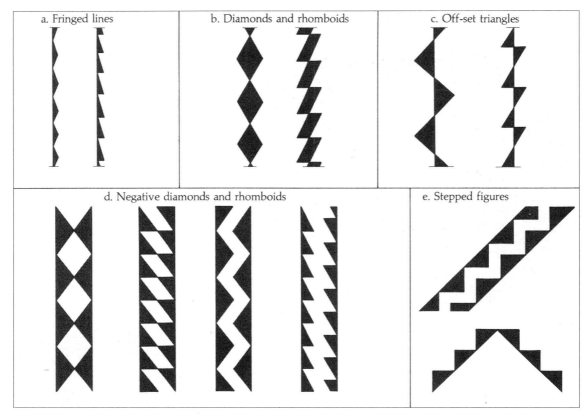

Figure 138. Triangles as zone-filling elements, line embellishments, and motifs in Mimbres pottery paintings.

used of Mimbres elemental forms, the shape appearing as zone fillers, in motif combinations, as motifs, and as line embellishments (fig. 138).

Motifs are of two general sorts: structural ones that serve as the dominant image on a vessel and nonstructural ones that were used as fillers or embellishments within design zones. The former, because of the logic of the design system and nature of the shape they had to dominate, tend to be organized with reference to the center of their vessel. They rotate around, expand from, or contract toward the center, which is often an imaginary rather than a manifest point in the picture space. Structural

motifs thus tend to resemble stars, fans, flowers, and similar forms, but their specific image is less a matter of structure than of detail, especially in the distribution of darks and lights. If, for instance, the basic structure is a quartered circle, then the two crossing lines that make the figure also create the image of four wedge-shaped triangles suspended point-inward from the rim border. Depending on subsidiary details, the focal motif made by those two lines could be a starlike or an hourglass figure, could rotate or be static, could expand from the center or implode toward it (figs. 54, 60, 117, 125, 139, 140). If one side of each of the wedge-

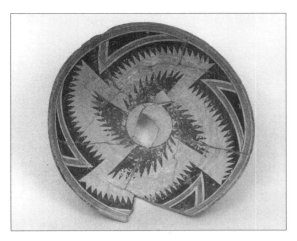

Figure 139. Bowl, Mimbres Classic Black-on-white (Style III), 11 x 27 cm, 4.3 x 10.6 in. A fourfold design that rotates clockwise has sharply angled, interlocking, dark-light serrations. Triangular counterclockwise units that are suspended from the rim band create rhythmic tensions while stabilizing the composition. Excavated by A. M. Thompson at an unknown location before about 1925. (MIAC/LAB 19906/11)

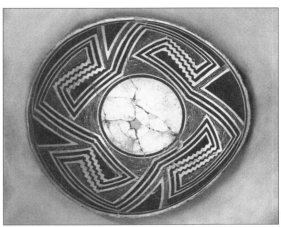

Figure 140. Bowl, Mimbres Classic Black-on-white (Style III), 11.5 x 30.5–33.5 cm, 4.5 x 12.0-13.2 in. A four-part, angular composition in gray, black, and white has a clockwise rotation stabilized by four triangles suspended from the rim band. Excavated at Oldtown Ruin by V. G. Tannich, 1929. (UARK 47–133–29)

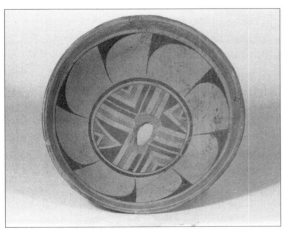

Figure 141. Bowl, Mimbres Classic Black-on-white (Style III), 9 x 21.5 cm., 3.6 x 8.6 in. Eight-unit feather or flower motif rotates around a central circle dominated by a static four-part composition with an ABAB rhythm. Excavated at the Eby site by V. G. Tannich, 1932. (UARK 47–125–65)

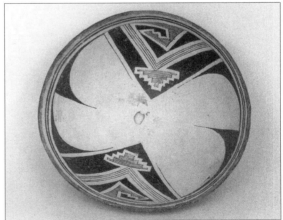

Figure 142. Bowl, Mimbres Classic Black-on-white (Style III), 12 x 26.7 cm, 4.7 x 10.5 in. Two wedge-shaped black and gray design units that are suspended from a framing line help define a negative, four-unit petal- or feather-shaped central motif. Excavation history unknown. (MIAC/LAB 54238/11)

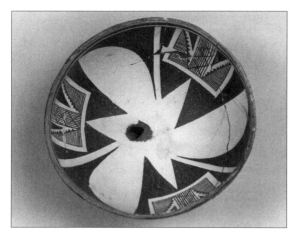

Figure 143. Bowl, Mimbres Classic Black-on-white (Style III), 8.3 x 22 cm, 3.3 x 8.7 in. A large, three-bladed, negative fan motif dominates the blank center of the vessel. Its counterclockwise rotation is stabilized by negative triangles between each blade and by three rectangular motifs suspended from the rim. Collected by William Endner before 1937; excavation history unknown. (MWC G433)

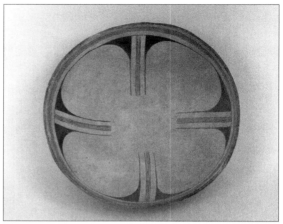

Figure 144. Bowl, Mimbres Classic Black-on-white (Style III), 5 x 11.3 cm, 2.0 x 4.5 in. Four evenly spaced, globular, negative shapes that are suggestive of clouds or flower petals dominate the interior of this small vessel. Excavated by the University of Minnesota Field School at the Galaz site, 1929–1931. (WM 15B 269)

shaped triangles was curved, a rotational fan would result (figs. 139, 141–143). If the two upper corners of each were curved, the resulting image would be petal-like, suggesting leaves, a flower, or perhaps feathers or puffy clouds (fig. 144). In all of these cases, despite clear differences of imagery, the basic quartered design structure is identical. The identification of an image with a natural form is an act of imagination on the part of the viewer that may bear no relation to what the artist had in mind. Other natural forms may also be imagined, none are mutually exclusive, and all are problematical.

Other central motif variants were made with equally simple means. Lines that converged toward a bowl's center could be incomplete, dividing the vessel by implication or suggestion even when the center was left blank and the dividing lines were reduced to mere stubs (figs. 120, 142–144). Structural motifs could be

made more or less complex by changing the number of their cross divisions, which also changed their geometric rhythms. Always, activity and ambiguity, motion and impact were determined by linear direction and line quality, by the specifics of geometric distribution, and by the use and balance of light and dark patterning.

A pair of triangles joined at their tips and each with one side curved in the same direction forms an **S**-shaped figure. This was among the more common of Mimbres motifs and in its many variations was used as an active major or minor image. As a major motif it usually extends from rim to rim, sometimes repeated to form a fanlike rotating figure (figs. 120, 121, 141, 145). As a minor motif it was often used as a fat, negative filler confined within a design zone. Motifs that were formed by pairs of **S**-shaped lines framed by the white spaces left between them provided an endlessly rich source

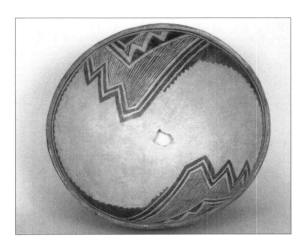

Figure 145. Bowl, Mimbres Classic Black-on-white (Style III), 22.8 cm x 10.3 cm., 9 x 4 in. A rotating negative S shape is the by-product of two black and gray serrated and fringed motifs suspended from the rim frame. Excavation history unknown. (DMNS 9151)

of ambiguous dark-light, positive-negative variations (figs. 51, 53, 62, 63, 64). For example, several could be placed in a line parallel to a bowl rim and within a design zone, each interlocked with those on either side of it to form a continuous chain whose interlocking curves could either be connected or extended to form spirals (figs. 62, 63, 64). Meanwhile, the shaped white spaces that surround and define each of these solid, dark motifs would carry their own contrapuntal imagery. Mimbres artists developed variations based on such compositions throughout the history of Mimbres painting, from the time of Three Circle Red-on-white to the very end of the Mimbres Classic era.

Zone-filling motifs were often derived from combinations of two or more triangles and placed on a line. Depending on the kind of triangle and the direction of the line, many different images, including negative ones, could be made. A series of small triangles on a line created a fringed line; two series, one on either side of a line, became series of diamonds or rhomboids. If offset and kept small, they created the effect of a zigzag line. Triangles on two lines facing each other made series of negative diamonds, rhomboids, or stepped white units in the space left blank between any of those motifs. Equilateral triangles placed on a diagonal line made a stepped figure. A pair of these in opposition left a white stepped line between them (fig. 138). When curvilinear forms are added to the triangle-based motifs and variations in scale, color, and rhythm are taken into account, the possible combinations appear to be endless.

Variations in tonal value created the equivalents of color effects, and these tonal "colors" were usually massed rather than evenly distributed. The black or red-brown paint itself, whether perceived as line or mass, carried tonal and textural values even beyond the color variations that were a product of the firing process. Painted lines and fill areas were often burnished, more than likely to make them adhere better to the white slip but perhaps also because of the subtle visual effects achieved by polishing the paint. In any case, color massing had the effect of developing active, contrasting, and sometimes ambiguous dark-light patterns. Half or more of a picture space was often covered by paint, but activity and contrasts of shape as well as color kept pictures from being somber. Where hatching was used, gray tones often dominate. Hatching and burnishing were as close as Mimbres artists ever came to painting apparent textures. At times, their fascination with the mechanics of drawing fine lines led to the creation of delicate traceries that could cover an entire vessel, but more usually hatching

was confined to filler areas within motifs (figs. 132, 146).

Large motifs and those with large interior spaces were often subdivided and sometimes had reserved spaces within them in which other motifs could be placed. These spaces were usually well defined in shape and by color contrast, and their interior motifs were generally basic signs such as crosses or circles (figs. 64, 127). The Mimbres geometric painting system often depended on the use of active, well-defined, overall motifs that can be read as either positive or negative images. Alternatively, and often simultaneously, it also called for subdividing space into ever smaller units that could be visually reintegrated into a single, dominating, overall pattern. Ambiguity, motion, and tension were built into the system and were reinforced by specific methodologies. Thus, color distribution made it possible to read designs sequentially or simultaneously as both dark patterns on white grounds and white patterns on dark grounds. Direction of movement was also ambiguous, leaving questions about whether a particular image expands or contracts or rotates from right to left or left to right. The end results are often complex, but the means were always so simple that full effectiveness made skillful brushwork an absolute requirement. Indifferent draftsmanship voided visual success no matter how fertile the imagination. Superb draftsmen who followed the rules could hardly go wrong.

The particular characteristics of Mimbres geometrical painting grew out of fascination with the visual potentials of ambiguity and

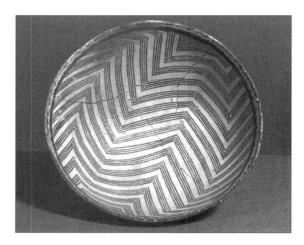

Figure 146. Bowl, Mimbres Classic Black-on-white (Style III), 26.7 cm x 11.5 cm., 10.5 x 4.5 in. Wavelike repetitions of white and gray zigzags fill all the interior space in a Hohokam-like overall composition unusual for the Mimbres. Excavation history unknown. (PAM 7211)

movement that were latent in all major Southwestern decorative traditions. Mimbres artists developed those potentials, and the emphatic value they placed on line control and the uses of interlocking forms and visual space is the hallmark of their tradition. The limitations and constraints of that tradition were a guarantee of consistency, and the superficial visual conservatism that seems to be so alien to the creative process was, instead, an essential protective device that made pictorial invention possible. Rather than inhibiting the artists, tradition provided them with a framework within which each one could build with confidence to the full limits of individual creative ability.

Representational Paintings

Two sets of terms—the first consisting of "representational" and "realistic" and the second of "nonrepresentational," "geometric," and "abstract"—are commonly used to characterize the subjects painted on Mimbres vessels, as if the two sets were mutually exclusive. But none of these terms is truly accurate, all of them can be misleading, and the two sets are complementary rather than mutually exclusive. For example, "representational" and "realistic" are sometimes used interchangeably to describe subjects in Mimbres art that are obviously based upon real-world observations. "Nonrepresentational," "geometric," and "abstract" are sometimes used interchangeably to describe subjects in Mimbres art that seem not to be based upon real-world observations. However, all artistic images are, at bottom, representations of observed phenomena. Whether of external or internal worlds, they are abstractions of a perceived reality, and the creation of a pictorial image, no matter how "realistic," is always an act of imagination.

Thus, instead of dealing with separable categories, we are faced with a sliding scale that has abstraction at one end and perceived reality at the other. "Realism" in art is only one way

of projecting images of phenomena as one imagines or wishes them to be. Conversely, "nonrepresentational" or geometric images may be stylized representations of observed, imagined, or dreamed phenomena. In any case, the representations are all of forms perceived either in the "real" world or in an imaginary one. Not only are the two sets of conceptual categories complementary, but the categories themselves are permeable, and there is a probability that all pictures in each set may have been equally meaningful in their own time and place.

If all Mimbres paintings are abstract images, if none is truly realistic and none fully nonrepresentational, then what language can be used to describe their subjects for purposes of discussion and analysis? The terms used here—or anywhere else—to classify the subject matter of Mimbres art are arbitrary, imprecise, and situational, for there is no other way. Subjects that unambiguously represent real-world or imaginary animal, vegetable, or other "natural" phenomena such as stars or lightning I generally call "representational subjects." Subjects whose natural points of reference are unclear and

ambiguous I generally call "geometric subjects," and inconsistencies abound.

Many of the representational pictures in Mimbres art differ from geometric ones in fundamental respects that seem to be a function of the subject matter. Some were organized as overall, complex patterns that differ from geometric paintings mainly by inclusion of an obvious life-form. But in most others, the picture field was conceived of as both a void and a background, or "living" space, for the illustrated figures. In that respect, they become a categorically different kind of painting, intellectually more stimulating, pictorially more difficult, and, very often, visually less dynamic. Perhaps most significantly, these differences can be taken as evidence that Mimbres artists also treated differently the two subject classes that we perceive as conceptually different from one another.

The geometric pottery paintings are usually center oriented and always have their own self-defined spatial reality. Because they are not overtly representational, all viewing angles are equally correct, and concepts of top, bottom, or side are irrelevant. Representational paintings, whether center focused or not, are implicitly or explicitly illusionistic. They refer to subjects that have the capacity to exist in real space, are dimensional, are subject to gravity and other natural laws, and are assumed to have correct and incorrect viewing positions. Concepts of top, bottom, and side are not only relevant but may be essential for the pictures to be intelligible.

The interior surface of a freestanding, movable, hemispherical bowl is the antithesis of a stable, horizontal picture space. So, added to the visual problems they share with geometric paintings, Mimbres representational pictures are expected—certainly by viewers today and perhaps by those in the past—to have a consistent and stable orientation even though they were made on surfaces that have neither. Most often, Mimbres painters resolved this problem in the most expedient way possible, by seeming to ignore it. For this reason, despite the psychological attraction or charm that any Mimbres representational image may have, its effectiveness as a work of art is often incomplete, and many such paintings lack the pictorial consistency that characterizes Mimbres geometric pictures. Lack of pictorial consistency makes it relatively easy to decontextualize the images that are seen on these paintings, and the ease with which they can be used as isolated logos is one of their attractions in the modern world. Some representational artists among the Mimbres recognized the inherent problem of orientation and developed solutions to it that balanced formal constraints with content and with decorative and expressive values to make paintings that are among the most effective known in any Native American art of pre-Columbian times.

Pictorial Organization: Single-Figure Compositions

Most representational pictures have only a single figure placed in or near the center of a bowl (table 2). Except for the painted frame, there are no lines other than those needed to describe the figure, and the organizational principle is simply one of isolating, or vignetting, a form against a blank background within a framed picture space. The figure is usually shown either in profile, in full face, or from above. Its posture is most often static, its position implies a relationship to an invisible ground line or the surface of the earth, and a top-bottom orientation is often explicit (figs. 147–150). Often, a geometric pattern with no obvious descriptive utility is shown within the

Table 2
Pictorial organization and subject complexity based upon a sample of 733 published and unpublished images of representational Mimbres pottery paintings.

	Vessels		Simple Frame		Complex Frame		Integrated Composition		Center Point Perspective	
Type of Picture	No.	%	No.	%	No.	%	No.	%	No.	%
One figure	468	64	319	68	149	32	—	—	—	—
Two figures, nonnarrative	113	15	43	38	70	62	36	32	—	—
Three or more figures, nonnarrative	34	5	15	44	19	56	17	50	—	—
Narrative with humans	69	9	51	74	18	26	5	7	21	30
Narrative without humans	49	7	43	88	12	6	1	2	3	6
Total	733	100	471	64	262	36	59	8	24	3

Source: Sample of 733 published and unpublished images of representational Mimbres pottery paintings examined by the author between 1972 and 1975.

body of a painted animal, as if to remind viewers that the image is not reality but only an illusion of reality (figs. 148, 150). At other times, a pattern painted within an animal describes feathers or some other visible qualities that might be seen on that animal (figs. 147, 149). The portable, concave, hemispherical surface was sometimes treated as if it were an immobile, vertical, flat surface for a circular painting intended to be seen from only one viewing position.

Picture frames are often no more than one or several banding lines that are so isolated from the pictorial subject that they emphasize the unintegrated quality of most representational paintings (fig. 149). Some framing lines may have been painted after an illustrative picture was made (Bryan 1962). In those cases, frame and picture were conceived of as visually unrelated, reinforcing a conceptual distinction between representational and geometric painting. Complex frames, which were used in about one-third of the single-figure paintings, resemble design zones that might occur in any geometric picture (figs. 69, 147, 150). Rarely,

an elaborate frame or central motif spilled over to integrate with the life-forms, effectively creating a dynamic geometric picture that happens to include a life-form motif (figs. 151–153). Although such paintings resolve the visual problems presented by the peculiar painting surfaces, they are often so decorative that representational meaning is almost lost. Pictorial success was achieved at the expense of illustrative content (figs. 152–154).

A small minority of single-figure paintings deal with pictorial as well as representational problems by manipulating a life-form so that it controls all or most of its assigned space (pls. 10-12). This was sometimes done by twisting a body or one of its appendages into a spiral or **S** shape that rotated through or about the vessel center in order to cope with the requirements of the concave hemisphere. By attempting to avoid rigid, one-view orientation, artists adopting this solution echoed the characteristic geometric design systems. Alternatively, an image such as a turtle, frog, fish, or bird might be placed within its framed space in a way suggesting that the pictorial void was in fact a

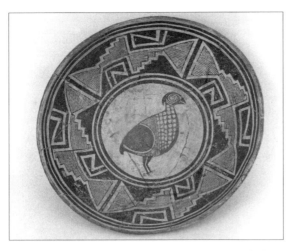

Figure 147. Bowl, Mimbres Classic Black-on-white (Style III), 9–10 x 26–28 cm, 3.5–3.9 x 10.2–11.0 in. A quail with the body pattern of an adult Montezuma, fairly common in southwestern New Mexico. Excavated for the University of Colorado at Swarts Ruin 2, 1926. (UCM 9366)

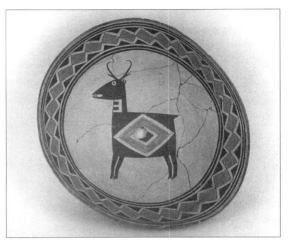

Figure 148. Bowl, Mimbres Classic Black-on-white (Style III), 10.5–12.5 x 26–31 cm, 4.1–4.9 x 10.2–12.2 in. Pronghorn with a diamond-shaped motif in its stylized rectangular body. Excavated at the Pruitt site by the Dr. Berry Bowen family, about 1930. (ASM GP 4953)

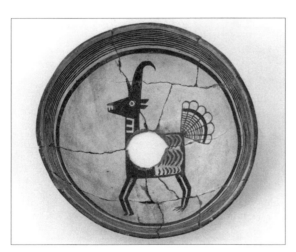

Figure 149. Bowl, Mimbres Classic Black-on-white (Style III), 9 x 21.5–22.5 cm, 3.5 x 8.5–8.9 in. Animal with pronghorn head, neck, legs, and fore-body but with a turkey's hindquarters and tail. Excavated by the Beloit College Field School at Mattocks Ruin, 1929–1930. (LM 16183)

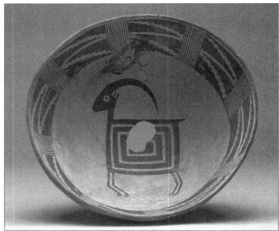

Figure 150. Bowl, Mimbres Classic Black-on-white (Style III), 12 x 24.7 cm, 4.8 x 9.8 in. Bighorn sheep with a stylized rectangular body in which is painted a series of concentric rectangles. Purchased 1916 from the Smithsonian Institution; originally purchased from E. D. Osborn by J. W. Fewkes. (AMNH 29.0/5974)

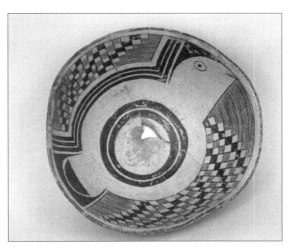

Figure 151. Bowl, Mimbres Classic Black-on-white (Style III), 8.5 x 19.5–20.5 cm, 3.4 x 7.7–8.1 in. A negative bird is described by an elaborate frame suspended from the rim line of the vessel. At the center is a void defined by two concentric circles. Excavated by Richard Eisele before 1926, site unknown. (TM 4492)

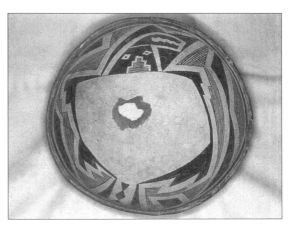

Figure 152. Bowl, Mimbres Classic Black-on-white (Style III), 12 x 23 cm, 4.7 x 9.1 in. A fantastic being with birdlike, humanlike head and legs is simultaneously created by and hidden by an elaborate design suspended like a frame from the rim frame. The body of the personage is the polygonal unpainted central space of the vessel. Excavated at the Eby 2 site for the University of Colorado, 1926. (UCM 3204)

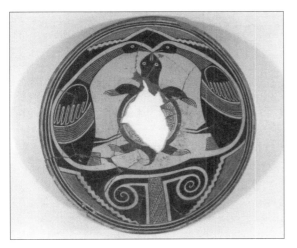

Figure 153. Bowl, Mimbres Classic Black-on-white (Style III), 11 x 30 cm, 4.4 x 11.9 in. A tortoise or turtle seems to be swimming within a central void that appears to be the product of an elaborate frame. On second look, the void is made by the profiles of a pair of long-necked, bittern-like waterbirds. Excavated at the Cummings site by V. G. Tannich, 1934. (UARK 47–124–2)

Figure 154. Bowl, Mimbres Classic Black-on-white (Style III), 12.3 x 21.3–22.8 cm, 4.8 x 8.4–9.0 in. A number of other Mimbres pottery painting and rock art images are similar to this embryonic-looking, tadpole-like, ghostlike figure. Collected by William Endner before 1937; excavation history unknown. (MWC G444)

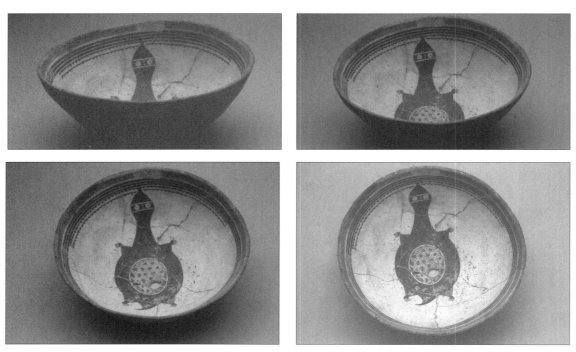

Figure 155. Bowl, Mimbres Classic Black-on-white (Style III), 11.8 x 25.7 cm, 4.7 x 10.1 in. All Mimbres bowls are fundamentally mobile and should be viewed as such. Here, the movement of the vessel activates an illusion that the turtle or tortoise is swimming in a pool of water. Excavated on the Eby Ranch, Mimbres Valley, by A. M. Thompson before 1952. (MIAC/LAB 19929/11)

body of water or the sky (fig. 155). Most single-figure paintings, however, control so little of their space and so lack any semblance of the integration and balanced complexity of the geometric pictures that they leave little basis for comparison with the geometric subjects.

Pictorial Organization: Multiple-Figure Compositions

In contrast to the static organization that characterizes most single-figure compositions, more than half of the paintings with two or more figures have complex, active, integrative compositions that generally use multipoint view-ing positions (table 2). Most of the remain-ing multiple-figure paintings are at least partly integrated with their total picture space and are more satisfactorily adjusted to their concave ground than are most single-figure paintings (figs. 3, 156–158; pls. 12, 14). No substantial differences appear in the framing systems used for single- and multiple-figure compositions, but pictures having more than one figure are more often organized into overall design patterns. Like similar single-figure compositions, these integrate life-forms with geometric forms that are often complex, and their figurative impact can be overwhelmed by that complexity (fig. 159; pl. 14). Other kinds of multiple-figure paintings are structurally similar to geometric ones but retain their illustrative focus (figs. 156–158).

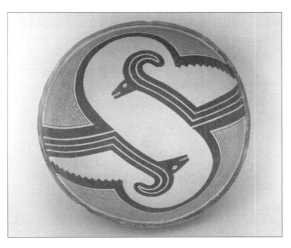

Figure 156. Bowl, Mimbres Classic Black-on-white (Style III), 10.5 x 23.5 cm, 4.5 x 9.3 in. Two highly stylized bighorn sheep heads emerge in bifold symmetry, creating a contrapuntal rhythm from an otherwise nonrepresentational pair of elongated hook motifs. Excavated by the Mimbres Foundation at Mattocks Ruin, 1976. (MMA 77.67.1)

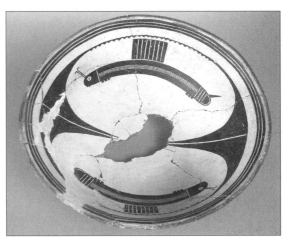

Figure 157. Bowl, Mimbres Classic Black-on-white (Style III), 10 x 23.5–24.5 cm, 3.9 x 9.3–9.7 in. Fertility and transformation seem to be suggested by this pair of caterpillars, each framed within an ovoid and with moth wings emerging from its back. Excavated by the Mimbres Foundation at Mattocks Ruin, 1976. (MMA 77.58.61)

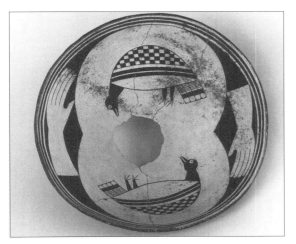

Figure 158. Bowl, Mimbres Classic Black-on-white (Style III), 11.5 x 28 cm, 4.5 x 11.0 in. A pair of gallinaceous birds in bifold symmetry are framed within a void flanked by a pair of negative human hands just below the rim. Excavated at the McSherry site by the Dr. Berry Bowen family, about 1930. (MMA 40.4.297)

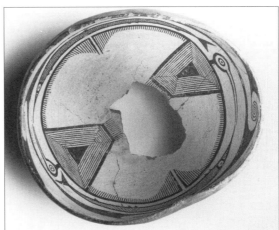

Figure 159. Bowl, Mimbres Boldface Black-on-white (Style I–II), 10.5 x 20.1 cm, 4.25 x 8 in. A pair of long, pikelike fish and a pair of long-beaked birds are hidden in bifold symmetrical opposition to each other near the rim of this vessel. Excavation history unknown. (MRM 1972-8-1 59)

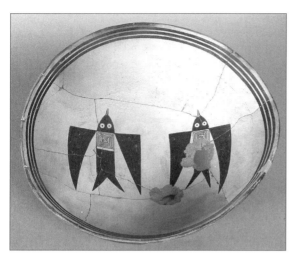

Figure 160. Bowl, Mimbres Classic Black-on-white (Style III), 9 x 23–25 cm, 3.5 x 9.1–9.8 in. Simple geometric figures, especially triangles, combine to create a pair of flying birds. The use of mirror symmetry is unusual in Mimbres art. Excavated by the Mimbres Foundation at Mattocks Ruin, 1976. (MMA 77.42.36)

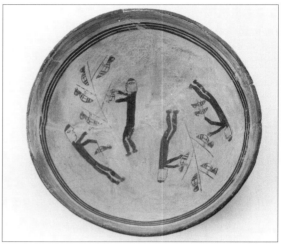

Figure 161. Bowl, Mimbres Classic Black-on-white (Style III), 11.2 x 26 cm, 4.4 x 10.2 in. Within a sinuous, bifold composition, four people, presumably men, seem to be gathering grasshoppers or locusts. Excavated by the Beloit College Field School at Mattocks Ruin, 1929–1930. (LM 16104)

In the simplest integrated multiple-figure organizations, life-forms are used as though analogous to the large motifs that dominate center-oriented geometric pictures (fig. 160). They also tend to be center oriented and some-times, but not always, contort into **S** curves, scrolls, or other radial postures that circulate about an invisible point located in the center of a bowl (figs. 161, 162). They may be more passive than active and more decorative than illustrative, and they usually lack obvious narrative implications. As in similar geometric structures, the picture space is divided into equal-size wedges, but the division lines are usually implicit rather than explicit. Other integrative characteristics of geometric paintings, such as positive-negative color distributions, are also sometimes seen in representational pictures (fig. 163).

A second organizational program is similar to the usual single-figure composition but with two or more life-forms vignetted in or near the center of a bowl. These are usually drawn in profile, are static, use twofold rotational sym-metry, and have a top-bottom viewing orienta-tion (figs. 156–158). Mirror symmetry is rare but is sometimes used as a strategy to suggest an interactive relationship between two life-forms. For that reason, and also because two or more figures of about equal size occupy more space than only one, such paintings tend to be structurally more complex and more tightly integrated than those with only a single figure. Their complexity is often as much a matter of subjective or psychological interaction as it is of pictorial integration (fig. 160).

A third compositional group includes fewer than half of the multiple-figure paintings and

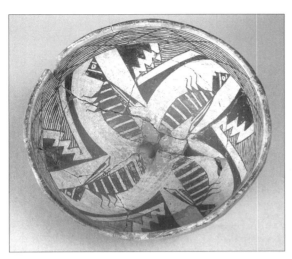

Figure 162. Bowl, Mimbres Classic Black-on-white (Style III), 10 x 20.8 cm, 3.9 x 8.2 in. Four striped, grasshopper-like animals rotate counterclockwise around the center, each framed within a petal- or featherlike negative motif. Excavated at Cienega Ruin by the Dr. Berry Bowen family, about 1930. (MMA 40.4.120)

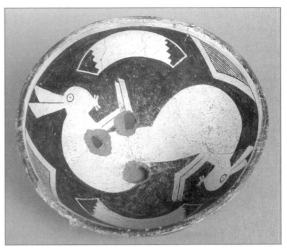

Figure 163. Bowl, Mimbres Classic Black-on-white (Style III), 8 x 19 cm, 3.2 x 7.5 in. Two negative rabbits are joined at the hip near curved objects that are throwing sticks (called "rabbit sticks") used in rabbit hunts by both ancient and modern Southwestern native people. Excavated by the Mimbres Foundation at Mattocks Ruin, 1976. (MMA 77.67.14)

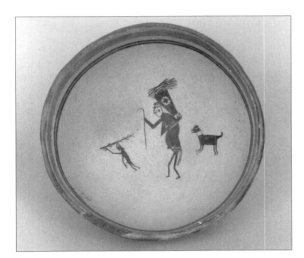

Figure 164. Bowl, Mimbres Classic Black-on-white (Style III), 10 x 21 cm, 3.9 x 8.3 in. A woman with a crooked staff in her right hand uses the left one to balance a basket of wood on her back. A dog is behind her, and the man to her left, who is shortened by a perspective convention to seem distant, carries a log on his head. Excavated at Cienega Ruin by the Dr. Berry Bowen family, about 1930. (MMA 40.4.276)

only one in six of all figurative ones. Its style is, however, by far the most like the illusionism of western European representational pictorial conventions. Pictures in this group usually have some specific narrative content, and the figures in them act in relation to this, to each other, to the framed picture space, and to an imaginary environment. In a sense, all the figures are vignetted, because background details such as horizon lines, landscapes, and interiors are at most hinted at and are never unambiguously specified (figs. 161, 164). Even so, a natural or artificial environment is usually understood because of the placement or the actions of the painted subjects. Most importantly, these pictures are composed with reference to illusionistic rather than geometric organizational principles.

In one example, a woman, a boy or man, and a dog are shown walking through an

invisible landscape (fig. 164). By their attitudes and actions they occupy and visually control most of the space defined by the framing line at the bowl rim. Orientation is primarily top-bottom, but the male figure is tilted, and his relation to a horizontal plane differs from that of the other two figures. This difference acknowledges the concavity of the painting surface and suggests a variable viewing orientation that helps to bring large unpainted areas of the hemisphere under pictorial control. Active relationships among the figures are reasonably specific and define the character and dimensions of the spaces between them. Paint application is flat and without grays, but mass, volume, and spatial depth are indicated by a kind of perspective drawing, especially as applied to the positioning of legs, the overlapping of arms, and body posture. Depth relationships between the two humans are unclear, and their size differences can be read as either an effect of deep horizontal distance, in which case the male figure is a man, or the portrayal of larger and smaller individuals who stand close to each other, in which case he is a boy.

In the absence of horizon lines, landscape details, or other specifics about the spatial environment, the illusion of real space is achieved solely by the interaction of the figures. The assumption that they are in narrative relationship to each other makes it conceivable that they occupy real-world space. But that space is in the mind of the viewer rather than pictorially explicit, and inconsistencies of draftsmanship and incomplete control of the pictorial space tell us that the artist only partly understood the natural laws of this particular micro-universe. Still, the intent to create a self-contained, complex representational entity is clear. Other paintings that are similar in their attempts to develop self-contained environmental illusions

were sometimes more successful.

Among these, a more complex grouping helps to demonstrate the correlation between subjective complexity and pictorial unity. In figure 29, nine humans are arranged near the center and around half the perimeter of a bowl, with two others on its opposite wall facing the larger group. Posture and attitude vary from figure to figure, defining both personality and interaction, and these variations contribute to the illusion that each one occupies real space. Most of the figures were placed on the vessel walls and look inward, defining the parameters of the space they occupy and control. Illusory, pictorial space and real space trapped within the hemisphere of the bowl are one and the same thing. Each figure is flatly painted and perspective drawing was minimal, but allusions to spatial depth are quite specific and are a deliberate function of draftsmanship and figural placement.

Further use of the concave hemisphere is seen by the full development in figure 29 of a convention hinted at in figure 164. Each figure is tilted along its own vertical axis, and these axes radiate from the center like so many steel needles pointing toward a magnetic pole. The central point functions as the equivalent of a horizon line that might be drawn on a flat, rectangular surface for the purpose of establishing an environmental base. This kind of polar orientation, relatively unsuccessful when used with only two figures and a dog, is given credence by numbers, and the tilting relationships among all the figures become a believable perspective device. As in any other one-point perspective system, illusion depends on consistency, and failure occurs when the system is not followed. The human in the center of figure 29 seems to float uncertainly in space, but despite this, and even though no landscape or

background details were drawn, the illusion that these figures occupy a real space is almost complete. Meanwhile, pictorial space is as fully controlled as in the most complex and geometrically formal of the geometric paintings.

Most narrative pictures that use polar orientation have informal compositions. However, formal geometric structures that avoided the rigidity of geometrical painting could be adapted to the system (fig. 162). In figures 35 and 36 (two views of the same vessel), four men are shown seated on a blanket. Each has an arrow in one hand and four others nearby. The compositional structure is a center-focused, quartered pattern, identical to those used in many rotational geometric paintings. However, all painted lines except for the frame are representational, and the narrative content is so strong and explicit that despite the geometric regularity of the composition, its logic contributes to rather than inhibits anecdotal realism.

The figures and objects are on a blank white ground with no indication of specific background. None is needed, because relationships between each figure and object define the operational space. The square mat or blanket in the center is the ground or base, around which all the figures squat. Each of the humans and most of the objects are on a polar axis, tilted to about a ninety-degree angle in relation to all of the others. Seen from above (fig. 36), the angle is extreme, and there is an apparent visual contradiction between the center mat, shown in plan, and the figures, painted in profile and at right angles to it. From any other perspective, the contradiction is denied, for each figure is placed on the upward-curving side of the bowl and, in real space, is actually at (or almost at) a right angle to the center (fig. 35). The three-dimensional physical character of

the picture surface reinforces a pictorial illusion that is best perceived when the surface is mobile and viewed at, or just below, eye level (other examples can be seen in figs. 12–15 and pl. 1). The compositional dynamics of the painting seem to anticipate and direct the physical actions of a potential viewer.

A flexible orientation system was also developed in relation to the frame rather than the center of a composition. Although pictures of this sort were generally developed along a vertical axis, their "bottom" was usually conceived of as any point along one-third or half of the outer circumference of a vessel. In some instances, any part of the circumference served as a base point (figs. 13, 166, 167). In one example (fig. 31), a seated man wearing an elaborate headdress is in the act of decapitating another. The victim lies in front of the seated figure, his body and partially severed head curved with reference to the framing line. By this device, the framing line becomes a ground line along a substantial part of its length, and the picture is spatially intelligible when viewed from any angle that includes part of the victim's body at the base. Thus, even though there is a top-bottom orientation, about one-half of the bowl can be read as the bottom, and the potential mobility of the vessel is controlled and incorporated into the painting as a visually active element.

A similar effect is achieved by different means in a painting of four men and a fish (fig. 165). In it, each figure is positioned in relation to a different point on the framing line, so that even though all are upright and on more or less parallel vertical axes, a large segment of the framing line becomes a ground line. As in figures 13, 31 and 167, the potential mobility of the vessel is incorporated into the painting as a compositional element, and any point along

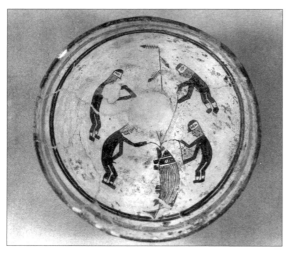

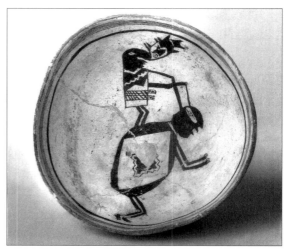

Figure 165. Bowl, Mimbres Classic Black-on-white (Style III), 9.6 x 21.5 cm, 3.8 x 8.5 in. Four men with a large fish on a line. Vertical stripes on the men's faces appear to be the same as those on the side of the fish. See also figures 6 and 13. Purchased from E. D. Osborn by J. W. Fewkes, 1923 (Fewkes 1924:30, fig. 8). (NMNH 326260)

Figure 166. Bowl, Mimbres Classic Black-on-white (Style III), 14 x 26.5–28 cm, 5.5 x 10.4–11.0 in. Two people, apparently men, and a fish. The smaller human stands on the back of the larger one and seems to have a fish on his nose. Purchased from E. D. Osborn by J. W. Fewkes, 1923 (Fewkes 1924:30, fig. 7). (NMNH 326294)

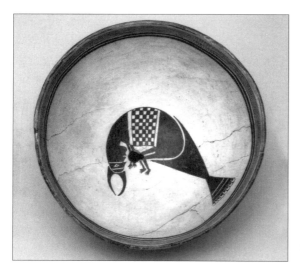

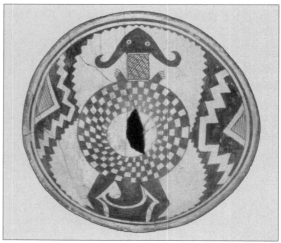

Figure 167. Bowl, Mimbres Classic Black-on-white (Style III), 11 x 27–27.5 cm, 4.3 x 10.6–10.8 in. A human in a fetal position wears a horned headdress and has either a bird-tailed fish or the tail end of a bird attached(?) to his buttocks. Excavated by Richard Eisele before 1926, site unknown. (TM 4493)

Figure 168. Bowl, Mimbres Classic Black-on-white (Style III), 9.1 x 21.7 cm, 3.7 x 8.7 in. A composite animal that is suggestive of a person wearing a costume has the head of a bighorn sheep as seen from above, the body and tail of a turtle or tortoise, and human legs. Excavated by the Texas A&M University Field School at NAN Ranch Ruin, 1978–circa 1996. (TAM 9–513 [29:B170])

about one-third of its outer perimeter provides an intelligible and "correct" viewing position.

In virtually all multifigure paintings, some attempt was made to cope with the visual problems presented by a picture surface that was in fact a three-dimensional, concave hemisphere. Formal solutions were sometimes based upon those used in geometric paintings that could be modified without crippling the representational intention. Often, however, the powerful logic of the geometric tradition overwhelmed representational intent, and life-forms were treated as if they were just another kind of nonfigurative motif (figs. 159, 162, 163, 168; pls. 10, 14, 17).

The most successful of the figurative paintings were narratives that accepted the constraints of the bowl shape, either by using the framing line as a ground line or by adapting a kind of polar, one-point perspective system to the vessel. Combined with a rough-and-ready linear perspective, these were perhaps unique solutions to a most difficult visual problem, one that gave the Mimbres artists an opportunity to use the peculiar shape of their painting surface as a positive visual tool. By working with the hemisphere instead of ignoring it, they found that it could help to establish and define the physical and spatial relationships of their painted figures (figs. 40, 41). The result was an inventive kind of picture making far different from both the systematic formalism of their geometric pictures and the static and casual structures of their figurative vignettes. It is the most expressive and inventive of all ancient Southwestern pictorial traditions.

Pictorial Means and Subject Matter

Although there are significant differences in pictorial organization between the figurative and geometric paintings of the Mimbreños, the technical means and the metaphorical and symbolic potential were about the same in both kinds of paintings. Emphasis was placed on draftsmanship and line, and the interior spaces of many representational figures were treated as if they were the interiors of geometric design zones (figs. 150, 169, 170, 171). Life-forms as well as geometric motifs were usually drawn in outline with their interiors left blank, filled solidly, or divided and subdivided by linear or triangular elements. Line was the primary visual element, but many figures appear to be more massive than linear because of their isolation as dark silhouettes against a white or gray ground (fig. 167) or, rarely, as white figures against a darkly solid or hatched ground (figs. 154, 163; pl. 15).

Framing lines just below the rim encircled virtually all Classic era bowls. These not only isolate pictorial space but also suggest a horizon, creating a metaphorical space with a border that can be perceived as marking off the earthlike lower half of a cosmic sphere from its skylike upper half (Brody and Swentzell 1996:20–21). The development of such perceptual and interpretive dualities and ambiguities is a fundamental feature of Mimbres pottery paintings regardless of their overt subject matter. Interchangeability, transformation, and being and becoming are the core creative principles of Mimbres art (Brody and Swentzell 1996:36–41). The visual representations and dynamics discussed here are only aspects of an expressive form that is both visual and conceptual.

Designs painted within life-forms were sometimes given illustrative meaning by association with some clearly drawn anatomical region of an animal, such as its neck, tail, or belly, or by some distinctive patterning feature such as fish scales or the carapace of a turtle or

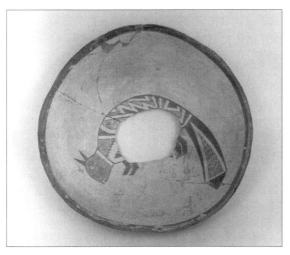

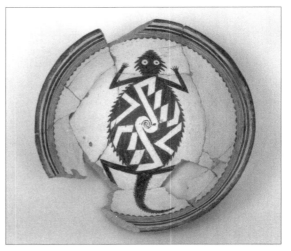

Figure 169. Bowl, Mimbres Polychrome (Style III), 6.7 x 20 cm, 2.6 x 7.8 in. A beaverlike animal with a complex geometric pattern on its back. Excavated at the Ranger Station site, upper Mimbres Valley, by the Dr. Berry Bowen family, about 1930. (ASM 26527–X-6)

Figure 170. Bowl, Mimbres Classic Black-on-white (Style III), 7.3 x 18.3 cm, 2.9 x 7.2 in. An animal with horned lizard attributes has a complex geometric pattern on its back that is less descriptive than metaphorical or symbolic of weather phenomena. Excavated by the Museum of New Mexico at the Coulson site, 1962. (MIAC/LAB 37942/11)

tortoise (figs. 155, 168). Geometric motifs, even beyond any that might have been understood as symbols of lightning, rain, or corn, could therefore be made to carry objective messages (figs. 169–173). On a purely symbolic level, abstract motifs and patterns in Mimbres art often suggest movement, and their inclusion in Mimbres representational paintings parallels the use by many modern Pueblo potters of rhythmic motifs in their painted designs (Brody and Swentzell 1996:100).

Visually coded ambiguities were a constant in Mimbres painting—for example, in the common use of geometric emblems painted inside single-figure animals or, as discussed in chapter 3, in the use of systematically ambivalent sex and gender indicators in representations of humans. It may never be known whether, or when, geometric motifs incorporated within the bodies of animals were intended to be

interpreted as symbols, but in visual terms they work to maintain the integrity of the picture plane by interpenetrating foreground and background spaces. For example, a solidly painted animal figure may create the illusion of physical solidity and seem to stand or move in front of a background void (fig. 174). If, instead of being solidly painted, the body of the animal is dominated by a large geometric design, then that pattern integrates with the background void, and the animal becomes a part of as well as apart from its spatial environment (figs. 168, 171–173). A spatial illusion may be destroyed by this convention, but it is in every respect consistent with the many other ambiguous strategies that characterize Mimbres art.

The confusion of a life-form with its background can always be read as a visual metaphor telling of the essential unity of all things and the indivisibility of a being and its environment.

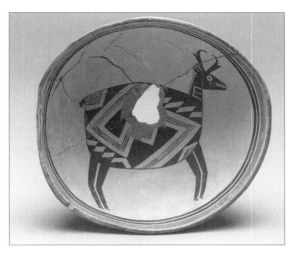

Figure 171. Bowl, Mimbres Classic Black-on-white (Style III), 9 x 21 cm, 3.6 x 8.4 in. Animal with the horns, head, and neck of a pronghorn and body design motifs that suggest lightning, rain, clouds, and mountains. Purchased 1919 from the Smithsonian Institution; originally purchased from E. D. Osborn by J. W. Fewkes. (AMNH 29.1/297)

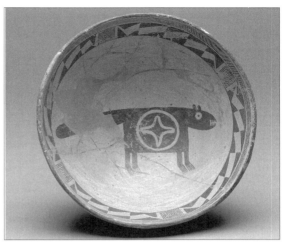

Figure 172. Bowl, Mimbres Classic Black-on-white (Style III), 10 x 23.3 cm, 4.1 x 9.3 in. Long-tailed mammal with a bearlike head and a body design of a four-pointed star in an oblate frame. Purchased from the Smithsonian Institution; originally purchased from E. D. Osborn by J. W. Fewkes. (AMNH 29.1/305)

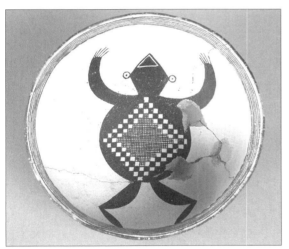

Figure 173. Bowl, Mimbres Classic Black-on-white (Style III), 8.5 x 17 cm, 3.4 x 6.7 in. Frog or toad painted as though diving into a deep bowl. The fine-line, cross-hatched body design is framed by concentric diamonds made by alternating black and white squares. Excavated by the Mimbres Foundation at Mattocks Ruin, 1976. (MMA 77.67.12)

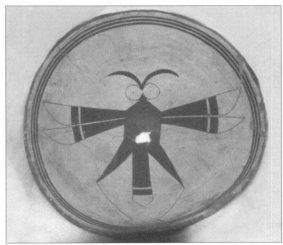

Figure 174. Bowl, Mimbres Classic Black-on-white (Style III), 14 x 28 cm, 5.5 x 11.0 in. A dragonfly-like insect with wing and body patterns that may describe an observed animal. Excavated by E. D. Osborn (site unknown) and purchased about 1923 for the Heye Foundation, Museum of the American Indian (now the National Museum of the American Indian) by J. W. Fewkes (Fewkes 1923:40, fig. 98). (NMAI 049672)

Rather than holding representational illusionism or illustration of the natural world as their goal, it would seem that Mimbres artists, in their life-form paintings, relished the invention of descriptive ambiguities and visual puns. Most of their pictures are most satisfactorily interpreted as deliberate distortions of observed nature for the purpose of creating dramatic transformational metaphors that were structured by a commonly shared belief system. To interpret visual anomalies as evidence of careless observation or ignorance of some natural process is to miss the point entirely.

The number of figures in a picture generally dictated its organizational complexity. Human subjects dominate the more complex, less rigidly organized multiple-figure paintings, and other animals provide the subject matter of most single-figure paintings. Nonhuman mammals and birds are the subjects in about half of the single-figure vignetted pictures studied. Other common subjects are reptiles, insects, fish, and imaginary creatures that combine attributes of two or more animals. Humans are not common subjects in single-figure paintings (see Appendix A). Most two-figure paintings are only slightly more complex versions of single-figure vignettes and usually repeat the same animal subject in bifold symmetry on two halves of a vessel (figs. 99, 156–159). A substantial minority of two-figure paintings show two different animals in narrative interaction. The subjects of these narrative pictures are markedly different from those of single-figure paintings. About half include fish and mammals other than humans. Mythic animals, insects, and birds also appear with frequency, whereas humans and reptiles are seldom shown.

Many multiple-figure paintings are also complex narratives in which humans, the most common subject, are ordinarily at the center of the action, both literally and figuratively. Other mammals, birds, and fish often appear in narrative paintings; insects and reptiles appear far less often, and fantastic animals only rarely. The key to subject selection in the more complex paintings seems to have been the figures' importance as actors in a narrative about some real, legendary, or imaginary event.

Identification of animal species is often problematical and is compounded by the seemingly casual way in which Mimbres artists combined details of different species and even of different genera on the same animal subject (figs. 2, 6, 168, 177). For the most part, Mimbres artists seem to have been uninterested in rendering anatomically accurate images of any species. Thus, species identification is generally controlled by two different but equally subjective factors: first, the accuracy and consistency of pictured details, such as posture, ears, horns, or tail, that seem to be diagnostic of a particular animal and, second, the attitude that any well-qualified modern taxonomic expert might have toward anomalous details. Some authorities identify species or genera on the basis of features that they take to be diagnostic, ignoring those that are anomalous or conflicting, whereas others, less tolerant of anomalies, refuse to identify ambiguously drawn life-forms. It is not unusual, therefore, for one respected ichthyologist to identify a Mimbres picture of a fish as a saltwater, Gulf of California animal and another to identify it as a local, freshwater fish with anomalous features (Bettison et al. 1996; Jett and Moyle 1986; Tom Turner, personal communication 2001). What is true for Mimbres paintings of fish is also true for their paintings of all other life-forms and perhaps even for all of their narratives. What we see may never have been intended to represent any one visual instant in time, space, or experience.

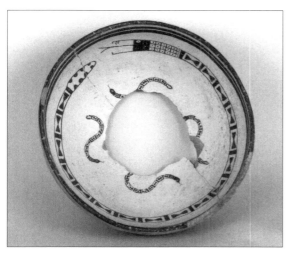

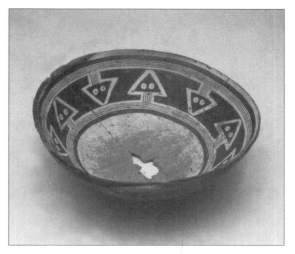

Figure 175. Bowl, Mimbres Classic Black-on-white (Style III), 9 x 17–18 cm, 3.5 x 6.7–7.1 in. A snake with hourglass patterns on its body and stylized rattlesnake tail is shown in profile just below the framing lines. It surrounds four smaller, similar animals. Excavation history unknown. (MRM 1972–12)

Figure 176. Bowl, Mimbres Classic Black-on-white (Style III), 8.5 x 26 cm, 3.4 x 10.2 in. An alternating pattern of triangular reptilian heads is integrated within the design band of the upper wall of a vessel whose well-worn center gives evidence of domestic use. Excavated by the Museum of New Mexico at the Coulson site for a highway clearance project, 1962. (MIAC/LAB 17953/11)

Only a few fish, such as pike, gar, and catfish, seem to have clear enough details to permit even tentative identification, and no conclusions can safely be made without consensus by several different specialists. Most fish are shown in profile and are richly decorated with geometric motifs that sometimes conform to anatomical parts and occasionally suggest scales or other observed details (figs. 13, 37, 95, 99). A surprising number of fish have the wrong number of wrong-shaped fins in the wrong place or bodies and tails whose shapes are inappropriate for their fins (Tom Turner, personal communication 2001).

Frogs, toads, turtles, tortoises, lizards, and snakes are usually shown from above, with emphasis placed on their bilateralism and some other obvious physical characteristic. For example, lizards and snakes might have their sinuosity emphasized by a series of S curves, and turtle carapaces might be shown with geometric fillers that suggest their natural patterning. All but snakes appear with about the same frequency (Appendix A), and few of these animals can be identified at the species level (figs. 155, 170, 173, 175, 176).

Most mammals other than humans are shown in profile, sometimes with their heads turned and usually with both eyes, ears, horns (if any), and all four legs visible. Species identification can often be made, but too many bats have birdlike wings or beaks, too many pronghorns have deer antlers, more than a few carnivores seem to have human hands and feet, and too often, other anomalous features are discovered upon close examination (figs. 177–180). Rabbits and bighorn sheep are proportionally the most common of the less dubious identified

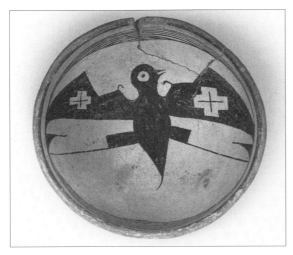

Figure 177. Bowl, Mimbres Classic Black-on-white (Style III), 5 x 13.5 cm, 2.0 x 5.3 in. A batlike animal with a bird's head and wings that are a composite of bat wings (leading edge) and either bird feathers or dragonfly-like wings (trailing edge). Excavated at the Mitchell site by the Dr. Berry Bowen family, about 1930. (MMA 40.4.108)

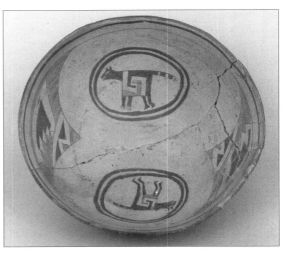

Figure 178. Bowl, Mimbres Classic Black-on-white (Style III), 11.5 x 24–25.5 cm, 4.5 x 9.5–10.0 in. Two felinelike animals are each framed within a pair of concentric ovates. One has humanlike hands and feet, and the other, humanlike feet both front and back. Excavated at the Pruitt site by the Dr. Berry Bowen family, about 1930. (MMA 40.4.275)

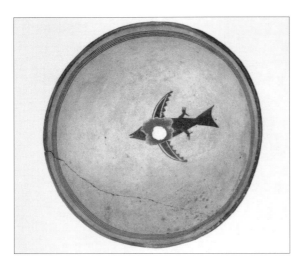

Figure 179. Bowl, Mimbres Classic Black-on-white (Style III), 8.3 x 20.3 cm, 3.3 x 8.0 in. A flying bird with swept-back, swallowlike wings and a fishlike body and tail. Excavated at the Pruitt site by the Dr. Berry Bowen family, about 1930. (ASM GP 4965)

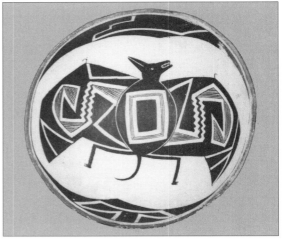

Figure 180. Bowl, Mimbres Classic Black-on-white (Style III), 11.5 x 25 cm, 4.5 x 9.8 in. A splayed animal that is mostly bat. Its "ears" closely resemble a raven's beak. Excavated at the Pruitt Ranch Site, Mimbres River. (ASM GP 4955)

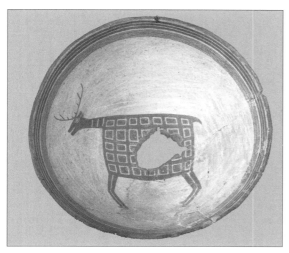

Figure 181. Bowl, Mimbres Classic Black-on-white (Style III), 10 x 24 cm, 3.9 x 9.5 in. A deerlike animal with deer or elk horns, a pronghornlike striped neck, and a rectangular body patterned with rows of small rectangles. Excavated by Harriet and C. B. Cosgrove at the Treasure Hill site, before 1936. (MNA 834/NA.7288.88)

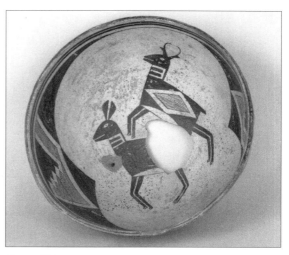

Figure 182. Bowl, Mimbres Classic Black-on-white (Style III), 11 x 23.5 cm, 4.3 x 9.3 in. Copulating pronghorns, the male with a diamond-shaped body motif. Excavated by Richard Eisele before 1926, site unknown. (WNMU 73.8.139)

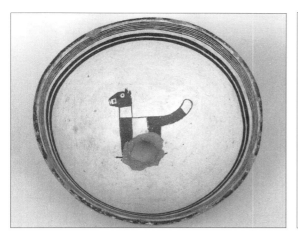

Figure 183. Bowl, Mimbres Classic Black-on-white (Style III), 8.5 x 18.5 cm, 3.4 x 7.3 in. Quadruped that could be a canine, a feline, or neither. Excavated at the Pruitt site by the Dr. Berry Bowen family, about 1930. (MMA 40.4.133)

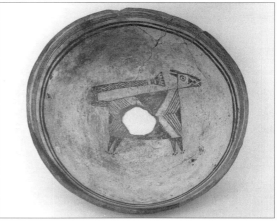

Figure 184. Bowl, Mimbres Classic Black-on-white (Style III), 11 x 24 cm, 4.3 x 9.5 in. Mountain lion–like animal with a stylized tail over its back in the manner of lion petroglyphs and stone carvings found along the upper Gila River drainage and in the Zuni area. The tip of the animal's tail resembles a bird's tail, and its body is patterned with a complex of triangular motifs. Excavated at the Mitchell site by the Dr. Berry Bowen family, about 1930. (MMA 40.4.130)

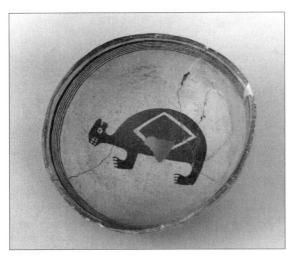

Figure 185. Bowl, Mimbres Classic Black-on-white (Style III), 7 x 15.2 cm, 2.8 x 6.0 in. Bearlike animal with a diamond pattern on its body. Excavated at the Mitchell site by the Dr. Berry Bowen family, about 1930. (MMA 40.4.171)

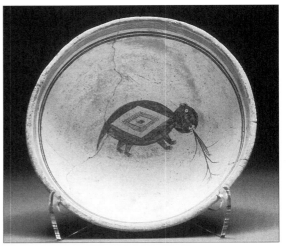

Figure 186. Bowl, Mimbres Classic Black-on-white (Style III), 10.8 x 21.5 cm, 4.3 x 8.5 in. Gopherlike animal with a diamond pattern on its body eating a corn plant. One of very few examples of either subject found in Mimbres art. Excavation history unknown. (NDUM 95.68.01)

animals. Deer, pronghorn, canines, and felines are less common but appear more often than other local species such as bears, raccoons, bats, beavers, and rodents (figs. 15, 181–186; pl. 1).

More than in other animal classes, there was great diversity in the degree of realism of bird pictures. Some are so conventionalized as to be little more than a series of triangles organized to suggest a bird form (fig. 187). Others are so detailed, and their posture and attitude so lifelike, that they evidence close observation and suggest precise representational intentions (fig. 188). Most standing birds are shown in profile, but flying ones have their wings spread and are usually seen from below (fig. 189). Turkeys, quail, and cranelike waterbirds, all among the easiest to characterize visually, are the most common of the identified bird species (figs. 190–194). Parrots or macaws, crows, ravens, hawks, blackbirds, hummingbirds, and swallows or swifts are also shown (figs. 44, 160, 187, 195,

216; pls. 2, 16). Most unidentified birds appear to be thrushes, wrens, or other songbirds (figs. 160, 188). In all bird pictures, when geometric decoration is used it usually conforms to some sort of feather patterning and often provides representational clues. Cranes or other long-legged waterbirds are often shown interacting with fish. Parrots or macaws, usually associated with humans, are among the birds most likely to appear in narrative settings, though others do as well.

Winged insects, including butterflies and moths, caterpillars (fig. 197), ant-lion larvae (fig. 198), and grasshoppers or locusts, are among the identified insects or insectlike animals represented with fair regularity. Few of these occur in narrative contexts, but perhaps because of their decorative potential, insects compose a substantial proportion of multiple-figure subjects (fig. 199; pls. 12, 17).

Human beings were usually shown head-on

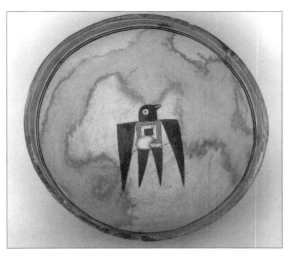

Figure 187. Bowl, Mimbres Classic Black-on-white (Style III), 12.5 x 24.5 cm, 4.9 x 9.7 in. Bird with stylized wings, body, and tail comprised entirely of triangles and concentric squares. Excavated by the School of American Research and Museum of New Mexico at Cameron Creek Village, 1923. (MIAC/LAB 20391/11)

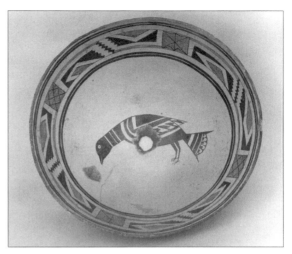

Figure 188. Bowl, Mimbres Classic Black-on-white (Style III), 14 x 29.5 cm, 5.5 x 11.6 in. Lifelike bird in a pecking position. Its body patterns seem to be far more representational than otherwise. Excavated by Richard Eisele before 1936, site unknown. (TM 4587)

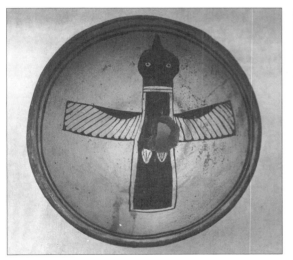

Figure 189. Bowl, Mimbres Classic Black-on-white (Style III), 8 x 21.8 cm, 3.2 x 8.6 in. Stylized flying bird seen from below. Excavated by the Peabody Museum, Harvard University, at Swarts Ruin, 1924–1927. (HP 96195)

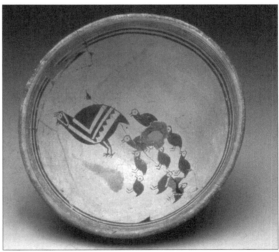

Figure 190. Bowl, Mimbres Classic Black-on-white (Style III), 10.5 x 23–24.8 cm, 4.1 x 9.1–9.8 in. A quail hen with nine young. Excavated by the University of Minnesota Field School at the Galaz site, 1929–1931. (WM 15B 355)

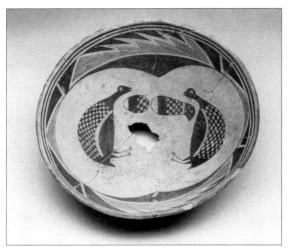

Figure 191. Bowl, Mimbres Classic Black-on-white (Style III), 12.5 x 24–31 cm, 4.9 x 9.5–12.2 in. A pair of gallinaceous birds, one egg, and one hatchling. All are decorated with checkerboard patterns suggestive of Montezuma quail. Excavation history unknown. (MRM 1972–22–1 68A)

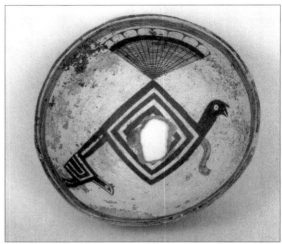

Figure 192. Bowl, Mimbres Classic Black-on-white (Style III), 8 x 21 cm, 3.2 x 8.3 in. A tom turkey with a square body enclosing concentric squares has feet that transform into the front end of a turtle- or skunklike animal with a similar body pattern. Excavated by Richard Eisele before 1923, site unknown. Fewkes (1924:34, fig. 33) identifies the smaller animal as a hen turkey. (WNMU 73.8.138)

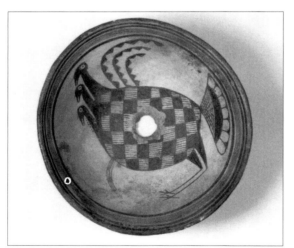

Figure 193. Bowl, Mimbres Classic Black-on-white (Style III), 8.5 x 20 cm, 3.4 x 7.9 in. A three-headed turkey with a checker board body. Collected by E. D. Osborn before 1923 (Fewkes 1923:36, fig. 58). (ASM GP 944)

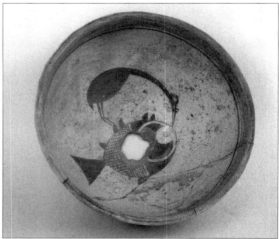

Figure 194. Bowl, Mimbres Classic Black-on-white (Style III), 9.7 x 18.8 cm, 3.8 x 7.4 in. A bitternlike wading bird seems to be pecking at a fish. Excavated by Richard Eisele before 1923, site unknown. Fewkes (1924:38, fig. 51) suggests that the animals are conversing. (WNMU 73.8.231)

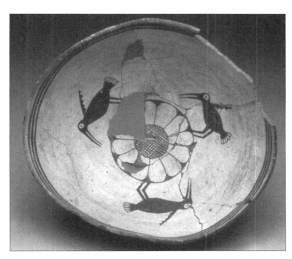

Figure 195. Bowl, Mimbres Classic Black-on-white (Style III), 12 x 23.7–27 cm, 4.7 x 9.3–10.6 in. Three hummingbirds perch on a sunflower-like flower. Excavated by the University of Minnesota Field School at the Galaz site, 1929–1931. (WM 15B 93)

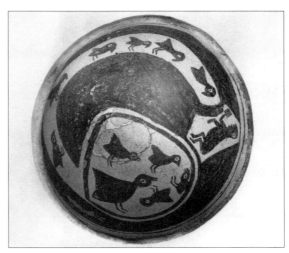

Figure 196. Bowl, Mimbres Classic Black-on-white (Style III), 8.9 x 18.4 cm, 3.5 x 7.3 in. An apparent underground scene in which a human digs into a tunnel where six small birds stand. A large bird and four smaller ones are in a cavelike room at the other end of the tunnel. Excavated at the Pruitt site by the Dr. Berry Bowen family, about 1930. (ASM GP 4961)

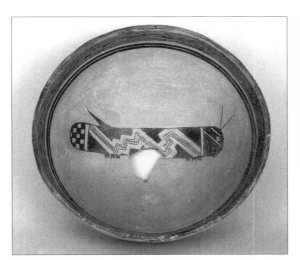

Figure 197. Bowl, Mimbres Classic Black-on-white (Style III), 9 x 20–20.5 cm, 3.5 x 7.9–8.1 in. A horned caterpillar with a body design of lightninglike zigzag lines. Excavation history unknown. (DMNS 9146)

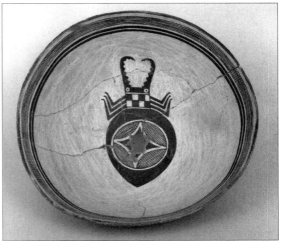

Figure 198. Bowl, Mimbres Classic Black-on-white (Style III), 10 x 29.5 cm, 3.9 x 11.6 in. An ant-lion larva with a body design of a four-pointed star in a circle. Excavated at the Pruitt site by the Dr. Berry Bowen family, about 1930. (MMA 40.4.250)

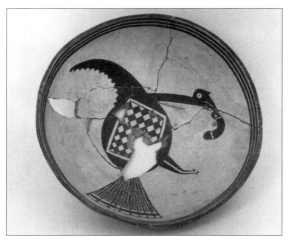

Figure 199. Bowl, Mimbres Classic Black-on-white (Style III), 10 x 27 cm, 3.9 x 10.6 in. A turkey with a larval insect in its mouth. It has a diamond-shaped body motif filled by a checkerboard pattern. Collected by William Endner before 1937; excavation history unknown. (MWC G 436)

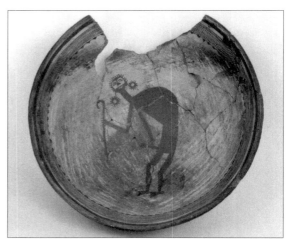

Figure 200. Bowl, Mimbres Classic Black-on-white (Style III), 9 x 22 cm, 3.5 x 8.7 in. A humpbacked man with an erect phallus faces forward with his body in three-quarter profile. A crooked staff is in his right hand, and what seem to be sunflower earrings dangle from his earlobes. Excavated by Richard Eisele before 1926, site unknown. (WNMU 73.8.301)

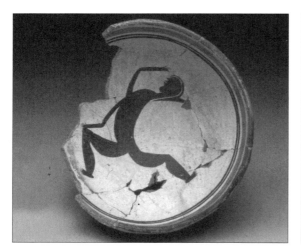

Figure 201. Bowl, Mimbres Classic Black-on-white (Style III), 11 x 22.5 cm, 4.3 x 8.9 in. A human in profile wearing a curved headdress seems to be dancing with grace and energy. Excavated by the University of Minnesota Field School at the Galaz site, 1929–1931. (WM 15B 97)

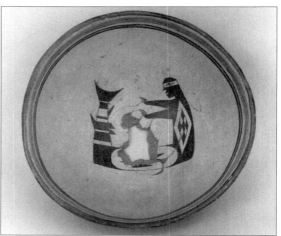

Figure 202. Bowl, Mimbres Classic Black-on-white (Style III), 11.5 x 23.25–24 cm, 4.5 x 9.2–9.5 in. Personage with a human head and body that transforms into the tail end of a fish. There is a diamond-shaped motif in the body of the human. Another emblem in a white cartouche once covered the joining of the two animals. Excavated by Richard Eisele before 1926, site unknown. (TM 4590)

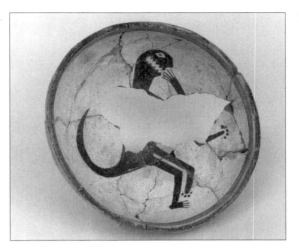

Figure 203. Bowl, Mimbres Classic Black-on-white (Style III), 6 x 15 cm, 2.4 x 5.9 in. A fantastic creature with a lizardlike head and tail has a human body, right arm, and right foot and what may be a mountain lion's legs and feet instead of a left arm and leg. Excavated at the Pruitt site by the Dr. Berry Bowen family, about 1930. (MMA 40.1.127)

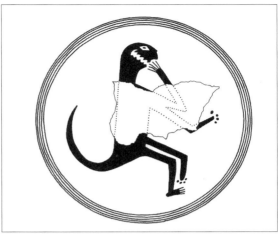

Figure 204. Drawing of figure 203 as though reconstructed. Drawing by Wesley Jernigan.

or in profile, sometimes with their heads facing front and their bodies in profile (figs. 27, 28, 200, 201; pl. 18). About a third wear clothing, and as discussed in chapter 3, only about a third have their sex characteristics specified (Munson 2000). Only about half of the clothed humans wear gender-specific costumes, but it is impossible to be sure of the sex of the majority of these or of any of the remainder whose sex is not specified. A figure identified as female by one scholar because of its graceful attitude (fig. 201) may be identified as male by another for the same reason (Brody and Swentzell 1996:42–43). Men were pictured far more often than women, and except for rare appearances as single-figure vignettes, humans of either sex were usually shown in some sort of active pose. When other animals or objects are associated with humans, the scale relation-

ships between the figures are usually realistic, but on occasion another mammal, a bird, or, most often, a fish was made to seem disproportionately larger than the people in a picture (figs. 6, 37).

Regardless of posture, all four human limbs, as well as fingers and toes, are usually indicated. Hands were sometimes cut off at the wrist, but often in a context suggesting that this was a convention, possibly to avoid having to draw that most difficult part of the human anatomy (fig. 38; pl. 2). Swellings of the limbs to suggest calf, thigh, or arm muscles, heel protrusions, genitalia, and facial features are other commonly rendered human anatomical details. People were usually drawn as solid dark silhouettes but were sometimes shown as outlined figures. The variety in degree of realism ranged from stick figures that have almost no representational

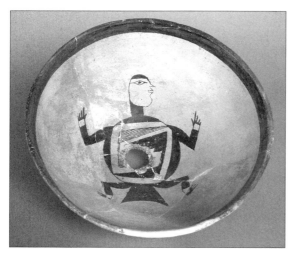

Figure 205. Bowl, Mimbres Classic Black-on-white (Style III), 9 x 22–23 cm, 3.5 x 8.7–9.1 in. A frontal squatting human with a fishlike body and tail faces to the right. A black and gray interlocking fret motif covers its body. Excavated by the Mimbres Foundation at the McKim site, circa 1976. (MMA 77.67.26)

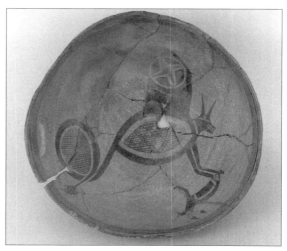

Figure 206. Bowl, Mimbres Classic Black-on-white (Style III), 13.5 x 26.5 cm, 5.3 x 10.4 in. A flying batlike animal with a snakelike tail that terminates in what seem to be raptor tail feathers carries a jackrabbit in its forefeet; it has no visible hind limbs. Excavated by the Beloit College Field School at Mattocks Ruin, 1929–1930. (MIAC/LAB 8535/11)

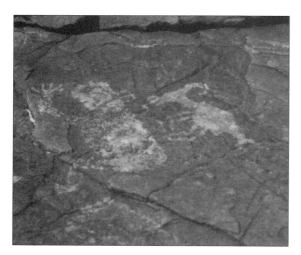

Figure 207. Petroglyph, Mimbres Classic period, Pony Hills, N.M., a site not far from the lower Mimbres Valley. Compare the animal on the right to figure 208. Photograph by J. J. Brody.

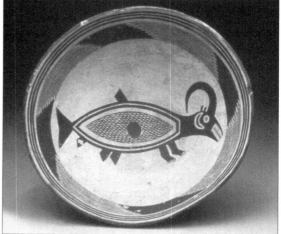

Figure 208. Bowl, Mimbres Classic Black-on-white (Style III), 11.8 x 25.6–26 cm, 4.7 x 10.1–10.2 in. A fishlike animal with gills has the front feet of a toed mammal and the head and horns of a bighorn sheep. Compare with figure 209, a similar creature drawn as a petroglyph. Excavated by the University of Minnesota Field School at the Galaz site, 1929–1931. (WM 2B 22)

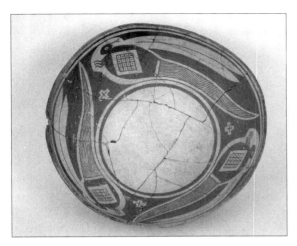

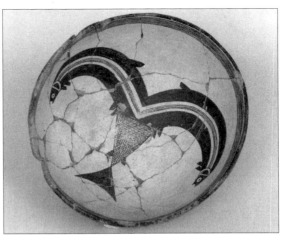

Figure 209. Bowl, Mimbres Classic Black-on-white (Style III), 12.2 x 27.5 cm, 4.8 x 10.8 in. Three insects with long, tail-like bodies circle around the inner wall of a vessel, each framed within the negative profile of a rabbitlike animal. Starlike crosses are shown between each insect. Excavated by Harriet and C. B. Cosgrove at the Treasure Hill site, before 1936. (MNA 834/NA 3288.50)

Figure 210. Bowl, Mimbres Classic Black-on-white (Style III), 8 x 18.2 cm, 3.2 x 7.2 in. Two conjoined fish. The point of junction of the two bodies is shown as a finely cross-hatched triangular shape that is suggestive of a basketry fish trap. Excavated at the Pruitt site by the Dr. Berry Bowen family, about 1930. (MMA 40.4.134)

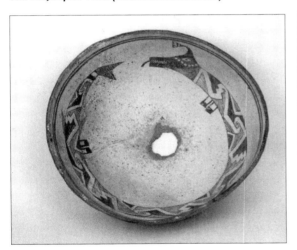

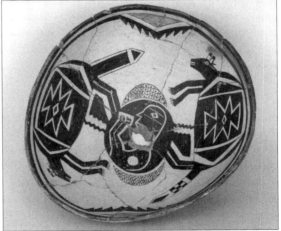

Figure 211. Bowl, Mimbres Classic Black-on-white (Style III), 10 x 22–24.5 cm, 3.9 x 8.7–9.7 in. A horned serpent with a mammal-like muzzle and forward-pointing horn terminating in a bird-tail tassel transforms into a creature with fins and a fish tail. It also has two pairs of stubby, leg-like, finlike body parts forward of the fish fins. Collected by E. D. Osborn before 1923, site unknown (Fewkes 1923:12, 33, fig. 41). (SWM 47–P-204)

Figure 212. Bowl, Mimbres Classic Black-on-white (Style III), 12–12.8 x 29–32 cm, 4.7–5.0 x 11.4–12.6 in. An embryonic human in an egg-shaped space at the center of the bowl is connected by umbilicus-like zigzag lines to a pair of quadrupeds. Excavated by A. M. Thompson at either the Three Circle or Eby site, before 1952. (MIAC/LAB 19939/11)

details to closely observed, lifelike illustrations.

Most subjects, but not all, that combine characteristics of different species have fish, human, or bird features joined to those of a mammal (table 3; Appendix B; figs. 202–208). Sometimes the intent seems have been to record a theatrical event featuring a person in animal costume representing an animal or a supernatural or mythic being (figs. 42, 167, 202). Many composite subjects, however, seem to portray the being itself (figs. 206, 210, 211; pl. 19). Bears, bighorn sheep, rabbits, felines, lizards, snakes, and insects are among the identified animals whose parts were recombined into compound, mythic beings. The births of such personages may also have been pictured (fig. 212). But whether or not that interpretation is correct, every such painting either specifies the transformation of one being or personage into another or carries within it the germ of such a transformation.

Except for artifacts such as baskets and costumes that are details in narrative paintings, representations of other objects or life-forms are rare. Abstract and realistic images of feathers, shell bracelets, prayer sticks, wands, prayer plumes and celestial bodies are almost the only nonliving figurative subjects, sometimes shown as isolated motifs, at other times associated with an animal in a vignette (figs. 43, 213, 214). Except for flowers, vegetal and landscape forms are even less common (figs. 57, 186, 215). Petaled flowers can sometimes be identified as motifs in other-wise geometric paintings, but these are often ambiguous and can also be read as the by-products of geometric patterning or even as clouds, rather than as deliberate pictures of plants (figs. 144, 195). The likelihood may be that they are a little of everything. Squashlike vegetables and cornstalks painted as background information in narrative pictures are rare, but

except for flowerlike geometric motifs, they are the most common growing plants the Mimbreños painted.

Considering the wealth of potential life subjects available, Mimbres representational paintings are remarkably limited. Some common large food animals, including deer and prong-horns, were often pictured, but others, such as elk, were rarely shown. Many small animals that were also important to the diet, such as gophers, squirrels, and mice, were seldom painted, nor were such common creatures as beavers, skunks, and porcupines (figs. 169, 186). Many visually distinctive and common birds of the area, including jays, roadrunners, owls, hawks, eagles (but not eagle feathers), and vultures, are also uncommon or not easily distinguished as subjects in Mimbres art (pl. 16). Subjects were limited and carefully selected, but neither the pattern of selection nor the meaning of the selections is clear. Few hints about either are to be derived ethnographically or from the oral literature of any living Southwestern people. Some animals that figure in Pueblo myths are the subjects of Mimbres art, but many others are not, and even the dragonfly, so common in contemporaneous Mimbres and Jornada Mogollon petroglyphs and somewhat later Pueblo art, is an uncommon motif in Mimbres pottery painting. Importance to sustenance, rarity, ubiquity, character, potential decorative value—none of these seems to have been the critical selective factor, and to a large degree, detailed information about the factors we can be sure of—myth, literature, history, and religion—may never be known.

Iconography

The original intended meanings of the paintings on Classic Mimbres pottery are

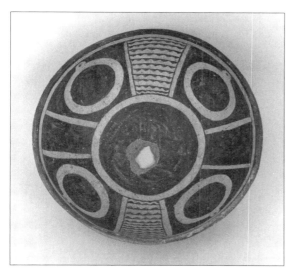

Figure 213. Bowl, Mimbres Classic Black-on-white (Style III), 7.5 x 19 cm, 3.3 x 7.8 in. Glycymeris clamshell bracelets are shown as negative forms in each quadrant of this quartered pattern. Excavated at the Pruitt site by the Dr. Berry Bowen family, about 1930. (ASM GP 4933)

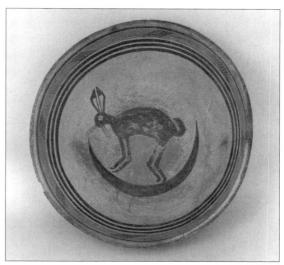

Figure 214. Bowl, Mimbres Classic Black-on-white (Style III), 9 x 20–20.8 cm, 3.5 x 7.8–8.2 in. A jackrabbit, identified by its black-tipped ears and long legs, stands on a crescent moon. Excavated by the School of American Research and Museum of New Mexico at Cameron Creek Village, 1923–1927. (SWM 1948–G-1)

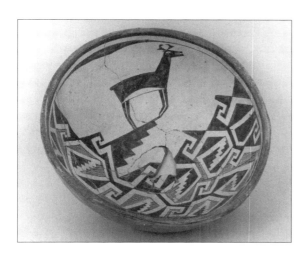

Figure 215. Bowl, Mimbres Classic Black-on-white (Style III), 10 x 22–23.8 cm, 3.9 x 8.7–9.4 in. A pronghorn stands on a terraced shelf in what may be a highly abstracted landscape. Collected by William Endner before 1937; excavation history unknown. (MWC G-497)

obscure at best. Not only do uncertainties surround the identification of many pictured subjects, but the seamless integration of pictorial structure and execution with perceptual, metaphorical, and interpretive transformations of imagery is the fundamental theme of Mimbres art. Individual subjects are often intentionally elusive and secondary to pictorial metaphors that seem to suggest philosophical principles that parallel those not only of the modern Pueblos but also of many ancient peoples throughout Mesoamerica and elsewhere in the Americas. In short, rather than suggesting specific historical connections to one or another ancient society, the metaphorical iconography of the Mimbreños seems more often simply to be generically ancient American.

For example, the use of twofold rotational

symmetry as a basic structural motif in Mimbres art is suggestive of the daily rotation of day and night and of other fundamental natural relationships such as that between life and death. It also suggests certain mythic interconnections that are nearly universal in the Americas—and not uncommon in Asia—such as those between upper and lower worlds and this earth's surface. Perhaps most basic and paramount is the interconnectedness of all things in nature. The suggestions of transformation that are almost ubiquitous in Mimbres paintings, as well as the frequent appearance of twins and stars within rotational visual structures, support an interpretation of Mimbres art in terms of a deeply rooted Native American philosophical system that underlies both Pueblo and Mesoamerican beliefs. Other examples with broad geographical and cultural implications suggest themselves—for instance, the fusion of birds and snakes that suggests a metaphoric interconnectedness of earth, sky, and water that is common to many Native American peoples (pl. 11). If only because Mimbres iconography is so deliberately ambiguous, it is simpler and more reasonable to accept generically cosmic interpretations of Mimbres art than to accept those that are more particularized and specifically historical.

Beyond speculations that can be neither proven nor falsified, iconographic interpretations of Mimbres art are necessarily limited to the often tentative identification of an image with some known natural or human-made being, thing, or activity. Those interpretable subjects do provide some solid information about Mimbres people, their daily lives and activities, and their interests in the world they lived in. They also provide tantalizing clues to rich oral traditions and ritual events and give texture and humanity to many archaeological facts that we knew beforehand. We think of the Mimbres today as a Southwestern people with continuing associations, and perhaps roots, in northern Mexico. But until 1847, when the United States seized the American Southwest from the Republic of Mexico, they were one of many ancient peoples, including all other Southwesterners, of the northern frontier of Mexico. The novel construction of a modern international border cannot obscure the fact that all of the ancient Southwest was the northwestern frontier of the "Gran Chichimeca" and a northern extension of Mesoamerica (Di Peso 1968). The Mimbreños were simultaneously a Southwestern and a northwestern Mexican people, and their descendants are almost certainly to be found in that part of the world among both Pueblo and other Native societies of the greater Southwest. But we know nothing beyond that and can interpret Mimbres iconography only within the limitations noted. Expect no Rosetta stone.

Some geometric motifs of Mimbres art suggest clouds, mountains, lightning, stars, flowers, butterflies, and other natural forms that can be associated in both Pueblo art and that of ancient Mesoamerica with rainfall, fertility, and warfare (Hays-Gilpin and Hill 1999). Similar motifs used by Pueblo potters in recent times are sometimes named for one or another natural form or natural force, but there is little evidence that they are intended to convey any specific message or even that they are, strictly speaking, symbols. Instead, the names identify motifs that are evocative of beneficial phenomena, the natural world, and interactions among different planes of existence that are suggested by the forms themselves. Some are given different names by different makers and users, and most names appear to be suggestive rather than specific in their meaning (Bunzel 1929).

On a different level, the physical organization,

pictorial structure, and abstract visual themes of Mimbres paintings of every subject class evoke a constant awareness of the struggle to create and maintain harmony in a complex, multidimensional, and potentially disorderly universe. The universe encapsulated within the picture space of a Mimbres bowl suggests a microcosm of the real world. A constant theme in Mimbres art is the tense balancing of polar opposites, most visible in the geometric paintings but also discernible in representational ones. The quartered compositions that so commonly structure the pictures suggest metaphorical representations of the fundamental cosmogony of the Southwest, Mesoamerica, and elsewhere in the Americas (J. C. Kelley 1966:98; Ortiz 1969; Swentzell 1989). They suggest representations of the four world quarters, and their reserved or patterned centers may represent points of communication between this earth surface and the worlds above and below. The "empty" center spaces may be read as symbolic navels, places of emergence, the *sipapu* of all Pueblo origin traditions.

Conceptual parallels to the new Mimbres architectural styles that were more or less contemporaneous with the emerging Classic Mimbres Black-on-white tradition, especially the novel use of rooftop entrances and central hearths that may also have served as sipapus, are too close to be ignored (Shafer 1995, 1996:6–7). Quartering systems are common in Classic Mimbres pottery art, but they were used proportionally far more often in earlier times. Classic era pottery painters were as likely to divide a vessel into units of two, three, or five as into units of four. Whatever metaphorical values may have been attached to quartered patterns in prior times were no longer so important, and it must be asked whether new architectural metaphors that seem to stress the

directional importance of four room corners were replacing an old pictorial metaphor. If so, then the increased use in Mimbres Classic paintings of bifold rotational symmetry becomes intriguing, for it suggests that greater importance was now being given in pottery art to a visual metaphor that referred simultaneously to the sky above, this earth surface, and underworlds below, to the daily rotation of night and day, and to the continuity of life and death.

Whether or not specific Mimbres geometrical compositions and motifs were given those or any other particular meanings cannot be determined, but there can be no question that representational paintings, at the very least, commemorated the real or imagined existence of a being or thing. Most single-figure pictures can be read as emblems. Many are of easily identified or anomalous animals that, it has been conjectured, might have been used as logos for clan or personal names (Kabotie 1949). But that conjecture is unsupported and possibly even contradicted by the fact that more often than not, pictures of several different animals appear on vessels that were buried with a single person (Bradfield 1931; Cosgrove and Cosgrove 1932).

Traditional Pueblo people identify the patterned shadows of the full moon as depicting a rabbit. Ancient Mesoamerican people, too, identified rabbits with the moon. Both cottontails and jackrabbits are characterized by arched backs that can easily suggest moonlike associations, and Mimbres artists sometimes stressed lunate qualities when they painted those animals (figs. 14, 163). There are other visual hints of Mimbres rabbit-moon connections, including those reminiscent of the Mesoamerican association of cranes with lunar eclipses (David Kelley, personal communication 1974, 1975; Linda Schele, personal

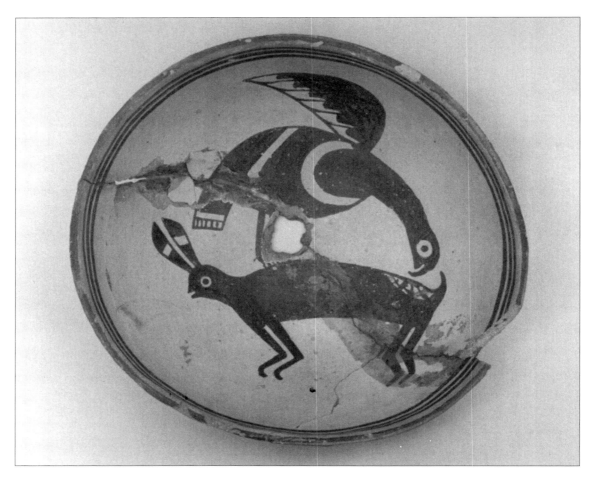

Figure 216. Bowl, Mimbres Classic Black-on-white (Style III), 7.5 x 16.9–18.5 cm, 3.0 x 6.7–7.3 in. A hawklike bird seems to be tearing at a jackrabbit. Eisely collection circa 1926; William Endner collection before 1937; excavation history unknown. (MWC H-449)

communication 1976; Thompson 1994). The several Mimbres paintings of a bird eating a rabbit suggest similar symbolizing of lunar eclipses (fig. 216). Even if so, there is no way to know whether (or when) a rabbit picture might refer to the moon, to a real or mythic individual named for the moon, to a verbal-visual rebuslike pun, simply to a rabbit, or to all or none of these potential meanings. Our present inability to move beyond the creation of logical constructs and toward finding ways to test their validity makes such conjecturing little more than a parlor game.

More complex figurative paintings, simply because they are more complex, carry greater potential for interpretation than do most single-

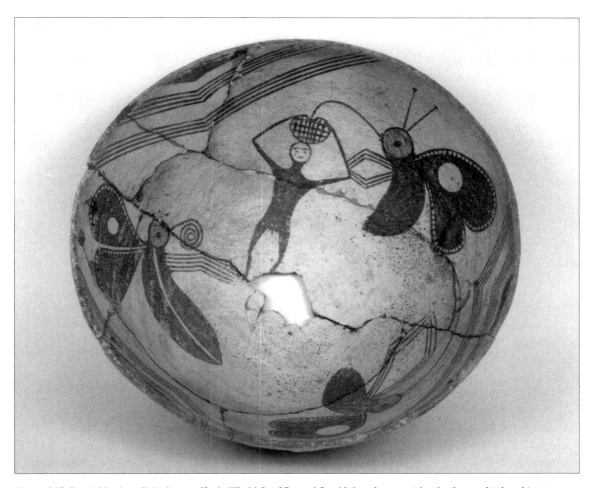

Figure 217. Bowl, Mimbres Polychrome (Style III), 11.3 x 27 cm, 4.5 x 10.6 in. A man with a basket on his head is seen from a bird's-eye perspective surrounded by three butterflies or moths (compare with fig. 41). Two of the insects are overhead; the third rests on the man's arm while seeming to suck something from the basket with its long tongue. Excavated by Richard Eisele before 1923, site unknown (Fewkes 1924:5, 29, fig. 2). (WNMU 73.8.150)

figure pictures. Those that show esoteric events (figs. 29, 42) or that describe group or daily activities such as hunting (figs. 14, 15; pl. 1), fishing (figs. 13, 165), gathering wood or honey, and trapping birds or insects (figs. 12, 161, 164, 217) are informative about aspects of Mimbres life that are otherwise obscure. Their full interpretive possibilities might simultane-

ously include illustrations of a local event, of a legendary one such as an earth-bound bear hunt by a long-dead culture hero, or of a mythic one such as a bear hunt by a supernatural on another plane of existence (pl. 1). We can never know which possibility had priority, because Mimbres artists very likely used the almost universal artistic strategy of domesticating legendary

events by placing them in familiar contexts. Considering the many fantasies drawn by Mimbres artists and their penchant for visual puns, there can be no assurance that any commonplace subject in any Mimbres painting is only the one thing. A painting that shows a Mimbres man snaring birds might also have been about a culture hero saving the stars by trapping the crows that were eating them (fig. 12; D. Kelley 1975).

Such pictures of everyday life provide many details about Mimbres technology, techniques, and social behavior. They illustrate the forms and decoration of such manufactures as baskets, arrow quivers, shields, and costumes. They tell us that everyday dress was simple and minimal and that elaboration of costume, body ornament, and hairstyle for ceremonial events also tended to be minimal. Details about motor habits are specific. How people sat, walked, danced, carried things, used tools, bore children, and trained animals were all described by Mimbres artists in pictures that carry the stamp of observed reality even as they diverge from that reality to merge with fantasy (figs. 12, 13, 23, 36; pls. 1, 2, 20).

Some paintings simulate reality but for one reason or another are fantastic or perhaps even whimsical (figs. 154, 193, 196). Siamese-twinned fish (fig. 210) and rabbit-eared insects (fig. 209) have been interpreted as almost anything from illustrations of folklore to private fantasy, from frivolous cartooning to awesome representations of supernatural beings. In recent years, strong logical arguments have been developed to support the identification of Mimbres subjects with a broad spectrum of Pueblo oral traditions recorded mostly since the 1880s, and even with sixteenth-century myth cycles of Mesoamerica (Carr 1979; Thompson 1994, 1999). In any case, it is probably safe to assume that most

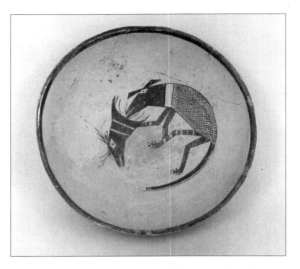

Figure 218. Bowl, Mimbres Classic Black-on-white (Style III), 8.5 x 20.5 cm, 3.4 x 8.1 in. An armadillo-like animal with one striped leg seems to be putting on or removing a deer-head mask. Excavation history unknown. (SWM 491-P-3772)

Mimbres representational subjects, especially those that were repeated in different communities or different media, had shared social meanings that transcended idiosyncrasy (compare fig. 31 with 33 and fig. 207 with 208). They provide clues to oral literature and, beyond any metaphorical values suggested by pictorial structure and execution, could simultaneously have served mnemonic, instructive, emblematic, illustrative, and proverbial purposes.

Some of the more complicated narrative paintings suggest folkloric illustrations; others seem to record ceremonial events. Among the former are those that depict waterbirds and fish and those that show confrontations between groups of men and a gigantic fish (figs. 6, 165). Composite figures and vignettes of man-beast interactions seem even to record ceremonial reenactments of mythic events in which humans

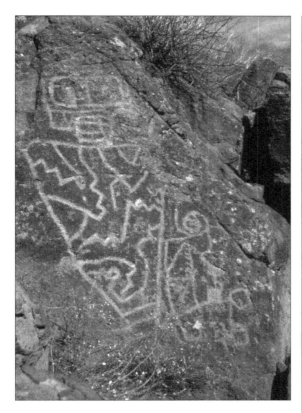

Figure 219. Petroglyph of a skeleton-like, goggle-headed figure with a trapezoidal body patterned with Mimbres-style interlocking stepped figure motifs. Classic Mimbres period, near NAN Ranch, Mimbres Valley. Photograph by J. J. Brody.

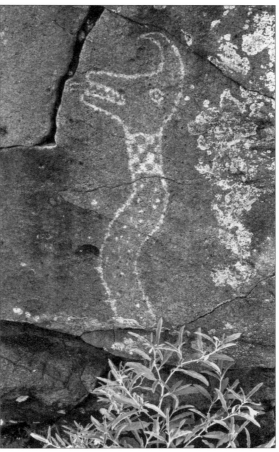

Figure 220. Petroglyph of a large horned serpent of the type called awanyu by the Tewa Pueblos. Rio Grande Pueblo Coalition period (1300–1600). Photograph by David Grant Noble.

appear in animal costumes (figs. 42, 167, 168). Enough other pictures of masks or masked figures are known to suggest that masking was so well-developed an art by Classic Mimbres times that even animals used animal masks (fig. 218). But few such paintings show more than a generic similarity to the known costumes, masks, or rituals of historic era Pueblo Indians (fig. 34; Shaffer, Nicholson, and Gardner 1993).

Some masks and elaborate headdresses depicted on Mimbres pottery suggest both Mexico and the Southwest. Paintings of a horned serpent headdress known from two examples are identified by some authorities with the Mexican deity Quetzalcoatl in his persona as Ehecatl, the wind god (figs. 31, 34; Di Peso, Rinaldo, and Fenner 1974:150, 707 n. 21). At least one Mimbres painting and several petroglyphs that may be of masked figures are

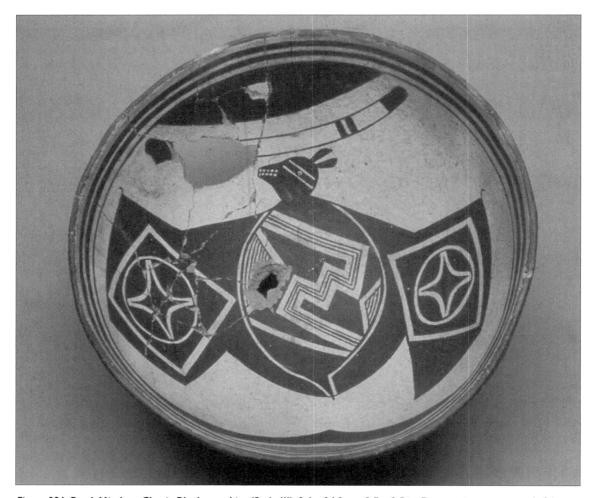

Figure 221. Bowl, Mimbres Classic Black-on-white (Style III), 9.4 x 24.2 cm, 3.7 x 9.5 in. Bat wearing an eye mask. A large, four-pointed star within a square is on each wing, and a gray and black geometric motif bisected by a lightninglike stepped figure is on its body. A slightly curved throwing or fending stick is above the head of the bat. Excavated by the University of Minnesota Field School at the Galaz site, 1929–1931. (WM 11B 481)

sometimes identified with the Mesoamerican rain god Tlaloc (fig. 219; Di Peso, Rinaldo, and Fenner 1974:566, 714 n. 103; P. Schaafsma 1980). However, the "Ehecatl" mask also resembles snouted horned serpents shown in other Mimbres pottery paintings (fig. 211) that are more similar to horned water serpents

known from various modern pueblos and places directly ancestral to them than to Mesoamerican representations of Quetzalcoatl (fig. 220). Similarly, the so-called Tlaloc images of the Mimbres more closely resemble contemporaneous and later Jornada Mogollon petroglyphs than they do any Mesoamerican

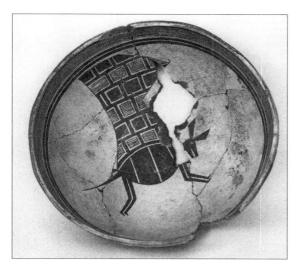

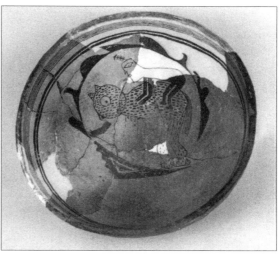

Figure 222. Bowl, Mimbres Classic Black-on-white (Style III), 12.5 x 28 cm, 4.9 x 11 in. Bat with a striped body and wing patterned with black and gray rectangles. Excavated by Richard Eisele before 1932, site unknown. (WNMU 73.8.140)

Figure 223. Bowl, Mimbres Classic Black-on-white (Style III), 9.8 x 19 cm, 3.9 x 7.5 in. Fragmentary image of a human on the back of a gigantic owl. Excavated by the Beloit College Field School at Mattocks Ruin, 1929–1930. (MIAC /LAB 8544/11)

deities. They are also suggestive of a class of proto-historic and modern Hopi, Zuni, and other Pueblo katsinam called "ogres." Thus, despite some iconographic parallels between Mimbres and Mesoamerican images, a broad spectrum of visual differences must also be recognized between the two artistic traditions, and alternative identifications and explanations are needed. Absent compelling evidence that similarities with Mesoamerican iconography are more than visually generic and that the images actually represent shared ideologies, there is no reason to accept any of them as transplanted Mesoamerican concepts, and every reason not to give them Mesoamerican names.

The only certainty that survives is that there were historic relationships of some sort between the Mimbres and other Southwestern people, on one hand, and between the Mimbres and Mesoamerican people, on the other. The first point is obvious, and the second is well supported by other evidence, including the presence of scarlet macaws in Mimbres villages and their use in ritual (fig. 44; pl. 2). Rituals involving macaws that are pictured in Mimbres paintings seem to parallel nineteenth-century Southwestern Pueblo uses of macaws, especially the plucking out of tail feathers, indicating that the Mimbres had already integrated these birds into their own system for their own reasons (Creel and McKusick 1994). In the end, the paintings are as silent as the Mimbres macaws are today about historical details or the nature of the Mimbres people's relationships with either ancient Mesoamerica or the modern Pueblos.

The difficulty in deriving original Mimbreño

meanings from any of these apparent identities is made manifest by examining two of the more dramatic Mimbres paintings, both of which depict a decapitation scene in which the person doing the decapitating wears a horned serpent headdress. The two known versions of this scene (figs. 31, 33) are alike in most formal and visual details. They were found in different Mimbres villages and differ enough in detail to make it reasonably certain that they were painted by different artists, probably at separate times and places.[1] For that reason it can be assumed that the theme was traditional and had known meaning to Mimbres people. However, interpretations based on well-documented Pueblo and Mesoamerican sources provide at least three different, equally plausible and mutually compatible scenarios: (1) It represents a human sacrifice made in time of drought by a local priest. This is supported by analogy with reported Hopi and Zuni practices of the nineteenth century and earlier (Kabotie 1949). (2) It represents the ritual decapitation of a Mimbres prisoner by a Casas Grandes warrior. Although supported by analogy with contemporaneous and earlier Mesoamerican practices, the revised chronology for the Casas Grandes system, centered at Paquimé, makes this the least tenable explanation (Di Peso, Rinaldo, and Fenner 1974:150, 707 n. 21). (3) It illustrates the Mimbres version of a Classic Mayan myth as recorded in the sixteenth century. In that Quiché Mayan version of the *Popol Vuh,* one of two twin culture heroes decapitates his brother as part of a scheme to trap and kill the Lords of the Underworld (Tedlock 1985:153–155).

The mortuary contexts in which so many Mimbres representational paintings are found adds meaning to this interpretation. The *Popol Vuh* is the oldest known surviving text telling of the Hero Twins and their conquest of the

Lords of the Underworld, the fearful masters of the worlds where dead souls must wander on a hazardous journey to their final resting place (Tedlock 1985). But the tale was ancient at the time of its sixteenth-century recording, and even that earliest recorded version is only one of an unknown number of variations that were told in countless ancient American societies, probably including some of the Southwest, in countless languages, over the course of countless centuries.

In the Quiché Mayan text, we are told of the houses and gardens of Underworld Lords that were guarded by different birds, jaguars, and bats, and it is clear that the narrative takes place in a tropical, highland Guatemala Mayan environment. Still, many of those animals or their near relatives figure prominently in Mimbres iconography, occasionally with details that are surprisingly close to those in Mayan art. Thus, "killer bats" of the Mayan underworld are depicted with crossed long bones on their wings (Coe 1973:14); some Mimbres bats and batlike creatures are drawn with crosses on their wings, and some can easily be imagined as dangerous and even malevolent (figs. 177, 180, 206, 221, 222). But what, where, and when were the root sources of those visual similarities? And how can we ever know of metaphorical transformations that may have occurred between one place and time and the other?

Other death-related beings and events that figured in ancient Mesoamerican art and have parallels in Mimbres art include the armadillo (fig. 218), the owl (fig. 223), and the centipede, in addition to stilt dances performed by the Hero Twins in the underworld. Mortuary iconography in the south also includes dogs, flying insects, waterbirds, frogs, a fish god, deer, rabbits—all familiar figures in Mimbres art as

well—and celestial signs associated with the twins and their father and uncle—the sun, the moon, and Venus as both morning and evening star. Morning and evening stars are sometimes shown as four-pointed stars in historic Pueblo ritual art, and at least some of the four-pointed figures of Mimbres art suggest representations of Venus in both of its manifestations (fig. 127). And in the Pueblo world as in Mesoamerica, the Hero Twins are associated with Venus and with warrior societies. The catalog of similarities is impressive and suggests that the pictures on many vessels that the Mimbres sacrificed to their dead referred to a complex mythology of death that is of unknown antiquity and that was and is shared widely throughout the greater Southwest and Mesoamerica. The earliest appearance in the Southwest of that iconography as a distinct complex appears to have been in the art of the Classic Mimbres era.

Ideological relationships between the Southwest and Mesoamerica were manifested in many ways and seem to have been intermittently active from time immemorial. They are specified and humanized in Mimbres paintings, which also depict large, treelike staffs that may relate to the "tree of life" of *volador* ritual (J. C. Kelley 1974), birds and serpents (pl. 11), twin culture heroes, and transformations of many sorts, including human-fish interactions suggestive of yet other underworld adventures of the twins (figs. 24, 42, 202, 205; Thompson 1994, 1999). Other shared representations include metaphorical ones of sipapus and of the daily rotation of day and night, and many other cosmological references to basic Southwestern and Mesoamerican origin legends which are also of unknown antiquity (Thompson 1999).

Several Mimbres pictorial variations of emergence themes are known, and all of them, while basically similar, differ in detail from any

recorded Southwestern version of the legend. In one, on a vessel whose present whereabouts is unknown, a group of men is shown in a spiral composition, crawling through a tunnel-like structure and climbing upward (Fewkes 1923:fig. 3). In another, an underground world is more clearly indicated in which a single man is chopping his way out of a womblike cave and into a tunnel filled with birds that seem to be metamorphosing. At the other end of the tunnel, a gigantic bird appears to be enclosed within another cave (fig. 196). Similarities with the religious iconography of both the Pueblos and Mesoamerica seem clear, but Mimbreño use of these common themes appears to be unique, just as modern Southwestern Pueblo expressions of similar themes are unique. The suggestions must be made, first, that some aspects of the ideology pictured were basic and ancient, and second, that the Mimbres people, when exposed to new ritual ideas, no matter what the source, characteristically adapted them in their own way.

For whatever reason, the Mimbres pottery-painting style, its iconography, and its pictorial metaphors were submerged in later times, just as Mimbres people everywhere lost every vestige of a particular visual identity before the end of the twelfth century. Some of their major iconic themes had appeared as early as the tenth century on Style I Black-on-white pottery, but most made their first appearance no earlier than the eleventh century. This was well before Paquimé had grown in importance as a trade center, but even so, trade contacts were bringing tropical macaws to the Mimbres and Southwestern turquoise and northern Mexican pigments (Mary Miller, personal communication 2002) to Mesoamerica. At about that time, too, similar contacts with the south were manifested at Chaco Canyon (Mathien 1993; J. C. Kelley

1960, 1966), and there may have been an influx of people from the south into the Hohokam region as well (Doyel 1975; Schroeder 1960). The peculiar iconography seen in the surviving Mimbres arts suggests that the Mimbreños' response to their knowledge of far-off places, peoples, and traditions was independent of both the northern Pueblos and the Hohokam.

Their pottery-painting tradition developed as an expression of and in coordination with a new, perhaps demanding, and almost certainly unique religious complex. Rock art, architecture, and burial practices are other tangible expressions of that complex, which flourished in response to the rapid population expansion that changed the nature of Mimbres society after the late 900s C.E. For more than a century thereafter, the Mimbreños of the Mimbres Valley, still essentially a subsistence-based society, managed well enough as they benefited from fortunate climatic conditions and their own technological innovations. But what was certainly a delicate balance of population numbers, technological skills, and resource sufficiency could not be maintained, and neither the large Mimbres villages nor the social and technical mechanisms that supported them survived the middle of the twelfth century.

Many of the qualities that characterize Mimbres art, especially aspects of its iconography and its concern for developing tense harmonies of opposing visual dualities such as dark and light, tend to support the proposition that Mimbres people were well aware of their delicate balance with nature. Mimbres paintings, after all, were created by and used by ordinary Mimbres people in their daily lives. They were simultaneously ordinary objects of daily life, expressions of a religious system, and potential mortuary offerings. On every imaginable level they implied a linkage between the world of ordinary humans and those inhabited by spiritual forces.

If the almost ubiquitous stylized motifs of geometric paintings are indeed abstractions of clouds, rain, and other weather-related phenomena essential for agricultural success, then themes related to fertility dominate the iconography of Classic Mimbres painting and of the religious complex of which it was an expression. Other, more particularly phallic references to fertility seem to occur most often late in Mimbres art (figs. 26, 200), as do subjects that seem to focus on death and the underworld (figs. 31, 206). The dual themes of fertility and mortality are consistent with the balancing of oppositions that so characterizes Mimbres art, and the greater specificity of those themes late in the tradition suggests awareness by the artists that their world might be slipping out of balance. Mimbres painted pottery and Mimbres religion were two different but related means for coping with the critical problems of their times.

Ethnoaesthetic and Other Aesthetic Considerations

The utility of the vessels on which Mimbres paintings were made is obvious. They were containers for food, water, ritual objects, and a great variety of other things, and many were ultimately used as mortuary offerings. The utility of the paintings is not so easily assumed or demonstrated. The paintings have little or no obvious relationship to vessel use, and they underline the proposition that the functions of a utilitarian object should never be confused with the functions of the decorations applied to it. A picture is not a pot; the two mean different things, are used for different purposes, and function in different ways for different ends.

To judge from their scarred interiors, many Mimbres bowls were used for food service and food preparation. These bowls are likely to have any kind or quality of geometric painting applied to them, but most figurative pictures are scarred in the same way, so presumably the vessels on which they appear were used for the same purposes. Most paintings that have been found whole or nearly so, whether with life-form or geometric subjects, are on bowls that were punctured in the center—"made breathless" (Brody and Swentzell 1996), "sacrificed,"

or "killed"—and used as mortuary offerings. But the thousands upon thousands of potsherds that once marked all Classic Mimbres sites testify that most Mimbres painted pottery was never buried with the dead. Reexamination of the evidence does not support the view that any Mimbres painted pottery was ever made solely to accompany the dead, even though the pictorial subject matter itself seems so often to refer to death.

Few Mimbres vessels and almost none with figurative paintings were traded outside the Mogollon region, but they are found in some numbers in other Mogollon areas, especially the Jornada district to the east, where some people made no painted pottery of their own. It is suggestive that many Mimbres-style petroglyphs are found deep within Jornada Mogollon areas and that Mimbres pictorial art, at least among Jornada Mogollon people, seems to have had values that transcended economics and utility. If, as has been suggested, Mimbres painted pottery was used for food service at large-scale public feasts, then guests from distant places might have received vessels as gifts, in which case they might indicate relationships more

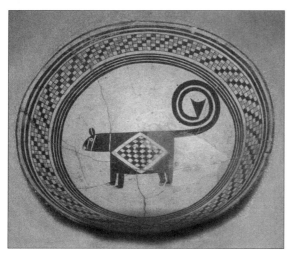

Figure 224. Bowl, Mimbres Classic Black-on-white (Style III), 12.5 x 28 cm, 4.9 x 11 in. Bearlike animal with a long, curled tail that has a fishtail-like form at its end. Excavated by E. D. Osborn (site unknown) and purchased about 1923 for the Heye Foundation, Museum of the American Indian (now the National Museum of the American Indian) by J. W. Fewkes. Fewkes suggests the animal may be a lion (Fewkes 1923:10,30, fig. 20). (NMAI 5/754)

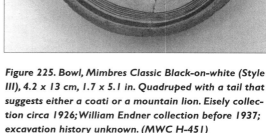

Figure 225. Bowl, Mimbres Classic Black-on-white (Style III), 4.2 x 13 cm, 1.7 x 5.1 in. Quadruped with a tail that suggests either a coati or a mountain lion. Eisely collection circa 1926; William Endner collection before 1937; excavation history unknown. (MWC H-451)

complex than those of simple trade (Shafer 1996). Where Mimbres pottery was traded for an economic return, it might have been for the contents of a vessel, for the vessel itself as a container, for the paintings on it, or for all or none of these reasons.

As well as being imaginative creations made to serve imaginative functions on utilitarian objects, Mimbres pottery paintings were made as decorative visual stimulants that pleased and titillated: they were made to be beautiful. The complex imagery of the geometric paintings creates intellectual puzzles, metaphorical visual games designed to exercise the imagination. The figurative pictures are stimulants of a different order: metaphors but also symbols, signs, illustrations that suggest moral, ethical, or didactic ends, emblems, social commentaries, and mnemonic

devices. Whatever their specific purposes, they held far more meaning for people familiar with their references than they can possibly have for any later observers (figs. 224, 225). They retain the power to stimulate the imagination, but for personal rather than social ends, evoking speculation that easily degenerates into romanticism or inanity. And their new, present-day social purposes have no bearing on their original intentions.

If the Mimbres used their paintings for sensual and emotive purposes, then their art functioned as art to its makers and their audiences. The pots served physical functions; the paintings on them served psychic and social ones. Among these last, two should be looked at with some care. First was the use of paintings as self-conscious symbols of the Mimbres com-

munity, and second was their use as imaginative attempts to "classify out the universe," to use Claude Lévi-Strauss's phrase (1963), or invent a form of what he called "objective coding."

Mimbres Painting as Community Identification

The Pueblo Indians may serve to illustrate the first of these functions, the use of paintings as self-conscious community symbols. At many modern pueblos, painted pottery art is an expression of individuality and strength. In some of the upper Rio Grande towns and at Acoma, Zuni, Zia, and Hopi, any strong decorative traditions that are deeply rooted in the past are consciously considered a sign of the group's integrity, vitality, and quality (Bunzel 1929; Maxwell Museum 1974; Wyckoff 1985). In many of these places, interpersonal rivalries and competition among potters sometimes create community tensions, but they also serve to maintain standards of craftsmanship and stimulate decorative invention. Competition between communities acts as an agent for integrative bonding within each one while promoting the spread of regional craft and decorative ideals. Assurance of technical and decorative equality or superiority, even when personified in the work of an individual artist, becomes important to the self-image of each community. As much as any other factor, this may account for the viability of the craft and the revivalism that periodically occurs in pueblos where pottery-making traditions have died.

The Mimbres Valley community as a whole was larger than many modern pueblos, including as it did perhaps a hundred or so large and small villages and three thousand or four thousand people. Although most pueblos today have satellite villages, the analogy to the past is most visible at Hopi, which is an entity composed of more than a dozen distinct towns scattered over about fifteen linear miles. At Hopi, and presumably at other pueblos, comparative judgments today may be made at several levels that determine the importance of pottery paintings as community self-images. At the lowest level, these are between the work of two potters or two families of the same village; at the next, between paintings produced by different communities that share a closely related design tradition; and at the next, between these and all the rest of the pueblos (Wyckoff 1985). Ultimately, the comparison is between the pottery art of all of the pueblos and that of the rest of the world.

Differences in design between any two contemporary pueblos are much more visually obvious than those that existed between any two Mimbres towns, but that does not affect the analogy. Intensification of differences is a relatively recent phenomenon resulting partly from the enormous population losses and restrictions on mobility that followed upon the European invasions. Reduction of the number of Pueblo villages by 90 percent or more means that design traditions that were once widespread and shared by dozens of towns became focused on the few that survived. To a greater or lesser degree, each modern pueblo, though much larger than even the largest of the Mimbres villages, is a shrunken vestige of a much larger group of communities that was in many respects comparable to that of the Mimbres.

Other factors have further intensified differences since the last decades of the nineteenth century. The Pueblo Indians are surrounded and dominated by alien people and have become a relatively powerless minority in their own land. Their need to assert identity in

opposition to immigration of new populations is obvious. Less obvious, perhaps, is that the economic domination of the painted pottery market by alien consumers has meant that Pueblo people must now accept some new aesthetic values. The new consumers insist on being able to identify individual artists and, to a lesser degree, individual communities, and this insistence further reinforces visual distinctions that arise not only from the unique qualities of each pueblo but also from idiosyncratic differences between artists of the same community. Because of these internal and external pressures, pottery art now proclaims identification and the self-worth of a particular community and, with increasing emphasis, of individual members of it.

It may be that the function of pottery painting as a community identifier was less important to Mimbres people than to those of the modern pueblos and perhaps less important even than it appears to have been to our alien eyes. The identity pressures of Mimbres times were different and possibly less intense than they are today. Precise historical parallels are impossible to draw and would be suspect in any case, but the fact remains that we identify the Mimbres by their pottery art, and it is almost unthinkable to us that it was not one of the means they used to identify themselves. That, in the end, there was some need to assert self-identity is evident, given that their communities did not survive.

Painting as a means of proclaiming Mimbres regional identity is more easily demonstrated than the use of the art for a similar purpose by towns or individuals within the region. There is at present no clear evidence of any village traditions or "schools" that produced works recognizably different from those of the regional type. In part this is because so much

that has survived is without provenience, but in part it is also because we may not know what to look for. Patterning systems and design values were similar throughout the region, and certain motifs that have the appearance of being individualistic seem also to have been used anywhere. It should be remembered that the specifics that defined individuality in the Zuni pottery-painting system, for example, were invisible to outside observers because it was not motifs but their patterned distribution that expressed idiosyncrasy (Bunzel 1929).

Attempts to define the visual differences between various kinds of decorated pottery made at the Tewa and Keresan pueblos within the last century further illustrate the problem (Dillingham 1992; Frank and Harlow 1974; Harlow 1967, 1973). Even when provenience is known and the paintings are only a few generations removed from the historical present, it sometimes is hardly possible to define any visual characteristics that proclaim either individual or town identity. We are left, then, with the belief, but no evidence, that the Mimbres tradition could not have intensified to the degree that it did in the absence of some comparative system for making critical corporate judgments about the quality of painted pottery. If comparative judgments were also made at the local and personal levels, then they must inevitably have led to the creation of locally recognized painting modes that served to identify particular places and, perhaps, people.

Mimbres Art as Metaphor

In one respect, at least, Mimbres paintings resemble all other expressive works of art: each one is a micro-universe within which the artist creates a drama. There are several dimensions to the postulated social function—the function

of "classifying out the universe"—of Classic Mimbres painting. This art, like any other, was a metaphorical ordering or classifying of phenomena, a kind of taxonomy used to create order in a disorderly universe. Thus, our own classification of it into two genera, the representational and the geometric, recognizes a distinction that seems, in fact, to have been made by the Mimbres. In their system, certain kinds of natural and imagined natural phenomena, especially animals, were pictured as existing in one kind of visual space, whereas other invented and geometric forms were made to fit into another.

Every successful Mimbres geometric picture is in stasis as a harmonic balance of tensions: dark-light, positive-negative, curve-straight, in-out, push-pull, physical space–illusory space. In every case the painter began with nothingness, deliberately created binary oppositions—of which any pair had the potential for fragmenting the composition—and then brought all of these forces into balance until the picture was made harmoniously self-contained. The balance was always a matter of linking each pair of oppositions to each other and of treating all pairs in parallel ways. Thus color, linear direction, visual direction, and visual space were all dealt with as pictorial coequals, and specific motifs were no more than by-products of the painting process. Geometric motifs may well have been recognized and even named, but they probably had no meaning out of context, and their context was structural. The motifs exist only in relation to each other and as elements of a pictorial universe. Everything, including the technology that produced the picture surface and its tense draftsmanship, contributed to creating the image of a universe whose substance was made up of pairs of opposing forces. If these were not in balance, the universe could not be

held together, and the picture, aesthetically and intellectually, was a failure.

The harmony of a geometric painting depended ultimately on the indivisibility of its physical surface, which was the picture space, and the illusory visual space that was created when marks were made on that physical surface. Symbolism intrudes on the metaphor of a harmonic universe of oppositions when the painted images are of life-forms. Living things in a real world occupy real space, whereas their images in the imaginary world of a painting can occupy only an ill-defined image of real space. The cohesive unity of the totally imaginary geometric universe can never be achieved when life-forms are portrayed. Real animals in the real world move incessantly in an open space without borders. But the space occupied by a painted animal is restricted and arbitrary, defined by a framing line that can be positioned in one spot as well as another. And because that illusory space is so ill-defined, it is perceived as different from the physical surface. Pictures of life-forms that are organized as though they were geometric motifs achieve a harmony of physical and illusory space, but only so long as they are hidden in the pictorial mass. The instant they are perceived, a spatial illusion occurs that separates them from the picture surface, and they can return to the harmonic universe of geometric painting only when perceived again as geometric masses (pls. 10, 14).

Vignetted representational pictures on Mimbres pots are emblems clearly divorced from the harmonic ideals of Mimbres geometric painting, and full reintegration of physical and visual space could be achieved only at the expense of figurative clarity. The continued invention of distinctive visual spaces in which representations would appear comfortably active in their picture space emphasizes the

value the Mimbreños gave to images of living things and to the idea of re-creating or reordering perceived reality. Their two kinds of painting were conceptually distinct and mutually exclusive. In one, the intent was to create an imaginary harmonic universe that was kept in stasis by the equivalence of all of its parts. In the other it was to create a universe to be dominated by and exist for certain imaginary beings. The objective of figurative painting was again to develop a harmony, but of a different order, for the physical and visual spaces were conceived of as distinctive opposites rather than as an indivisible unity.

In their geometric paintings Mimbres artists built models of a spatial system occupied by forces that were in tense opposition to each other. In their complex figurative paintings they built models of real space that was occupied by images of real things. In both, the structuring of a harmonic balance was an ideal, but two separate kinds of reality were involved, and each required different systematic solutions based on differing sets of assumptions. Rather than the by-products of a painting process, the images and motifs of representational paintings are their subject matter and reason for being. They introduce other sets of relationships that are ideogrammatic rather than visual—that exist between the images of the things, the things themselves, and any meanings that might have been given to either.

Ideogrammatic meanings are indivisible from formal presentations but are ever changing and absolutely dependent on social time and place. The energy Mimbres painters spent in inventing plausible operative spaces for their figures is a measure of their concern for perceptual reality, a concern they shared with other artists in other times and places, and its message is unequivocal. The ideogrammatic language is, however, a far more specific kind of communication than the visual one and is always defined by cultural and social contexts. As every satirist knows, an ideogram must be put into formal harmony with socially defined expectations for its meaning to be clear. Since those expectations are always transitory and arbitrary, they are irrelevant to pictorial functions, however necessary they may be to communicative ones. After their meanings have been lost, those communicative formalities may become neutral, but they always carry a disharmonic potential. A portrayal of the Italian Fascist dictator Benito Mussolini as a green-faced jack-in-the-box, painted by the American artist Peter Blume in the 1930s, was a powerful and ideogrammatically harmonic image. It has since become increasingly disharmonious. Because of its formal peculiarities, its message became first quaint, then bizarre, and then a conundrum as memories of the dictator, his character, and his political actions were erased by time.

If a representation survives the society for which it was made, it often does so devoid of its original meanings, but it may be given new ones by new audiences. A painting of Saint Sebastian tied to a stake and punctured with arrows may have been intended to inspire veneration for the man and condemnation of his tormentors. The image is graphic and evocative, but had he not survived the attempted execution, or had his torment been less picturesque, he might well have been ignored by the image makers. However, the picture can be made meaningful in any number of novel, imaginative ways that need have no relationship to the painter's original intentions or might even be antithetical to them. Identification of the figure as a Christian saint may limit the range of interpretation but is still not definitive. The

picture could reasonably be interpreted as a warning about the foolhardiness of saintly behavior and its dire consequences.

In the absence of any documentation except the images themselves, archaeological iconography can offer little toward discovering any original and specific meanings, other than calling a thing by its name. To identify a horned serpent in a Mimbres painting as perhaps related to Quetzalcoatl of Mexico or to the *awanyu* of the Tewa Pueblo Indians approaches the limits of interpretative possibilities. To identify it unequivocally by either name gives it historical meaning that is not only unsupported by evidence but may be forever unsupportable and is thereby indefensibly misleading. Further refinement may be made through familiarity with documents referring to precontact practices in Mexico and Mesoamerica and by knowledge of contemporary Pueblo religion. Though other important historical purposes may be served by these refinements, and reasonable original meanings of the motif may be postulated, they can never be proven. Paleolithic wall paintings or ancient Arctic figurines may be identified as "fertility," "magic," or "sacred" images, but there is no way of knowing why they were made, how they were used, or what they were originally supposed to mean, and such characterizations may, in the end, be meaningless. Iconographic studies in these circumstances can be useful for the reconstruction of history and ethnography, but they can hardly re-create a lost ideology.

Even when they cannot be specified, original social ideogrammatic meanings can be surmised by later audiences familiar with the social and historical matrices of a work of art. The same is true of more private and emotive expressions, which are also indecipherable out of context because their conventions are defined by social matrix. The smile on the *Mona Lisa* may express knowing wisdom, a broken heart, or indigestion. Having outlived her time, her expression is a puzzle to which only documentation may offer an intellectual solution, which is the very antithesis of emotive communication. In terms of direct expressive values, the absence of documentation is no great loss, for only imaginative interpretations can hope to approach original expressive intentions. Yet such interpretations can have no bearing on the reconstruction of original meanings or history, for they are evidence of the re-creation of the work of art by a new audience. They merely illustrate the philosophical conundrums created by Marcel Duchamp with his "readymade" art of the early twentieth century.

The assumption that modern interpretations of Mimbres expressive conventions correspond to the original ones has led to stereotyping. For example, interactions between cranes and fish in some Mimbres pictures have suggested conversations to some observers (Fewkes 1914, 1923, 1924; Snodgrass 1973, 1975; Watson 1932). It is not at all clear that the animals shown in these paintings are in verbal communication, although some sort of by-play is obvious, but the idea has taken hold and given rise to anthropomorphic interpretations that belong to the world of fantasy, children's stories, and cartoons. If Mimbres animals are "beasties"—harmless, cuddly, cute, and comical pictures illustrating the homely, folksy, childish wisdom of the Mimbres people—then the expressive intentions of the artists, no matter how profound they might have been, are trivialized by the expectations of an alien world.[1]

In other social contexts, talking animals can carry other social meanings, and the range of possible meanings is as great as the range of human intellectual expression. Acceptance of

one set of meanings as being timelessly correct forecloses all others. The intellectual and expressive content of Mimbres pictures is thought to be understood, and the painters and their original audiences are stereotyped into categories made by and for the interpreters. The obvious expressive complexity of the pictures, their structural harmony, and their frequent mortuary associations make any frivolous reconstruction of original social meanings absurd. An audience that cannot read a language but insists on translating it only illustrates the potential for disharmony that is latent in any ideogrammatic art.

Paintings are imaginative artifacts that have the intrinsic capability of being reused for purposes that could not have been imagined by their makers. Resurrection in a new context may be an obscenity or a sacrilege, but misuse can be prevented only by the timely destruction of a picture when its original meanings become obscure. To pragmatists able to discover new values in old artifacts, considerations of obsolescence are meaningless, but the new values can have social authenticity only if their novelty is acknowledged. To do otherwise simply makes over the past in the image of a present whose values must be judged by the future as ethnocentric. There is no escaping the limitations: the symbolic and expressive meanings of the imaginative product must change as it interacts with new times, places, and people.

New Uses for Old Art

In the context of Southwestern archaeology at the turn of the twentieth century, the rediscovery of Mimbres paintings was startling. The geometric metaphors could be understood on an intuitive level; they were unique but still fitted a model based on experience of what prehistoric Southwestern painted pottery

should be. But nothing discovered earlier, not even the figurative paintings of the Sikyatki tradition, could have prepared an observer for the realism of Mimbres figurative paintings. The novelty lay not so much in their imagery as in their apparent concern for a kind of perceptual reality. A parallel to the illusionism of familiar European picture making seemed obvious, and the "naturalism" or "realism" of Mimbres figurative painting, at once familiar and alien, called for a kind of understanding that went beyond intuition but was impossible to achieve. In their new context the paintings were considered more as the key to a code than as imaginative artifacts that existed independently of their own past.

Resurrected by people mostly interested in their historical and ethnographic values and then confined to institutions committed to investigating such matters, Mimbres paintings had little impact as, or on, twentieth-century art until recent years. Most earlier analysts concentrated on the iconographic specifics of the representational paintings and their documentary potentials and were more or less frustrated by their inability to crack the code. Because the art could not be made to reveal any timeless messages, investigations were shelved and the pictures were set aside as curiosities to be looked at later.

That situation began to change in the 1970s when two parallel scholarly activities began to interact. New archaeology in the Mimbres Valley had begun at about the same time I completed a first draft of the first edition of this book. Then, at about the time of its publication in 1977, what may have been the first large, interpretive, and highly popular exhibition of Mimbres art was organized jointly by the Maxwell Museum of Anthropology of the University of New Mexico in Albuquerque and the Taylor Museum and Colorado Springs

Fine Arts Center in Colorado Springs. Soon, other Southwestern institutions organized small exhibitions of Mimbres art. Its first large-scale, national exposure came in 1983, when the American Federation of Arts opened a major traveling exhibition of the art. Shown in large cities across the United States over a two-year period, it closed at New York's Metropolitan Museum of Art. For the first time, some of the most spectacular examples of Mimbres painting were brought together from major collections to be seen and treated seriously in art venues by the art community.

Since then, important exhibitions of Mimbres art have been developed by several major art museums, which also published popular and scholarly books and catalog essays to accompany the exhibits. Those publications, along with critical exhibition reviews and art magazine essays, have in some ways been even more influential than the ephemeral exhibitions themselves (Brody, Scott, and LeBlanc 1983; Brody and Swentzell 1996; Townsend 1992). No longer an invisible art, Mimbres paintings had become incorporated into the art structure of the contemporary, postindustrial world.

Still, almost the only modern uses of the art have been as inspiration for curios and as models for serious work by some Pueblo and northern Mexican potters and easel painters. For the most part, people's concern has been with the ideo-grammatic potential of Mimbres art, rather than with its structural or metaphorical qualities. Whether Mimbres painters were directly, indi-rectly, or not at all ancestral to any modern Pueblo people, they were indisputably ancient and Southwestern, and Mimbres motifs have current symbolic value for all of the Pueblo Indians as emblems of legitimacy and antiquity. They are selected not for any specific ancient meanings but for practical reasons: because they fit particular formal and decorative requirements and because, rightly or wrongly, they are identi-fied metaphorically with antique independence.

Julian Martinez of San Ildefonso Pueblo may have been the first modern Pueblo pottery painter to adapt Mimbres motifs to his own art. During the second and third decades of the twentieth century, he and his wife, Maria, came to personalize the revival of pottery making at San Ildefonso. He used motifs from several ancient Southwestern sources, including pottery recovered from nearby ruins, museum speci-mens, and photographs made available to him by friends and employers at the Museum of New Mexico in Santa Fe. One Mimbres motif in particular was translated to the new pottery with a great deal of success. This was a radiating pattern suggestive of a feather fan that was applied to the interiors of flat plates or the exteriors of bowls or ollas (fig. 226). The model for it seems to have been a bowl first pictured in 1923 that did not come into a public collec-tion until many years later (fig. 121; Fewkes 1923:fig. 120). By the 1930s the motif not only was part of the design inventory of San Ildefonso pottery painters but had become almost a logo for the pueblo. It spread from there to other Rio Grande pueblos and ultimately became a generic modern Pueblo emblem. To that degree at least, the Mimbres decorative system entered the twentieth century as an active stimulant after seven hundred years of dormancy.

Julian Martinez and his contemporaries rendered the feather-fan motif much like those in the original paintings, but in more recent examples, each petal or feather-shaped unit is smaller, more delicate, and, on flat surfaces, more attenuated (fig. 226). Mimbres painters did not use the motif on exterior surfaces, and when San Ildefonso painters place it there, it has a sedate rhythm. On flat plates it is even more swiftly comprehended than on Mimbres bowls. The greatest difference between past and

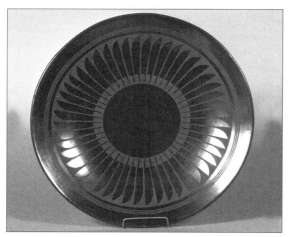

Figure 226. Pottery plate, black on black, 4.4 x 36.9 cm, 1.7 x 14.5 in. Plate by Maria Martinez, painting by Santana Martinez, both of San Ildefonso Pueblo, N.M., 1945–1950. (IARC IAF 2981)

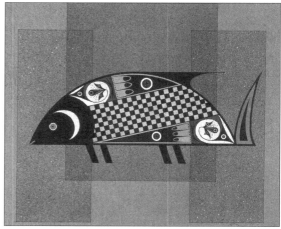

Figure 227. Mimbres. Painting, gouache on paper, 30.2 x 40.6 cm, 11.9 x 16.0 in. By Tony Da, San Ildefonso Pueblo, 1970. (HM 340)

present is a function of color and texture. On San Ildefonso vessels, black on black and red on red are the usual colors, rather than the strongly contrasting black on white of the Mimbres originals. San Ildefonso slips are burnished to the highest possible gloss, and the thick paint applied over them has a dull matte texture. Slip and paint are identical in color, and only the textural contrast reveals the painted designs. The subtly elegant results are entirely different from the strong, deliberate oppositions of Mimbres Black-on-white paintings, and the harmonies are of a different order, with modern paintings depending on the balance and perfection of fewer visual elements. A highly burnished black surface, when properly fired, has a mirror-like luminosity against which the dull paint can operate. An unending variety of images is produced by the effects of light on these surfaces, but if reflectivity is reduced, visual interest goes with it.

Antique motifs, including those derived

from the Mimbres, are used in other contemporary Pueblo arts, especially easel painting. Tony Da, a grandson of Julian Martinez and a creative potter as well as a painter, was one of the first artists to use Mimbres emblems in easel paintings. The textured backgrounds of his paintings interact with the motifs to maintain a two-dimensional picture plane, but the integration of paint and physical surface depends almost entirely on tactile qualities unrelated to Mimbres visual problems or Mimbres pictorial conventions (fig. 227). In more recent years, such easel paintings have become almost commonplace in Pueblo art, which has absorbed a broad spectrum of Mimbres motifs in a variety of media. For the most part their use is emblematic only.

The adoption of Mimbres art at Acoma Pueblo has an entirely different history. Because of its isolation, Acoma was able to maintain something very like preindustrial conditions until almost the middle of the

twentieth century. Its pottery tradition, with an aesthetic firmly based on ancient Socorro and Chacoan styles despite centuries of polychrome painting, remained strong, even though no great efforts were made to develop new outside markets for it. Acoma potters manufactured significant quantities of tourist pottery beginning in about 1880, but decorative continuity with the past was supported by continued home use of pottery products. By the time Euro-American customers became an important enough segment of the Acoma pottery market to exert a critical influence, the Acoma aesthetic was quite distinctive, simply because the pueblo had not altered its decorative traditions very much.

Nonetheless, after about 1950 a greater degree of intellectualization and self-awareness on the part of Acoma pottery painters led to new enthusiasm for an antiquarian revival of black-on-white traditions that had begun as early as 1915. Though some participants in this revival made use of museum specimens and photographs, the primary models were Chacoan, Tularosa, Reserve, and Socorro wares found at sites located on and near the Acoma reservation. The reinvigorated black-on-white styles were enthusiastically supported by both the outside audience and the people of the pueblo. During the 1950s, several potters seem simultaneously to have introduced Mimbres designs, based mostly on published illustrations, and Mimbres figurative motifs were painted as emblems on bowls, plates, and globular vessels. The Acoma Mimbres revival is characterized by neatly, precisely, and accurately drawn motifs, sometimes modified to fit a particular pottery form but generally very like their Mimbres prototypes (fig. 228). As at San Ildefonso, they are often emblems—modern translations of motifs rather than of a design system—but

these ancient patterns also stimulated a more fundamental response, especially in geometric paintings (fig. 229). In these, structural patterns rather than motifs seem to have inspired the modern painters, and all of the tensions and harmonies of Mimbres geometric art can be adapted to the contemporary wares.

The most typical modern Acoma shape is globular rather than hemispherical, and other ancient painting traditions, especially those of the Reserve and Tularosa systems, are better suited to these forms. Nonetheless, some Mimbres bowl designs were freely translated to Acoma jars and other exterior shapes, with about the same or even greater visual success than was achieved by Mimbres painters who attempted to apply hemispherical designs to globular forms (fig. 229). As replication of all of these antique paintings became less mechanical, a modern Acoma black-on-white tradition emerged, and its Mimbres elements are not always easily isolated. The most significant aspect of this revival is Acoma potters' adoption of ancient structural principles, and in this respect their use of the past is unique among the modern Pueblos.

Mimbres art motifs are now seen in many other new Indian and non-Indian contexts, ranging from the absurd to the respectable, from comic souvenir napkins to costly dinnerware. They have been incorporated into a revival of ancient Casas Grandes ceramic traditions at the village of Mata Ortiz in northern Chihuahua. Except at Mata Ortiz, in its resurrected state Mimbres art is used almost universally as an emblem, valued for what it represents rather than for what it is. In that respect its reentry has not been dissimilar to that of other exotic arts that have become a part of the visual inventory of the modern world since the nineteenth century. Even when seen in serious

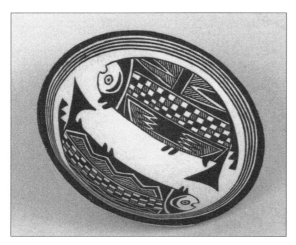

Figure 228. Pottery bowl, black on white, 3.5 x 13.8 cm, 1.4 x 5.4 in. Made and painted by Marie Z. Chino, Acoma Pueblo, 1973. (MMA 74.1.24)

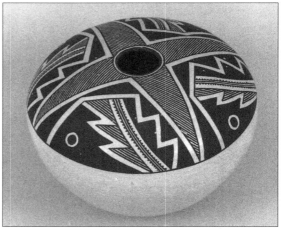

Figure 229. Pottery seed jar, black on white, 14.4 x 21.2 cm, 5.7 x 8.4 in. Made and painted by Anita Lowden, Acoma Pueblo, 1967. (MMA 67.96.2)

contemporary art, the emblematic nature of that use cannot be disguised. Instead, it can be creatively adapted, as by Diego Romero of Cochiti Pueblo, whose use of Mimbres iconography is frankly political and satiric in its inversion of a Mimbres stereotype (fig. 230).

Neither the structural values nor the metaphorical organizations of Oceanic, African, or Mesoamerican art were generally integrated by those moderns who used these arts idiosyncratically. Instead, the native arts merely provided primitivizing ideograms. Even more obviously than in the case of Mimbres paintings, they were reused as stereotypes, formed to fit their new users rather than to revive the ideals of the original makers (Goldwater 1967). It is such stereotyping that destroys the humanity of an art object and converts it into a natural one. Concentration on supposed ideogrammatic meanings diverts attention from the structural ones intended to "classify out the universe," and the art object

can too easily become a "found object," made by as well as belonging to the finder. Romero's exploitation of the stereotype and his inversion of it creates a new kind of humanity for Mimbres art.

As the structural metaphors and the original makers of Mimbres pottery paintings both become more familiar, the modern-made myths dissolve and the resurrected art can become rehumanized. Full realization that the art artifact was made by human hands comes with the knowledge that it served its makers as art. Only when there is certainty that Mimbres paintings were made to function as imaginative products, that they are metaphorical even if they were ideogrammatic, will they begin to serve the same function for new audiences. But never, until due respect is given to the humanity of the makers, can the imaginative artifacts serve their original purpose in unimagined new ways to unimaginable new audiences.

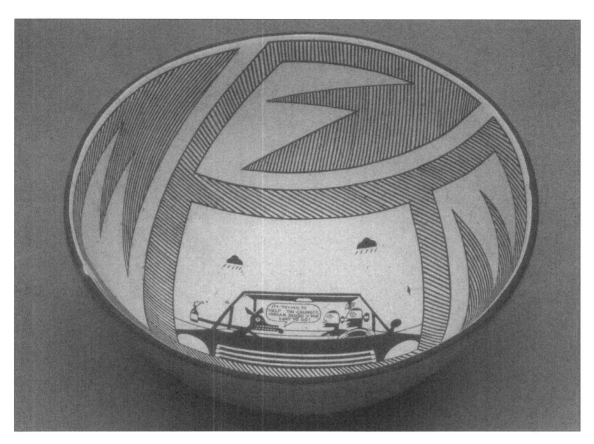

Figure 230. "I'm trying to help you Chungos, Indian Bingo is the way to go." Pottery bowl, black on white, 12.5 x 27 cm, 4.9 x 10.6 in. Made and painted by Diego Romero, Cochiti Pueblo, 1994, as one of an ongoing series featuring the "Chungo Brothers." (MIAC/LAB 54131/12)

Appendix A

Distribution of Pictorial Subjects on 733 Figurative Vessels

All Subjects	All Vessels			Nonnarrative Compositions					
				One Fig.			Two Figs.		
	No. Figs.	No. Pots	% Pots	No. Figs.	No. Pots	% Pots	No. Figs.	No. Pots	% Pots
1. Nonhuman mammals									
Pronghorn	15	15	12	15	8	18	—	—	—
Canine	12	12	10	10	5	11	—	—	—
Deer	10	10	8	11	6	13	—	—	—
Feline	6	6	5	1	1	2	—	—	—
Rabbit	23	23	19	28	14	31	4	1	25
Sheep	25	25	21	16	10	22	—	—	—
Other[1]	19	19	16	2	1	2	—	—	—
Unidentified	11	11	9	6	3	7	9	3	75
Total	121	121	(100)	89	48	(106)	13	4	(100)
2. Amphibians and reptiles									
Frog/toad/tadpole	19	19	28	—	—	—	9	3	60
Lizard (includes horned toad)	25	25	37	4	2	50	4	1	20
Snake	1	1	1	—	—	—	—	—	—
Turtle or tortoise	24	24	35	2	2	50	4	1	20
Total	69	69	(101)	6	4	(100)	17	5	(100)
3. Insects									
Ant-lion larva	9	9	15	6	3	20	—	—	—
Caterpillar	8	8	13	—	—	—	—	—	—
Dragonfly	5	5	8	—	—	—	—	—	—
Grasshopper	8	8	13	4	2	13	4	1	50
Other[2]	6	6	10	8	4	27	—	—	—
Unidentified	24	24	40	12	6	40	4	1	50
Total	60	60	(99)	30	15	(100)	8	2	(100)

Narrative Compositions

Three Figs.		With Humans				No Humans			
No. Figs.	No. Pots	% Pots	No. Figs.	No. Pots	% Pots	No. Figs.	% in Class	No. Figs.	% in Class
3	3	19	4	4	13	37	13	29	13
4	4	25	—	—	—	26	9	21	10
2	2	13	3	2	7	26	9	20	9
1	1	6	11	10	33	19	7	18	8
1	I	6	5	5	17	61	22	44	20
1	1	6	5	3	10	47	17	39	18
3	2	13	6	3	10	30	11	25	11
4	2	13	3	3	10	33	12	22	10
19	16	(101)	37	30	(100)	279	(100)	218	(99)
—	1	33	—	—	—	29	30	23	28
—	—	—	—	—	—	33	34	28	34
2	2	67	2	2	100	5	5	5	6
—	—	—	—	—	—	30	31	27	33
3	3	(100)	2	2	(100)	97	(100)	83	(101)
—	—	—	—	—	—	15	13	12	14
2	2	50	3	2	33	13	11	12	14
—	—	—	—	—	—	5	4	5	6
1	1	25	1	I	17	18	16	13	IS
—	—	—	1	1	17	15	13	11	13
7	1	25	3	2	33	50	43	34	39
10	4	(100)	8	6	(100)	116	(100)	87	(101)

All Subjects	All Vessels			Nonnarrative Compositions					
				One Fig.			Two Figs.		
	No. Figs.	No. Pots	% Pots	No. Figs.	No. Pots	% Pots	No. Figs.	No. Pots	% Pots
4. Birds									
Parrot	5	5	5	4	2	20	—	—	—
Quail	15	15	15	2	1	10	—	—	—
Turkey	4	4	4	2	1	10	10	3	17
Other Galliformes	6	6	6	6	3	30	8	4	22
Waterbird—long leg	8	8	8	—	—	—	—	—	—
Waterbird—short leg	6	6	6	—	—	—	—	—	—
Other[3]	4	4	4	—	—	—	—	—	—
Unidentified	53	53	53	6	3	30	42	11	61
Total	101	101	(101)	90	10	(100)	60	18	(100)
5. Totals—all subject classes									
Nonhuman mammals	121	121	26	89	45	40	13	4	12
Humans	32	32	7	4	2	2	2	1	3
Amphibians and reptiles	69	69	15	6	4	4	17	5	15
Insects	60	60	13	30	15	13	8	2	6
Birds	101	101	22	20	10	9	60	18	53
Fish	38	38	8	42	21	19	22	6	18
Mythic creatures	47	47	10	34	17	15	4	1	3
Total number of pots involved[4]	468	468	(101)	225	113	(102)	126	34	(110)

Source: Sample of 733 published and unpublished images of representational Mimbres pottery paintings examined by the author between 1972 and 1975.
1. Includes possible armadillo (2 on 2), bat (5 on 5), bear (10 on 7), beaver (3 on 2), coati (2 on 2), raccoon (8 on 7).
2. Includes aphid (4 on 1), blister beetle (1 on 1), damselfly (2 on 1), inchworm (3 on 3), millipede (2 on 2), moth (2 on 2), scorpion (1 on 1).
3. Includes hummingbird (6 on 1), roadrunner (5 on 5).
4. Pot number corrected for occasional use of two or more subjects on one vessel.

Narrative Compositions

Three Figs.			With Humans			No Humans			
No. Figs.	No. Pots	% Pots	No. Figs.	No. Pots	% Pots	No. Figs.	% in Class	No. Figs.	% in Class
7	6	50	2	1	3	18	6	14	8
—	—	—	16	4	14	33	12	20	12
1	1	8	2	1	3	19	7	10	6
—	—	—	4	2	7	24	9	15	9
—	—	—	26	12	41	34	12	20	12
—	—	—	10	4	14	16	6	10	6
—	1	8	6	1	3	11	4	6	3
IS	4	33	9	4	14	125	45	75	44
24	12	1991	75	29	1991	280	(101)	170	(100)
19	16	23	37	30	61	279	24	216	29
152	69	(100)	—	—	—	171	15	104	14
3	3	4	2	2	4	97	8	83	11
10	4	6	8	6	12	116	10	87	12
24	12	17	75	29	59	280	24	170	23
11	11	16	20	16	33	133	11	92	13
—	—	—	—	—	—	88	7	65	9
219	69	(166)	142	49	(169)	1,161	(99)	733	(111)

Appendix B

Specific Attributes of Compound or Mythic Animals: 85 Images on 65 Vessels

	Bat	Bear	Deer	Feline	Rabbit	? Sheep	Human	? Mammal	Frog	Lizard	Turtle
Bat	—	—	—	—	—	—	1	—	—	—	—
Bear	—	—	—	—	—	—	1	—	—	—	—
Deer	—	—	—	—	—	—	—	—	—	—	—
Feline	—	—	—	—	—	—	2	—	—	—	—
Rabbit	—	—	—	—	—	—	—	—	—	—	—
? Sheep	—	—	—	—	—	—	—	—	—	—	—
Human	—	1	—	2	—	—	—	7	—	—	—
? Mammal	1	—	—	—	—	—	7	—	—	—	—
Frog	—	—	—	—	—	—	—	—	—	—	—
Lizard	—	—	—	—	—	—	—	—	—	—	—
Turtle	—	—	—	—	—	—	—	—	—	—	—
Snake	—	—	—	—	—	—	1	—	1	—	—
Fish	—	1	—	—	1	2	4	6	1	1	1
Grasshopper	—	—	—	—	—	—	—	—	—	—	—
Scorpion	—	—	—	—	—	—	—	—	—	—	—
? Insect	—	—	—	—	1	1	2	—	—	—	—
Owl	—	—	—	—	—	—	1	—	—	—	—
Turkey	—	—	—	—	—	—	—	—	—	—	—
? Bird	3	—	1	1	—	—	1	3	—	1	—
? Animal	—	—	—	—	—	—	1	—	1	—	—
Total	4	2	1	3	2	3	20	17	3	2	1

Source: Sample of 733 published and unpublished images of representational Mimbres pottery paintings examined by the author between 1972 and 1975.

Snake	Fish	Grass-hopper	Scorpion	? Insect	Owl	Turkey	? Bird	? Animal	Total	% of Artifacts (131)	% of Images (85)
—	—	—	—	—	—	3	—	—	4	3	5
—	1	—	—	—	—	—	—	—	2	2	2
—	—	—	—	—	—	—	1	—	1	1	1
—	—	—	—	—	—	—	1	—	3	2	3
—	1	—	—	1	—	—	—	—	2	2	2
—	2	—	—	1	—	—	—	—	3	2	3
1	4	—	—	2	1	—	1	1	20	15	23
—	6	—	—	—	—	—	3	—	17	13	20
1	1	—	—	—	—	—	—	1	3	2	3
—	1	—	—	—	—	—	1	—	2	2	2
—	1	—	—	—	—	—	—	—	1	1	1
—	—	1	—	—	—	—	1	—	4	3	5
—	2	1	—	—	—	—	5	4	29	22	34
1	1	—	—	—	—	—	—	1	3	2	3
—	—	—	—	1	—	—	—	—	1	1	1
—	—	—	1	—	—	—	—	—	5	4	6
—	—	—	—	—	—	—	—	—	1	1	1
—	—	—	—	—	—	1	—	—	1	1	1
1	5	—	—	—	—	—	3	1	20	15	23
—	4	1	—	—	—	—	1	1	9	7	11
4	29	3	1	5	1	1	20	9	131		

Notes

Chapter 1. Discovery of the Mimbres

1. The buyer, E. Hollis Hopkins, had been commissioned by Julius Carlebach, of the art gallery specializing in what was then called "primitive art" that once bore his name.

2. The earliest recorded purchase seems to have been made in early June 1914 by J. Walter Fewkes for the Smithsonian Institution. He bought twenty-one painted bowls from E. D. Osborn of Deming, New Mexico, for $150, or about $7.14 each (National Anthropological Archives [hereafter NAA], Box 69, Fewkes to F. W. Hodge, June 4, 1914). Fewkes made occasional purchases of Mimbres bowls from Osborn until 1924 for prices ranging from $2.50 to $10 each (NAA, Box 69, Fewkes to Hodge, January 19 and February 4, 1915; Fewkes to E. D. Osborn, November 27 and December 14, 1915; F. W. Hodge balance sheet, June 6, 1922; Fewkes to Osborn, July 27, 1923, and February 2, 1924). All of Fewkes's purchases seem now to be in the collections of the National Museum of Natural History and the National Museum of the American Indian (Heye Foundation), Smithsonian Institution, Washington, D.C., and at the American Museum of Natural History in New York.

3. Records of the Cincinnati Art Museum identify a 1902 gift by Mrs. Owens of two Mimbres pictorial vessels. One, of a pronghorn, is noted as having been found in the Gila Valley. No provenience is given for the other, a fish painting that may be the one mentioned by Hough in 1907 (p. 83).

4. Catalog records at several Southwestern museums suggest that prices rose slowly between 1914 and the mid-1950s, by which time they had reached about $25 per vessel. Movement upward was moderate until after about 1968. In 1969, a Santa Fe dealer in Indian art showed me either three or four Mimbres vessels that were being packed for shipment to an Eastern art museum. He was ecstatic because the purchase price for the group, $3,000, was the highest he knew of for any Mimbres vessels. By the 1990s, well-promoted auctions in New York, London, and elsewhere had helped raise prices to well over $100,000 for unusual examples, and those considered ordinary sold for more than $10,000 each. Pothunters in the field were paid with pennies on the dollar.

5. Nesbitt's report on Mattocks Ruin (1931) was the first published, detailed excavation report of a Mimbres site. Largely descriptive, its conclusions are tentative and contribute little to the problems of historical reconstruction. Bradfield's posthumous report on Cameron Creek Ruin was published in the same year. In some respects it is the most useful of the early reports, because it includes catalog descriptions and in situ excavation details for each artifact. It is also the most frustrating, for little attempt was made to develop interpretations beyond the point reached by Bradfield at the time of his death. The Cosgroves' 1932 report is the most thorough, neatly balanced between

objective descriptions and clear-headed analysis. Perhaps wisely, they elected to postpone a thorough stylistic study of pottery design until a later time, which never came. They did reproduce drawings of every painted vessel excavated from the site, as well as others collected from nearby ruins. Regrettably, they neglected to follow Bradfield's lead and did not publish full catalog information for each specimen. The Galaz report, eventually published by Anyon and LeBlanc in 1984, is based primarily on half-century-old archival materials from the original field schools, but it also includes work done in emergency excavations by the authors in the 1970s just prior to destruction of the site by mechanized looters. The site was on private land, and its destruction was, at the time, perfectly legal.

6. As knowledge of ancient Southwestern history expanded, other investigators applied the term "culture" to other regional groupings whose lifeways and histories seemed to differ significantly from those of both the "Anasazi" and the Hohokam. Southwestern specialists now recognize at least four and perhaps seven or more distinct ancient cultural groups (Cordell 1997; Martin and Plog 1973:23–34).

7. Portions of several Mimbres sites have been excavated under salvage, or cultural resource management, contracts by the Museum of New Mexico, and others have been surveyed under the same or similar conditions (Wendorf 1957). Those parts of a site that are not threatened by government mandated construction may not be excavated under contract, so the scope of the archaeology is limited by concerns that are scientifically irrelevant. "For example, while [Stewart] Peckham was excavating a few rooms of the Baca Ruin because of highway construction, [pothunter's name deleted] was looting the entire rest of the site" (Steven LeBlanc, personal communication, 1975).

8. The work was supported by the Janns Foundation of Los Angeles.

Chapter 2.
The Mimbres in Their Place and Time

1. Judgment regarding affiliation ultimately depends on whether pottery, a portable commodity, was made at a given place or imported. The assumption made by David Breternitz (1966:86), for example, that Mimbres Black-on-white found at the Three Rivers site was indigenous, must lead to the conclusion that Mimbres phase sites extended well east of the Rio Grande. But the basis for the assumption seems to be impressionistic, and no objective evidence seems to support it.

2. Charles Di Peso (Di Peso, Rinaldo, and Fenner 1974:630) suggested that serpentine, chrysotile asbestos, and meerschaum were also mined in the Mimbres region.

Chapter 3. Mimbres Village Life

1. Wooden kickballs, wooden throwing sticks used for hunting rabbits and other small game, and nets used to trap driven small game are among artifacts found in cave sites in the Mimbres country. See Cosgrove 1947; Kaemlein 1971; Lambert and Ambler 1961; Martin et al. 1952; Shaffer and Gardner 1995a, 1996; Shaffer, Gardner, and Baker 1996.

Chapter 4.
The Mimbres and Their Neighbors

1. Paul S. Martin, who did as much as anyone to conceptualize and define the Mogollon, in the end called it "merely a subsystem of Southwestern culture and not a distinct cultural entity" (Martin and Plog 1973:180). Significantly, Joe Ben Wheat's landmark monograph on the Mogollon ends at 1000 C.E. Definitions of the word "culture" as used by anthropologists must be the province of anthropology, but regardless, archaeologists have demonstrated the analytical and historical value of the concepts Mogollon, Mimbres branch, and Classic Mimbres period.

Chapter 5.
Inventing Mimbres Painted Pottery

1. A. V. Kidder (1932:xxi) suggested that the Mimbres figurative painting tradition may have begun as an "artistic mutation" invented by some anonymous genius. The suggestion has been discussed seriously by others, including other anthropologists, who would reject out of hand any suggestion that an entire society might suddenly

adopt an idiosyncratic new form of spear point or kinship terminology without some significant social reason for the change. Nineteenth-century western European romanticism about artists, art, and how artists work in terms of a larger society penetrated deeply and insidiously into the fabric of Euroamerican intellectual life.

2. A slip is a fine clay mixed with water to the consistency of a light cream and applied over the surface of an unfired but dry clay body that is generally a different color from the slip. Traditional Southwestern Pueblo potters, both ancient and modern, ordinarily applied several coats of slip with a soft cloth or furry hide so that it would penetrate as deeply as possible into the clay body, reducing the chances of its separating from the body after the vessel was fired. In the Pueblo Southwest, the only function of a slip was, and is, to provide a smooth, decorative surface on a pottery vessel.

3. Professional ceramist Bill Gilbert and experimental archaeologist and potter Eric Blinman were both kind enough to consult with me on these technical issues, separately and together, on several different occasions during 2001 and 2002.

Chapter 6.
The Potters and Their Wares

1. Jonathan Batkin notes throughout his 1987 volume that potters at several nineteenth- and twentieth-century pueblos worked as teams, with different people sometimes applying their skills, especially in painting, to the same vessel. So many references to similar practices are found elsewhere in the literature on historic era Pueblo pottery making as to make further citations unnecessary.

Chapter 8.
Representational Paintings

1. A drawing of the vessel shown here as figure 33 was published by J. W. Fewkes (1923:29, fig. 23). At the time, the bowl was in the collection of E. D. Osborn in Deming, New Mexico. The drawing reproduced here as figure 33 was made by Harriet Cosgrove, probably in the 1920s, while the vessel was still in Osborn's possession (Davis 1995:180). The vessel's present whereabouts are unknown. Fewkes inquired about its availability in a letter to Osborn in 1916, when it was still owned by the original finder, a man named Pryor who had excavated it on the NAN Ranch (NAA, Box 69: Fewkes to Osborn, February 7, 1916). The vessel pictured here as figure 31 was excavated in 1926 by Earl Morris on the Eby Ranch, also in the Mimbres Valley and not far from NAN Ranch Ruin. A large portion of the vessel bottom was missing, and details of the repainted vessel were based either on direct knowledge of the other decapitation scene or on Fewkes's illustration of it.

Chapter 9.
Ethnoaesthetic and Other Aesthetic Considerations

1. Bruce Bryan (1927:325) was neither the first nor the last to refer to Mimbres artists as "the first and original American cartoonists." Descriptive catalogs of Mimbres painted pottery in museums refer to Mimbres animal pictures as "beasties," and an aura of cuteness pervades even Mimbres iconographic studies. For example, Editha Watson (1932) described the "fun" it must have been "to draw the little comic people and the funny animals" and wrote of the "gay good humor" in having "all the jokes of the villages…painted on their bowls."

Illustration Credits

Chapter 1
Figures 1, 2: Courtesy of the Department of Anthropology, Smithsonian Institution.
Figure 3: Courtesy of the Peabody Museum of Archaeology and Ethnology.
Figure 4: Courtesy of the Museum of Indian Arts and Culture/Laboratory of Anthropology, Cultural Affairs Department, www.miaclab.org. Fred Stimson, photographer.
Figures 5, 6: Courtesy of the Logan Museum of Anthropology, Beloit College.
Figure 7: Collection of the Frederick R. Weisman Art Museum, University of Minnesota, Minneapolis. Transfer, Department of Anthropology.
Figures 8 and 9: Courtesy of the Mimbres Foundation, Maxwell Museum of Anthropology.

Chapter 2
Figures 10, 12: School of American Research. Fred Stimson, photographer.
Figure 11: Courtesy of Steven LeBlanc.
Figure 12: Courtesy of the Heard Museum. Fred Stimson, photographer.
Figure 13: Museum of Indian Art and Culture/Laboratory of Anthropology, Cultural Affairs Department, www.miaclab.org. Blair Clark, photographer.
Figure 14: American Museum of Natural History, Photo Studio, R. Mickens, photographer.
Figure 15: William P. Palmer III Collection, Hudson Museum, University of Maine.

Chapter 3
Figure 16: Bond Wheelwright.
Figures 17, 18, and 19: Courtesy of the Mimbres Foundation, Maxwell Museum of Anthropology, and Steven LeBlanc.
Figures 20 and 21: Courtesy of Harry Shafer.
Figure 22: Courtesy of the Seaver Center for Western History Research, Los Angeles County Museum of Natural History, no. V-920. Adam Clark Vroman, photographer.
Figures 23, 36: Courtesy of the Museum of Indian Art and Culture/Laboratory of Anthropology, Cultural Affairs Department, www.miaclab.org. Blair Clark, photographer.
Figures 24, 26, 40: Collection of the Frederick R. Weisman Art Museum, University of Minnesota, Minneapolis. Transfer, Department of Anthropology.
Figure 25: Courtesy of the National Museum of the American Indian, Smithsonian Institution. Photograph courtesy of J. J. Brody.
Figures 27, 41: Courtesy of the Maxwell Museum of Anthropology. Fred Stimson, photographer.
Figure 28: Courtesy of the American Museum of Natural History, Photo Studio, R. Mickens, photographer.
Figure 29: Courtesy of the Princeton University Art Museum. Gift of Dr. Arthur M. Sackler, y1970-106.

Figure 30: Courtesy of the Museum of Northern Arizona. Fred Stimson, photographer.

Figure 31: Courtesy of the University of Colorado Museum.

Figures 32, 33: Drawn from Mimbres Indian bowls by Harriet S. Cosgrove in the 1920s and 1930s when she studied Mimbres ruins in southwest New Mexico; used by permission of Burt Cosgrove III, her grandson.

Figure 34: Courtesy of the Taylor Museum, Colorado Springs Fine Arts Center. Fred Stimson, photographer.

Figure 35: Courtesy of the Museum of Indian Art and Culture/Laboratory of Anthropology, Cultural Affairs Department, www.miaclab.org. Fred Stimson, photographer.

Figure 37: Courtesy of the Heard Museum.

Figure 38: Courtesy of the Peabody Museum of Archaeology and Ethnology.

Figure 39: Courtesy of the Arizona State Museum, Jannelle Weakly, photographer.

Figure 42: Courtesy of Margaret Hinton and Texas A&M University Station © Margaret Hinton, published by permission. Photograph courtesy of Brian Shaffer.

Figure 43: Courtesy of the Maxwell Museum of Anthropology. Catherine Baudoin, photographer.

Figure 44: Courtesy of the Department of Anthropology, Smithsonian Institution.

Chapter 4

Figure 45: Courtesy of the National Park Service.

Figure 46: Courtesy of the Museum of Indian Art and Culture/Laboratory of Anthropology, Cultural Affairs Department, www.miaclab.org. Blair Clark, photographer.

Chapter 5

Figures 47, 70, 71, 73, 75: Courtesy of the Arizona State Museum. Jannelle Weakly, photographer.

Figures 48, 59, 77, 79, 80, 81: Courtesy of the Museum of Indian Art and Culture/Laboratory of Anthropology, Cultural Affairs Department, www.miaclab.org. Fred Stimson, photographer.

Figure 49: Drawing by Emil Haury, courtesy of the Arizona State Museum Library.

Figures 50, 51, 57, 76, 83, 88: Courtesy of the Museum of Indian Art and Culture/Laboratory of Anthropology, Cultural Affairs Department, www.miaclab.org. Blair Clark, photographer.

Figure 52: Courtesy of J. J. Brody and Rina Swentzell.

Figure 53, 78, 84, 85, 86: Courtesy of the Maxwell Museum of Anthropology. Fred Stimson, photographer.

Figures 54, 58, 63, 69: Courtesy of the Maxwell Museum of Anthropology. Catherine Baudoin, photographer.

Figure 55: Drawn from Mimbres Indian bowls by Harriet S. Cosgrove in the 1920s and 1930s when she studied Mimbres ruins in southwest New Mexico; used by permission of Burt Cosgrove III, her grandson.

Figure 56: Courtesy of the Heard Museum. Fred Stimson, photographer.

Figure 60: Collection of the Frederick R. Weisman Art Museum, University of Minnesota, Minneapolis. Transfer, Department of Anthropology.

Figure 61: Courtesy of Texas Archeological Research Laboratory, the University of Texas at Austin.

Figures 62, 66, 67: Courtesy of the Peabody Museum of Archaeology and Ethnology.

Figure 64: Courtesy of the Museum of Northern Arizona.

Figures 65, 74: Courtesy of the University of Colorado Museum.

Figure 68: Courtesy of the Deming Luna Mimbres Museum, Deming, N.M.

Figure 72: From *The Hohokam: Desert Farmers and Craftsmen—Excavations at Snaketown, 1964-1965*, by Emil W. Haury, © The Arizona Board of Regents. Reprinted by permission of the University of Arizona Press. Composite figure by Wesley Jernigan, courtesy of the School of American Research.

Figures 82, 92: Courtesy of the University of Pennsylvania Museum.

Figure 87: Courtesy of Western New Mexico University Museum, Eisele Collection. Fred Stimson, photographer.

Figure 89: All rights reserved, Image Archives, Denver Museum of Nature and Science. Fred Stimson, photographer.

Figure 90: Courtesy of the Taylor Museum, Colorado Springs Fine Arts Center. Fred Stimson, photographer.

Figure 91: Seventeenth Annual Report of the Bureau of American Ethnology.

Chapter 6

Figure 93: Courtesy of Western New Mexico University Museum, Eisele Collection. Anthony Howell, photographer.

Figure 94: William P. Palmer III Collection, Hudson Museum, University of Maine.

Figure 95: Courtesy of the Arizona State Museum. Jannelle Weakly, photographer.

Figures 96, 97: Courtesy of J. J. Brody.

Figure 98: Courtesy of the Peabody Museum of Archaeology and Ethnology.

Figure 99: Courtesy of Drs. Margaret Nelson and Michelle Hegmon, Directors, Eastern Mimbres Archaeological Project, Arizona State University.

Figure 100: Courtesy of the Maxwell Museum of Anthropology. Fred Stimson, photographer.

Figure 101: Courtesy of the Heard Museum. Fred Stimson, photographer.

Figures 102, 103, 104, 105, 106: Courtesy of the Museum of Indian Art and Culture/Laboratory of Anthropology, Cultural Affairs Department, www.miaclab.org. Blair Clark, photographer.

Chapter 7

Figure 107: American Anthropological Association.

Figures 108, 109: Courtesy of the University of Colorado Museum.

Figures 110, 111: Courtesy of Margaret Hinton and Texas A&M University Station © Margaret Hinton, published by permission. Photographs courtesy of Brian Shaffer.

Figures 112, 113, 124, 126, 127: Courtesy of Western New Mexico University Museum, Eisele Collection. Fred Stimson, photographer.

Figures 114, 128, 135: Courtesy of the Peabody Museum of Archaeology and Ethnology.

Figure 115: Courtesy of the Museum of Northern Arizona. Fred Stimson, photographer.

Figures 116, 117: Courtesy of the Maxwell Museum of Anthropology. Catherine Baudoin, photographer.

Figure 118: William Edner Collection, Museum of Western Colorado. Fred Stimson, photographer.

Figures 119, 132, 137: Courtesy of the University of Colorado Museum. Fred Stimson, photographer.

Figure 120: Courtesy of the Maxwell Museum of Anthropology. Fred Stimson, photographer.

Figure 121: Courtesy of the Heard Museum. Fred Stimson, photographer.

Figures 122, 134, 136, 139, 142: Courtesy of the Museum of Indian Art and Culture/Laboratory of Anthropology, Cultural Affairs Department, www.miaclab.org. Fred Stimson, photographer.

Figures 123, 125, 133: Courtesy of the Taylor Museum. Fred Stimson, photographer.

Figures 124, 126, 127: Courtesy of the Western New Mexico University Museum, Eisele Collection.

Figures 129, 130: Courtesy of the Logan Museum of Anthropology, Beloit College.

Figures 131, 138: Courtesy of the School of American Research.

Figures 140, 141: Courtesy of the University of Arkansas Museum.

Figure 143: William Edner Collection, Museum of Western Colorado.

Figure 144: Collection of the Frederick R. Weisman Art Museum, University of Minnesota, Minneapolis. Transfer, Department of Anthropology.

Figure 145: All rights reserved, Image Archives, Denver Museum of Nature and Science. Fred Stimson, photographer.

Figure 146: Courtesy of the Princeton University Art Museum. Gift of the George G. Frelinghuysen, Class of 1932, Foundation, y1972-11.

Chapter 8

Figures 147: Courtesy of the University of Colorado Museum. Fred Stimson, photographer.

Figures 148, 169, 213: Courtesy of Arizona State Museum, University of Arizona. Fred Stimson, photographer.

Figures 149, 161: Courtesy of the Logan Museum of Anthropology, Beloit College.

Figure 151: Courtesy of the Taylor Museum. Fred Stimson, photographer.

Figures 154, 215, 216: William Edner Collection, Museum of Western Colorado.

Figures 155, 176: Courtesy of the Museum of Indian Art and Culture/Laboratory of Anthropology, Cultural Affairs Department, www.miaclab.org. Blair Clark, photographer.

Figures 156, 158, 164, 183, 184, 185, 203, 210: Courtesy of the Maxwell Museum of Anthropology. Fred Stimson, photographer.

Figures 157, 160, 162, 163, 173, 177, 178, 198: Courtesy of the Maxwell Museum of Anthropology. Catherine Baudoin, photographer.

Figures 159, 191: Courtesy of the Millicent Rogers Museum.

Figures 165, 166: Courtesy of the Department of Anthropology, Smithsonian Institution.

Figures 167, 188, 202: Courtesy of the Taylor Museum, Colorado Springs Fine Arts Center.

Figure 168: Courtesy of Margaret Hinton and Texas A&M University Station © Margaret Hinton, published by permission. Photograph courtesy of Brian Shaffer.

Figures 170, 187, 206, 212, 223: Courtesy of the Museum of Indian Art and Culture/Laboratory of Anthropology, Cultural

Affairs Department, www.miaclab.org. Fred Stimson, photographer.

Figures 174, 224: Courtesy of the National Museum of the American Indian, Smithsonian Institution. Photographs courtesy of J. J. Brody.

Figure 175: Courtesy of Millicent Rogers Museum. Fred Stimson, photographer.

Figures 182, 192, 194, 200, 217, 222: Courtesy of the Western New Mexico University Museum, Eisele Collection. Fred Stimson, photographer.

Figure 186: Courtesy of the Snite Museum of Art, University of Notre Dame.

Figures 190, 195, 201, 208, and 221: Collection of the Frederick R. Weisman Art Museum, University of Minnesota, Minneapolis. Transfer, Department of Anthropology.

Figure 197: All rights reserved, Image Archives, Denver Museum of Nature and Science. Fred Stimson, photographer.

Figure 199: William Edner Collection, Museum of Western Colorado. Fred Stimson, photographer.

Figures 207, 219: Courtesy of J. J. Brody.

Figures 211, 214, 218: Courtesy of the Autry National Center/Southwest Museum, Los Angeles. Fred Stimson, photographer.

Figure 220: Courtesy of David Grant Noble.

Figures 171, 172: Courtesy of the American Museum of Natural History, Photo Studio, R. Mickens, photographer.

Figures 179, 180, 193, and 196: Courtesy of the Arizona State Museum. Jannelle Weakly, photographer.

Figures 181, 209: Courtesy of the Museum of Northern Arizona.

Figure 189: Courtesy of the Peabody Museum of Archaeology and Ethnology.

Figure 204: Courtesy of the School of American Research. Drawing by Wesley Jernigan.

Chapter 9

Figure 224: Courtesy of the National Museum of the American Indian, Smithsonian Institution. Photograph courtesy of J. J. Brody.

Figure 225: William Edner Collection, Museum of Western Colorado. Fred Stimson, photographer.

Figure 226: Courtesy of the School of American Research, IAF.2981.

Figure 227: Courtesy of Joyce Da Odell, on behalf of Anthony E. Da, and the Heard Museum.

Figures 228, 229: Courtesy of the Maxwell Museum of Anthropology. Fred Stimson, photographer.

Figure 230: Courtesy of the Museum of Indian Art and Culture/Laboratory of Anthropology, Cultural Affairs Department, www.miaclab.org. Blair Clark, photographer.

Plates

Plates 1, 4, 8, 10, 16: Collection of the Frederick R. Weisman Art Museum, University of Minnesota, Minneapolis. Transfer, Department of Anthropology.

Plate 2: Courtesy of the Logan Museum of Anthropology, Beloit College.

Plate 3: Courtesy of the National Museum of the American Indian, Smithsonian Institution. Photograph courtesy of J. J. Brody.

Plate 5: Courtesy of the Museum of Indian Art and Culture/Laboratory of Anthropology, Cultural Affairs Department, www.miaclab.org. Fred Stimson, photographer.

Plate 6: Courtesy of the Museum of Indian Art and Culture/Laboratory of Anthropology, Cultural Affairs Department, www.miaclab.org. Blair Clark, photographer.

Plates 7, 13, 14, and 18: Courtesy of the American Museum of Natural History, Photo Studio, R. Mickens, photographer.

Plate 9: Courtesy, Deming Luna Mimbres Museum, Deming, N.M.

Plate 11: Courtesy of Margaret Hinton and Texas A&M University Station, © Margaret Hinton, published by permission. Photograph courtesy of Brian Shaffer.

Plate 12: Courtesy of the Peabody Museum of Archaeology and Ethnology.

Plate 15: Courtesy of the University of Colorado Museum.

Plate 17: Western New Mexico University Museum, Eisele Collection. Anthony Howell, photographer.

Plate 19: Courtesy of the University of Colorado Museum. Fred Stimson, photographer.

Plate 20: William Edner Collection, Museum of Western Colorado. Fred Stimson, photographer.

Bibliography

Archival Source:
National Anthropology Archive (NAA), Smithsonian Institution

1913, Box 69
October 28, E. D. Osborn to F. W. Hodge, letter with photographs of "some of the bowls I have."
November 4, Hodge to Osborn, letter asking for photographs of individual bowls, "especially animal figures."
December 13, Hodge to Osborn, letter thanking Osborn for his "comprehensive letter" of December 8, 1913, explaining that J. W. Fewkes was out of the country, and scolding Osborn for digging without "scientific auspices."

1914, Box 60
J. W. Fewkes field notebooks with field sketches of excavations near Oldtown, petroglyphs near Cooks Peak, and sketches of Mimbres "relics" in local collections, including those given in 1914 by Minnie Weaver Swope to the Deming High School.

1914, Box 69
May 19, F. W. Hodge to J. W. Fewkes, letter authorizing a research trip to Luna County, N.M., and expenses of $400.
June 4, Fewkes to Hodge from Deming, N.M., letter summarizing Fewkes's initial impressions of the archaeology of the region and its unique qualities. Reporting on the first week of Mimbres Valley fieldwork, he noted that with the help of E. D. Osborn's two sons and the loan of the Osborn automobile, he was "able to accomplish more than expected." He collected about 35 "good specimens of pottery," including "17 bowls with human and zooic pictures." Fewkes purchased these from Osborn or excavated them on the Osborn ranch or from a small site near Oldtown Ruin. "I purchased the Osborn collection for a remarkably low sum considering its importance. For a pick of twenty one (except "hunters") I gave him $150. All these are to my mind choice....Yesterday... [I] obtained for $2.50 (two fifty) a very fine double bird."
June 16, Fewkes to Hodge, from Deming, N.M., letter reporting on his field and collecting activities and on financial matters.

July 1, Hodge to Fewkes, letter authorizing an extension of that field trip to July 15, 1914.

September 19, Fewkes to Hodge, letter discussing hiring artists to make drawings for Fewkes's 1914 monograph.

1915, Box 69

January 5, Hodge to Fewkes, letter authorizing Fewkes to work in the Mimbres country in 1915.

January 19, Fewkes to Hodge from Deming, N.M., letter reporting a visit to the Osborn ranch near Deming to look at materials collected by Osborn since July 1, 1914. Fewkes, after haggling, offered to purchase "all he had" for $700, reasoning that the pots could later be sold to George Heye or the Peabody Museum at Harvard. "My [1914] report has stimulated collecting and a rich ranchman, who will not sell has made a collection of size since my departure." He noted that most of the vessels had been collected between Silver City and Santa Rita.

January 20, Fewkes to Hodge, postcard noting that the Osborn materials (600–700 objects, including 200 painted bowls) were to be shipped on January 20.

February 4, Fewkes to Hodge, letter noting that the purchase price for the Osborn collection shipped on January 20 was $750 and that "about half" of the 200 painted bowls "are new" (since 1914).

July 1, Fewkes to Hodge, annual report noting that the collection purchased from Osborn in 1915 had been sold to George Heye. Fewkes also reported on a paper he had read to the National Academy of Sciences on April 15, 1915.

November 27, J. W. Fewkes to E. D. Osborn, letter offering to buy "100 of your best specimens" in the proportion of three geometrics for every "picture pot." "Send photos of your best, I'll send $300.00 in payment."

December 14, Fewkes to Osborn, letter with payment of $300 and instructions for Osborn to ship the collection to George Heye in New York. Fewkes asks for a photograph of the "human sacrifice bowl" from the Pryor collection (see fig. 33).

1916, Box 69

February 18, Fewkes to Osborn, letter thanking him for the drawing of the human sacrifice bowl.

April 6, Fewkes to Osborn, letter reporting that George Heye probably did not want any geometric bowls and asking the price of "animal bowls."

November 24, Fewkes to Osborn, letter regretting not buying "the last collection you… offered me" and hoping that a Boston donor might be able to buy "about 100 more picture bowls."

1922, Box 69

June 6, J. W. Hodge balance sheet showing $642.36 spent on Osborn collection that year.

1923, Box 69

July 27, Fewkes to Osborn, letter offering to purchase the "vinagaroon specimen in the Chamber of Commerce" for $10. The vessel, possibly the same as that in Fewkes 1924:fig. 54, arrived in Washington on September 2, 1923.

1924, Box 69

February 2, Fewkes to Osborn, letter offering to spend the same amount as in 1923 ($600) to buy more Mimbres "specimens" and asking Osborn for photographs.

1925, Box 69

February 25, Osborn to Fewkes, letter offering to sell the entire Osborn collection.

March 9, Osborn to Fewkes, letter offering to sell 1,500 to 2,000 "articles," including 300 Mimbres bowls, for $2,500, or 75 bowls for $1,000, and noting that "Mimbres Valley pottery is getting very scarce."

1926, Box 69
August 16, Osborn to Fewkes, letter offering to sell "our entire collection of Indian relics" and soliciting "any interested offer."
October 2, Fewkes to Osborn, letter declining the offer of August 16, 1926.

Published Sources

Adams, E. Charles
1991 *The Origin and Development of the Pueblo Katsina Cult.* University of Arizona Press, Tucson.
1994 The Katsina Cult: A Western Pueblo Perspective. In *Kachinas in the Pueblo World,* edited by Polly Schaafsma, pp. 35–46. University of New Mexico Press, Albuquerque.

Anyon, Roger, Patricia A. Gilman, and Steven A. LeBlanc
1981 A Reevaluation of the Mogollon-Mimbres Archaeological Sequence. *Kiva* 46(4):209–25.

Anyon, Roger A., and Steven A. LeBlanc
1980 The Architectural Evolution of Mogollon-Mimbres Communal Structures. *Kiva* 45(3):253–77.
1984 *The Galaz Ruin.* Maxwell Museum of Anthropology and University of New Mexico Press, Albuquerque.

Archaeological Conservancy
1999 News brief. *American Archaeology* 2(4):11.

Bahre, Conrad J., and Charles F. Hutchinson
2000 Historic Vegetation Change in *la Frontera* West of the Rio Grande. In *Changing Plant Life of la Frontera: Observations on Vegetation in the U.S./Mexico Borderland,* edited by Grady L. Webster and Conrad J. Bahre, pp. 67-83. University of New Mexico Press, Albuquerque.

Bandelier, Adolph F.
1892 *Final Report of Investigations among the Indians of the Southwestern United States, Carried on Mainly in the Years from 1880 to 1885,* part 2. Papers of the Archaeological Institute of America, American Series no. 4. J. Wilson and Son, Cambridge, Mass.

Bartlett, John R.
1854 *Personal Narrative of Explorations and Incidents in Texas, New Mexico, California, Sonora, and Chihuahua....* 2 vols. Reprint edition, 1965, Rio Grande Press, Chicago.

Batkin, Jonathan
1987 *Pottery of the Pueblos of New Mexico: 1700–1940.* Taylor Museum of the Colorado Springs Fine Arts Center, Colorado Springs, Colo.

Beckett, Patrick H., and Kira Silverbird, eds.
1982 *Mogollon Archaeology: Proceedings of the 1980 Mogollon Conference.* Acoma Books, Ramona, Calif.

Benson, Charlotte, and Steadman Upham, eds.

1986 *Mogollon Variability.* University Museum Occasional Paper 15. New Mexico State University, Las Cruces.

Bettison, Cynthia Ann, Roland Shook, Randy Jennings, and Dennis Miller

1996 New Identifications of Naturalistic Motifs on a Subset of Mimbres Pottery. Paper prepared for the *Proceedings of the Ninth Mogollon Archaeology Conference,* 1997. Tucson.

Blake, Michael, Steven A. LeBlanc, and Paul E. Minnis

1986 Changing Settlement and Population in the Mimbres Valley, Southwestern New Mexico. *Journal of Field Archaeology* 13(4):439–64.

Bradfield, Wesley

1925 A Day's Work on the Mimbres. *El Palacio* 19:170–72.

1927 Notes on Mimbres Culture. *El Palacio* 22:550–57.

1931 *Cameron Creek Village: A Site in the Mimbres Area in Grant County, New Mexico.* Monograph of the School of American Research, no. 1. Santa Fe.

Brand, Donald D.

1935 The Distribution of Pottery Types in Northwest Mexico. *American Anthropologist* 37:287–305.

1937 *Landscape of Northwestern Chihuahua.* University of New Mexico Bulletin, Geology Series, vol. 5, no. 2. Albuquerque.

1938 Aboriginal Trade Routes for Sea Shells in the Southwest. In *Association of Pacific Coast Geographers Yearbook,* vol. 4, pp. 3–10. Oregon State University Press, Corvallis, OR.

Bray, Alicia

1982 Mimbres Black-on-white: Melamine or Wedgewood? A Ceramic Wear Analysis. *Kiva* 47(3):133–49.

Breternitz, David A.

1966 *An Appraisal of Tree-Ring Dated Pottery in the Southwest.* Anthropological Papers of the University of Arizona, no. 10. University of Arizona Press, Tucson.

Brody, J. J.

1974 In Advance of the Readymade: Kiva Murals and Navajo Dry Painting. In *Art and Environment in Native America,* edited by Mary Elizabeth King and Idris R. Traylor Jr., pp. 11–21. Texas Tech University Press, Lubbock.

1977 *Mimbres Painted Pottery.* School of American Research Press, Santa Fe..

1991 *Anasazi and Pueblo Painting.* University of New Mexico Press, Albuquerque.

1997 *Pueblo Indian Painting: Tradition and Modernism in New Mexico, 1900–1930.* School of American Research Press, Santa Fe.

Brody, J. J., Catherine J. Scott, and Steven A. LeBlanc

1983 *Mimbres Pottery: Ancient Art of the American Southwest.* Hudson Hills Press, New York.

Brody, J. J., and Rina Swentzell

1996 *To Touch the Past: The Painted Pottery of the Mimbres People.* Hudson Hills Press, New York.

Bryan, Bruce

1927 The Galaz Ruin in the Mimbres Valley. *El Palacio* 23:323–37.

1931a Excavation of the Galaz Ruin. *Masterkey* 4:179–89.

1931b Excavation of the Galaz Ruin. *Masterkey* 4:221–26.

1931c Excavation of the Galaz Ruin, Mimbres Valley, New Mexico. *Art and Archaeology* 32:35.

1961 Initial Report on Galaz Sherds. *Masterkey* 35:13–18.

1962 An Unusual Mimbres Bowl. *Masterkey* 36:29–32.

Bullard, William R., Jr.

1962 *The Cerro Colorado Site and Pithouse Architecture in the Southwestern United States prior to A.D. 900.* Papers of the Peabody Museum of Archaeology and Ethnology, Harvard University, vol. 44, no. 2. Peabody Museum, Cambridge, Mass.

Bunzel, Ruth L.

1929 *The Pueblo Potter: A Study of Creative Imagination in Primitive Art.* Columbia University Contributions to Anthropology, vol. 8. Columbia University Press, New York.

Calvin, Ross

1951 *Lieutenant Emory Reports.* University of New Mexico Press, Albuquerque.

Carlson, Roy L.

1970 *White Mountain Redware: A Pottery Tradition of East-Central Arizona and Western New Mexico.* Anthropological Papers of the University of Arizona, no. 19. University of Arizona Press, Tucson.

1978 Review of *Mimbres Painted Pottery. American Indian Art* 3(2):70–72.

1982 The Mimbres Kachina Cult. In *Mogollon Archaeology: Proceedings of the 1980 Mogollon Conference,* edited by Patrick H. Beckett and Kira Silverbird, pp. 147–57. Acoma Books, Ramona, Calif.

Carr, Pat

1979 *Mimbres Mythology.* Southwestern Studies Monograph, no. 56. Texas Western Press, El Paso.

Coe, Michael D.

1973 *The Maya Scribe and His World.* Grolier Club, New York.

Cordell, Linda

1997 *Archaeology of the Southwest.* 2d ed. Academic Press, San Diego.

Cosgrove, Cornelius B.

1947 *Caves of the Upper Gila and Hueco Areas in New Mexico and Texas.* Papers of the Peabody Museum of Archaeology and Ethnology, Harvard University, vol. 24, no. 2. Peabody Museum, Cambridge, Mass.

Cosgrove, Harriet S., and Cornelius B. Cosgrove

1932 *The Swarts Ruin: A Typical Mimbres Site of Southwestern New Mexico.* Papers of the Peabody Museum of Archaeology and Ethnology, Harvard University, vol. 15, no. 1. Peabody Museum, Cambridge, Mass.

Creel, Darrel

1989 Status Report on Test Excavations at the Oldtown Site (LA1113), Luna County, New Mexico, Summer 1989. Report on file. U.S. Bureau of Land Management; New Mexico State Office: Department of Anthropology, Texas A&M University, College Station.

1998 Investigating an Old Mimbres Town: Excavations at the Old Town Site near Silver City, New Mexico. *Glyphs* 49(1):8–10.

1999 The Black Mountain Phase in the Mimbres Area. In *The Casas Grandes World,* edited by Curtis Schaafsma and Carroll L. Riley, pp. 107–20. University of Utah Press, Salt Lake City.

Creel, Darrel, and Charmion McKusick

1994 Prehistoric Macaws and Parrots in the Mimbres Area, New Mexico. *American Antiquity* 59:510–24.

Crown, Patricia L.

1995 *Ceramics and Ideology: Salado Polychrome Pottery.* University of New Mexico Press, Albuquerque.

2001 Learning to Make Pottery in the Prehistoric American Southwest. *Journal of Anthropological Research* 57:451–69.

Crown, Patricia L., and W. H. Wills

1996 The Origins of Southwestern Ceramic Containers: Women's Time Allocation and Economic Intensification. *Journal of Anthropological Research* 51:173–86.

Danson, Edward B.

1957 *An Archaeological Survey of West-Central New Mexico and East-Central Arizona.* Papers of the Peabody Museum of Archaeology and Ethnology, Harvard University, vol. 44, no. 1. Peabody Museum, Cambridge, Mass.

Davis, Carolyn O'Bagy

1995 *Treasured Earth: Hattie Cosgrove's Mimbres Archaeology in the American Southwest.* Sanpete Publications, Old Pueblo Archaeology Center, Tucson.

Dean, Jeffrey S., and John C. Ravesloot

1993 The Chronology of Cultural Interaction in the Gran Chichimeca. In *Culture and Contact: Charles C. Di Peso's Gran Chichimeca,* edited by Anne I. Woosley and John C. Ravesloot, pp. 83–104. Amerind Foundation, New World Studies Series, no. 2., University of New Mexico Press, Albuquerque.

Dickey, Roland

1957 Potters of the Mimbres Valley. *New Mexico Quarterly* 27:45–51.

Diehl, Michael W., and Steven A. LeBlanc

2001 *Early Pithouse Villages of the Mimbres Valley and Beyond.* Papers of the Peabody Museum of Archaeology and Ethnology, Harvard University, vol. 83. Peabody Museum, Cambridge, Mass.

Dillingham, Rick, with Melinda Elliott

1992 *Acoma and Laguna Pottery.* School of American Research Press, Santa Fe.

Di Peso, Charles C.

1968 Casas Grandes and the Gran Chichimeca. *El Palacio* 75:47–61.

Di Peso, Charles C., John B. Rinaldo, and Gloria J. Fenner

1974 *Casas Grandes: A Fallen Trading Center of the Gran Chichimeca.* 3 vols. Amerind Foundation Publication, no. 9. Amerind Foundation, Dragoon, AZ.

Dittert, Alfred E., and Fred Plog
1980 *Generations in Clay: Pueblo Pottery of the American Southwest.* Northland Press, Flagstaff.

Dockstader, Frederick J.
1961 *Indian Art in America.* New York Graphic Society, Greenwich, Conn.

Doyel, David E., ed.
1975 *Excavations in the Escalante Ruin Group, Southern Arizona.* Archaeological Series 37. Arizona State Museum, University of Arizona, Tucson.

Duchamp, Marcel
1957 The Creative Act. Paper presented at the convention of the American Federation of Arts.
1959 The Creative Act. In *Marcel Duchamp,* by Robert Lebel, pp. 77–78. Paragraphic Books, New York.

Duff, U. Francis
1902 Ruins of the Mimbres Valley. *American Antiquarian* 24:397–400.

Duran, Meliha S., and David T. Kirkpatrick, eds.
1992 *Archaeology, Art, and Anthropology: Papers in Honor of J. J. Brody.* Papers of the Archaeological Society of New Mexico, vol. 18. Archaeological Society of New Mexico, Albuquerque.

Eggan, Fred
1994 The Hopi Indians, with Special Reference to Their Cosmology and World View. In *Kachinas in the Pueblo World,* edited by Polly Schaafsma, pp. 7–16. University of New Mexico Press, Albuquerque.

Ellis, Florence Hawley
1967 Where Did the Pueblo People Come From? *El Palacio* 74:35–43.
1978 Review of *Mimbres Painted Pottery. Journal of Anthropological Research* 34(1):147–53.

Ellis, Florence Hawley, and Laurens Hammack
1968 The Inner Sanctum of Feather Cave, a Mogollon Sun and Earth Shrine Linking Mexico and the Southwest. *American Antiquity* 33:25–44.

Erdoes, Richard, and Alfonso Ortiz
1984 *American Indian Myths and Legends.* Pantheon Books, New York.

Evans, Roy H., R. Evelyn Ross, and Lyle Ross
1985 *Mimbres Indian Treasure.* Lowell Press, Kansas City.

Farmer, James D.
1993 Painted Pottery from the Galaz Ruin: Figurative Style in Mimbres Art. M.A. thesis, Department of Art History, University of Texas, Austin.

Fewkes, J. Walter
1897 Tusayan Katcinas. *Fifteenth Annual Report of the Bureau of American Ethnology,* pp. 245–313. U.S. Government Printing Office, Washington, D.C.
1903 Hopi Katcinas Drawn by Native Artists. *Twenty-first Annual Report of the Bureau of American Ethnology,* pp. 3–126. Reprint edition, 1982, Rio Grande Press, Glorieta, NM.
1914 *Archaeology of the Lower Mimbres Valley.* Smithsonian Miscellaneous Collections, vol. 63, no. 10. Washington, D.C.

1916 Animal Figures on Prehistoric Pottery from Mimbres Valley, New Mexico. *American Anthropologist* 18(4):535–45.

1919 Designs of Prehistoric Hopi Pottery. *Thirty-third Annual Report of the Bureau of American Ethnology,* pp. 207–84. U.S. Government Printing Office, Washington, D.C.

1923 *Designs on Prehistoric Pottery from the Mimbres Valley.* Smithsonian Miscellaneous Collections, vol. 74, no. 6, The Smithsonian Institution, Washington, D.C.

1924 *Additional Designs on Prehistoric Mimbres Pottery.* Smithsonian Miscellaneous Collections, vol. 76, no. 8. Washington, D.C.

Fields, Virginia M., and Victor Zamudio-Taylor
2001 *The Road to Aztlan: Art from a Mythic Homeland.* Los Angeles County Museum of Art, Los Angeles.

Fish, Paul R., Suzanne K. Fish, George J. Gumerman, and J. Jefferson Reid
1994 Toward an Explanation for Southwestern "Abandonments." In *Themes in Southwest Prehistory,* edited by George J. Gumerman, pp. 135–64. School of American Research Press, Santa Fe.

Fitting, James E.
1971a *The Burris Ranch Site, Dona Ana County, New Mexico.* Department of Anthropology, Southwestern New Mexico Research Reports, no. 1. Case Western Reserve University, Cleveland.

1971b *Excavations at MC 110, Grant County, New Mexico.* Department of Anthropology, Southwestern New Mexico Research Reports, no. 2. Case Western Reserve University, Cleveland.

1971c *The Hermanas Ruin, Luna County, New Mexico.* Department of Anthropology, Southwestern New Mexico Research Reports, no. 3. Case Western Reserve University, Cleveland.

1972 Preliminary Notes on Cliff Valley Settlement Patterns. *Artifact* 10:15–30.

Ford, Richard I., Albert H. Schroeder, and Stewart L. Peckham
1972 Three Perspectives on Puebloan Prehistory. In *New Perspectives on the Pueblos,* edited by Alfonso Ortiz, pp. 19–39. University of New Mexico Press, Albuquerque.

Fowler, G. William
1999 Early American Fishing: Mimbres Classic Period, 1050–1200 A.D. *American Fly Fisher* 25(3):2–7.

Frank, Larry, and Francis L. Harlow
1974 *Historic Pottery of the Pueblo Indians, 1600-1880.* New York Graphic Society, Boston, Mass.

Gilman, Patricia A.
1980 The Early Pueblo Period: Mimbres Classic. In *An Archaeological Synthesis of South-central and Southwestern New Mexico,* edited by Steven A. LeBlanc and M. E. Whalen, pp. 206–70. Office of Contract Archaeology, University of New Mexico, Albuquerque.

1987 Architecture as Artifact: Pit Structures and Pueblos in the American Southwest. *American Antiquity* 52:538–64.

1990 Social Organization and Classic Mimbres Period Burials in the Southwestern United States. *Journal of Field Archaeology* 17(4):457–69.

Gilman, Patricia A., V. Canouts, and R. L. Bishop
1994 The Production and Distribution of Classic Mimbres Black-on-White Pottery. *American Antiquity* 59:695–708.

Gladwin, Harold S.

1928 *Excavations at Casa Grande, Arizona.* Southwest Museum Papers, no. 2. Southwest Museum, Los Angeles.

1945 Foreword. In *The San Simon Branch: Excavations at Cave Creek and in the San Simon Valley,* part 1, *Material Culture,* by E. B. Sayles. Medallion Papers no. 34. Privately printed for Gila Pueblo, Globe, AZ.

1957 *A History of the Ancient Southwest.* Bond Wheelwright, Portland, ME.

Gladwin, Winifred, and Harold S. Gladwin

1933 *Some Southwestern Pottery Types, Series III.* Medallion Papers, no. 12. Gila Pueblo, Globe, Ariz.

1934 *A Method for the Designation of Cultures and Their Variations.* Medallion Papers, no. 15. Privately printed for Gila Pueblo, Globe, AZ.

Goldwater, Robert

1967 *Primitivism in Modern Art.* Vintage Books, New York.

Harlow, Francis H.

1967 *Historic Pueblo Indian Pottery: Painted Jars and Bowls of the Period 1602–1900.* Museum of New Mexico Press, Santa Fe.

1973 *Matte Paint Pottery of the Tewa, Keres, and Zuni Pueblos.* Museum of New Mexico, Santa Fe; University of New Mexico Press, Albuquerque.

Haury, Emil W.

1932 *Roosevelt: 9:6, a Hohokam Site of the Colonial Period.* Medallion Papers, no. 2. Privately printed for Gila Pueblo, Globe, AZ.

1936a *The Mogollon Culture of Southwestern New Mexico.* Medallion Papers, no. 20. Privately printed for Gila Pueblo, Globe, AZ.

1936b *Some Southwestern Pottery Types (Series IV).* Medallion Papers, no. 19. Privately printed for Gila Pueblo, Globe, AZ.

1943 A Possible Cochise-Mogollon-Hohokam Sequence. *Proceedings of the American Philosophical Society* 86:260–63.

1976 *The Hohokam, Desert Farmers and Craftsmen: Excavations at Snaketown.* University of Arizona Press, Tucson.

Hayden, Julian B.

1970 Of Hohokam Origins and Other Matters. *American Antiquity* 35:87–89.

Hayes, Alden C.

1981 *Excavations of Mound 7, Gran Quivera National Monument, New Mexico.* Publications in Archaeology 16. National Park Service, U.S. Department of Interior, Washington, D.C.

Hays, Kelley A.

1994 Kachina Depictions on Prehistoric Pueblo Pottery. In *Kachinas in the Modern World,* edited by Polly Schaafsma, pp. 47–62. University of New Mexico Press, Albuquerque.

Hays-Gilpin, Kelley A., and Jane H. Hill

1999 The Flower World in Material Culture: An Iconographic Complex in the Southwest and Mesoamerica. *Journal of Anthropological Research* 55(1):1–37.

Hedrick, Basil C., J. Charles Kelley, and Carroll L. Riley, eds.
1971 *The North Mexican Frontier: Readings in Archaeology, Ethnology, and Ethnography.* Southern Illinois University Press, Carbondale.

Hegmon, Michelle
2002 Recent Issues in the Archaeology of the Mimbres Region of the North American Southwest. *Journal of Archaeological Research* 10(4):307–57.

Hegmon, Michelle, Margaret C. Nelson, and Susan Ruth
1998 Abandonment, Reorganization, and Social Change: Analysis of Pottery and Architecture from the Mimbres Region of the American Southwest. *American Anthropologist* 100:148–62.

Hegmon, Michelle, and Wenda R. Trevathan
1996 Gender, Anatomical Knowledge, and Pottery Production: Implications of an Anatomically Unusual Birth Depicted on Mimbres Pottery from Southwestern New Mexico. *American Antiquity* 61(4):747–54.

Henshaw, Henry W.
1879 Cliff-House and Cave on Diamond Creek, New Mexico. In *Report upon United States Geographical Surveys West of the One-Hundredth Meridian…*, vol. 7, *Reports upon Archaeological and Ethnological Collections…*, by Frederick W. Putnam. U.S. Government Printing Office, Washington, D.C.

Herrington, La Verne
1979 Settlement Patterns and Water Control Systems of the Mimbres Classic Phase, Grant County, New Mexico. Ph.D. diss., University of Texas, Austin. University Microfilms, Ann Arbor.
1982 Water Control Systems of the Mimbres Classic Phase. In *Mogollon Archaeology: Proceedings of the 1980 Mogollon Conference,* edited by Patrick H. Beckett and Kira Silverbird, pp. 75–90. Acoma Books, Ramona, Calif.

Hough, Walter
1907 *Antiquities of the Upper Gila and Salt River Valleys in Arizona and New Mexico.* Bureau of American Ethnology Bulletin no. 35. U.S. Government Printing Office, Washington, D.C.
1914 *Culture of the Ancient Pueblos of the Upper Gila River Region, New Mexico and Arizona.* U.S. National Museum Bulletin no. 87. U.S. Government Printing Office, Washington, D.C.

Huckle, Bruce
1995 *Of Marshes and Maize: Preceramic Agricultural Settlements in the Cienega Valley, Southeast Arizona.* Anthropological Papers of the University of Arizona, no. 59. University of Arizona Press, Tucson.

Irwin-Williams, Cynthia
1979 Post-Pleistocene Archaeology, 7000–2000 B.C. In *Handbook of North American Indians,* vol. 9, *Southwest,* edited by Alfonso Ortiz, pp. 31–42. Smithsonian Institution, Washington, D.C.

James, W. D., R. L. Brewington, and H. J. Shafer
1995 Compositional Analysis of American Southwestern Ceramics by Neutron Activation Analysis. *Journal of Radioanalytical and Nuclear Chemistry* 192(1):109–16.

Jett, Steven C., and P. B. Moyle

1986 The Exotic Origin of Fishes Depicted on Prehistoric Mimbres Pottery from New Mexico. *American Antiquity* 51:688–720.

Kabotie, Fred

1949 *Designs from the Ancient Mimbreños with a Hopi Interpretation.* Graborn Press, San Francisco.

Kaemlein, Wilma

1971 Large Hunting Nets in the Collections of the Arizona State Museum. *Kiva* 36:20–52.

Kamp, Kathryn A.

2001 Prehistoric Children Working and Playing: A Southwestern Case Study in Learning Ceramics. *Journal of Anthropological Research* 57:427–50.

Kelley, Jane Holden

1966 The Archaeology of the Sierra Blanca Region of Southeastern New Mexico. Ph.D. diss., Harvard University, Cambridge, Mass.

Kelley, J. Charles

1960 North Mexico and the Correlation of Mesoamerican and Southwestern Cultural Sequences. In *Selected Papers of the Fifth International Congress of Anthropological and Ethnological Sciences,* pp. 566–73. University of Pennsylvania Press, Philadelphia.

1966 Mesoamerica and the Southwestern United States. In *Handbook of Middle American Indians,* vol. 4, edited by Robert Wauchope, pp. 95–110. University of Texas Press, Austin.

1974 Speculations on the Culture History of Northwestern Mesoamerica. In *The Archaeology of West Mexico,* edited by Betty Bell, pp. 19–39. West Mexican Society for Advanced Study, Ajijic, Jalisco, Mexico.

Kent, Kate Peck

1983a *Prehistoric Textiles of the Southwest.* University of New Mexico Press, Albuquerque.

1983b *Pueblo Indian Textiles: A Living Tradition.* School of American Research Press, Santa Fe.

Kessell, John L.

1971 Campaigning on the Upper Gila, 1756. *New Mexico Historical Review* 46:133–60.

Kidder, Alfred Vincent

1927 Peabody Museum Expedition to the Mimbres Valley, New Mexico, Season of 1927. Mimeographed manuscript. Peabody Museum of Archaeology and Ethnology, Harvard University, Cambridge, Mass.

1932 Introduction. In *The Swarts Ruin: A Typical Mimbres Site of Southwestern New Mexico,* by Harriet S. Cosgrove and Cornelius B. Cosgrove. Papers of the Peabody Museum of Archaeology and Ethnology, Harvard University, vol. 15, no. 1. Cambridge, Mass.

Kidder, Alfred V., Harriet S. Cosgrove, and Cornelius B. Cosgrove

1949 *The Pendleton Ruin, Hidalgo County, New Mexico.* Contributions to American Anthropology and History, no. 50. Carnegie Institution of Washington, Publication 585. Washington, D.C.

King, Mary Elizabeth, and Idris R. Traylor Jr., eds.

1974 *Art and Environment in Native America.* Texas Tech University Press, Lubbock.

Kramer, Barbara

1996 *Nampeyo and Her Pottery.* University of New Mexico Press, Albuquerque.

Kurath, Gertrude Prokosch, with Antonio Garcia

1970 *Music and Dance of the Tewa Pueblos.* Museum of New Mexico Research Records, no. 8. Museum of New Mexico, Santa Fe.

Lambert, Marjorie, and J. Richard Ambler

1961 *A Survey and Excavation of Caves in Hidalgo County, New Mexico.* Monographs of the School of American Research, no. 25. Santa Fe.

Lebel, Robert

1959 *Marcel Duchamp.* Paragraphic Books, New York.

LeBlanc, Steven A.

1975 *Mimbres Archaeological Center: Preliminary Report of the First Season of Excavation, 1974.* Institute of Archaeology, University of California, Los Angeles.

1976 Mimbres Archaeological Center: Preliminary Report of the Second Season of Excavation, 1975. *Journal of New World Archaeology* 1(6):1–23.

1977 The 1976 Field Season of the Mimbres Foundation in Southwestern New Mexico. *Journal of New World Archaeology* 2(2):1–24.

1980 The Dating of Casas Grandes. *American Antiquity* 45(4):799–806.

1983 *The Mimbres People: Ancient Pueblo Painters of the American Southwest.* Thames and Hudson, London.

1986 Development of Archaeological Thought on the Mimbres Mogollon. In *Emil W. Haury's Prehistory of the American Southwest,* edited by Jefferson J. Reid and David E. Doyel, pp. 297–304. University of Arizona Press, Tucson.

LeBlanc, Steven A., and Carol L. Khalil

1987 Flare-rimmed Bowls: A Subtype of Mimbres Classic Black-on-White. *Kiva* 41(3–4):289–98.

Lehmer, Donald J.

1948 *The Jornada Branch of the Mogollon.* University of Arizona Bulletin, vol. 19, no. 2; Social Science Bulletin, no. 17. University of Arizona Press, Tucson.

Lekson, Stephen H.

1986a The Mimbres Region. In *Mogollon Variability,* edited by Charlotte Benson and Steadman Upham, pp. 147–155. University Museum Occasional Paper 15. New Mexico State University, Las Cruces.

1986b Mimbres Riverine Adaptation. In *Mogollon Variability,* edited by Charlotte Benson and Steadman Upham, pp. 181–89. University Museum Occasional Paper 15. New Mexico State University, Las Cruces.

1988 The Mangas Phase in Mimbres Archaeology. *Kiva* 53(2):129–45.

1989 *Mimbres Archaeology of the Upper Gila.* Anthropological Papers of the University of Arizona, no. 53. University of Arizona Press, Tucson.

1991 Chaco, Hohokam, and Mimbres: The Southwest in the Eleventh and Twelfth Centuries. *Expedition* 35(1):44–52.

1992a The Surface Archaeology of Southwestern New Mexico. *Artifact* 30(3):1–36.

1992b Mimbres Art and Archaeology. In *Archaeology, Art, and Anthropology: Papers in Honor of J. J. Brody,* edited by Meliha S. Duran and David T. Kirkpatrick, pp. 111–22. Papers of the Archaeological Society of New Mexico, vol. 18. Albuquerque.

1996a Mangas Redivivus: The Dinwiddie Site and Mimbres Unit Pueblos. Unpublished manuscript in possession of the author.

1996b Southwestern New Mexico and Southeastern Arizona. In *The Prehistoric Pueblo World, A.D. 1150–1350,* edited by Michael A. Adler, pp. 170–76. University of Arizona Press, Tucson.

1999 Unit Pueblos and the Mimbres Problem. In *La Frontera: Papers in Honor of Patrick H. Beckett,* edited by Meliha S. Duran and David T. Kirkpatrick, pp. 105–25. Papers of the Archaeological Society of New Mexico, vol. 25. Albuquerque.

Lévi-Strauss, Claude

1963 *Totemism,* trans. R. Needham. Beacon Press, Boston.

Lowell, Julia C.

1991 *Prehistoric Households at Turkey Creek Pueblo, Arizona.* Anthropological Papers of the University of Arizona, no. 40. University of Arizona Press, Tucson.

Martin, Paul S.

1940 *The SU Site: Excavations at a Mogollon Village, Western New Mexico, 1939.* Anthropological Series, vol. 32, no. 1. Field Museum of Natural History, Chicago.

1979 Prehistory: Mogollon. In *Handbook of North American Indians,* vol. 9, *Southwest,* edited by Alfonso Ortiz, pp. 61–74. Smithsonian Institution, Washington, D.C.

Martin, Paul S., and Fred Plog

1973 *The Archaeology of Arizona: A Study of the Southwest Region.* Doubleday and Natural History Press, New York.

Martin, Paul S., and John B. Rinaldo

1950 Turkey Foot Ridge Site: A Mogollon Village, Pine Lawn Valley, Western New Mexico. *Fieldiana: Anthropology* 38:237–396.

Martin, Paul S., John B. Rinaldo, Elaine Bluhm, H. C. Cutler, and Roger Grange Jr.

1952 Mogollon Cultural Continuity and Change: The Stratigraphic Analysis of Tularosa and Cordova Caves. *Fieldiana: Anthropology* 40:1–528.

Masterkey

1971 Mimbres Site Tested by Curator. *Masterkey* 45:151–53.

Mathien, Frances Joan

1993 Exchange System and Social Stratification among the Chaco Anasazi. In *The American Southwest and Mesoamerica,* edited by Jonathan E. Ericson and Timothy G. Baugh, pp. 27–63. Plenum Press, New York.

Mathien, F. Joan, and Randall H. McGuire, eds.

1986 *Ripples in the Chichimec Sea: New Considerations of Southwestern-Mesoamerican Interactions.* Southern Illinois University Press, Carbondale.

Maxwell Museum of Anthropology

1974 *Seven Families in Pueblo Pottery.* University of New Mexico Press, Albuquerque.

McCluney, Eugene B.

1965 *Clanton Draw and Box Canyon; an interim report on two prehistoric sites in Hidalgo County, New Mexico, and related surveys.* Monograph of the School of American Research, no. 26. School of American Research Press, Santa Fe.

McKenna, Peter J., and James E. Bradford

1987 *TJ Ruin, Gila Cliff Dwellings National Monument, New Mexico.* Southwest Cultural Resources Center Professional Papers, no 1. Branch of Cultural Resource Management, Division of Anthropology, National Park Service, Santa Fe.

Mills, Barbara J.

1986 Temporal Variability in the Ceramic Assemblages of the Eastern Slope of the Black Range, New Mexico. In *Mogollon Variability,* edited by Charlotte Benson and Steadman Upham, pp. 181–89. University Museum Occasional Paper no. 15. New Mexico State University, Las Cruces.

1995 The Origins of Southwestern Ceramic Containers: Women's Time Allocation and Economic Intensification. *Journal of Anthropological Research* 51:149–172.

Mills, Barbara J., and Patricia L. Crown, eds.

1987 *Ceramic Production in the American Southwest.* University of Arizona Press, Tucson.

Minnis, Paul

1985 *Social Adaptation to Food Stress: A Prehistoric Southwestern Example.* University of Chicago Press, Chicago.

Minnis, Paul E., M. E. Whalen, J. H. Kelley, and J. D. Stewart

1993 Prehistoric Macaw Breeding in the North American Southwest. *American Antiquity* 58:270–76.

Moore, Michael

1979 *Medicinal Plants of the Mountain West.* Museum of New Mexico Press, Santa Fe.

Moulard, Barbara L.

1984 *Within the Underworld Sky: Mimbres Ceramic Art in Context.* Twelvetrees Press, Pasadena, Calif.

Munson, Marit K.

1997 Sex and Gender in Black and White: Human Images from Mimbres Ceramics. Frieda Butler Memorial Lecture, Maxwell Museum of Anthropology, University of New Mexico, Albuquerque. Unpublished paper.

2000 Sex, Gender, and Status: Human Images from the Classic Mimbres. *American Antiquity* 65:127–43.

Nelson, Ben A., and Roger Anyon

1996 Fallow Valleys: Asynchronous Occupations in Southwestern New Mexico. *Kiva* 61(3):275–307.

Nelson, Ben A., and Steven A. LeBlanc

1986 *Short-term Sedentism in the American Southwest: the Mimbres Valley Salado.* Maxwell Museum of Anthropology and University of New Mexico Press, Albuquerque.

Nelson, Margaret C.

1993a Classic Mimbres Land Use in the Eastern Mimbres Region, Southwestern New Mexico. *Kiva* 58:27–47.

1993b Changing Occupational Pattern among Prehistoric Horticulturalists in Southwestern New Mexico. *Journal of Field Archaeology* 20(1):43–57.

1999 *Mimbres during the Twelfth Century: Abandonment, Continuity, and Reorganization*. University of Arizona Press, Tucson.

Nelson, Nels C.

1914 *Pueblo Ruins of the Galisteo Basin, New Mexico. Anthropological Papers of the* American Museum of Natural History, vol. 15, part 1. The Trustees, New York.

Nesbitt, Paul H.

1931 *The Ancient Mimbreños*. Logan Museum Bulletin, no. 4. Beloit College, Beloit, Wis.

1938 *Starkweather Ruin*. Logan Museum Bulletin, no. 6. Beloit College, Beloit, Wis.

Ogle, Ralph H.

1939 Federal Control of the Western Apaches, 1848–1886. *New Mexico Historical Review* 14:309–65.

Olinger, Bart

1989 Mimbres Compendium. Neutron activation analysis of Classic Mimbres sherds from twenty-one core area sites. Unpublished manuscript.

Ortiz, Alfonso

1969 *The Tewa World: Space, Time, Being, and Becoming in a Pueblo Society*. University of Chicago Press, Chicago.

Peterson, Susan

1977 *The Living Tradition of Maria Martinez*. Kodansha International, Tokyo.

Plog, Stephen

2003 Exploring the Ubiquitous Through the Unusual: Color Symbolism in Pueblo Black-on-white Pottery. *American Antiquity* 68(4): 665–95.

Reid, J. Jefferson

1989 A Grasshopper Perspective on the Mogollon of the Arizona Mountains. In *Dynamics of Southwest Prehistory*, edited by Linda S. Cordell and George J. Gumerman, pp. 65–97. Smithsonian Institution Press, Washington, D.C.

Rice, Prudence M.

1987 *Pottery Analysis: A Source Book*. University of Chicago Press, Chicago.

Riley, C. L., and B. C. Hedrick, eds.

1988 *Across the Chichimec Sea: Papers in Honor of J. Charles Kelley*. Southern Illinois University Press, Carbondale.

Robbins, R. Robert, and Russell B. Westmoreland

1991 Astronomical Imagery and Numbers in Mimbres Pottery. *Astronomy Quarterly* 8:65–88.

Sanchez, Julia C.

1996 A Reevaluation of Mimbres Faunal Subsistence. *Kiva* 61:295–307.

Sauer, Carl O., and Donald D. Brand

1930 *Pueblo Sites in Southeastern Arizona.* University of California Publications in Geography, vol. 3, no. 7. Berkeley.

Sayles, Edwin B.

1945 *The San Simon Branch: Excavations at Cave Creek and in the San Simon Valley,* part 1, *Material Culture.* Medallion Papers, no. 34. Privately printed for Gila Pueblo, Globe, AZ.

Schaafsma, Curtis F., and Carroll L. Riley, eds.

1999 *The Casas Grandes World.* University of Utah Press, Salt Lake City.

Schaafsma, Polly

1980 *Indian Rock Art of the Southwest.* University of New Mexico Press, Albuquerque.

1992 *Rock Art in New Mexico,* Museum of New Mexico Press, Santa Fe.

1994 The Prehistoric Kachina Cult and Its Origins as Suggested by Southwestern Rock Art. In *Kachinas in the Pueblo World,* edited by Polly Schaafsma, pp. 63–79. University of New Mexico Press, Albuquerque.

Schaafsma, Polly, ed.

1994 *Kachinas in the Modern World.* University of New Mexico Press, Albuquerque.

Schroeder, Albert H.

1960 *The Hohokam Sinagua and the Hakataya.* Society for American Archaeology, Archives of Archaeology, no. 5. Washington, D.C.

Scott, Catherine J.

1983 The Evolution of Mimbres Pottery. In *Mimbres Pottery: Ancient Art of the American Southwest,* by J. J. Brody, Catherine J. Scott, and Steven A. LeBlanc, pp. 39–67. Hudson Hills Press, New York.

Shafer, Harry J.

1982a Classic Mimbres Phase Households and Room Use Patterns. *Kiva* 48(1–2):17–48.

1982b Prehistoric Agricultural Climax in Southwestern New Mexico: The Classic Mimbres Phase. In *Southwestern Agriculture: Pre-Columbian to Modern,* edited by Henry C. Dethloff and Irvin M. May Jr., pp. 3–15. Texas A&M University Press, College Station.

1985 A Mimbres Potter's Grave: An Example of Mimbres Craft Specialization? *Bulletin of the Texas Archaeological Society* 56:185–200.

1988 *Archaeology at the NAN Ruin: The 1987 Season.* Department of Anthropology, Texas A&M University, College Station.

1990 Archaeology at the NAN Ruin: 1984 Interim Report. *Artifact* 28(4):1–42.

1991a Archaeology at the NAN Ruin (LA15049): 1985 Interim Report. *Artifact* 29(1):1–29.

1991b Archaeology at the NAN Ruin: 1986 Interim Report. *Artifact* 29(2):1–42.

1991c Archaeology at the NAN Ruin: 1987 Interim Report. *Artifact* 29(3):1–44.

1991d Archaeology at the NAN Ruin: 1989 Interim Report. *Artifact* 29(4):1–44.

1995 Architecture and Symbolism in Transitional Pueblo Development in the Mimbres Valley, Southwestern New Mexico. *Journal of Field Archaeology* 22(1):23–47.

1996 The Classic Mimbres Phenomenon and Some New Interpretations. Paper presented at the Ninth Mogollon Archaeology Conference, Silver City, NM.

1999 The Mimbres Classic and Postclassic: A Case for Discontinuity. In *The Casas Grandes World,* edited

by Curtis Schaafsma and Carol L. Riley, pp. 121–33. University of Utah Press, Salt Lake City.

2003 *Mimbres Archaeology at the Nan Ranch Ruin*. University of New Mexico Press, Albuquerque.

Shafer, Harry J., and Robbie L. Brewington

1995 Microstylistic Changes in Mimbres Black-on-White Pottery: Examples from the NAN Ruin, Grant County, New Mexico. *Kiva* 61:5–29.

Shafer, Harry J., and Constance K. Judkins

1997 *Archaeology at the NAN Ranch, 1996 Season*. Special Report 11, Anthropology Laboratory, Department of Anthropology, Texas A&M University, College Station.

Shafer, Harry J., and Anna J. Taylor

1986 Mimbres Mogollon Pueblo Dynamics and Ceramic Style Change. *Journal of Field Archaeology* 13:43–68.

Shaffer, Brian S.

2002 The Mythology of Classic Period Mimbres Painted Pottery Iconology: Evaluation of the Iconographic Interpretations. Ph.D. diss., Texas A&M University, College Station.

Shaffer, Brian S., and Karen M. Gardner

1995a The Rabbit Drive through Time: Analysis of the North American Ethnographic and Prehistoric Evidence. *Utah Archaeology* 8(1):13–25.

1995b The Fish-Carrying Pole of the Mimbres: A Perishable Technology Preserved on Pottery. *Artifact* 33(2):1–7.

1996 Reconstructing Animal Exploitation by Puebloan Peoples of the Southwestern United States using Mimbres Pottery, A.D. 1000–1150. *Anthropozoologica* 25–26:263–68.

1998 Female Jar Carriers of the Mimbres: Probable Prehistoric Depictions of Water Transportation. *North American Archaeologist* 19(3):223–31.

Shaffer, Brian S., Karen M. Gardner, and Barry W. Baker

1996 Prehistoric Small Game Snare Trap Technology, Deployment Strategy, and Trapper Gender Depicted in Mimbres Pottery. *Journal of Ethnobiology* 16(2):145–55.

Shaffer, Brian S., Karen M. Gardner, and Harry J. Shafer

1997 An Unusual Birth Depicted in Mimbres Pottery: Not Cracked Up to What It Is Supposed to Be. *American Antiquity* 62(4):727–32.

Shaffer, Brian S., H. A. Nicholson, and Karen M. Gardner

1993 Possible Mimbres Documentation of Pueblo Snake Ceremonies in the Eleventh Century. *North American Archaeologist* 16(1):17–32.

Snodgrass, O. T.

1973 A Major Mimbres Collection by Camera: Life among the Mimbreños, as Depicted by Designs on Their Pottery. *Artifact* 2:14–63.

1975 *Realistic Art and Times of the Mimbres Indians*. O. T. Snodgrass, El Paso, Tex.

Spier, Leslie

1917 *An Outline for a Chronology of Zuni Ruins*. Anthropological Papers of the American Museum of Natural History, vol. 18, part 3. The Trustees, New York.

Spivey, Richard L.
1979 *Maria.* Northland Press, Flagstaff, Ariz.

Stevenson, Matilda Coxe
1993 *The Zuni Indians and Their Uses of Plants.* Dover Publications, New York. (Reprint of
[1915] "Ethnobotany of the Zuni Indians," *Thirtieth Annual Report of the Bureau of American Ethnology,* pp. 31–102, Smithsonian Institution, Washington D.C., 1915.)

Stewart, J. D., P. Matousek, and J. H. Kelley
1990 Rock Art and Ceramic Art in the Jornada Mogollon Region. *Kiva* 55:301–319.

Sudar-Laumbach, Toni
1993 Mimbres White Ware. *New Mexico History and Archaeology* 1:7–9. (COAS Publishing and Research, Las Cruces, N.M.)
1994 Observations on Mimbres Whiteware. In *Mogollon Archaeology: Proceedings of the 1980 Mogollon Conference,* edited by Patrick H. Beckett and Kira Silverbird, pp. 137–46. Acoma Books, Ramona, Calif.

Sweet, Jill D.
1985 *Dances of the Tewa Pueblo Indians: Expressions of New Life.* School of American Research Press, Santa Fe, N.M.

Swentzell, Rina
1989 Pueblo Space, Form, and Mythology. In *Pueblo Style and Regional Architecture,* edited by Nicholas C. Markovich. Von Nostrand Reinhold, New York.
1997 An Understated Sacredness. In *Anasazi Architecture and American Design,* edited by Baker H. Morrow, and V. B. Price, pp. 186–89. University of New Mexico Press, Albuquerque.

Taylor, William
1898 The Pueblos and Ancient Mines near Allison, New Mexico. *American Antiquarian* 20:258–261.

Teague, Lynn S.
1998 *Textiles in Southwestern Prehistory.* University of New Mexico Press, Albuquerque.

Tedlock, Dennis
1985 *Popol Vuh: The Definitive Edition of the Mayan Book of the Dawn of Life and the Glories of Gods and Kings.* Simon and Schuster, New York.

Thompson, Mark
1994 The Evolution and Dissemination of Mimbres Iconography. In *Kachinas in the Pueblo World,* edited by Polly Schaafsma, pp. 93–105. University of New Mexico Press, Albuquerque.
1999 Mimbres Iconology: Analysis and Interpretation of Figurative Motifs. Ph.D. diss., Department of Archaeology, University of Calgary, Calgary.

Townsend, Richard F., ed.
1992 *The Ancient Americas: Art From Sacred Landscapes.* Art Institute of Chicago.

Traugott, Joseph
n.d. Thanks for the Mimbres! Exhibition handout. University of New Mexico Art Museum, Albuquerque.

Turner, Christy G., II

1999 The Dentition of Casas Grandes with Suggestions on Epigenetic Relationships among Mexican and Southwestern U.S. Populations. In *The Casas Grandes World,* edited by Curtis F. Schaafsma and Carroll L. Riley, pp. 229–33. University of Utah Press, Salt Lake City.

Wade, Edwin L.

1974 Change and Development in the Southwest Indian Art Market. *Exploration* magazine, pp. 16–21. School of American Research, Santa Fe, N.M.

Washburn, Dorothy Koster

1977 *A Symmetry Analysis of Upper Gila Area Ceramic Design.* Papers of the Peabody Museum of Archaeology and Ethnology, Harvard University, vol. 58. Peabody, Museum, Cambridge, Mass.

1992 The Structure of Black-on-white Ceramic Design from the Mimbres Valley. In *Archaeology, Art, and Anthropology: Papers in Honor of J. J. Brody,* edited by Meliha S. Duran and David T. Kirkpatrick, pp. 213–23. Papers of the Archaeological Society of New Mexico, vol. 18. Albuquerque.

Watson, Editha A.

1932 The Laughing Artists of the Mimbres Valley. *Art and Archaeology* 33:189–93, 224.

Webster, C. L.

1912a Archaeological and Ethnological Researches in Southwestern New Mexico. *Archaeological Bulletin* 3:101–15.

1912b Some Burial Customs Practiced by the Ancient People of the Southwest. *Archaeological Bulletin* 3:69–78.

Webster, Grady L., and Conrad J. Bahre, eds.

2000 *Changing Plant Life of* La Frontera: *Observations on Vegetation in the U.S./Mexico Borderlands.* University of New Mexico Press, Albuquerque.

Wendorf, Fred

1957 A Mimbres Pueblo near Glenwood, New Mexico. *Highway Salvage Archaeology* 3:71–84. Santa Fe.

Wheat, Joe Ben

1955 *Mogollon Culture Prior to A.D. 1000.* Memoirs of the American Anthropological Association, no. 82. Menasha, Wis.

White, Leslie A.

1935 *The Pueblo of Santo Domingo, New Mexico.* Memoirs of the American Anthropological Association, no. 43. Menasha, WI.

Wilcox, David R.

1999 A Peregrine View of Macroregional Systems in the North American Southwest. In *Great Towns and Regional Politics in the Prehistoric Southwest and the Southeast,* edited by Jill E. Neitzel, pp. 115–141. Amerind Foundation, New World Studies Series, no. 3. University of New Mexico Press, Albuquerque.

Withers, Arnold

1996 Three Circle Red-on-White: An Alternative to Oblivion. In *Southwestern Culture History,* edited by Charles H. Lange, pp. 15–26. Papers of the Archaeological Society of New Mexico, no. 10. Sunstone Press, Santa Fe.

Wobst, H. Martin

1997 Stylistic Behavior and Information Exchange. In *For the Director: Research Essays in Honor of James B. Griffin,* edited by C. E. Cleland, pp. 317–342. University of Michigan Anthropological Papers no. 61. Museum of Anthropology, University of Michigan, Ann Arbor.

Woodbury, Richard B., and Ezra B. W. Zubrow

1979 Agricultural Beginnings, 2000 B.C.–A.D. 500. In *Handbook of North American Indians,* vol. 9, *Southwest,* edited by Alfonso Ortiz, pp. 43–60. Smithsonian Institution, Washington, D.C.

Woosley, Anne I., and Allan J. McIntyre

1996 *Mimbres Mogollon Archaeology: Charles C. DiPeso's Excavations at Wind Mountain.* University of New Mexico Press, Albuquerque.

Woosley, Anne I., and J. C. Ravesloot, eds.

1999 *Culture and Contact: Charles C. DiPeso's Gran Chichimeca.* Amerind Foundation, New World Studies Series, no. 2. University of New Mexico Press, Albuquerque.

Wyckoff, Lydia L.

1985 *Designs and Factions: Politics, Religion, and Ceramics on the Hopi Third Mesa.* University of New Mexico Press, Albuquerque.

Young, M. Jane

1988 *Signs from the Ancestors: Zuni Cultural Symbolism and Perceptions of Rock Art.* University of New Mexico Press, Albuquerque.

Zedeño, Maria Nieves

1994 *Sourcing Prehistoric Ceramics at Chodistaas Pueblo, Arizona: The Circulation of People and Pots in the Grasshopper Region.* Anthropological Papers of the University of Arizona, no. 58. University of Arizona Press, Tucson.

Index

Pendants, 21, 24, 41, 60
Penises in paintings, *39, 160,* 176
Personal adornment. *See* Clothing;
 Jewelry
Personal expression, 102
Personal names, emblems as, 167
Perspective in bowl designs, *145,* 146
Petroglyphs, *101;* Jornada Mogollon,
 172; male activities and, 100;
 Mimbres-style, *171,* 177; Pony
 Hills, *162;* population shift and,
 66; Rio Grande Pueblo Coalition,
 171; rock art, 176
Phallic symbols, *39, 160,* 176
Photographic archives, xv
Pinaleño mountains, 19
Pine Lawn Valley, 55, 69
Pioneer period, 59
Pithouses, 54, 55, 56; burials in, 49;
 chronology and, 12–13; Early
 Pithouse, 30–31; kivas and, 62;
 Late Pithouse, 30–31; NAN
 Ranch, 16; structure of, 33–34
Plain of San Augustín, 18
Plain wares in Mimbres chronology, 31
Planting sticks, 24, 47, 110
Plant life: flowers, *75, 76, 133, 134,*
 164, 166; food plants, 25, 36; illus-
 trations of, 164; native, 21–22; slip
 colors and, 108
Plates: early Mogollon, 69; Hohokam,
 82
Plazas, 33, 34–35, 49, 61
Polar orientation, *128,* 138, 146–147
Polishing techniques, 69, 107, 108, 109,
 135, 186
Polychrome pottery: ancestral Pueblo,
 63, 90–91; Casas Grandes, 91; his-
 toric Pueblo, 104; Mimbres, *47,*
 129, *150;* Mogollon, 97; Ramos
 Polychrome, *65, 91;* Sikyatki
 Polychrome, 95–97, *96,* 184;
 Tabira Polychrome, 94–95
Polygon figures, 70
Pony Hills area, *162*
Popol Vuh, 174
Population: estimates, 31; excavations
 and, 16; growth in, 53; migrations,
 63–66, 97; Pueblo losses in, 179;
 stress, 36, 98
Porcupines, 164

Positive-negative designs. *See* Dualities
Pot-hunting. *See* Looting
Potters: learning techniques, 99–104;
 male or female role, 39; recogni-
 tion of work, 99; specialization of,
 17–18, 102, 103
Potter's wheels, 104
Pottery: chronologies, 11–12; climax
 wares, xxiii; as commodity, 1–2,
 10, 104, 180, 187; cross-dating, 57;
 grave offerings, 49; heirlooms, 58;
 intrusive wares, 51, 57, 58; paral-
 lels to Mimbres phases, 176; sea-
 sonal aspects, 51; techniques, 60,
 99–104; textured, 68; tools, 49,
 110; utility wares, xxiii; viewing
 from above, 117–118, 122. *See also
 names of specific traditions and phases*
Pouring vessels, 73–74, *131. See also*
 Asymmetrical bowls
Powerlessness, 179–180
Prayer plumes, 164
Prayer sticks, 48, 164
Preservation of protected sites, 28
Priests in bowl designs, 45–47
Primitive art documentation, xx
Problems as archaeological focus, 14
Professional archaeologists, 5–11
Pronghorns, 22–23, *140, 151,* 153,
 155, 164, *165*
Proveniences, 180
Pruitt Ranch, *24, 78, 140, 154, 155,
 159, 161, 163, 165*
Pryor, Mr., *43*
Psychic functions of paintings, 178–179
Publications: Mimbres wares in, 185;
 pottery values and, 10
Pueblo village contemporary wares,
 166, 179–180, 185
Pueblo villages: *caciques,* 39–40; gender
 and pottery, 101; Mimbres cul-
 tural resemblances, 46–49. *See also*
 Ancestral Pueblo groups
Puns, visual, 152
Purchasing pottery: Fewkes' purchases,
 5; massive purchases, 1; pottery as
 commodity, 1–2, 10, 104, 187;
 tourist wares, 180
Pyramids, 60

Quail, *140,* 156, *157, 158;* analysis,

192–193; native, 22
Quartered patterns. *See* Segmented pat-
 terning
Quartz, 21
Quetzalcoatl, 171, 173, 183
Quiché Maya, 174
Quivers, *44,* 170

Rabbits, *82, 145,* 153, *163, 165, 168;*
 analysis, 190–191; birds eating,
 167; death symbols, 174; hunting,
 23, 36, 50; moon association, 167;
 mythic, 194; rabbit-eared humans,
 7
Rabbit sticks, 23–24, *25, 145*
Raccoons, 153, 192
Radial patterns, 75, 125
Radioactive carbon 14 dating, 57
Rainfall, 26, 166
Ramos Polychrome, *65, 91*
Ranger Station site, *100, 150*
"Readymades," xix, 183
Realistic subjects. *See* Representational
 subjects
Red-brown colors, 108, 111, 112
Red Mesa Black-on-white, 89
Red pottery wares: ancestral Pueblo, 62,
 86; early comparisons, 13; red-on-
 red wares, 186; unpainted, 68
Red slips, 71
Reduction firing, 72, 86, 89, 111, 112
Regional identity, painting styles and,
 180
Regional variations in designs, 103
Regularity in designs, 120
Religious societies. *See* Ceremonial
 areas; Rituals
Repetition of design elements, 121
Representational subjects: ambiguity
 and, 150; ancestral Pueblo wares,
 90; basic structure, 137–138; basic
 styles, *128;* designs within life-
 forms, 149, 153; draftsmanship,
 149; early techniques, 77–79; fram-
 ing, 77; *vs.* geometric designs, 67;
 Hohokam wares, 84–85; Hopi
 wares, 95–97; iconography,
 164–176; inspiration for, 80; mean-
 ing of, 182–183; Mimbres design
 evolution, 79; mythic. *See* Mythic
 creatures; narrative compositions,

139, 144–145, 149, 152, 190–193; nonnarrative compositions, 190, 192; objective of, 182; relationships in, 182; Sikyatki wares, 95–97, 184; single figures, 138–142, 190–194; skill in, 99–100; subjects, 149–156, 161, 164; symbolism of, 181; Tabira Black-on-white and Polychrome, 94–95; void spaces, 77

Reptiles, 22, 152, *153,* 190–194. *See also specific reptiles*

Reserve Black-on-white, 92, *92,* 93, 97, 187

Reserve phase, 57

Reshaping pottery. *See* Asymmetrical bowls

Restored bowls, 1–2

Rhomboids, *126,* 131

Rims, 73, 77, 82, 115

Rinaldo, John B., 13, 14

Río Carmen, 63

Rio Grande Pueblo ceramics, 91

Rio Grande Pueblo Coalition period, *171*

Rio Grande Valley, 19, 27, 64

Rituals, *41,* 45–47, 53; ancestral Pueblo, 63; clues to, 166; community-wide, 114; dances, 48; digging sticks, 47; Hohokam, 60; Katsina societies, 114; Mogollon, 56; trade goods and, 51. *See also* Burials; Ceremonial areas; Mortuary practices

Rivers in Mimbres territory, 19–20

Roadrunners, 22, 164, 192

Rock art, 176. *See also* Petroglyphs

Rodents, 156, 164

Romero, Diego, 188, *189*

Roof supports, 34

Rooftop entries, 48, 167

Room orientation, 48

Rosa Black-on-white, *90*

Rotating bowl designs, *133,* 134, 164–165

S-shapes, 129, 134, *135*

Sacrificed bowls ("killed" bowls), 49, 50, 177

Salado tradition, 52, 58, 66, 91, 97

Salinas pueblo, 66, 97

Salt, 21

Salvage excavations, 15, 16, 28

Sandals, 43

San Diego Museum of Man, 8

San Francisco mountains, 18

San Francisco phase, xiv, 31, 69

San Francisco Red ceramics, 31

San Francisco river drainage, 4–5, 13, 18, 19

San Ildefonso pottery wares, 104, 185–186, *186*

San Pedro Valley, 60

San Simon people, 55, 68, 80, 82

San Simon Valley, 19, 55

Santa Cruz Red-on-buff, *83, 85*

Santa Rita area, 2, 107

Sapillo Creek, 27

Satire, 182

Saw-toothed motifs, 70

Sayles, E. B., 13, 14

Scale of figures, 161

Scars on bowls, *109,* 113, 177

School of American Research (School of American Archaeology), 6, 7, *44, 75, 109, 157, 165*

Schwartz, Douglas W., xiii, xvi, xx

Scoops, 120

Scorpions, 192, 194–195

Scott, Catherine, xiv, xv, 58

Scraping techniques in pottery, 60, 81, 107

Scratches in used bowls, *109,* 113, 177

Scroll patterns, 70, 76, 77, *78,* 83, 88, 93, 129

Seasonal activities, 51, 111

Seasonal dwellings, 36, 58

Seated men, 147

Secular life, 50–51

Sedentary lifestyles, 61

Sedentary period, 60, 61, 86

Seed jars, *116,* 117, *127, 188*

Segmented patterning: ancestral Pueblo, 88; basic styles, *128;* divided bands, 122, *128;* Dos Cabezas, 68; filler motifs, 135; four-quartered, 83, *128;* Hohokam, 83; Mimbres, 76; Mogollon, 92–93, 97; panels in bowl designs, 122, 125, *128;* Salado, 97

Serpents, horned. *See* Horned serpents; Snakes

Severed heads, *42, 43,* 147, 173–174

Sexual attributes in human figures. *See* Gender

Shafer, Harry, xvi; ceramic sequences, 58; excavations, 29; Mimbres research, xv; on mortuary practices, 49; NAN Ranch work, 16, 29; on population, 31; on style phases, xiv; on subfloor burial, 34; Texas A&M field schools, xiii

Shaffer, Brian, xv, xvi

Sheep. *See* Bighorn sheep

Shells: clam shells, *38,* 41, 164, *165;* Hohokam use, 61; illustrations, *38, 165;* jewelry, 49, 60; trade and, 51, 60

Shields, *44,* 170

Shovels, 24

Shrines, 48

Shrubs, 21

Siamese-twinned fish, 170

Sikyatki Polychrome, 95–97, *96,* 184

Silhouettes, 85, 149

Single-figure subjects, 138–142, 190–194

Sipapus, 118, 167, 175

Site destruction. *See* Looting

Skullcaps, 41–42, *44*

Skunks, 164

Sky, representing, 139–142, 149

Slips: brown, 71; colors, 108; filler elements, 129; layers, 107–108; materials, 107, 108; Mogollon, 69; red, 71; San Ildefonso, 186; techniques, 107; Three Circle, 71; variations, 103; white, 88, *107,* 111

Smears, 108

Smoke: passing through, 48; smoke holes, 34

Smoothing techniques, 107, 115

Snakes, *79, 153, 153;* analysis, 190–191; mythic, 194–195; symbolism, 175. *See also* Horned serpents

Snaketown Ruin, *82, 83, 85*

Snares and traps, *24,* 168

Social anthropology, 14–15

Social change, 31–32, 52, 81–82

Social life. *See* Communities

Socorro Black-on-white, 89, 92, 93, *93,* 94, 95, 97, 187

Sonoran Desert, 19, 22

Southwest Museum, 8, 12, 201